Indie 2.0

Indie 2.0

change and continuity
in contemporary
American indie film

Geoff King

Columbia University Press

NEW YORK

Columbia University Press
Publishers Since 1893
New York Chichester, West Sussex
cup.columbia.edu
Copyright © 2014 Geoff King

First published by I.B.Tauris & Co Ltd. in the United Kingdom.

Library of Congress Cataloging-in-Publication Data
King, Geoff, 1960–
 Indie 2.0 : change and continuity in contemporary American indie film / Geoff King.
 pages cm
 Includes bibliographical references and index.
 ISBN 978-0-231-16794-9 (cloth : alk. paper) — ISBN 978-0-231-16795-6 (pbk. : alk.
 paper) — ISBN 978-0-231-53789-6 (e-book)
 1. Independent films—United States—History and criticism. 2. Motion pictures—
 United States—History—21st century. I. Title.
 PN1993.5.U6K466 2013
 791.430973—dc23

 2013019584

Columbia University Press books are printed on permanent and durable acid-free paper.
This book is printed on paper with recycled content.

Printed in the United Kingdom
c 10 9 8 7 6 5 4 3 2 1
p 10 9 8 7 6 5 4 3 2 1

Cover Image: *Four Eyed Monsters*, directed by Arin Crumley and Susan Buice (2005)
Cover Design: Paul Smith

References to websites (URLs) were accurate at the time of writing. Neither the author nor
Columbia University Press is responsible for URLs that may have expired or changed since
the manuscript was prepared.

Contents

Illustrations

Introduction: Discourses on the state of indie film

Times of crisis are times for opportunity. But first you have to admit there is a crisis.

Ira Deutchman[1]

The proclamations of Indie Film's demise are grossly exaggerated. How can there be a 'Death of Indie' when Indie – real Indie, True Indie – has yet to even live?

Ted Hope[2]

The early part of the twenty-first century witnessed a period of potentially radical new openings and opportunities for independent filmmakers. The advent of inexpensive digital video as a production medium and of broadband internet as a channel for distribution, sales and other activities combined to create the possibility of unprecedented freedom from external controls and restraint. At the same time, however, something approaching a crisis was frequently diagnosed in the more-established model of the indie feature business. The power

of studio-owned speciality divisions continued to be seen as a threat to small-scale or more innovative indie production, even while some of these subsidiaries faced closure or other difficulties of their own. More profoundly, perhaps, for some commentators, the very notion of an 'authentic' indie alternative to the mainstream was questioned, both generally and in the specific context of a period some two decades or more after its rise to prominence in the latter part of the 1980s.

So, what is the status of the American indie sector after the first decade of the millennium? The main title of this book, *Indie 2.0*, implies that this has been a period of change, a new iteration of the indie model that became institutionalized in a particular form in the last two decades of the previous century. This is true to some extent in certain dimensions, but this book also argues for a strong vein of continuity in indie practice, both industrially and in the textual qualities through which individual features mark their distinctive attributes from those usually associated with the Hollywood mainstream. The term 'iteration' seems appropriate in its suggestion of a particular incarnation or version of a system but one that entails a central dimension of repetition or continuity.[3] As has always been the case, differences at the textual level tend to be relative and variable rather than absolute, terms such as indie and independent or Hollywood and mainstream needing to be used with some caution, as broad markers of cinematic territory rather than as signifiers of absolute or necessarily clear-cut difference.

I use the term indie here to denote the particular form of independent feature production that achieved cultural prominence in the period suggested above, a still far from exact quantity but one that can be distinguished in broad terms from wider uses of independent to encompass all varieties of non-Hollywood production in the history of American cinema.[4] Indie has the merit of suggesting a particular range of textual qualities and bases of audience appeal in a specific cultural formation rather than exclusively privileging industrial grounds of definition, as has sometimes been the case in attempts to pin down the term independent in literal terms. Indie, thus, suggests a particular sensibility or set of sensibilities − a particular cultural realm, or range, a particular kind of film practice, with its own material basis − not just a separation from the production of the major

studios, even if its boundaries might often remain somewhat fuzzy and it might include considerable variety.[5]

As Michael Newman suggests, '*indie* gained salience as a more general term for nonmainstream culture in the 1990s', to some extent as 'simply a synonym for *independent* but with an added connotation of fashionable cool', in film and music and also a wider sphere including booksellers, zines and various other forms of alternativie media.[6] The term can be seen as a mystification of notions of independence in film, as Newman puts it, in its decoupling of the concept from a strict notion of separation from anything connected to the realm of the Hollywood studios, but it also seems usefully to capture a sense of the broader contours of this particular cultural field, as opposed to all possible uses of independent in economic terms.[7]

A key thread running through this book concerns not just indie films themselves, in their various industrial and textual dimensions, but also the discursive structures of this kind within which they are situated. The main focus, with the exception of one chapter, is on lower-budget, smaller-scale indie features, particular examples of which have been celebrated by some commentators as offering a maintenance of, or return to, 'true' indie roots. Such a conception can be grounded in particular factual detail, in textual features or the characteristics of the contexts of production and/or distribution; but it is always also a notion that requires interrogation in its broader implications for our understanding of the processes through which cultural terrain is marked out and given particular associations.

An ongoing process of position-taking can be identified in the manner in which particular variants are situated as more or less 'true' indie or authentic, or in which others are rejected as inauthentic (in some accounts, the division here might be between the use of the term indie, where an emphasis is put on its diminutive connotations, and the more steely implications of 'independent'). The latter applies especially to those seen as in some way invalidated through either proximity to the studio speciality divisions or the use of textual qualities judged by some critics to display evidence of an attempt consciously to confect (or, put more strongly, to fake) an indie impression by playing into already-too-established conventions; often, it seems, a combination of the two.

This is typical of the kinds of debates and position-takings established around cultural productions of any kind that make claims to some degree of alternative status, often elitist in social implications, in relation to an established commercial mainstream. The world of indie music offers perhaps the most obvious parallels with that of indie film.[8] A useful framework within which to understand such realms is Pierre Bourdieu's conception of the 'field of cultural production' as a dynamic space within which various mutual articulations occur between more and less mainstream or commercial forms of production and consumption, including the various gradations often established within the sphere of the indie/alternative itself.[9] A variety of different kinds of production provide, in turn, grounds for acts of distinction on the part of viewers/consumers through the exercise of differing resources of cultural capital.[10]

The bottom line, for this approach, is that acts of cultural consumption and expressions of taste and preference are structured in a manner strongly related to the social position of the consumer, those with greater accumulations of cultural capital (a product of upbringing and education) generally being more equipped not just to consume but to derive pleasure from the consumption of products marked out as distinct from the mainstream; a process through which they mark their own belonging to groups to which particular kinds of cultural cachet are attached.[11] The implication of this way of understanding the consumption of non-mainstream products such as indie cinema is that various kinds of socially-rooted investments tend to be made in notions of different kinds and degrees of independence or indie-ness, an issue to which this book returns on a number of occasions.

The notion of an *indie 2.0*, as a particular iteration that might have some of its own grounds of appeal or on which to be questioned, is explored in this book at a number of levels. The most obvious resonance is with the term 'Web 2.0', although this applies in its strongest form in only a small number of cases. Web 2.0, a concept developed in the mid-2000s, signifies a shift of orientation that enables and encourages collective participation and collaboration in the production of online materials. This applied only to a very limited extent at the end of the 2000s to the production of feature-length indie films, the principal subject of this book. Existing uses of the web, still

evolving at the time of writing, focused primarily on dimensions such as promotion, distribution and sales by filmmakers whose production practice remained located in a more traditionally hierarchical context of separation between creative artist and audience. The internet still offered radically new potential in these dimensions, however, sufficient to constitute a new phase of indie development, particularly as a means of evading the control over the market exerted by the studio speciality divisions and some larger indie players. A number of more radical innovations in collaborative web-based funding, production and post-production are considered in Chapter 2, although these remain relatively marginal practices, with the exception of the work of some independent documentary filmmakers.

The term indie 2.0 is also used in a broader sense in this book, to suggest the existence of a second generation of indie films and film-makers, coming to fruition some 20 or so years after what is now established as the 'classic' indie breakthrough period of the 1980s and early 1990s. The context here is one in which indie exists as an already-established and institutionalized category in which both to work and for work to be placed – positively or negatively – by critics and other commentators. It is in this sense in particular that the notion of an artificially confected or commodified version of indie cinema gains much of its currency, as explored in Chapter 1, both in itself and per-haps more importantly as a negative point of reference against which to assert the greater authenticity of other examples. More narrowly, the term also serves to denote a certain historical period of indie film, from 2000 to the early part of the second decade of the century.

As far as the overall health of the indie sector was concerned in this period, the verdict appeared to be mixed. There was much talk of crisis, as suggested above, either actual or impending. This was partly related to the specific economic difficulties of the late 2000s and after, following the 'credit crunch' of 2008 and the consequent global reces-sion, but also to some more local tendencies in the indie film landscape itself. For some commentators, however, certain of these develop-ments were seen as either heralding a return of indie cinema to something closer to its roots or as offering new opportunities to the sector. In both cases, the diagnosis can be interpreted in the context of the kinds of discursive formations outlined above.

The dominant tenor of discourses in the trade press in the late 2000s, both Hollywood-centric publications such as *Variety* and *The Hollywood Reporter* and the indie-specific online *indieWIRE*, tended towards an emphasis on the crisis end of the spectrum. This is unsurprising, given the likely impact of recession on the indie sector, not to mention the fact that crisis tends to make for better short-term headlines. Funding has always been a problem, especially for new filmmakers or smaller operations without ties to the corporate majors, and a tightening of credit was widely assumed to impact on indie production. Downturns and recessions are generally expected to make investors more risk-averse, presenting a real and immediate difficulty to the indie sector.

This, in itself, was nothing new, however, even if the recession from the late 2000s was particularly deep. The sector had faced similar problems in the past, including the aftermath of the 1987 Wall Street crash, the effect of which included the closure of a number of indie distributors in the late 1980s and early 1990s. This came at a time when public sources of funding, an important ingredient in the indie recipe for some filmmakers in that period, were also sharply curtailed for political reasons. Various other financial ups and downs have affected the indie business in the past two decades or so, making it far from easy always to be clear whether particular signs of crisis are related to specific factors – such as a particular economic downturn – or the broader pressures often felt by those operating in the more marginal parts of the industry.

Throughout the 1990s, however, despite various setbacks, indie cinema as a whole continued to thrive in many respects. The numbers of films produced rose consistently during the decade, although many failed to achieve theatrical distribution, a trend that has been more or less constant throughout the recent history of the sector and appeared to be sustained into the second decade of the new century. A measure often used in the trade press is the number of films competing for inclusion in the now always-oversubscribed Sundance festival, a figure that continued to rise in 2009, 2010, 2011 and 2012.[12] If there was nothing to indicate a fall-off in production, the key locus of notions of crisis might be sought in the central arena of theatrical distribution. A common theme of coverage in the trade press in this period was the increasing difficulty faced by indie films in this domain, particularly

for relatively smaller productions. But this, again, is a problem that had been identified in one way or another for at least a decade, without the indie sector being destroyed or grinding to a halt as a result. Fears have been repeatedly expressed since at least the late 1990s of the impact of too many indie films competing among themselves, effectively cannibalizing each other's market.

So this is another factor that does not appear to offer any clear-cut grounds for identifying a new crisis specific to the late 2000s, even if the period may have been characterized by some particular difficulties, including a general reduction in the advances paid by distributors to those films that did get picked up for theatrical release. Such concern was also qualified by a return to a cautious optimism about the potential sustainability of the established market for theatrical acquisition in the wake of an upturn in sales at the 2010 Toronto and 2011 Sundance festivals (an improvement followed by solid if less spectacular sales at Sundance in 2012), further evidence of the hazards involved in – and rhetorical nature of – much of the reporting of such short-term fluctuations.[13]

The sense of threat posed to more traditional theatrical distribution is closely connected to another key element in these discourses, the development of what became known in the 1990s as Indiewood, the area in which Hollywood and the indie sector seem to merge or overlap, particularly in the form of the speciality divisions owned by the Hollywood studios and seen as having gained or exerted undue control over the sector as a whole, particularly through their ability to dominate access to theatres.[14] The very existence of Indiewood is perhaps viewed as a more profound threat, however, regardless of any of the specific strategies with which it became associated (these include developments such as a move to a more hit-based economy, increased involvement by speciality divisions in production, bigger spending on acquisitions and marketing, and a general shift in broadly more conservative directions). The presence of Indiewood has often been treated as a threat to the very notion of indie as anything that can at all clearly be distinguished from the mainstream. The term Indiewood is often used in a derogatory manner in indie circles, a classic example of the negative reference point against which a discursive concept such as 'true' indie might be defined.

Discourses of crisis, frequently subject to rhetorical overstatement in the trade press and elsewhere, are often accompanied, however, by what appears to be their opposite: an emphasis on the existence of more positive opportunities, especially at the lower end of the indie scale. Major contributions to this discourse in the late 2000s revolved around the potential offered by digital production and distribution, as suggested above. A positive spin could also be put on the status of the studio speciality divisions, themselves seen by some as entering a period of crisis at the end of the decade. Commentators were quick to seize upon a number of setbacks faced by the divisions, most prominently the decision by Time Warner to close its indie/speciality division, Warner Independent Pictures, in May 2008 as part of a series of changes that also led to the dismantling of its more mainstream/genre oriented New Line Cinema and New Line's indie-leaning Picturehouse wing. This was followed by other events including the effective closure of Paramount Vantage, the operations of which were folded into those of the main studio. Disney's Miramax division underwent a radical downsizing after the departure of its founders Harvey and Bob Weinstein in 2005, eventually being sold in 2010 to a group of private equity investors including the construction magnate Ron Tudor. The closure by Disney of the Miramax offices in New York was at this point a development of symbolic as much as more substantial significance, given the iconic role played by the company in the growth of the indie scene and the process through which parts of it morphed into Indiewood in the 1990s (the Weinsteins went on to form their own new entity, The Weinstein Company, the fortunes of which were also viewed as questionable in this period).

A general impression was created by many commentators that Hollywood was engaged in a withdrawal from the indie sector. This may have been exaggerated, given the continued prominence of other divisions such as Fox Searchlight and Universal's Focus Features, and of releases from these subsidiaries at both the box office and prestige events such as the Academy Awards (and the fact that this can be a changing territory: Paramount announced a new Insurge division to develop micro-budget films in 2010, for example, after its success with the distribution of *Paranormal Activity* [2007], an initiative greeted with some skepticism in indie circles;[15] The Weinstein Company,

meanwhile, appeared to be thriving following its successes with *The King's Speech* [2010] and *The Artist* [2011]). What was striking about the discourse of withdrawal on the part of the studios, however, was less the question of its veracity than the tone in which it was expressed, which tended to be highly favourable. That is to say, if the studios were pulling out (or, at least, some of them were doing so or reducing the scale of their commitment) it was widely seen as 'good riddance'. A panel at the London Film Festival in October 2008 was titled, somewhat hyperbolically, 'Indiewood is Dead… Long Live the New, True Indies', while a broadly similar sentiment was expressed in a discussion of the contemporary state of the business in *Filmmaker* magazine, published by the Independent Feature Project. Ira Deutchman, a long-term indie stalwart, suggested that 'the market correction that is happening with the majors getting out of this business is the best thing that has ever happened', a view echoed by the prominent indie producer Ted Hope: two substantial voices from inside the indie sector.[16]

One person's crisis, according to these responses – in this case, that believed by some to be facing the Indiewood studio divisions – is another's source of potential revival. Further examples can be found in press coverage, both mainstream and trade-oriented. A feature by *The New York Times* critic Manohla Dargis in September 2008 was headlined in similar fashion to the London festival panel: 'The Revolution Is Dead, Long Live the Revolution'.[17] The 'current line' on independent film, Dargis suggests, 'is that it's dead, in crisis or at least in trouble' (quite a variety of verdicts), the 'biggest shock' having been the closures announced by Time Warner. This may be bad news for those who lost their jobs, she writes, 'but I'm not persuaded that it means all that much for true independents, those who have never worked inside the studios, never wanted to and probably couldn't if they tried.'

Much of the coverage of the first Sundance festival to follow the Time Warner announcement and the development of the credit crunch, in January 2009, took a similarly positive line as far as the underlying state of 'true' indie values was concerned. The festival was judged to have been less crowded than usual, as a result of the straightened times. For *Variety*, this prompted a positive overall verdict: 'fewer

folks jamming into Park City made for a more pleasant festival this year. For once, with industry and media entourages cut back, more locals and film buffs got into the venues.'[18] *indieWIRE* headlined it as 'A Quieter Sundance' in a tone that also implied that this made it in some respects a 'better' festival, more in tune with its roots. A similar view was taken by Dargis in *The New York Times* – 'the most pleasant Sundance in memory' – although accompanied by expressions of caution about future sources of production funding.[19] As with the downsizing of Miramax, the expression of such views about Sundance can be viewed as carrying more weight than the literal meaning, the growth of the festival and its links with the studios having become another major signifier of departure from smaller-scale and supposedly more authentic beginnings.

What, then, should we make of these notions of crisis and their opposite, often linked, in celebrations of the 'true' indie that might thrive or have prospects for revival, either alongside or as a more or less direct result of the constraints faced by the Indiewood end of the spectrum? There appears to be more to these discourses than just a series of matter-of-fact reflections on the various ups and downs of different parts of the indie landscape. Diagnoses of crisis or renewal can be understood as parts of the same discursive regime surrounding indie cinema, one in which the two positions are mutually implicated rather than simply opposed. Both could be said always to have been in play. Indie cinema often seems to have been viewed as existing in a state of close-to-permanent crisis of one kind of another – while also seeming always to retain some potential either to continue to thrive, at some level, or to undergo revival at some point in the future. One way of understanding this is to suggest that, within the prevailing discourse, the indie sector almost *needs* to be seen as existing in a per- manent state of crisis; that this is, in a sense, part of its definition. To be truly indie, in this view, is not to be too stable and secure but to exist in a manner that is understood as being in some way 'on the edge', or at least embattled if located with the arms of a studio division.

One of the problems diagnosed from this perspective is any kind of institutionalization of indie, other than at the smallest scale, something that might be seen as a contradiction in terms. This might include the

very use of a term such as indie itself, in the way it is employed here to signify a particular consolidation of a number of independent traits within a particular period (and particularly for those who might use the term in the diminutive sense, to suggest something more compromised than what might be signified by 'independent'). Institutionalization was clearly an important part of the formation of indie cinema that crystallized in the 1980s and 1990s – a story that is now familiar – through the creation or consolidation of a distinct realm of indie distributors, festivals and other organizations. This can be understood in the terms used in Howard Becker's classic account of the formation of a particular 'art world', the constitution of which also involves the work of critics and receptive audiences, issues to which we return later.[20] The problem comes when this kind of process is perceived to have gone too far, through too much institutionalization or consolidation. This immediately raises a number of questions, however, along the lines of: how much is too much?

How big can an indie distributor or an indie-oriented festival become before it is seen as posing a threat to some core notion of independence? Any association with one of the Hollywood studios is an obvious cut-off point for many; hence, the aversion often expressed towards their speciality divisions or the Hollywood presence at events such as Sundance. The Oscar aspirations of some Indiewood films are another source of suspicion. While the indie sector has its own equivalent, the Independent Spirit Awards, these are seen to have let down the barriers by not excluding films produced and distributed by the main divisions of the studios. Guidelines for selections followed by the nominating committee suggest that films made with 'an economy of means' could still be considered independent when fully financed by a studio or a studio speciality division 'if the subject mater is original and provocative.'[21] The how-much-is-too-much argument is conducted in a particularly open way in relation to the Spirit awards, a specific budget ceiling having been imposed on entrants into the main competition since 2006, a frequent source of debate and controversy in the indie community, the threshold being a substantial $20 million.

At the heart of much of this discourse is an emphasis on the importance of authenticity as a marker of indie status; or, loss of authenticity

as a source of one kind of perceived crisis. This is a recurrent trope, whether expressed directly or more indirectly. Claims to the status of some kind of authenticity are made by many indie films, practitioners or spokespeople, at various levels. These include certain formal qualities, as displayed in many of the films examined in this book, notable examples including the grainy black-and-white photography of key films now established as indie classics or the pixilation of low-budget DV features. Pitches for authenticity are also made, implicitly, through devices such as the absence of certain kinds of plotting or narrative structure. It is notable that what is characteristically involved here is usually understood as a negation of qualities associated with Hollywood, the latter being something of a byword for all that is assumed to be false, fake and contrived. It is easy to over-simply this picture. Far from all indie production has positioned itself as authentic and Hollywood can also embrace a wider range than is sometimes acknowledged. But over-simplification is precisely the currency of these kinds of discursive regimes.

The notion of authenticity spreads more widely than just being a matter related to specific qualities of indie films. It applies not just to the form and content of texts, but also to all other aspects of the business. This would include areas such as marketing and distribution strategies, key regions of debate around the nature and qualities of whatever makes the indie sector more or less distinctive. 'Authentic' approaches to marketing and distribution would be seen as those that take their cue from individual films themselves, rather than being more formulaic. One of the distinctive markers of indie distribution as it grew from the 1980s was an emphasis on close attention to the particular qualities of the individual text, and the constituencies to which those might appeal. The authentic version of marketing would be 'grass-roots' marketing, in which campaigns are carefully tailored to the particular audience that might be reached by a particular film if it were given a chance. This was the niche occupied by many of the earlier indie distributors, giving that extra care to films that were unlikely to succeed without it.

Opposed to this would be the growing tendency from the later 1990s for indie or Indiewood films sometimes to be treated more like their mainstream equivalents: a formula based on higher spending on

advertising and on wider, quicker theatrical openings. The implica-
tion here is treatment more as generic industrial product and less as
individual works of art in need of special attention. This is another
dimension in which distinctions are often made between the
approaches of the smaller indie distributors, remaining true to the
original recipe, and studio divisions searching for sources of larger,
cross-over success (even here, though, this is an area in which it is easy
to over-simplify the distinction; Indiewood features, for example, are
often handled in ways that draw on aspects of both the indie and
larger-market strategies, while the classic indie recipe could also be
considered to have become a generic formula of its own kind, in
some respects).

How should we understand the location of this kind of discourse?
It is quite possible to see discourses relating to authenticity, or its
absence, evolving organically from the actual development of indie
film in this era. It did start very small and has grown larger, in a process
that might be expected to be a cause of concern to many of those
with investments in the distinctive nature of the earlier form. This
might be posited without implying the existence of any entirely pure
and prelapsarian original; just in a more proximate sense of one kind
of entity being to a greater or lesser extent overwhelmed by another.
Why, though, so much investment in this? The tenor of much of the
debate about the nature of indie cinema at any moment often seems
to imply something more than just an immediate literal concern
about particular concrete issues, developments or threats. I am drawn
back here to a phrase I have used elsewhere in passing, in more or less
rhetorical style myself, to characterize those who seek to position
themselves as policing the boundaries: 'defenders of the indie faith'.
Something of that kind of quality, a quite deep-rooted investment,
appears to characterize the terms in which these debates are some-
times conducted.

A useful and in some ways provocative framework in which to under-
stand the nature of this investment is offered by Wendy Fonarow's
study of indie music, *Empire of Dirt: British Indie Music, Aesthetics and
Rituals*, a work of social anthropology. Fonarow begins with a portrait
of indie music that suggests quite substantial similarities to the way
indie is usually conceived in the realm of film, which is not surprising,

given the extent to which the adoption of the term in relation to film appears to have drawn on discourses associated with music. There is no exact, single definition of indie music, she suggests, in much the same way that I and others would argue about indie film. But, she continues: 'Although indie has no exact definition, the discourses and practices around the multiple descriptions and definitions of indie detail a set of principals that reveal the values and issues at stake for the community.'[22]

At the heart of the process of definition, as Fonarow suggests, is one of differentiation, as is the case with all cultural groupings: 'To form a group, members need to create a set of boundaries between what constitutes and excludes membership.'[23] That is quite straightforward cultural anthropology and can clearly be applied to the manner in which discourses function around indie film along the kinds of lines associated with Bourdieu outlined above or Becker's concept of the art world. What, though, exactly is at stake in this process as it operates in the indie arena? What Fonarow finds at work here is, indeed, something related to faith, although in a secularized context. The underlying discourse, she suggests, is one that owes much to Puritanism: 'The core issues of indie and its practices are in essence the arguments of a particular sect of Protestant reformers within the secular forum of music.'[24] This seems to apply equally well to the indie film sector, even if religious discourse might at first appear an unusual or uncomfortable place to go in search of understandings of indie music or film.

The primary difference between Protestant and Catholic churches at the time of the Reformation, Fonarow suggests, concerned the means of reaching the goal of achieving a true relationship with the divine. Key questions related to how a connection with the divine might be established, where religious authority lay, how the divine was accessed, and so on. 'Within indie', Fonarow argues, 'we find similar arguments regarding the nature of experience, but in this case experiencing the divine is displaced onto the experience of "true" or "authentic" music', for which we can also read film.[25]

> Should music be produced by centralized authority (major labels) or
> by independent local operations (independent labels)? What form
> should music take to promote the experience of true music

(the generic characteristics of indie vs. the generic characteristics of other genres)? How should listeners experience music to foster a true encounter with music (live vs. recorded)? How is one's authentic musical experience measured? Indie's arguments replace the experience of the true spirit of the divine with that of the true spirit of music. The common goal set forth for music listeners within indie cosmology is to have a communion with the sacred quintessence of music. Differences in musical practices are interpreted through a moral frame, producing an aesthetic system based on moral values.[26]

Much of this can be applied to the realm of indie film, if with some exceptions. There may be no exact equivalent to the opposition between live and recorded music, for example, although for some there might be a similarity to the distinction between the theatrical and home-viewing experiences. Numerous parallels can be identified, including the often rather vague manner in which each version of indie is defined against notions of 'the mainstream', the latter often being employed as a loose, negative catch-all term.[27] In each case, there is a strong discourse related to notions of authenticity, including a grass-roots do-it-yourself aesthetic at the lower-budget end of the scale, that is contrasted with the corporate domination of the mainstream. In each case, from an industrial perspective, distribution is identified as a key battleground and an arena in which particular indie strategies have been developed.

Distribution is also a key territory in which lines have become blurred. Indie music experienced a very similar trajectory in the late 1980s and 1990s to that undergone in the world of indie film: a growth that included cross-over success into larger markets and higher cultural profile, a process that led to many formerly independent companies being taken over or funded by major music corporations.[28] Indie music also shares the indie film emphasis on the importance – and, it is implied, moral superiority – of grass-roots marketing over reliance on saturation advertising campaigns.[29] There is also, in both cases, a strong tendency to distrust anything that achieves wider popularity, on the basis of an assumption that this must be the result of 'selling out' or diluting the basic principles of the indie aesthetic in some way, as seen in the cases of breakout films such as *Little Miss*

Sunshine (2006) and *Juno* (2007), examples examined in detail in Chapter 1.

The key point for Fonarow is that: 'It is the persistence of these metaphysical cultural narratives that creates such consistency in the indie community's discourse despite the changes in its personnel, the variations in its music, and the crossing of national borders.'[30] This, again, seems useful as a framework to apply to discourses that have been employed quite consistently in relation to certain central aspects of indie cinema. *Why* the world of indie film or music should be tied up with broader cultural discourses of this kind is clearly an important question. There seems little doubt that this would not be something happily embraced in these terms by most of those who would situate themselves within the indie community. As Fonarow suggests in relation to music, some latent recognition can be identified in the use of terms such as 'purist' and 'puritanical' with a small 'p'. But the roots of this in religious doctrine are not generally recognized within what is considered to be an entirely secular and culturally alternative sphere. Most of those involved might be expected to be appalled by the suggestion that many of their key values are associated with what is likely to be seen as a conservative and repressive ideology; that, as Fonarow puts it, instead of a form of rebellion, indie discourse involves a recapitulation of dominant cultural ideology and narratives. On the surface, there seems to be a strong disjunction between the two.

How might this be explained? Fonarow's sociologically-based argument is simply that aesthetic discourses tend to follow the same lines as broader religious or metaphysical discourses in all cultures. While this is territory familiar to anthropologists studying other cultures, Fonarow suggests, it is something of a blind-spot in the study of the arts and other secular realms of Western societies. 'It is a Western conceit', she argues, 'to think that only in other societies do religious notions pervade all domains of life. We consider our own secular spheres [to be] free of metaphysical concerns', when that is actually far from the case.[31] An argument can certainly be made for the deep-rooted presence of many Puritan concepts within American culture. In tracing elements of these discourses across the history of the nation, James Morone concludes that they are one of the 'mainsprings' of American history and culture.[32] The history of Puritan currents in

America is one that involves periods of threat or crisis, followed by revivalist outbreaks. As Morone suggests, the content of these discourses changes, from literal religious meanings to secularized versions. But, as he concludes, 'the rhetorical trajectory lives on: lamentations about decline, warnings of doom, and promises of future glory [...]' with which the tenor of ongoing discourses about the state of indie cinema seem to have much in common.[33]

The broader cultural resonance of these discourses might help to account for the appeal of what indie is constructed to stand for in the wider culture, particularly given the relatively narrow social constituency that appears to be the main audience for this kind of material. As Michael Newman suggests, indie is a somewhat contradictory notion 'insofar as it counters and implicitly criticizes hegemonic mass culture, desiring to be an authentic alternative to it, but also serves as a taste culture perpetuating the privilege of a social elite of upscale consumers.'[34] Newman cites the deployment of tropes from indie music and film in advertising as instances of the use of such qualities to seek to appeal to a wider audience, a selling of notions of anti-corporate authenticity that might also resonate with the broader secularized Puritan dimension in American culture. (We could add to this its fit with related discourses associated with various mythologies of the 'frontier' as a supposed guarantor of the authenticity of the American experience, a ubiquitous component of literary and popular culture.) Whether or not broader articulations of aspects of indie discourse of the kind cited by Newman have the effect of undermining the distinctive concept of indie, and, as a result, its basis as a marker of particular socio-cultural distinctions, remains open to debate. As Newman suggests, such practices can also function to promote and disseminate the distinctly indie sensibility, an argument similar to that made by David Hesmondhalgh in relation to indie music.[35]

The aim of Hesmondhalgh is to complicate what he sees as overly simplistic conceptions of the 'selling-out' of indie through developments such as the formation of alliances with corporate distributors or the 'professionalization' of what started out as more amateur-scale operations. Hesmondhalgh's terminology is significant in the context of the preceding argument, identifying as 'purist' the position that sees any such move as one of unacceptable co-optation. As opposed to this

stance, he suggests: 'The choice to set up more permanent positions and careers, while despised by many enthusiasts, is often based on a genuinely idealistic commitment to fostering talent, and to providing an alternative,' a point that might apply equally well to many of those involved in operations such as the studio speciality divisions.[36]

If the negative object in the purist account might be opened up to a more complex reading, the opposite pole is also a mythic notion, in the realms of music, film or any other such forms of cultural production. As Hesmondhalgh puts it in relation to one of his case studies: 'there was no pure, original moment where anarcho-punk was "untainted" by entrepreneurialism.'[37] A similar argument is made by Philip Auslander in the context of assertions of authenticity in relation to issues of liveness and recording in rock music more generally. As Auslander puts it, 'the creation of the effect of authenticity in rock is a matter of culturally determined convention, not an expression of essence.'[38] The same can be said of notions of the 'true' indie in film, no version of which that has been part of the established discourse is likely to have been void of any forms of institutionalization at some level, or is likely to be in the future.

While a range of different scales of production or other kinds of operation can be identified, from the no- or micro-budget to the margins of the Hollywood studio system and from the subversive to the conservative in form and content, articulations rooted in notions of an original truth or purity remain within the ideological realm of rhetorical distinction-marking. The latter is a process that seems central to many of the kinds of investments made in the consumption and advocation of the values associated with indie, but one that must be distinguished from the more complex nature of the material reality. However questionable the ground upon which they stand, such discourses have a real and substantial presence of their own within the indie cultural field, as is demonstrated on numerous occasions in this book. As Auslander puts it in the case of rock, 'the fact that the criteria for rock authenticity are imaginary has never prevented them from functioning in a very real way for rock fans.'[39]

The coining of a notion such as 'true' indie, or variations on the term, immediately suggests an institutionalized discursive conception of some kind in itself. To make such a point is not necessarily to

criticize the use of such terms but merely to recognize the inevitable status of any such constructs from the moment of their entry into prevailing discursive regimes. A hyperbolical example of this kind of discourse is the notion articulated by the producer Ted Hope of what he terms, variously, 'A Truly Free Film Culture', 'New Truly Free Filmmaking' or 'True Indie', posited as a potential successor to 'The Indie Period'.[40] The capitalized formulation, largely reliant on an appeal to the use of the internet as a source of more genuine contact with audiences, is almost entirely rhetorical, calling among other things for an abandonment by filmmakers of dreams of distribution through the existing, limited channels.

The point here is not to dismiss the notion that the online world might bring some new freedoms and opportunities, or any of the more specific arguments made by Hope, but the absolute terms in which this is put, as if the online terrain would ever be one entirely free of institutionalized forms and mechanisms of its own. The latter are, in fact, likely to be essential to the effective mobilization of the internet for the kinds of purposes advocated by Hope (including dimensions such as the building of relationships with audiences), as suggested in Chapter 2 of this book. Hope himself seems to recognize this, calling for the building of a new infrastructure, something that seems at odds with the language of the 'Truly Free' in which he situates his intervention. The use of such terminology has rhetorical power and resonance, however, in the discursive context outlined above. The implication of Hope's argument is that 'Indie', which he credits with having increased the diversity of films available to the viewer, has become an ossified institution ('a distortion, growing out of our communal laziness and complacency – our willingness to be marketed blandly and not specifically'), but something equally distorted seems to result from the hypostatization of a reified notion of anything 'truly' free or independent in this realm.

A more concrete illustration of this phenomenon is provided by the status of an initiative launched in 2006 with the title 'Truly Indie', one of a number of novel approaches to distribution/exhibition considered in Chapter 2. For an upfront fee, Truly Indie offered filmmakers a guaranteed run in the Landmark Theaters chain, the largest indie/art-cinema group in the country, along with publicity

and advertising support from its allied company, the indie distributor Magnolia Pictures. This was a novel arrangement likely to appeal to relatively smaller projects or less-established filmmakers. But it was also very much a part of the existing institutionalized landscape, both in the use of the Landmark chain and because both companies were part of a larger, vertically-integrated media/entertainment company, 2929 Entertainment, other activities of which included production and the high-definition cable networks HDNet and HDNet Movies. If it merited the Truly Indie title, with all the connotations of such a label, it did so in distinctly relative terms, as is likely to be the case in all such rhetorical usages and formulations.

None of this is to suggest that discriminations cannot meaningfully be made between different levels and kinds of indie practice, or that arguments cannot be made for the greater cultural value of some individual features or parts of the landscape over others. I would be happy, for example, to argue for the greater social worth of the films examined in Chapter 4 (the work of Kelly Reichardt and Ramin Bahrani) than those considered in Chapters 1 and 3 (*Little Miss Sunshine*, *Juno* and the films associated with the term 'mumblecore'). No such judgements are made from a position of Olympian objectivity, however. All are the product of particular situations and investments, and in pursuit of particular socially-situated agendas, more or less explicit, and also tied up inevitably in further processes of cultural distinction-marking that often run the risk of over-simplification.

The main emphasis of the chapters that follow is on the detailed examination of individual examples of a number of different tendencies in indie film since 2000, although these are located quite firmly within the discursive parameters established above. Although most of the book is focused on lower-budget practice, a field clearly located as indie rather than in any proximity to Indiewood, it begins at least partially within the orbit of the studio speciality divisions with an analysis of *Little Miss Sunshine* and *Juno* as two examples often cited at the negative pole in discourses relating to degrees of supposed indie authenticity. A central theme of this chapter is an examination of notions of quirkiness, particularly as a quality perceived by some to have been confected in what is understood to be an inauthentic manner in work of this kind, as evidenced both textually and in

consideration of a range of responses to the films. What both titles offer to the viewer, I suggest, is a combination of ironic distance and the substantial deployment of markers of sincerity, avowed seriousness and emotional implication in the material on screen, a blend the precise balance of which might be associated with a particular location in the industrial landscape. The second and third chapters focus on dimensions and tendencies more closely specific to the immediately contemporary period.

Chapter 2, 'Industry 2.0: The digital domain and beyond', uses a case study of Susan Buice and Arin Crumley's *Four Eyed Monsters* (2005) as an opening into a wider analysis of the extent to which the internet has been embraced as a major resource by lower-budget indie filmmakers, in dimensions ranging from finance and collaborative production to distribution and sales. A number of recent initiatives are examined, in the broader context of the concept of Web 2.0 and arguments about the democratic potential of the digital realm, although these are shown often to be employed in conjunction with more traditional indie practices. The third chapter focuses on what became the first distinctive tendency to be identified in the indie landscape of the 2000s, the term mumblecore being used to describe a particular variety of very low-budget naturalism often associated both off-screen and on with the same 'digital generation' at the heart of many of the new media practices examined in the preceding chapter. Close textual analysis of the work of filmmakers including Andrew Bujalski, Joe Swanberg and Aaron Katz is combined with consideration of the extent to which their work can be associated with the experiences of particular generational or class-based constituencies and debates about the location of such production within discursive categories such as the authentic or the amateur.

A number of continuities can be traced between the formal qualities of mumblecore and established indie traditions, particularly in their appeal to certain notions of realism, an argument that can also be made in relation to the filmmakers whose work is explored in Chapter 4. While mumblecore has often been criticized for a narrowness of focus, related largely to the white middle-class 'slacker' lifestyles of its protagonists, the films of Kelly Reichardt and Ramin Bahrani are situated in relation to broader social issues, particularly for those living

closer to the social margins. As such, they are also understood here – in terms of form, content and industrial practices – in the wider context of international art cinema as constituted through institutional dimensions such as appearances at festivals and positive critical reception, issues key to the circulation of all the films examined in this book.

The final chapter, 'The desktop aesthetic: First-person expressive in *Tarnation* and *Four Eyed Monsters*', examines some of the distinctive textures made possible by the use of a range of audio-visual effects available to the contemporary micro-budget digital filmmaker. The two featured examples, an almost no-budget and highly expressive subjective documentary by Jonathan Caouette and the Buice and Crumley production featured in Chapter 2, are situated in a typically indie hybrid territory between more or less mainstream domains, in this case the poles established by music video and the film avant-garde. A brief conclusion then returns to some of the broad issues considered above, including a general verdict on the state of indie film – and the status of 'indie' as a discursive term – at the end of the period examined in this book.

1

Quirky by design? Irony vs. sincerity in *Little Miss Sunshine* and *Juno*

'Quirky' (or alternatives such as 'off-beat' or 'idiosyncratic') is a term often used in the characterization of indie films, whether within the industry itself, in journalistic coverage or in more substantial considerations of whatever textual qualities are understood to mark the distinctive nature of these regions of the cinematic landscape. With the institutionalization of indie at the level of industrial and other support structures, concern has been expressed by some commentators that a similar institutionalization might occur, or have occurred, at the level of the films themselves: that something like a prefabricated quirky indie recipe or template might have emerged and taken over, or that this might apply in at least some cases, rather than indie films continuing to constitute (or, for some, having ever constituted) a realm freed from the influence of any such pre-existing constructs. To propose a binary opposition of this kind, between a valorized implied notion of some kind of pure indie (or independent, which might be the preferred term in this case) and a version judged to have become

victim of institutionalization, is, of course, to fall into an essentialist trap, as suggested in the introduction; as if any variety of indie/independent cinema has ever existed in a vacuum and not built upon some, in their own ways, institutionalized or regularized norms. Such essentialized accounts have a presence in discourses in and around indie cinema and are of interest in their own right, however, as manifestations of the way this kind of film is sometimes understood, as will be seen later in this chapter.

As far as quirkiness is understood, however, or any other dimensions, it is possible to consider the extent to which such qualities might deliberately seem to have been confected in particular examples of indie cinema, without positing or presupposing the possibility of an entirely 'pure' or 'natural' alternative. Some indie productions, this chapter argues, can be seen to be making a display of features that are overtly and demonstratively marked as quirky, italicized and highlighted as such, and seem clearly to be investing in an appeal to such qualities as markers of their particular variety of indie status. A parallel can be suggested with what Bruce Kawin terms the 'programmatic' variety of cult film, one that appears to have been designed with a bid for cult status consciously in mind, as opposed to films that gain such a reputation inadvertently, as a result of factors that could not be anticipated at the time of production or original release.[1] The programmatic might be expected to appear particularly in circumstances in which a distinct niche market has been created into which such productions might be targeted, a situation that obtained in both the cult and broader quirky realms in the years leading up to and including the first decade of the twenty-first century.

To suggest that some films openly trade on a quirky appeal need not be to assume that a clear dividing line can be drawn between this practice and other uses of material that might be judged to be quirky in one way or another, either at the time or in the kind of retrospect that typically characterizes the inadvertent attainment of cult status. It is, perhaps, to risk establishing another false opposition to distinguish between quirkiness that appears to have been designed-in from the start and that which might only emerge after the fact. Apart from anything else, an attempt to make such judgements would raise difficult questions relating to intentionality on the part of filmmakers

(or those who enable particular films to gain particular levels of funding and/or distribution). Direct, deliberate conscious intent may be a factor in the design of the quirky characteristics of some films, but it is perhaps more likely, and more typical of the way cultural products are designed in general, for elements of this kind that are already in circulation in a particular realm in a particular time and place to be drawn upon more broadly, as part of an existing repertoire of available conventions, rather than in the cynical act of confection or imitation suggested in the responses of some critics and viewers.

There is always a danger, in singling out instances where quirkiness seems most clearly worn on the sleeve, as it were, of establishing questionable oppositions of one kind or another. But this can be understood as a matter of varying degrees, and of different contexts in which the use of certain devices might or might not be understood in this manner. The notion of the quirky-by-design can be understood through close analysis of particular textual examples, as is the case in the first part of this chapter. But it is also an important part of some of the secondary discourses that have surrounded certain films, in the work of professional critics and other responses. Indie filmmakers themselves have often been keen to disavow any association with the term, in what might be interpreted as a defensive reaction to any suggestion that the individuality of their work might be compromised by its placement within any such pre-existing category (a response that seems more widely to typify that of many cultural producers to any attempt to fit their work into compartments that might appear to threaten the notion of the individual as untrammelled sovereign creator).

This chapter focuses on two features that were drawn into this wider debate, *Little Miss Sunshine* and *Juno*. Each has plenty of qualities that can be viewed as fitting into the realm of the programmatically quirky, as detailed below. They have also been objects of suspicion for some commentators on indie film, particularly those who seek to police the boundaries between what might or might not be seen as truly deserving of the label, on at least two other related grounds. First is the fact that each was distributed by the speciality wing of one of the Hollywood studio companies, Fox Searchlight (part of Twentieth Century Fox and thus part of the News Corporation empire), and so might be understood as Indiewood as much as or

more than indie features, in a territory where the lines between indie
and Hollywood are blurred. Secondly, each was highly successful at
the box office and in gaining a wider cultural currency than that
achieved by most indie features, a prominence always likely to lead
to closer inspection or questioning of indie/independent credentials.
Almost by definition, in some indie discourses, to have achieved such
success is to become suspect and/or seen as guilty of selling out. In
each of these dimensions, the phenomena constituted by *Little Miss
Sunshine* and *Juno* could be viewed as the result not of accident or
chance but of a carefully honed strategy by the distributor, if not the
filmmakers, consolidating a trend established with the breakout suc-
cess enjoyed by Searchlight in 2004 with the markedly quirky *Garden
State* and *Napoleon Dynamite*.

Before examining the two films in more detail, along with aspects
of their industrial background, marketing and reception, more con-
sideration is necessary of what exactly might be understood by that
often elusive term, quirky. Its general use, by critics and in everyday
discussions, tends to be rather vague and non-specific. The term
is often deployed as a general descriptor, in place of any closer con-
sideration of exactly by what qualities it might specifically be
characterized. It tends to imply relatively small, slightly odd and
sometimes comical departures from familiar/mainstream norms, as
opposed to more radical or wholesale variations. Quirkiness often
seems to be closely related to incongruity, although again in a modest
and relatively gentle rather than any more disturbing or surreal form.
It might be a matter of slightly unusual juxtapositions, combinations
or variations, either of characters/objects, events or in various aspects
of audio-visual form.

Quirkiness is best measured in relation to particular norms and
understood as a relative concept. I have previously suggested, in
American Independent Cinema (2005), that the term, along with its
cognate 'off-beat', can be substantiated in many cases in relation to
specific relatively minor departures from established mainstream
norms in dimensions such as narrative, other formal qualities and genre.
A quirky narrative structure, therefore, might be one that departs
slightly oddly, rather than radically, from what is usually expected
in the 'classical' Hollywood/mainstream variety. Other quirky

effects might be generated by slight shifts from the norm in camera position, lens usage or perspective, or slight departures from the familiar conventions of classical continuity editing style. Or they might result from slight variations from the norms associated with a particular genre framework.[2] The most sustained attempt to date to quantify the meaning of the term in relation to indie film has been made by James MacDowell, who highlights some frameworks that seem particularly germane to the qualities offered by *Little Miss Sunshine* and *Juno*.[3]

MacDowell suggests that quirky is strongly associated with comedy, often a painful and emotional variety of comedy. The latter is certainly true of the films examined in this chapter, although the extent to which quirky is restricted to the realm of comedy in the indie sector is perhaps debatable. The slight oddness associated with the quirky is often comic, to a greater or lesser extent, but might also be found in instances in which comedy seems less obviously evident or to the fore. It is certainly the case, as argued above, that the term suggests 'a safe and non-controversial kind of strangeness', as MacDowell puts it, '(strange, but not *weird*)'. In the formal dimension, MacDowell identifies a number of trends that he suggests are prevalent without being essential components of the quirky. One of these, associated particularly with the films of Wes Anderson, is 'a flat-looking medium or long shot, feeling nearly geometric in its calculation, of isolated and carefully arranged characters looking, or *doing something*, ever so faintly ridiculous or uncomfortable, often directly out towards us'. This, as MacDowell acknowledges, is an approach similar to what Jeffrey Sconce identifies as the 'blank style' characteristic of what he terms the 'new American smart film' of the 1990s, a category defined by Sconce according to an attitude of ironic detachment and dampened affect.[4]

Quirkiness, in MacDowell's account, entails elements of the 'somewhat ironic' and the self-consciously artificial, combined with a courting of 'the pointedly simple', often in a melancholic vein. The latter quality is often reflected, he suggests, in the choice of accompanying music, which 'favours the sweet and simple, and the continual repetition of the sweet and simple, via melodies or patterns played at the higher end of the musical register, often in a 3–4 waltz time signature' (examples cited here include scores by John Brian for *Punch*

Drunk Love [2002], *I Heart Huckabees* [2004] and *Eternal Sunshine of the Spotless Mind* [2004], along with Mark Mothersbaugh's music for the films of Wes Anderson). Such music often has associations with child-hood, which links this formal quality to what MacDowell identifies as a key theme of films associated with his definition of quirkiness, which is a connection with the childlike and notions of innocence, whether through the presence of child and/or adolescent figures or tendencies towards regression.

MacDowell's account captures a number of central characteristics of many films in the body of work he suggests has been associated with the term (including that of Wes Anderson, Paul Thomas Anderson, the Coen brothers, Michel Gondry, Hal Hartley, Jared Hess, Spike Jonze, Jim Jarmusch, Charlie Kaufman, David O. Russell and Alexander Payne). Whether it can be used as a more or less strict definition rather than as an indication of certain tendencies in a par-ticular range of examples is less clear, but it is useful as a starting point (and MacDowell only claims for it a provisional status). *Little Miss Sunshine* and *Juno* are among the examples MacDowell cites, although not in detail, and fit into this definition in a number of dimensions, as will be seen below, including some use of the ironically detached camera in the former, the use of music in the latter and the centrality of child or adolescent figures to both.

The strongest part of MacDowell's argument in relation to my reading of these films, however, is the distinction he draws between his understanding of quirky and Sconce's account of the 'smart' film. The emphasis of Sconce is on irony and detachment, as the key basis on which a particular group of indie and/or Indiewood films mark their distinction from mainstream norms and provide grounds for viewers to make their own distinctions by 'getting' the dark humour that is usually involved. At the other pole of the divide examined by Sconce are conservative pundits who decry smart films for their emphasis on negativity and nihilism at the expense of any positive engagement in the contemporary social terrain they traverse. A strong element of detachment is found in the releases from 1998 with which Sconce begins (*Happiness*, *Your Friends and Neighbors* and *Very Bad Things*). But, as MacDowell argues, this does not fully characterize all of the films and filmmakers to which Sconce attributes the smart label,

many of which offer a more complex mixture of the ironic/detached and that which is positioned as more positively, sincerely and emotionally engaged, a combination for which the label quirky seems more apt.[5] This is precisely the blend examined below in my reading of *Little Miss Sunshine* and *Juno*.

Overt quirkiness, irony and distance

Material that appears quite overtly to be marked as quirky is found in *Little Miss Sunshine* and *Juno* at several different levels. The following textual analysis begins with the design of the central characters, quirkiness being a quality often associated specifically with character foibles. It then examines the opening sequence of each film to see how markers of quirkiness are established in key tone-setting moments at the start, including the use of particular formal devices and musical accompaniments, along with some of the other more-overtly quirky features of the two productions. This is followed by a consideration of what are presented as the more serious/sincere dimensions of the texts and the manner in which these and quirky/distanced/ironic qualities are blended, both across the length of each feature and in moments of close interrelation or integration.

One of the dimensions of *Little Miss Sunshine* that seems most obviously open to accusations of indie-contrivance is its ensemble cast of characters, which seems a veritable gallery of more-or-less established quirky/offbeat types. First there is Olive (Abigail Breslin), the nerdily-characterized and slightly tubby seven-year-old who appears so ill-suited to the Barbie-fantasy dominated world of the American child beauty contest around which the main plot device revolves. Then there is her father, Richard (Greg Kinnear), whose 'nine steps refuse-to-lose' success routine appears, with obvious irony, to be a total failure. He is also presented on numerous occasions as a brittle and superficial conformist, and thus more-or-less deserving of this fate, a familiar benchmark figure against which to set the quirks of others (even if he eventually undergoes an equally conventional learning/reconciliation process). There follows a trio of relatively 'alternatively' positioned male figures: Dwayne (Paul Dano), the somewhat stereotypical moody teen who reads Nietzsche and has taken a vow of silence, with dreams

of becoming a military test pilot; the incongruously drug-addicted and sex-obsessed Grandpa Edwin (Alan Arkin), recently evicted for misbehaviour from a retirement home; and Frank (Steve Carell), the homosexual Proust-expert brother of the mother, Sheryl (Toni Collette), who moves in with the family after a recently failed suicide bid. Sheryl herself is figured closer to the conventionally 'normal' end of the scale, particularly in her attempts to hold the family together, although she appears to be more than a little frazzled as a result.

Juno revolves more closely around two central characters, the eponymous pregnant 16-year-old Juno McGuff (Ellen Page) and her maybe-boyfriend and father of her unborn child, Paulie Bleeker (Michael Cera). Juno fits into a familiar indie mould as the sparky, free-spirited teenager, many of whose lines and surrounding props appear overtly designed to establish quirky territory, as can be seen in the opening scenes considered below. Paulie is a relatively standard-issue nervous/nerdy male teen, a hesitant, uncertain figure almost permanently outfitted in the uniform of the school running team, with skimpy bright yellow shorts and headband, and finished off with the essential quirky tick: an addiction to orange-flavoured tic tac sweets. Certain quirky dimensions are also given to a number of supporting characters, including a drug-store clerk who features in one early sequence examined below.

Opening sequences are privileged moments in any type of film, usually performing a central role in the establishment of general tone, attitude and broader situation within the cinematic landscape. Works that seek to position themselves as quirky or off-beat, more or less explicitly, tend to establish such qualities from the start. To begin with something marked as to some degree odd or off-centre is, in itself, a marker of broader relatively alternative status (as opposed, for example, to some more conventionally-marked opening moment of drama, non-ironic character-establishment, action or grandeur of location), although such an approach can also be associated with broader or more mainstream forms of comedy. The opening image of *Little Miss Sunshine* is a big close-up on Olive's face. This is a breach of classical continuity conventions, in its leap to such detail without any longer and/or establishing shots, although a breach that has become somewhat conventional in its own right as a marker of freshness or relative (but not radical) alterity (an important

earlier example is the huge close-up on the lips of Faye Dunaway that launches *Bonnie and Clyde* [1967], a key moment in the development of the Hollywood 'Renaissance' in the 1960s). The impression created is one of jumping directly in to a close interrogation of character, rather than building more gradually to such penetrating detail.

The image of Olive, dominated by the frame of a pair of spectacles and suggesting a state of intense concentration, immediately establishes quirky/nerdy dimensions in the character. In her lenses are reflected the flickering images of a television set on which plays the climax of a Miss America beauty contest. An immediate incongruity is produced between the markedly 'dull' and 'ordinary' appearance of Olive and the airbrushed/fake quality signified by the on-screen contestants. A cut back to Olive's face is followed by a return to the image on the television screen, where VCR 'pause' and 'rew' text appears, as she prepares to view the sequence again.

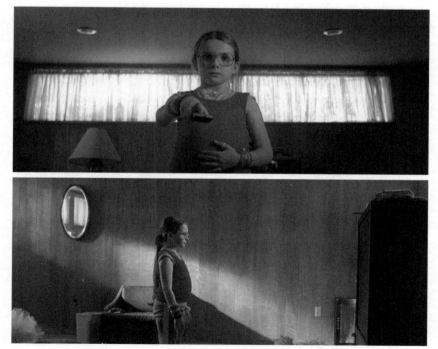

1. and 2. Quirky composition: Olive transfixed in front of the TV at the start of *Little Miss Sunshine* © Twentieth Century Fox Film Corporation

A cut then follows to a distinctive medium-long shot of Olive from the waist upwards, taken from an almost floor-level low angle, as she wields the remote control, both it and her gaze facing into the camera (it is, effectively, a point-of-view shot from the position of the television). The unusual angle, clearly designed for emphatic effect and departing from the unmarked norms of continuity editing, is another signifier of quirkiness, an effect that is emphasised slightly as the camera moves in closer to the character while maintaining the upward angle (making Olive's figure loom slightly more above the camera).

Another cutaway to the television image is followed by a more withdrawn, but equally stylized and marked, long shot of Olive taken from the side, a flat and shallow composition in which she stands transfixed in front of the TV set. A further shot of the on-screen action leads to a return to the head-on low-angle, as Olive clasps her hands to her cheeks in what appears to be empathetic (but perhaps also pathetic) imitation of the behaviour of the winner of the contest. A subsequent shot of Olive, mediated by another cutaway, is a 180-degree reverse to a position flatly from behind, in which her figure is framed in front of the on-screen images of celebration, her arms wafting to and fro to the sides.

Each of the shots of Olive in this sequence, with the partial exception of the upward angle, are taken from flat planes, either in front, behind or to her side, shifting at more or less precise angles of 90 or 180 degrees. This is another stylized or mannered departure from dominant continuity norms, in which such geometrics tend to be avoided in favour of a more subtle and nuanced range of angles and positions, generally designed not to draw attention to the camera. In this case, the flatness of the positions creates a rather different effect: if not necessarily one in which the camera is drawn overtly to attention, one in which an impression is created of greater-than-usual withdrawal from character (even if this is combined with the subjectively-marked images of the television action as seen from Olive's point of view). Continuity norms tend to create an impression of intimate proximity to character, through a balance between various relative degrees of objectivity and near-subjectivity of visual perspective, a position that has become comfortable and familiar to film viewers through widespread use but one that is subtly undermined in

this sequence. The result is precisely the kind of ironic detachment identified in other instances by Sconce.

The ironic commentary implicit in the visual organization of these opening moments is spelled out verbally in a sound overlap that accompanies the last of the shots outlined above, although one that soon develops an irony of its own. The voice, established in the next shot as that of Richard doing his 'nine steps' routine, comments, seemingly pointedly, that: 'There are two kinds of people in this world: winners and losers.' The image seems a perfect illustration of this (crass, superficial and essentially reactionary) philosophy: Olive, the 'loser', lost in her infatuation with the 'winner' on screen (although, in a film of this kind, as far as that has already been established, either textually or pre-textually, it would be expected that any such dictate would at least partially be undermined: the quirky 'loser' protagonist – or the 'loser who eventually wins through' – is another familiar ingredient in a certain variety of indie recipe, as also in some more mainstream comedy).

The film transitions into a sequence featuring Richard's performance on stage, presenting from a series of overhead projector slides, keeping him framed from side angles (more varied and conventionally marked than those employed in the introduction of Olive) and a final front-on position, during each of which any view of his audience is denied. An eventual reverse-cut has an immediately deflating effect, undermining his status (and the high-flown rhetoric of success) by revealing that he has been addressing a mere handful of listeners in a sparsely attended classroom. *Little Miss Sunshine* then proceeds to introduce the remainder of the principals, one at a time, in variously similar quirky fashion, the sequence tied together through the persistence of a simple but insistent keyboard-led refrain on the soundtrack. Dwayne is first viewed from a directly overhead position, blank-faced as he lifts weights towards the camera, followed by a montage sequence of jump-cut and sometimes off-centred shots as he completes a range of other exercises. The incongruous combination of apparently respectable old(ish) age and the taking of hard drugs is marked in a series of closely shot images in which Grandpa locks himself in a bathroom and proceeds to inhale a white powder.

We see a clearly strained Sheryl in her car, smoking, while denying doing so on the phone to Richard. She then arrives at the hospital to collect Frank after his suicide attempt. One shot of Frank from the side, towards the edge of the frame, is followed by another marked note of incongruity. He is framed head-and-shoulders, facing the camera but looking blankly just off to one side (itself a conventional perspective in such a context). Dark-haired and bearded and with bags under his eyes, his expression is singularly grim, as across the screen, in progressively larger capitals, is spelled out the title of the film, the final 'SUNSHINE' straddling the features of a character clearly several worlds away from expressing the characteristics associated with the phrase.

On-screen titles also play a noticeable part in the establishment of overtly quirky credentials in the opening of *Juno*, although in this case it is the quality of the lettering itself that creates the effect. The film starts, after the Searchlight logo, with the word 'Autumn', picked out initially against a black screen and then continuing over the first images. The text is presented in a shimmering, three-dimensional block capital font that suggests hand-drawn animation, a signifier of low-key, DIY, indie/quirky *naïveté* (the shimmering or pulsating effect is the result of a deliberate misalignment of the image from frame to frame, a quality associated with the work of Bob Godfrey among others).[6] The opening image offers a striking contrast between such qualities and what is (less overtly) marked as a signifier of cinematic beauty: a quotidian scene, featuring a dull-looking suburban house and garden, but rendered aesthetically pleasing by the magic-hour qualities of golden low-angle sunlight, both in the sky and shining on a small patch of grass on which stands Juno as a small figure located off-centre in the lower-left-hand corner of the screen. The title shimmers away and a cut is made to a closer position, although still a long shot, focused on the sunlit patch. A marked degree of quirkiness is again present as the diminutive figure of Juno stands to screen left, swigging from a drink carton the size of her head, seeming to confront the incongruous presence of a brown armchair framed across from her towards the other side of the screen. The chair is backlit by the golden sunlight, producing a glowing

halo-edge effect that adds to impression of incongruity in its applica-
tion to an otherwise mundane object-out-of-place.

A cut to a close head-on shot of Juno is then accompanied by her
comment in voice-over that: 'It all started with a chair.' This adds to
the overall impression of marked quirkiness and incongruity, 'a chair'
not being a usual starting point for film drama (although also see *The
Puffy Chair* [2005], a lower-budget indie feature by Jay and Mark
Duplass). This is another device that has a deflating kind of ironic
rhetorical effect, as do many such injections of voice-over from Juno
in the film, acting to distance the viewer from the immediately on-
screen action. It is followed by a markedly low-key rendition of what
a screenwriting manual might term 'the inciting incident', in which
Juno has sex with Paulie, starting with a close-to-floor-level shot in
which Juno's legs are framed below the knee, as she sheds her under-
wear, the as-yet unidentified figure of Paulie sitting naked across the
room, framed from nipples downwards, on an armchair. The initial
quiet manoeuvring of the couple, closely shot, is followed by an
abrupt cut back to the considerably later scene in the garden, where
a small dog barks at Juno and the mood is changed by her rather
incongruously sharp response: 'Jeeze, Banana, shut your frigging gob,
OK.' Her voice-over then resumes, proclaiming, as she looks at the
chair and we can now see a batch of other furniture behind it on the
grass: 'This is the most magnificent discarded living room set I've
ever seen', another seemingly incongruous over-investment in the
nature of the material concerned.

At this point in *Juno,* the title sequence begins and further under-
lines what seems to be a strong up-front declaration of quirky status.
This starts with a burst of song on the soundtrack, Barry Louis Polisar's
jaunty and upbeat 'All I Want Is You', its first line declaring: 'If I was
a flower growing wild and free'. The resonances of the song, with its
guitar and harmonica accompaniment, contribute strongly to the
indie/quirky impression, as does most of the music in the film, con-
sidered in further detail below. The first line of 'All I Want Is You'
comes in unaccompanied, and is all the more quirky-seeming as a
result, an effect reinforced by the framing of the sequence. Juno walks
into a frame empty apart from sidewalk background just after the start

of the song, the camera then tracking sideways to follow her as she walks towards screen-left. As she goes, a line of several runners trots past, flatly across the screen in a deadpan manner to which neither she nor the camera makes any response (a device variations of which occur during the film, Paulie subsequently being identified as a member of the same track team).

3. Lo-fi animation in the opening titles of *Juno* © Twentieth Century Fox Film Corporation

The credits begin, as the song continues, with a marked transition in which Juno's walking figure passes a tree and is transformed into animated form. 'Fox Searchlight presents' appears against an animated background version of a grass verge, the colouring of which has the appearance of having been done roughly by hand. The cut-out style used throughout the sequence – in which the figure of Juno continues on her way to a destination that proves to be her local drug store – keeps the emphasis on qualities that signify lo-fi, quirky/indie status. The original elements in the animation were hand made, according to the designer Gareth Smith. The frames were then photocopied, to degrade the quality of the images, which were then hand coloured and cut out with scissors, making this a particularly clear instance in which the quirky quality was a conscious and deliberate lo-fi confection.[7]

In each case, these films provide numerous signifiers of what seem to be quite overt pitches for quirky-indie status, even before the start of the main body of the text, signifiers that include the use of particular formal strategies. There is also much more to follow. Further examples include aspects of dialogue and the use of particular marked objects or props (music, which performs a particularly central role in *Juno*, will be considered in more detail below in the context of the mixing of quirky and sincere registers). Stylized forms of dialogue play an important role in the establishment of the quirky texture of *Juno*, including many comments from the title character herself. The most outlandish dialogue examples come from a different character, however, the drug store clerk, Rollo (Rainn Wilson), who serves her in the sequence that immediately follows the opening titles. The very fact that the clerk openly comments on the fact that his customer ('McGuff the Crime Dog', as he addresses her) is 'back for another test' seems somewhat incongruous from the start, as a breach of the convention according to which the employee of such an establishment would usually be expected to avoid such banter about so potentially sensitive a subject as a pregnancy test.

Rollo's subsequent language is peppered with heavily stylized formulations that establish ironic distance between the discourse and the reality of what might otherwise be presented as the emotionally loaded situation of teenage pregnancy, a quirk that created discomfort for some critics and other viewers, as considered later in this chapter. Observing that this is Juno's third test of the day, Rollo refers to her as 'Mamma Bear', adding: 'Your eggo is preggo, no doubt about it!' Subsequently, when Juno returns from the toilet after taking the test, he addresses her as 'Fertile Myrtle', adding, after she shakes the indicator stick in an attempt to change the result: 'That ain't no Etch-a-Sketch. This is one doodle that can't be undid, homeskillet.' The register occupied by this use of language might be described as full-on overtly quirky mode, to a greater degree than most of that found elsewhere in the film, including many of the wisecracks uttered by Juno.

Juno is also characterised by her association with manifestly quirky props, most notably, in addition to the armchair, a pipe that she has a habit of sucking (incongruous on grounds of both age and gender) and her bedroom telephone, which is in the shape of a hamburger.

By some margin the most prominent quirky object in these two films, however, is the predominantly yellow Volkswagen bus that plays a central role in *Little Miss Sunshine*, a key part of the iconography of the film, as featured in posters, DVD covers and other publicity or spin-off materials. In order to achieve Olive's dream of taking part in the Little Miss Sunshine contest, the entire family group is forced to embark on a two-day drive from home in Albuquerque to California. The bus itself signifies quirkiness to a significant extent, the result of the long-established associations of the older-model VW bus or camper with (originally hippy-related) nonconformity, and its contrast with more typically large and powerful American vehicles, an effect increased by the particular connotations of bright yellow as a colour not usually associated with the serious or the substantial (cf. Paulie's shorts and headband).

The status of the bus is at first underplayed but it gains progressively in overtly quirky characteristics as the film continues, coming to play a conspicuous role in the broader establishment of the mood of the piece. Damage to the clutch cues a number of comically-coded sequences in which the bus has to be push-started, the characters taking it in turn to jump aboard the moving vehicle one-by-one. The first time this is achieved, the manoeuvre is accompanied on the soundtrack, incongruously, by an heroically-coded whistling-and-guitar theme of the kind that might be associated with a spaghetti western, the effect increased by the initially low camera position from behind the group of pushers. Frank takes the opportunity, equally incongruously, to remind the others of his status as 'the pre-eminent Proust scholar in the United States'. The sequence ends with the last three having to run hard to keep up with and be pulled into the bus, a comic routine that also acts (in the more sincere register, of which more below) as a bonding routine for the group.

A more deadpan-comic/quirky variation comes after a subsequent rest-stop, when Olive is left behind and has to be picked up by the van swinging through a filling station without stopping. An extra dimension of incongruity is added later, after the death of Grandpa. To escape bureaucratic delay, a decision is taken to steal his body away from the hospital to which he was taken, the push-and-jump-aboard routine gaining effect in the tragic-farcical context of what in

this case becomes a hurried illegal getaway operation. The peak of the performance of the bus in this realm of signification comes shortly afterwards, when the horn becomes jammed, maintaining a feeble modulated bleating tone that adds another very overt dimension of comical quirkiness to the proceedings. The bus is, perhaps inevitably, pulled over by a cop as a result, any tension about the outcome – will he discover the body in the back? – being undercut by the persistence of the decidedly foolish sound of the horn. There is a distinct structure, then, to the manner in which the role of the bus is developed during *Little Miss Sunshine*, starting with implicit dimensions of quirkiness that become increasingly marked and emphasised as the film progresses.

Quirkiness combined with markers of sincerity, seriousness and emotional implication

Both films establish degrees of ironic distance through the use of these various devices, but this is combined with a counter-dynamic in which the register is marked as more serious and sincere. In each case, the latter dimension tends to strengthen with the progression of narrative events. There is a characteristic shift of balance from the one to the other, in which what are marked as moral lessons are drawn, more or less explicitly, from the material. A closer relation of the two dynamics is also found in both films, in which avowedly emotionally serious/sincere moments are mixed with or interspersed between the ironic/distanced, creating the kind of balance between the two dimensions identified in MacDowell's definition of the quirky.

Little Miss Sunshine exhibits a pattern of regular shifts of modality of this kind. If the opening sequence puts the emphasis on the ironic component of the quirky, this from the start includes a dimension of pathos as well as more comically-coded distance. The first more substantially serious resonance comes in relation to Frank, following the end of the credit sequence. With the passing of the ironic juxtaposition of his visage and the title block and the end of the upbeat drive produced by the opening music theme, we learn of his failed suicide attempt. A quiet, serious moment is established through Sheryl's general demeanour and her tearful comment, 'I'm so glad you're still

here.' This is partially undercut by Frank's response ('That makes one of us'), although this is spoken flatly and without any overtly ironic inflection, and more so through a quick cut out of the scene to a shot of the car driving them back to the family home. A sombre/concerned tone remains in Sheryl's comments to Frank after their arrival, combined with a deadpan note in the latter's blank expression. The ironic qualities associated with Frank are then developed through interchanges with other members of the family, particularly Dwayne. A degree of discomfort is added to the subsequent dinner table scene, when Olive's persistent questions lead to an explanation of the reasons for Frank's suicide attempt.

One of the seriously-coded themes with which *Little Miss Sunshine* seeks to engage relates to questions of bodily appearance and 'beauty', as established from the start and in the background presence of the Little Miss Sunshine contest, an issue related to Richard's obsession with questions of success or failure. The first explicit engagement with the subject comes after the initial on-the-road sequence, when the group stops for breakfast at a diner and Olive orders waffles with ice-cream. Richard, further establishing his shallow conformist status, comments on how fat in ice cream becomes fat in the body, angering Sheryl, who makes what is positioned as the more caring/enlightened case to Olive that it is fine to be either skinny or fat, 'whatever you want is OK', after which Richard interjects a comment relating to the bodies of the women in Miss America.

The beauty issue is taken up again that night in exchanges between Olive and Grandpa. Olive says she is 'kinda scared' about the upcoming contest and asks if she is pretty. Grandpa offers the rather familiar/obvious moral dictum that she is beautiful 'inside and out'. She says she does not want to be a loser, breaking into tears, because 'daddy hate losers', a further moral indictment of Richard and the broader attitude he is taken to represent. A real loser, Grandpa argues, is someone so afraid of losing that they don't even try; she is trying, so is not a loser. This is all presented in a modality marked clearly as serious/sincere and as one of the effective moral messages offered by the film: a message that implicitly distances itself from certain established American myths/ideologies of success, but only to replace them with quite familiar clichés of its own.

The next sustained outbreak of serious/sincere modality accompanies the death of Grandpa the following morning. A sequence in a hospital waiting room plays an important role in the dynamic through which the film progressively asserts the bonding of the family, a process launched with the collective efforts required in the starting of the bus. They are a family, Sheryl observes, her voice breaking, and what is important is that they love each other. The quiet, sincerely-coded drama of this moment is undercut to a degree by the silent Dwayne's mode of discourse: he scribbles a note to Olive reading 'Go Hug Mom', which she does, after which the doctor comes in to confirm the worst. Dwayne's involvement here is telling, as he has been established as the most alienated member of the group. The sombre mood is held for several more beats, before the arrival of the officious hospital 'bereavement liaison' acts as a transition to the lighter mood of the escape with the body.

Dwayne features more centrally in the next instalment in the process of unifying the family group through seriously-coded crisis, after his devastated reaction to the revelation that he is colour blind and thus ineligible ever to be a pilot. Richard pulls over to the roadside and Dwayne runs off down a slope, screaming 'fuck!', weeping and responding to Sheryl's comment about their being his family, for better or worse, with an outburst of abuse. The dilemma that results is resolved when Richard suggests that Olive tries talking to Dwayne. Olive squats down beside her brother, puts her arm around him and rests her head on his shoulder for several seconds, saying nothing. This wordless engagement of the innocence of childhood, as represented by Olive, appears to have the magical effect, leading Dwayne to mutter 'let's go' and to apologize, saying he was upset and did not mean what he said (the childish innocence/honesty of Olive, capable of cutting through various other imperatives, is established early in the film, in the scene in which she probes Frank on the reasons for his suicide attempt). The sequence is clearly marked as entirely in the serious/sincere register (apart, perhaps, from the somewhat incongruous figure of Olive when she climbs down to join Dwayne, in her red boots, pink shorts and red dinosaur t-shirt). The supposed sanctity of the family bond is strongly imposed and affirmed, further preparing the ground for the culmination of this

dynamic in the climactic scenes in and around the beauty contest itself.

Outside the contest venue, on the beach, Dwayne's character is given the task of spelling out the wider, metaphorical significance of the event, declaring that life is one beauty contest after another. Fuck all that, he declares, including the Air Force Academy, concluding with another rather obvious and clichéd homily: if he wants to fly he will find a way to; 'You do what you love and fuck the rest.' Inside, amid the ghastly spectacle of the contest, Dwayne, now a fully engaged component of the family, does not want Olive to take part, a position he shares here, significantly, with Richard, previously established as his chief antagonist. Sheryl gives Olive the chance to opt out, but she declines, proceeding to outrage most of the crowd with her performance of an inappropriately raunchy number, Rick James' 'Super Freak' (but one that lays bare the sexual queasiness of the whole enterprise). The final act of family bonding ensues as they clap along before eventually joining Olive's performance on the stage; the latter process led, again markedly given his previously conformist behaviour, by Richard.

At its heart, then, or in the moments when it most clearly appeals itself to a notion of 'the heart', in its canvassing of emotional empathy, *Little Miss Sunshine* includes a largely mainstream-conventional affirmation of a combination of 'family values' and 'individual freedom'. Ironic distance and the foregrounding of quirks tends to give way to a more direct appeal on this ground that seems to be intended seriously and unironically. This goes also for the manner in which the majority of the film is shot, which does not display the ironic detachment used in the opening images of Olive watching the beauty contest on television or the montage-detail style employed in the introductions of Dwayne and Grandpa.

For Sconce, the smart film is characterised visually by the use of tableau-style long shots and static compositions, a key factor in the dampening of affect. *Little Miss Sunshine* makes some use of this style, but it is not the predominant form. In the early scenes in the family home, after Sheryl's arrival from the hospital with Frank, a number of images are presented in which figures appear isolated on the screen, often in frames within the frame created by the architecture of the

house, an approach that seems particularly to be applied to Frank and one that more generally suggests the initial state of distance and separation between the family members. This is not the typical style of the film once the journey to California begins, however. It tends to deploy quite standard classical devices, including the use of pairs of shot/reverse-shots when dealing with character interactions. Something akin to the tableau shot is present in some moments in two of the emotionally heightened sequences considered above, but it is significant that in these instances any such view is broken up by a more Hollywood-conventional array of other perspectives. The hospital sequence includes a long shot in which we see the various surviving members of the family deployed around a waiting room, sitting or standing. But this is not maintained throughout, as might be expected to be the case in the smart film as described by Sconce. The start of Sheryl's speech about the importance of family is marked by a cut to a close-up of her, followed by various reaction shots. There is a subsequent return to the more distant perspective but this is, again, temporary and followed by shifts to closer positions to capture various details of the developing scene.

Something broadly similar happens in the visual organization of Dwayne's roadside outburst. The first shot is another that has distanced tableau potential, a low angle taken from down the slope, looking up at the bus, which sits towards the lower edge of the screen against a big blue sky faintly streaked with cloud. The image is strikingly aestheticized, in its unusual angle and bright combination of sunlit colours. But it is functional to the unfolding of the emotional qualities of the drama, rather than creating an impression of remaining apart. The camera tilts down slightly to accommodate the figure of Dwayne, as he runs down the slope and into the foreground. The distance established in the first part of the shot proves to have been a creation of space for character, and character in emotive mood, the emotional response literally foregrounded, rather than distance for its own sake. At the start of Dwayne's angry outburst, a cut is made from the long upward angle to a medium-to-long two-shot of the teenager and Sheryl, who has joined him at the foot of the slope, in another move than seems conventional in its following and highlighting of the emotional interaction.

4. Creating space for character emotion: The striking low-angle roadside shot in *Little Miss Sunshine* © Twentieth Century Fox Film Corporation

Another use of the low-angle shot is followed, as Dwayne directs his ire at different individual members of the family, by a closer shot of Olive, Richard and Frank standing on the horizon beside the bus. The image remains somewhat stylized, but the pattern is again one in which the shot structure appears quite clearly to be motivated by the shifting focus of the emotional action. When the climax of the sequence is reached, with Olive's embrace of her brother, the initial striking low-angle shot is again employed and again serves the functional purpose of foregrounding the emotive content of the scene.

Little Miss Sunshine begins by establishing an opposition between conformity and a combination of individuality, alienation and/or rebellion, most obviously figured by the opposition between Richard and the pair comprised by Dwayne and Frank. But this is, by the end, magically reconciled, in a process that seems very close to the kind of magical reconciliation often associated with mainstream Hollywood productions. Family unity is asserted, it seems, through the contributions of its various individual members, and hence is implied to be a product of, rather than a threat to, the realm of quirky individualism. It is often in their very quirkiness, it is implied, that the characters gain the resources for this task and, when we step back and examine the way all this is structured, the differences appear to have been engineered with this resolution clearly in mind (a feature typical of many Hollywood narratives). The relatively sustained nature of

Dwayne's alienation, for example, and the crescendo it reaches when pushed to crisis, serves as a device by which to establish and reinforce the significance of his return to the fold. Much the same goes for Frank: on the surface, the most distanced from the 'all-American' norm, his character is deployed as in many ways the most sensible of the bunch. It seems significant that Dwayne's first moment of renewed commitment is conveyed in the quirky register, in the form of the brusque but caring quality of the note he writes to Olive.

For all this, the positions taken up by the film remain in many cases the product of little more than pure assertion of a collection of rather fuzzy clichés (you can't be a loser if you try; you do what you love and fuck the rest; and the general message that families eventually pull through and triumph together) that offer little ground to mark difference from the kinds of broadly conservative sentiments (and sentimentality) that might be expected of mainstream Hollywood productions. The same is generally true of *Juno*, which also offers its own eventual homily, in this case relating to the supposedly true nature of love. Like *Little Miss Sunshine*, *Juno* has some sequences marked strongly as material designed to encourage unambiguous and undistanced emotional allegiance, although the film tends in some cases to mix its registers more closely than does its predecessor. One of the most clear-cut instances of serious/sincere emotional engagement is offered in the scene in which the prospective adoptive father of her unborn child, Mark Loring (Jason Bateman), confesses to Juno that he is leaving his wife and is not ready for the role. This provokes a strong reaction from Juno, who walks out in tears.

Juno's response, and that encouraged in the viewer, is based on the considerable investment made up to that point in Mark's position within the film as a sympathetic character with whom she has made a connection. The two bond, during Juno's first visit to the Loring house, over a shared interest (although some different tastes) in popular music. Mark's character is defined partly in opposition to that of his wife, Vanessa (Jennifer Garner), who is established on first view (montage close-up details of precise tidying and adjustment of artefacts) as obsessive/conformist in nature (an equivalent in some respects to the 'square' role of Richard in *Little Miss Sunshine*), although her desire for a baby is marked as entirely sincere. Mark appears essentially to have

sold out, his work as a composer being for crass TV commercials, but to have retained some of his investment in more interesting parts of the pop-cultural landscape. He seeks to induct Juno into his musical tastes, burning CDs for her, and achieves a hit by convincing her of the merits within the splatter horror film genre of the work of Herschell Gordon Lewis, whose *The Wizard of Gore* (1970) they watch together and she concedes to be 'even better than *Suspiria*', a reference to the Dario Argento film of 1977. 'You have decent taste in slasher movies', she comments (a point with which not all devotees might agree).

It is significant that the film here not just foregrounds the issue of taste, and taste in relation to movies, but also gives each character the opportunity to display or share some of their cultural capital (or sub-cultural capital, given the nature of the texts concerned) in this domain. An implicit invitation is made to viewers to join in this process, either through their own familiarity with these non-mainstream cinematic reference points and/or through their investment in the indie-distinctive qualities of a film such as *Juno* itself. This is marked as a territory from which Vanessa is excluded: Mark stops the video when he hears the latter's arrival and Vanessa seems discomforted, more generally, by the relationship that develops between the two. It comes as a shock to Juno, then, and also potentially to the viewer, when Mark proves to be an unreliable source of allegiance. His inability to make the necessary commitment to fatherhood and his tendency to hark back to the music of his youth appears at this point to be a marker of immaturity, prompting Vanessa's injunction that he 'grow up'. Juno at this points shifts her loyalty, although this remains unclear to the viewer until the closing moments of the film, leaving Vanessa a note confirming her willingness to proceed with the adoption even without the presence of Mark.

It is after this sequence that *Juno* offer its most explicit message, in what are presented as heartfelt exchanges between the protagonist and her 'down-to-earth' father, Mac (J. K. Simmons). The scene begins with one of the more muted of Juno's ironic comments, answering a question about what she has been doing with: 'Just out dealing with things way beyond my maturity level.' She elaborates, saying she has been losing her faith in humanity and wondering whether two people can stay together. This is a direct reflection of

the preceding conversation with Mark, but also resonates more widely, the film having established an underlying dynamic according to which expectations are encouraged of a renewal of the so-far under-developed relationship between herself and Paulie.

It is clear that there is more at stake here than just her response to the imminent separation of Mark and Vanessa (and this kind of layering, feeding into the background presence of a not-yet-fully-established romantic relationship, is the kind of structure that would be very much at home in a Hollywood production). Mac then offers his dose of folk wisdom, one that seems evidently to be shared by the film. The best you can do, he suggests, is 'find a person who loves you for exactly what you are: good mood, bad mood; ugly, pretty, handsome, what have you; the right person's still going to think the sun shines out of your ass.' And, for Juno, we know that this is, of course, Paulie, with whom she has recently had a falling-out after his decision to invite another girl to the school prom.

One big juicy quirk later – Juno stuffs the mail can at Paulie's house with orange tic tacs, as a gesture of apology for her attitude in their last meeting – the pair make their mutual declarations of love, in a register that leans towards the highly conventional and the emotionally sincere. She says she thinks she is in love with him, because he is the coolest person she has ever met. There is one ironically-toned comment from Paulie, a reply to her suggestion that he does not even have to try to be cool: 'I try really hard actually.' But after that, the film moves towards very straight romantic cliché. Every time I see you, she says, the baby starts kicking, taking his hand so that he can feel and adding: 'I think it's because my heart starts pounding every time I see you', to which he replies that his does, too (= very standard romantic discourse, played straight). Can we make out now, he asks, which undercuts the mood somewhat, after which they kiss and another quirkily-marked song, Kimya Dawson's 'So Nice So Smart', comes up on the soundtrack.

The overall dynamic is very like that established in *Little Miss Sunshine*, in which various kinds of overt quirkiness and ironic distance are marshalled but surround a core that seems far more mainstream-conventionally invested in a realm of more straightforwardly delivered emotional sincerity, accompanied by the deployment of explicit moral/ ideological messages on familiar subjects such as love, family and the

need to recognize the merits of individuals on their own terms. The two registers are far from being entirely separate in *Little Miss Sunshine* but seem to operate more often in close concert in *Juno*, a phenomenon that includes some of the overtly quirky dialogue sequences.

When Juno arrives home from the drug store, she rings her friend Leah (Olivia Thirlby) on the already-incongruous burger-phone, telling her the news of her pregnancy. Leah's initial response is doubtful, prompting Juno's assertion that she is definitely pregnant and that her friend is being 'shockingly cavalier' in her reaction, a comment that could be made of many of Juno and other characters' ironic quips throughout the film. Leah asks if it is for real – 'Like, for real, for real' – to which Juno replies in the affirmative and her friend responds: 'Oh my God! Oh shit! Phuket, Thailand!' Juno's reply to this is the distinctly ironic: 'There we go. That was kind of the emotion I was searching for on the first take.'

This is characteristic of the multi-layered manner in which some of the film's discourse seems to work. Juno makes an ironic comment, which also seems reflexive from the point of view of the film, in its use of the movie reference 'first take', but this distanced register is used in relation to the subject precisely of wanting a more real-emotional response from her friend to the reality of the situation in which she finds herself. Leah's subsequent emotional response, when that reality sinks in, itself contains what might seem to be odd or quirky language – 'Phuket, Thailand' presumably being a stylized play on 'fuck it' or something of that nature – but mobilized in a manner that seems none the less sincerely felt for the use of such lingo. There is a close intermingling, in these exchanges, of language that is marked either as drily ironic or more emotionally engaged, with the additional dimension on this occasion of a reference that can be taken as reflexive commentary on the use of different discursive registers.

Juno's smart one-liners display irony as a kind of defensively distancing rhetoric. When she rings the Women Now clinic, for example, she uses the breezily mannered phrase: 'I'm just calling to procure a hasty abortion' ('procure' seems somewhat archaic and self-consciously distanced, as does the term a 'hasty' abortion). Some comic incongruity then follows with the phone, which she has to shake to re-establish her connection

('can you hold on for a second, I'm on my hamburger phone'), after which Juno says, in a more straightforward and sober register, 'I need an abortion', with a downward emphasis pattern towards the end.

A similar mixture, in which a superficial and ironic banter is combined with a more serious undertone, is found on several other occasions in the film, including the sequence in which Juno informs Paulie of her pregnancy. His reaction is one of silence, in what the film presents as a serious moment of quiet inward panic. He asks what they should do and she says she thought she would just 'nip it in the bud', before it gets worse, quipping that she heard in health class that 'pregnancy can often lead to an infant.' 'Typically, yeah, yeah', he replies, maintaining the same level of coolly droll surface engagement while it is clear that this discourse obscures realms of more serious emotional turmoil lurking underneath. The viewer is, as a result, offered a combination of pleasures: that of the freshness, wit and distinction marked by the ironic asides, accompanied by the more familiar dynamics of emotional engagement with character.

As with *Little Miss Sunshine*, most of this is shot and edited very conventionally for emotional emphasis. It is again the case that moments can be identified that have something in common with the tableau effect identified by Sconce, but they remain relatively brief and occasional in nature. One instance of the tableau that functions very similarly to those discussed by Sconce occurs during the first visit to the Loring house, while Juno and Mark are playing guitar together upstairs. Moments of strained silence during a stilted conversation between Mac and Vanessa are marked by two uses of a symmetrical long shot that places the characters opposite one another, perched awkwardly on the edges of matching sofas in a pristine living room, the Loring's lawyer sitting in between and facing towards the camera. This is exactly the kind of evocation of discomfort within such settings that is found in examples of smart cinema such as *American Beauty* (1999), although the two distanced shots are separated by routine pairs of shots/reverse-shots of the protagonists.

Another instance of ironically-marked framing, this time more blankly flattened in perspective, is used in a sequence in which Vanessa attempts to interest Mark in the preparation of the baby's room. The pair walk into an empty shot, square on to one wall, facing towards

5. One of those 'awkward' moments: Occasional use of the tableau shot in *Juno* © Twentieth Century Fox Film Corporation

the camera, while Vanessa seeks an opinion on the two shades of yellow she has tried on the opposite wall ('custard' and 'cheesecake'). This is followed by a reverse-angle facing directly towards the wall on which the sample patches have been painted, framed from behind their backs, and a repetition of the same two setups in the next pair of images. The geometrical framing and 180-degree cuts, along with the presence of background music that seems marked as gently banal Muzak, seem clearly designed to create ironic distance from, and a degree of mockery of, Vanessa's earnest position, which Mark quietly undercuts in comments such as his questioning of the notion that yellow is gender neutral and his reference to 'dessert colour' walls.

Mark concludes, reasonably enough, it might seem at the time and from the emphasis created by the framing, that it is too early to paint. In retrospect, however, the film might be understood to pivot around the different registers established in this sequence. Mark's gently ironic distance seems, at this point, to be that of the filmmakers, quite clearly marked by the formal organisation of the sequence, although by the end of *Juno* it is the earnestness of Vanessa, however awkwardly projected, that appears to be valorized instead. Vanessa's awkwardness is presented, in fact, as a marker of her sincerity (as indicated by her self-consciousness when she kneels down to talk to the

baby inside Juno, in an attempt to feel it kick, during a sequence in a crowded mall, and her explicit questioning of how she looks later, when she first has the baby in her arms at the hospital).

The general strategy of *Juno* when it comes to its moments of sincerity, or those in which the two registers are combined, is consistently to follow a very standard pattern of moving the camera in closer to the principals to reinforce the emotional emphasis. This is the case in the mall sequence, where one move into a close shot of Juno captures a smile that marks the point at which she is shown fully to appreciate how much Vanessa wants a baby, as she spies her playing with a friend's child. A similar use of close shots can be seen in a number of the sequences examined above, including those in which Juno announces her pregnancy to Paulie, the scene in which her father offers his wisdom on the subject of relationships, and the final declarations of love between the central couple. In each of these cases, patterns of shot/reverse-shots between the two characters involved are moved inwards, implying greater intimacy, in the most heightened moments of the sequence.

The first example displays a clear pattern in which camera distance is motivated, conventionally, by degree of sincerity. The start of the interchange, as Paulie leaves his front door to be confronted by Juno in the armchair with her pipe, is in long- or mid-shots and characterized by ironic banter (Juno commenting on his shorts being especially brightly coloured that morning; his reply about his mother using colour-safe bleach; a more distanced ironic voice-over aside from Juno as the running team passes by on the sidewalk, accompanied by slow-motion footage of 'their *things* bouncing around in their shorts'). Closer perspectives are used for the heart of the sequence, starting with a close shot of Paulie's facial reaction to the news, reinforcing what is presented as the true state of the implied emotional discomfort that underlies the affectedly casual tone of the dialogue. The sequence then ends with a return out into mid- or long-shots that accompany more throw-away-seeming lines about whose idea it might have been for them to have sex together, with Juno exiting and leaving Paulie all the more confused.

The formal dimension of *Juno* that most clearly manifests a combination of the overtly quirky and the sincere is the accompanying

music, which plays a central role in establishing the overall impression created by the film. The dominant musical presence is the distinctive sound associated with the singer-songwriter Kimya Dawson, a mixture of solo contributions and her work with The Moldy Peaches and Antsy Pants. According to a much-repeated story, told in the soundtrack album notes and numerous interviews with those involved, the film's director Jason Reitman asked Ellen Page what kind of music she thought Juno would listen to. The latter suggested The Moldy Peaches, particularly 'Anyone Else But You', which became a key signature track, played in the closing moments of the film in a duet by Page and Michael Cera. Reitman subsequently proposed to Dawson the use of a number of other songs, which led to her taking part in a recording session with the composer of the score, Matteo Messina, who based other elements of the soundtrack on aspects of Dawson's music.[8] The Dawson sound fits strongly with the quirky dimension of the film, sharing with the animated credit sequence an emphasis on a lo-fi DIY aesthetic. The songs used in the film foreground a combination of simple acoustic guitar rhythms and lyrics that display what seems to be a deliberately confected *naïveté*, a quality shared with some of the other music, including Polisar's 'All I Want Is You' and 'I'm Sticking With You' by The Velvet Underground.

6. 'Anyone Else But You': Irony and sincerity blended in the closing duet of *Juno* © Twentieth Century Fox Film Corporation

Some of the use of music in *Juno* is clearly ironic and distanced, the strongest instance being the accompaniment of 'A Well Respected Man' by The Kinks to the early sequence in which Paulie is depicted in his preparations for a morning run. The lyrics are appropriate up to a point (beginning 'Cause he gets up in the morning' as we see Paulie in the later stages of getting dressed, and suggesting the following of a familiar and punctual routine) but evidently intended also to run in ironic counterpoint. Paulie's childish car-shaped bed, his quirky kit, the deodorising of his inner thighs, the microwaving of a breakfast pastry and his generally gawky deportment – plus the fact that these are viewed in a sequence of fragmented detail shots, like some of the introductions to character in *Little Miss Sunshine* – contribute to the deflation of the associations of the title lyric.

Elsewhere, however, much of the music, especially that of Dawson, offers a blend of quirky/ironic and sincere registers similar to that achieved by the film as a whole. The closing rendition of 'Anyone Else But You', for example, includes demonstrably quirky-naïve, but also knowing, lines such as: 'Here is the church and here is the steeple / We sure are cute for two ugly people.' But it follows this with a chorus, sung in turn by Paulie and Juno as the song develops ('I don't see what anyone can see, in anyone else / But you') that seems strongly invested in the underlying emotional-romantic dynamic of the film, especially given its location in the confirmation of the eventually-established ongoing nature of the relationship between the central characters. The emotional-romantic dimension of the song remains understated, however, as is its staging, with the two characters sitting on a low wall in front of Paulie's house and the camera gradually pulling back (a conventional exiting-the-narrative device). The end of the song is followed by a brief kiss between the two and a final deflating effect, as the running team again troops flatly across the scene.

The music contributes significantly to the broader indie/quirky associations of *Juno*, which borrows some specific effects and a broader indie/alternative/lo-fi cachet from the soundtrack. This is true generally and in the particular location of the film as quirky in a manner that suggests a limited or gentle form of departure from particular mainstream norms. The Dawson sound that figures centrally is a softer selection than that found in some of her other work with The Moldy

Peaches, which includes jarring and punkish 'anti-folk' music registers and more acute incongruities in which the quirky qualities of the sound are combined with distinctly adult-oriented lyrics (for example, from 'Steak for Chicken': 'Who mistook the steak for chicken / Who'm I gonna stick my dick in').

The music serves broadly mainstream-conventional purposes within the film, in addition to marking its position in the wider cinematic spectrum, but it does so in a characteristically low-key manner. Some of the song titles and/or lyrics function to reinforce the underlying impression that Juno and Paulie belong together and/or will be re-established as a couple, a notable example in addition to the two uses of 'Anyone Else But You' being the title and opening line of 'I'm Sticking With You', which comes in at the start of a sequence focused on Paulie. This is also a markedly quirky number, though, in both some of the subsequent lines ('Cause I'm made out of glue') and the high voice in which it is delivered. Music contributes directly to the general impression created by the film in many instances, including the charting of some emotional ups and downs. Examples of the latter include the relatively sombre-toned (although still manifestly quirky) 'Tire Swing', which accompanies the downbeat sequence that follows the confirmation of Juno's pregnancy, and the upbeat (and once again quirky) 'Tree Hugger', by Dawson and Antsy Pants, used in the scenes that follow her father's thoughts about love, running from the planting of the tic tacs in Paulie's mailbox to their discovery and the subsequent coming together of the protagonists the following day.

Music is markedly absent from the most heightened emotional moments in the film, however, including Juno's admissions of her pregnancy to Paulie and to her parents, Mark's revelation that he is leaving Vanessa, Mac's thoughts on love, and Juno and Paulie's mutual declarations of love (although a gentle guitar theme begins towards the end of the latter). This is a way of marking the more seriously-coded dimension of the material within the diegesis, but also serves as another ground of distinction from the associations of the Hollywood mainstream, in which such sequences are likely to be heighted by the use of more or less subtle underscoring (the same applies to *Little Miss Sunshine*). One exception is the use of 'Sea of Love' by Cat Power, which accompanies scenes in the hospital after Juno has given birth. These begin with Juno

and Paulie lying in bed together, she quietly tearful, and continue as we witness Vanessa's first contact with the baby and subsequent sequences involving her and the child at home. The tone of the song is gentle and tentative, however, in keeping with the general tenor of the film as a whole. Overall, the music in *Juno* serves some familiar purposes, but it functions largely to contribute to the establishment of specifically quirky or more broadly indie qualities, the centrality of small-scale acoustic guitar-led songs and accompaniments standing in clear contrast to the larger orchestral or pop-ballad sounds often associated with Hollywood or other more mainstream forms.

An expression of a cultural sensibility?

One of the central arguments in Sconce's account of smart cinema is that the appearance of films evidencing these characteristics during the 1990s can be related to certain aspects of their broader socio-cultural context. The smart film, for Sconce, is designed to appeal to a specific demographic: a relatively young, educated, urban 'bohemian' audience, often associated somewhat loosely with the notion of the existence of a 'Generation X', a disaffected post-baby-boom generation said to have 'retreated into ironic disengagement as a means of non-participatory coexistence with boomers and their dominance of the cultural and political landscape.'[9] While cautious on its status as a fully realized or clear-cut phenomenon, Sconce suggests that the 'Gen-X' label became 'a popular point of identification' for some members of the educated white middle class: 'Mobilizing irony as a tactic of disaffection, a certain social formation (defined perhaps more by bohemian aspirations than generational boundaries) created a culture of semiotic exile during the 1990s, reading "against the grain" of so-called mainstream culture while cultivating a "new voice" of cynical detachment.'[10] The widening spread of a similarly 'cool' and detached attitude during the second half of the twentieth century – especially prevalent in the 1950s, 1960s and 1990s, although originally traced in part to a 'survival mentality' during African-American slavery – is read somewhat similarly by Dick Pountain and David Robbins, as a defence mechanism, especially for younger generations, in the face of a range of contemporary anxieties.[11]

If Sconce's argument about the nature of many of the works he includes in the smart category overstates their degree of detachment, however, much the same might be said of his understanding of how they might appeal to audiences located within this kind of demographic territory, a ground on which MacDowell again makes the case for a revision of the Sconce position. Films such as *Little Miss Sunshine* and *Juno* seem to make an appeal to an audience that embraces both ironic detachment and a desire for more sincere engagement, a sensibility characterized in MacDowell's account by the term 'Romantic irony'. MacDowell draws here on the work of the Dutch philosopher Jos de Mul, who defines this brand of Romantic irony as a contemporary sensibility resulting from a blend of traits associated with modernism (optimism and belief in progress) and postmodernism (ironic detachment as a result of belief in relativism and plurality). This is not, for de Mul, a reconciliation of the differences between the two poles but an ambivalent position, the resulting experience being one that 'oscillates between modern enthusiasm and postmodern irony'.[12] MacDowell also likens the concept of Romantic irony to Susan Sontag's classic definition of 'camp' as embodying an oscillation between irony and sincerity.[13]

Films such as *Little Miss Sunshine* and *Juno* can be understood as being targeted at an audience for which irony is one particular ground of appeal. This might be an audience – defined in some of the ways suggested by Sconce, although perhaps in need of some updating to the later 2000s – the social-cultural experience of which is one that encourages a distinction-marking distancing from certain qualities associated with notions of the mainstream. But these films seem also to appeal to a longing for engagement, one that, as MacDowell suggests via de Mul, might also be an important component of the contemporary sensibility (it is less clear in de Mul's account, however, whether this is associated with any particular demographic, rather than society as a whole).

This is, certainly, a contested terrain, as will be seen in some of the responses considered below. It is true, as MacDowell puts it, 'that when the quirky comes under attack it tends to be because of its *optimism* or lack of critique' rather than for the opposite reason, although this might depend on the source of the criticism.[14] There is a strong

investment for some indie-oriented commentators in what are identified as the more distinctive qualities of the ironically detached, which might be seen as being in some way betrayed by the more conventionally emotionally-engaged dimensions of the likes of *Little Miss Sunshine* and *Juno*. But it could equally well be argued that the kinds of audience groups identified by Sconce are likely actively to seek a degree of emotional engagement and sincerity, as a source of pleasure in its own right, alongside or in combination with the particular pleasures of cool detachment and irony.

MacDowell associates this position with what he terms 'a general growing desire – particularly among a younger generation' – to find some way beyond the nihilism or fatalism often associated with the postmodern. This is viewed as part of a broader 'post-ironic' turn, a move towards a 'New Sincerity', identified by a number of commentators in certain regions of culture, key figures in most accounts of which include novelists such as Dave Eggars and David Foster Wallace.[15] MacDowell follows Sconce is adopting the term 'structure of feeling' (originally coined by Raymond Williams) as a ground on which to understand such a sensibility – as a distinct, historically-specific cultural phenomenon, although not one necessarily embraced by anything like an entire generation – without making what might be considered to be excessive claims to the status of something as grand as an historical epoch.

The term New Sincerity was originally coined in relation to film by Jim Collins, in a study of different trends in some Hollywood genre films in the early 1990s. Collins focuses on two tendencies, each of which he associates with the proliferation since the 1980s of access to media texts through the widespread adoption of new technologies such as the VCR. A key dimension of the texture of postmodern cultural life, in this and many other accounts, is an intermingling of old and new texts, constituting what Collins terms 'the array', 'the perpetual circulation and recirculation of signs'.[16] One response to this situation identified by Collins is the production of genre films that offer dissonance, in an ironic and eclectic juxtaposition of elements that clearly do not belong together, his main example of which is *Back to the Future III* (1990). Another response 'to the same media-sophisticated landscape' takes an opposite tack,

seeking a return to a pre-ironic state of sincerity, as manifested for Collins by examples including *Dances With Wolves* (1990) and *Field of Dreams* (1989): 'Rather than trying to master the array through ironic manipulation, these films attempt to reject it altogether, purposely evading the media-saturated terrain of the present in pursuit of an almost forgotten authenticity, attainable only through a sincerity that avoids any sort of irony or eclecticism.'[17]

In this account, the ironic and the sincere are separated out, into different kinds of genre films, although this is something of an over-simplification given that some measure of sincerity is rarely entirely absent from Hollywood features (including the likes of *Back to the Future III*, which still invites considerable emotional proximity to the central characters). In MacDowell's definition of quirky, however, and my reading of *Little Miss Sunshine* and *Juno*, the two components tend to be combined in a manner that seems likely to have particular appeal to the primary target audience demographic (it might be argued that *some* combination of the two is also more typical of the Hollywood mainstream than either of the alternatives outlined by Collins). This is also the sense in which the term New Sincerity has been used more recently, alongside de Mul's Romantic irony, to suggest a blend of the ironic and the sincere rather than a return to a neoconservative nostalgia of the kind identified by Collins.

The teenage characters of the two films examined in this chapter seem, themselves, to be seeking some negotiation of the kind of territory outlined by de Mul. This is suggested perhaps most explicitly in the presence of Nietzsche as a point of reference in *Little Miss Sunshine*, the work of the philosopher being widely viewed as one of the chief theoretical underpinnings of a nihilistic reading of the implications of postmodern relativity and doubt. This seems to add to the significance of the process through which Dwayne is eventually re-engaged emotionally with the family group. He represents, at least in part, a youthful dalliance with a Nietzschean perspective, but one from which he departs in the interest of family/collective emotional solidarity.

Juno is also a character who seems constructed to express a 'genuine' impression of adolescent confusion and uncertainty, including the question of what discursive register to adopt. If her ironic asides seem

to be part of a defensive armour, the film also gives her moments in which a more hesitant and vulnerable interior is exposed, including her comment to her father, after the revelation of her pregnancy, that she has no idea what kind of girl she is. This kind of material appears designed to appeal to an audience of her contemporaries, just as much as the particular form of ironic banter that provides a more generation-specific source of markers of sub-cultural distinction.

The notion of a New Sincerity, as a counter to the irony often taken to characterize parts of recent/contemporary media discourses, has been adopted in various spheres, including film and broader areas of American culture. One of the earlier usages in this context was in relation to a number of alternative rock bands in the late 1980s. The concept was celebrated in the mid-2000s by the young radio host and podcaster Jesse Thorn, a source cited by MacDowell, whose 'Manifesto for The New Sincerity' described it as 'irony and sincerity combined [...] to form a new movement of astonishing power.'[18] Nicolas Rombes finds a similar combination of the ironic and the sincere in the culture of punk, including what he terms a 'punk cinema' tendency from the 1990s, manifestations of which are found in cinemas ranging from American independent to the Danish Dogme 95 movement.[19]

The term New Sincerity was used in relation to late 1990s indie film by Mark Olsen, writing in *Film Comment*, in a celebration of the first two features of Wes Anderson, a figure declared to stand against the prevailing trend in that he 'does not view his characters from some distant Olympus of irony'.[20] This is a stance in which Olsen seems to differ from prevailing opinion, in which Anderson is often cited as an exponent of dry, ironic style. Like Sconce, however, Olsen tends to exaggerate the extent to which qualities such as sympathy and allegiance towards character are absent from the work of Anderson's contemporaries, either in Hollywood (he makes general reference to 'the contemporary youth picture') or the indie sector. The filmmakers to which he places Anderson as most in opposition, in what he terms 'the arch-irony cult', are Todd Solondz, Gregg Araki and 'that ironist old-timer Hal Hartley'. The work of these three does offer plenty of ironic distance, but this is far from always at the expense of any more sincere engagement. Araki's most stylized feature, *The Doom Generation*

(1995), for example, still invites considerable attachment to the central characters, especially the somewhat naïve Jordan (James Duval).

Emotional engagement is also possible in Solondz's *Happiness* (1998), a key example of Sconce's smart film, despite its very strong vein of irony. There is an invitation to feel for the characters on some occasions – if, perhaps, some more than others – and sincere engagement is offered in some scenes, a notable example being that in which the blandly characterized paedophile Bill (Dylan Baker) is closely and painfully questioned about the nature of his sexual activities by his own young son. It is also easy to overstate the use of the distanced tableau shot in such films. This device is used quite frequently in *Happiness* but far from always; not, for example, in the sequence cited above featuring Bill and his son. Space for some emotional engagement is also provided in Solondz's *Palindromes* (2004), even if, again, in the context of a film that radically departs from some mainstream norms, mostly evidently in its use of multiple performers in the central role and its resolute refusal to offer any single point of orientation towards issues such as abortion rights. Much the same is true within the mannered style associated with the films of Hartley. The 'newness' of any New Sincerity seems somewhat overstated in many accounts, as is often the case in such discourses, largely as a result of the exaggeration of the extent to which irony was ever a single or dominant note, either in indie film or certain parts of American culture at large.[21]

It is also important to note that sincerity itself, in all of its forms, historical and contemporary, is best understood as a rhetorical construct rather than the 'natural' expression of inner truth implied in its traditional usage. As Ernest van Alphen, Mieke Bal and Carel Smith argue, sincerity is an effect created through theatricality and performance, just as much as the 'postmodern irony' with which it has unfavourably been compared by some social commentators.[22] Sincerity, as Alison Young adds, 'is always staged, performed, and enacted (although the very notion is counterintuitive to sincerity's semantic register, since "staged" sounds "forced" or "fake"), and is thus dependent upon a textual inscription for its effects upon the reader or viewer.'[23] This is clearly the case in the films examined in this chapter, even if the avowedly sincere dimension is liable to be

taken for granted and naturalised to a far greater extent than are the moments of more apparently overt irony and distance.

None of the above is to suggest that the balance between irony and sincerity does not vary significantly from one kind of indie film to another. *Little Miss Sunshine* and *Juno* are marked by a particular combination that leans considerably more towards the sincere end of the scale than do the films of Hartley or Solondz. Whether or not such differences can be attributed to the sensibilities of particular audience demographics is open to debate. They can also be understood quite directly in the context of the industrial positioning of the films, which is, of course, related to questions of audience targeting. A broad correlation can be proposed between relative degrees of irony/sincerity in films of this kind and degrees of distance from or proximity to the commercial mainstream. From an industrial perspective, ironic detachment is generally likely to feature more strongly in films with less connection to the studio subsidiaries and more likely to be balanced by strong appeals to sincerity and emotional engagement in films funded or distributed by the speciality divisions and, thus, in many cases aspiring to reach larger audiences.

This is not to suggest that sincerity is the exclusive preserve of work that leans further towards the mainstream in all dimensions. A distinctly sincere emotional engagement is also offered by the other films examined in detail in this book, variants of lower-budget indie production for which ironic distance tends to be a less-central dimension and in which other qualities stand as markers of indie-distinction. The films of Kelly Reichardt and Ramin Bahrani examined in Chapter 4 are avowedly sincere in pitch, for example, as befits the variety of socially-concerned realism with which they are strongly associated. The marker of distinction from the mainstream in this case is related to a combination of the subject matter involved – focusing largely on what would usually be considered to be the margins of society – and the relative downplaying of emotional melodrama (but the latter is only relative, far from absolute). *Tarnation* (2003), by contrast, one of the case studies in Chapter 5, adopts a highly melodramatic variety of sincerely emotional engagement, but in this case complicated by the density of its expressive audio-visual fabric and the use of a more distanced and withdrawn form of narration. Mumblecore,

as examined in Chapter 3, is filled with what appears to be a sincere youthful angst of a certain kind, but here evoked in a manner that is characterised as raw and direct. Indie status might be marked equally by either a heightened degree of ironic distance, in some cases, or by what is perceived to be a more authentic form of sincere engagement than is usually associated with the mainstream, but the particular mix of such qualities varies from one instance to another and can also do so to some extent within Hollywood as well as in the indie sector.

Whether the kind of cross-over performance achieved by *Little Miss Sunshine* and *Juno* means reaching outside the kind of demographic proposed by Sconce and other such commentators is open to question, although that might be the implication of reactions that see some films as manifestations of a betrayal of certain distinctive values. This might suggest that the degree of sincerity/engagement found in films such as *Little Miss Sunshine* and *Juno* goes beyond that likely to be sought by the Gen-X-type niche, or its mid-2000s successor. But it is difficult to propose any hard-and-fast boundaries in such a case, or to establish which might effectively be the determining factor: particular industrial strategies that shape the take-up and distribution of certain titles in favour of others, or how the qualities of particular films might appeal to one combination of audience segments or another. Correlations are likely between the two, but these may be both far from exact and difficult to trace with any certainty.

Production, distribution and reception

The box-office performance of each film certainly suggested a cross-over beyond traditional indie territory, and one that was managed in ways characteristic of the operations of the speciality divisions. *Little Miss Sunshine* grossed a very healthy $60 million in the United States, while *Juno* became the first Fox Searchlight release to break the $100 million mark, with $143 million. Both had quite modest beginnings, although the point at which Searchlight became involved was different in each case. *Little Miss Sunshine*, budgeted at $8 million, spent a total of five years in development, a 'Cinderella' story often repeated after its breakthrough success. It was a first feature for both the writer, Michael Arndt, and co-directors Jonathan Dayton and Valerie Faris.

After two rounds of being offered to the speciality divisions at various stages, the project was initially established at USA Films, which during this period became part of Universal's Focus Features. It was eventually dropped by Focus after various disagreements, including the subsidiary's desire to shoot in Canada to reduce costs, at which point one of the producers, Marc Turtletaub, decided to fund it himself.[24]

Juno was also put together as a package independently, by Mandate Films, a relatively mainstream-oriented company with a track record of producing critically approved comedies and other commercial genre films (Mandate was subsequently bought by the substantial independent, Lionsgate).[25] Searchlight was involved at an early stage in this case, providing finance for the $7.5 million production and an agreement in advance to distribute – two key factors that positioned the film as a product of Indiewood at the industrial level. *Juno* came from another first-time script, by Diablo Cody, who was encouraged to write for the screen by a manager who came across a blog recording her experiences as a stripper, later published in book form as *Candy Girl* (2006), another background story that was widely recounted during the release.

The status of *Little Miss Sunshine* as something out of the ordinary was established at the Sundance Film Festival in January 2006, where distribution rights were sold for a striking $10.5 million during a bidding war in which most of the other speciality divisions were involved, breaking a record established by the sale of *Happy, Texas* to Miramax in 1999. The sale, which followed reports that the film received a rapturous reception from the festival audience, became a major point of reference for almost all subsequent discussion of the production in both the trade and general press (and was not generally seen as positive factor, previous record holders, including *Happy, Texas*, having performed disappointingly at the box office). It was opened on seven screens for its first weekend, at the end of July, a typical indie-scale platform release, but this was quickly widened, to 58 screens in the second week and a further escalation towards a maximum of 1,600 a few weeks later (a large number for an indie production, even if well below the level of the largest studio releases). Keen to make good on its investment, Searchlight established what it termed 'a very aggressive screening programme' in which the release was preceded by

214 previews in 60 markets designed to build word-of-mouth momentum for the film.[26] This is a strategy associated with the indie sector, but adopted here on a larger-than-usual scale. The midsummer date was untypical of that chosen for indie/speciality releases but not without precedent, designed to offer counter-programming to audiences seeking an alternative to seasonal blockbuster fare.

Juno gained far less pre-release coverage, coming to prominence on the basis of positive reviews, like those of *Little Miss Sunshine*, and its box-office performance, especially when it reached the $100 million mark. It started on the same number of screens as had its Searchlight predecessor, moving to 40 in its second week and then on to a considerably higher peak of 2,354, the widest release in the history of the division at the time. Appearances on the festival circuit played an important role in convincing the distributor of the potential of the film to reach a cross-over audience, the reception of *Juno* at the Telluride Film Festival and the Toronto International Film Festival in September 2007 reportedly having convinced Searchlight to release it that winter rather than the following spring, as had originally been planned.[27] The film was said by company executives to have been 'drawing all ages' and to have generated 'tremendous word of mouth' and repeat viewing.[28]

The company again sought to build on the initial reaction, as it had done in the case of *Little Miss Sunshine*, organizing some 300 pre-release screenings and sending the star, writer and director on an 11-city promotional tour.[29] The mixture of quirky and sincere registers was identified by senior Searchlight executives as a source of the likely appeal of each film, although with the emphasis on comedy in general (as, presumably, a quality of broader appeal) more than its specifically off-beat dimension. After its acquisition at Sundance, the division's head, Peter Rice, declared *Little Miss Sunshine* to be 'an incredibly appealing movie with a big heart and big comic set pieces'; 'it's both that funny and delivers real emotional moments.'[30] One reason for the choice of a December release date for *Juno* was said to be the alternative its comedy offered to a number of 'heavy' rivals in the speciality market at the time. 'We're a fabulous alternative', said chief operating officer Stephen Gilula, 'but in spite of its humor *Juno* has great resonance. People are really moved by the film but they come out feeling very good.'[31]

Both films were established early as potential contenders for major awards, an important dimension of the discourses surrounding such productions, going on to achieve nominations and prizes in both the Hollywood-oriented Academy Awards and the Independent Spirit Awards. *Little Miss Sunshine* won the Oscar for best supporting actor, having been nominated for best film (the most prestigious category) and best supporting actress. It swept the major Spirit awards, winning best director, feature and best first screenplay. *Juno* performed similarly, winning best original screenplay in the Academy Awards (with nominations also for best film, director and actress) and best film, actress and first screenplay in the Spirits. While the triumph of both films in the Spirit awards was a clear marker of indie-distinction, their presence in the nominations for major Oscars was a classic indicator of actual or potential cross-over status, a source of widening appeal for some audiences but of further suspicion for those who distrusted their 'true' indie credentials or subsequently considered the films to be overhyped.

The marketing of both films in trailers and poster/DVD artwork put the initial emphasis on quirky-comic characteristics. The trailers are comprised primarily of short extracts from dialogue scenes: witty argumentative banter in the case of *Little Miss Sunshine* and the foregrounding of quirky dialogue in *Juno*, including portions of the drug-store sequence cited above. The sincere dimension is also foregrounded, however, a series of quotations from press reviews in the *Little Miss Sunshine* trailer beginning with 'Heartfelt and Hilarious' (attributed to *Rolling Stone*), a phrase that seeks to encapsulate the dual basis of appeal offered by the film. The *Juno* trailer approximates the structure of the film itself, both in its sketch of the plot and in its use of the resonances of the 'true love' recipe offered by Mac towards the end.

Poster/DVD artwork is in both cases dominated by bright 'quirky' colours: the yellow background of *Little Miss Sunshine*, borrowed from the colour of the bus to become the dominant feature of all publicity materials associated with the film, including its website, and an orange-and-white striped background for *Juno*, echoing the colour of a t-shirt worn by the protagonist. The imagery chosen to illustrate the former is, unsurprisingly, taken from one of the sequences in which the family runs to catch up with the VW. The latter puts the

emphasis on 'quirky' youth comedy, featuring Michael Cera, stand-ing full length in his running kit with a quizzical expression on his face, positioned at right-angles to Page, whose prominent bulge is acknowledged in the poster tagline: 'A comedy about growing up... and the bumps along the way.' The posters each include selections of quotations from the reviews, the dominant emphasis of which is on up-beat, feel-good qualities, especially comedy, but again with some suggestions of more serious undertones, including one for *Juno* that describes it as 'Hilariously Funny, Unexpectedly Moving, And Totally Original' (attributed to *Heat* magazine, UK).

Both films received generally very widespread positive critical notices, as evidenced by the findings of the review aggregation web-sites Rotten Tomatoes and Metacritic. Rotten Tomatoes gave *Little Miss Sunshine* an overall rating of 91 per cent. Out of a total of 191 reviews counted, 174 were categorized as positive ('fresh') and 17 negative ('rotten'), with an average mark calculated at 7.7 out of 10. The figures for *Juno* were slightly higher: a rating of 93 per cent, with 180 out of 193 reviews marked as positive and only 13 negative, an average of 8.1 out of 10. Similar findings are provided by Metacritic, although on the basis of smaller samples. *Little Miss Sunshine* is given 80 per cent and *Juno* 81 per cent, each based on an interpretation of 38 reviews. Ratings by users of the website produce a somewhat larger gap between the two: *Little Miss Sunshine* scores 7.4 out of ten from 344 votes, while *Juno* is rated 8.6 as a result of 911 votes.[32]

For the purposes of this chapter, I have more closely examined a limited sample of reviews, including the two print sources tradition-ally seen as carrying the greatest impact, respectively, in the east and west coast markets: *The New York Times* and the *Los Angeles Times*.[33] 'Quality' press reviews of this kind are still considered to be of impor-tance in the generation of positive word of mouth and in helping to establish the critical agenda, especially in the speciality market, despite the growing presence of online reviews and sources such as blogs and social network sites. The key New York and Los Angeles titles continue to have high status among opinion-leaders, particularly given their location in the two cities within which initial platform releases of the kind given to *Little Miss Sunshine* and *Juno* are usually concen-trated. My aim here is to consider the general tenor of review coverage

but also to see to what extent critics question the films on the basis of a quirkiness that might be understood as contrived and/or identify the blend of comic-ironic and more sincere qualities examined above.

The New York Times and the *Los Angeles Times* each responded positively to *Little Miss Sunshine* as a combination of effective comedy with 'sharp' or 'satirical' dimensions. Some reference is made in each of these reviews to actually or potentially schematic dimensions of the film. *The New York Times* points out that eccentric families are a mainstay of comedy, suggesting that, 'at least in their schematized personalities (the sullen son, the desperate dad), the Hoovers are not so much different from most, despite the vials of white powder tucked into Grandpa's fanny pack.'[34] The *Los Angeles Times* gives this dimension a more positive interpretation, however, arguing that: 'What keeps these characters – and the vehicle – from feeling as arbitrarily schematic as characters in a sitcom' is that the filmmakers 'understand how all the characters have carefully constructed their identities from noncompatible, mass-produced kits.'[35] It is the characters themselves who are presented as inhabiting contrived positions, at one remove, according to this reading, rather than being the outcome of primary contrivance on the part of the production.

One of the better known online review sources, Salon.com, also provides a generally very positive response, even while expressing some concern about moments when the film is 'trying too hard to reinforce its own quirks' and despite the fact that 'the movie's eccentricities often feel as if they've sprung from some master plan.'[36] The most negative of the responses in the sample considered here is found, as might be expected, in the more alternative-culture-oriented New York *Village Voice*, which accuses the film of being contrived in many of its features, including the role played by the VW bus and the underlining of the ironic juxtaposition of the opening title and the image of Frank's visage considered above.[37]

The blend of quirky/comic/ironic and sincere qualities in *Juno* is positively identified and seen as a key strength of the film by a range of critics, including those of *The New York Times* and *Los Angeles Times*. A striking consensus is apparent in many reviews, the conclusions of some of which could almost have been written by the Searchlight marketing team. *The New York Times* has some reservation

about the early sarcastic utterances of the title character ('bracing and also a bit jarring'), but the film is said to take on 'surprising delicacy and emotional depth'; 'like Juno herself, the film outgrows its own mannerisms and defenses, evolving from a coy, knowing farce into a heartfelt, serious comedy.'[38] Much the same is the verdict of the *Los Angeles Times*: 'At first, it seems as if the script is going to stay glib and superficial', but: 'Deceptively superficial at the outset, the movie deepens into something poignant and unexpected.'[39]

A slightly stronger initial doubt is expressed in Salon.com, for which *Little Miss Sunshine* provides one of several examples of 'hip little indie movies' that are to be distrusted because they 'spend more time winking at the audience than drawing it into any kind of conspiratorial intimacy'.[40] For filmmakers, this critic suggests, 'there's safety in putting quotation marks around everything: no one ever has to know what you really meant to say because all that matters is what you "meant" to say.' For the first 20 minutes or so, *Juno* also appears to be one of these films, 'clogged with quotation marks', but the writer and director are credited with having also managed to shape the story 'into something emotionally direct, unsparing and generous'. A somewhat more critical version of this initial reservation is offered by *The Village Voice*. *Juno* threatens in its early stages 'to choke on its quotation-marks catchphrases', with 'early going rough patches that are more Wes Anderson than even Wes Anderson could imagine'.[41] But, the review continues, 'after a little while, the movie calms down and finds its center – no, its *heart*, which already sets it apart from the cutesy–quirky realm of Anderson, for whom ticks and affectations have replaced deliberation and emotion.'

A more unqualified appreciation of the two dimensions of the film is offered in other reviews in the sample considered here, including those from the *Chicago Sun-Times*, the tabloid *New York Post* and *USA Today*. Where reviews were less favourable, it is not clear that they had any negative impact on the performance of the film once word of mouth began to spread. A feature in the *Los Angeles Times* remarked on the success of *Juno* in the 'heartland' of the Midwest, beyond the markets usually associated with the speciality sector. A cinema in Columbus, Ohio, is singled out as one example, where the film is reported to have sold more tickets than did equivalents in Boston and

San Francisco.[42] This was despite the fact that one of the main local papers, *The Columbus Dispatch*, described the film as 'manufactured', offering a 'homogenization of alienation' and with a central character 'more boilerplate smart-aleck cipher than fully formed teenager.'[43]

A sense that *Little Miss Sunshine* and *Juno* might seem contrived in certain respects is conveyed in some coverage by the most influential trade press publication, *Variety*, as might be expected from a source positioned as one from within the business and aimed at a knowing/insider audience seeking to place such films somewhat more objectively within their commercial contexts. *Variety* notes of the former that 'a few complain that the film wears its quirks on its sleeve', but concludes in a piece on its Academy Award prospects, some months after release, that it is nonetheless likely to 'make too many year-end top-10 lists not to receive nomination consideration'.[44] In its original review at the Sundance festival, *Variety* was more positive on the merits of *Little Miss Sunshine*, however, the director declared to have a 'light, *uncalculated* touch' (my emphasis) and the screenwriter to know 'never to push its character quirks too hard', the review concluding, in line with the wider consensus, that its 'humanity and heart make it a natural to transcend the indie niche to a broader audience.'[45] Success was also predicted, accurately, for *Juno*, in a review published after one of its early festival appearances, despite reservations about some of the earlier dialogue (the 'voluminous ruminations' of the central character, 'so heavy are they with self-conscious cleverness'), the tone of which is similar to those subsequently expressed by more mainstream critics.[46]

What about the response to the two films in more specialist indie-oriented spheres? It is here that any critique on the basis of contrivance or 'selling-out' might be expected to be at its strongest, although the evidence is mixed. *indieWIRE*, an established online publication serving the indie community, responded generally positively to *Little Miss Sunshine* after its premiere and sale at Sundance. The film was judged, in what would become familiar terms, to be: 'Enormously big-hearted, hip but earnest and rousingly funny, in fits and starts', although 'certainly the most commercial film to have unspooled in the opening few days of Sundance', the latter point containing at least an implicit undertone of suspicion/criticism in the *indieWIRE* context.[47]

Juno fared very differently, coming under increasingly stringent question.[48] A roundup review of films showing at the Toronto festival initially described it as 'a sparklingly spunky romantic comedy', but the reviewer was clearly annoyed by some of the dimensions considered earlier in this chapter, although not in this case the nature of the dialogue: 'Whimsical title designs and a painfully precious folk-rock score stress the film's naked attempt to ape the quirky appeal of "Napoleon Dynamite" and "Rushmore", shamefully marring [rather strong terms] what is otherwise a cheeky and surprisingly touching story filled with a roster of delightful performances.'[49]

When the film was given its full *indieWIRE* review on theatrical release in December, it received what read like the entire weight of anger aimed at films deemed by some to represent a betrayal of 'true' indie values. The review starts with reference to the 'hype machine' behind the film, commenting that 'it's amazing what a little festival attention can do.'[50] The critic continues: 'Shrewd marketing and Cody's tantalizing, oft trotted-out bio, may make "Juno" the flavor of the season, yet, taking a step back from the hype, it's hard not to feel like this aggressively clever, ultimately sentimental high-school comedy is less true seasonal counterprogramming than just another Hollywood wolf in indie sheep clothing.' From the outset, it is suggested, 'the film is as alarmingly self-satisfied as its protagonists' and 'endlessly schematic, from its post-West Anderson (and post-"Napoleon Dynamite", and post-"Rocket Science", etc) fetishizing of goofy objects (orange tic tacs! yellow sweatbands!) to its rattling off of Diablo Cody's favourite things (The Stooges! Herschell Gordon Lewis!), to its Belle & Sebastian and Moldy Peaches interludes and twee, closing guitar sing-along.'

It is notable that this critique appeared before the film made its breakthrough at the box office, the basis of attack being a combination, it seems, of the qualities of the film itself and the level of pre-release 'buzz' it had already achieved. The latter certainly appears to be a factor, given its prominence at the start of the piece, and it seems reasonable to speculate (even if any certainty is impossible) that it might have been treated at least to some extent more favourably if not for the impression that the film was in some way being elevated beyond its merits in the surrounding discursive sphere. The view of

this critic was far from entirely shared by those associated with *indieWIRE* more broadly, however, as is suggested by the presence of the film in the site's 'Top Ten Lists' for the year, a domain in which it fares considerably better than *Little Miss Sunshine*, even if neither scores very high.

Little Miss Sunshine does not appear in any of the 10 'Top Ten' lists produced at the end of 2006, compiled by editors and regular contributors to the site. One does not include it even in a top 20, one has it as an 'almost', while another lists it separately as 'Most Overrated', commenting that 'it felt as meticulously calculated as a teenager's myspace profile'.[51] *Juno* does considerably better, if not among the most highly rated films of 2007. Again out of a total of 10 lists (not including one that focuses only on documentary), it figures in three (fourth place in one, fifth in another, among an unranked list in a third) and is cited as an 'also ran' or 'plus' in two others. Three ignore the film, one has it on a list of films yet to be seen and another cites it, intriguingly, in the self-created category 'Movie I wanted to hate but in fact really liked' (in other words, it was received positively by six out of the nine by whom it had been seen).[52] *Juno* also received uncritical coverage in *Filmmaker* magazine, published by the Independent Feature Project and another key forum for the indie community. An interview with Cody and Reitman published in the Fall 2007 issue, before the theatrical release but after the attention gained by the film at Telluride and Toronto, included no challenging or questioning along the lines of the attack mounted in the *indieWIRE* review or elsewhere.[53]

Among film-related blogs, *Juno* also came under attack from some quarters, including *New York* magazine film critic David Edelstein, who suggests that most reviewers were 'duped' by failing to recognize that Cody and Reitman had 'engineered every response' generated by the film.[54] It is not clear that such a view is representative of blog discussion of the film more generally, however. A random sample of 50 blogs about the film, from a variety of individual or institutionally affiliated sources, demonstrated an overwhelmingly positive response: only four negative, 25 positive (in various general ways), nine offerng qualified praise (including some criticism of the more stylized aspects of the dialogue) and 12 neutral and/or just factual in tone.[55]

The existence of a more general 'backlash' against the film was noted in a feature article in the *Los Angeles Times*, after the awards season, which also identified what it termed the 'tricky game' played by such films (along with usual suspects such as *Napoleon Dynamite* and the works of Wes Anderson) 'in trying to be at once sincere and self-consciously oddball', a mix seen as likely to appeal to some, largely on a generational basis, but that 'tends to raise a flag of caution among those who outgrew their "sensitive but defiant outsider" phase years ago'.[56] Other blogs and online discussion fora also debated the backlash, from one perspective or another, sometimes generating quite heated argument. One thoughtful example is from the critic Jim Emerson on his 'Scanners' blog, associated with the *Chicago Sun-Times*, who reports finding more than 26,000 results when Google searching '"Juno" + "snark"', a search that produces a number of online discussions of the backlash against the film, along with counter-responses.[57]

Contributors to such debate also included the *Rolling Stone* critic, Peter Travers, earlier quoted approvingly in the trailer and posters for the film, who attributes the level of negative response to the fact that *Juno* committed 'the cardinal sin for a small movie – it's making money,' a post that prompted 112 further comments of varying opinion.[58] The process in which once-admired indie products are condemned from some quarters if they achieve large-scale cross-over success is not hard to understand, as suggested in the introduction, the transition being one in which the original grounds for the marking of distinctions on the part of niche audiences become undermined, a dynamic familiar from the world of indie/cross-over music.

Some wider evidence of this kind of reaction can be found in individual customer reviews of *Juno* posted on the Amazon.com website, although it is again the case that negative reactions of any kind remain very much in the minority. Out of a total of 382 reviews, 189 offer the maximum five-star rating, 101 give four stars, 37 give three stars, 23 give two stars and 32 offered the lowest ranking of one star.[59] Just over three-quarters (290, or 75.91 per cent) opt for the two highest categories, with only 14.39 per cent choosing the two lowest. Fourteen accuse the film of being a contrived indie and/or quirky product, as compared with 22 who use terms such as 'quirky' or

'offbeat' as positive descriptors and four who use such concepts in mixed or neutral terms (making a total of only just over 10 per cent who write in such terms). Thirty-three (8.63 per cent) explicitly raise the question of whether or not the film was overrated or overhyped, but these split quite evenly in terms of the judgement of the reviewer (16 argue that *Juno* was undeservingly overhyped, 12 argue that it merited the critical and other praise it received, while another five conclude that the film was overrated but that they like it none the less as a result).

The biggest single point of focus in discussion of the quirky characteristics of the film is the stylized nature of some of the dialogue, as is the case in the work of professional critics, but here again opinion is divided. Thirty-six offer negative comments, often strongly so, but 35 single out the dialogue for praise; another 20 offer mixed judgements, a frequent response being that the dialogue becomes less 'irritating', 'grating' or contrived-seeming after the earlier stages of the film. The total number who comment on this dimension of the film is relatively substantial (91, or 23.82 per cent of the sample), especially given the scattered and, in some cases quite brief, nature of review postings on Amazon.com, but still clearly a minority. Most reviews do not go into such issues in any specifics, if at all, a majority offering brief praise that appears to take the film at face value, rather than considering what kind of product it might constitute in more reflexive terms. Greater priority overall is given to dimensions such as performance (with widespread praise for Page, often featuring very prominently) and more general debate about the storyline (dominant themes here being how realistic or not it is considered to be, along with moralistic judgements relating either to the depiction of adolescent life in general or the particular issues arising from questions of teenage pregnancy and/or abortion).

The Amazon review picture is broadly the same in the case of *Little Miss Sunshine*. A very similar proportion of the 529 postings offer four or five stars (122 and 270 respectively, totalling 74.10 per cent), while the lower two categories account for 17.95 per cent (59 one star, 36 two star, with another 42 in the middle three-star category).[60] Some do complain about the film not living up to the hype, but this comes up proportionately less than in the case of *Juno*

(15 suggest that the film was overhyped or overrated, while three raise the issue in order to contest such a suggestion). The issue of contrivance is also taken up by fewer of the postings (six negative, three mixed). Twenty-eight use terms such a quirky and offbeat in a positive sense, four negatively (these in addition to, rather than including, the accusations of contrivance). As a whole, these issues have even less prominence for Amazon reviewers than in the case of *Juno*, especially when compared with the much larger number who focus more immediately on the film as one that provides comedy in combination with darker, more serious and/or more heartfelt emotional qualities, or those whose primary attention is on aspects of theme/content such as the picture the film offers of American society (a considerable number also express concern about the nature of the language used in the film, including some of those who otherwise report favourably).

Both films appear to have had a broadly mainstream type of 'feel-good' appeal for large numbers of Amazon reviewers, often not requiring anything clearly marked in these responses as a particularly indie/specialist investment. Some do establish distinctions between these and more conventionally Hollywood treatments, but no such overtly expressed differentiation appears to be necessary for the films to be enjoyed by respondents. It is notable also that rejection seems as likely to come from more 'straight' or mainstream than indie-investing positions, often involving articulations of moral disapproval in relation to language usage or character behaviour. Overall, a reasonably clear correlation can be identified between the qualities singled out for admiration by many approving viewers and those highlighted in the films themselves – as examined above, particularly their progressive movement towards the establishment of more sincere dynamics – and those identified by both Searchlight executives and mainstream professional critics. Markers of indie distinction are mixed with more mainstream (some would say, softer) feel-good resonances, the latter seeming, as evidenced by many Amazon responses, to explain the ability of the films to achieve substantial cross-over success.

The result can be understood as a more intensely commodified form of indie/Indiewood cinema, when compared with some of the more challenging or uncomfortable qualities, marketable generally to

much smaller audiences, offered by less commercially successful exam-
ples such as the films of Todd Solondz cited earlier in this chapter.
This is clearly the outcome of a deliberate policy on the part of spe-
ciality divisions such as Fox Searchlight, as demonstrated by some of
the similarities between *Little Miss Sunshine* and *Juno*, both in the pitch
of the texts themselves and the strategies through which the company
succeeded in building the initial word-of-mouth reputation that pro-
pelled their commercial breakthrough. This approach had, by the time
of *Juno*, become a widely recognized part of Searchlight's market strat-
egy following the earlier successes of *Garden State* and *Napoleon
Dynamite*, with progressively greater success at the box office (*Garden
State*, an independent production budgeted at an estimated $2.5 mil-
lion, grossed $26.7 million in the United States; *Napoleon Dynamite*, for
which Searchlight was one of the producers as well as US distributor,
grossed $44.5 million on a budget of just $400,000).[61]

If not an exact recipe, a distinct tendency can be identified in such
films, in which a particular variety of quirky-oddness, often quite
overt, is combined with the kinds of ultimately sentimental feel-good
effects examined above. This differs in balance from some variants
prominent in discussions of the quirky, including the more archly
mannered style typical of the films of Wes Anderson (a frequent ref-
erence point in discussions of *Little Miss Sunshine* and *Juno*), particularly
in later films such as *The Royal Tenenbaums* (2001), *The Life Aquatic
with Steve Zissou* (2004), *The Darjeeling Limited* (2007) and *Moonrise
Kingdom* (2012). These films did not enjoy anything like the same
scale of box office success as *Little Miss Sunshine* and *Juno*, certainly
not in relation to their higher budgets, a fact that might directly be
attributed to their less romanticized, more distanced and ironic style,
even if this remains a question of relative degrees rather than absolute
contrasts.[62]

One aspect of the strategy embodied in many such films is an
attempt to market a certain notion of that which is 'hip' and 'cool',
although in a variant that can be sold to a larger audience than that
which might strictly be signified by such terms (if, that is, it is possible
to offer so strict a definition of a category that often seems so slippery
and relative in character). This often involves a tricky balancing act,
as suggested in an analysis of Searchlight's strategy published in *The*

Hollywood Reporter in 2009. Marketing to a 'hip' constituency, defined as 'a sophisticated young audience' (akin to that identified by Sconce in the 1990s), can be difficult, the piece concludes, 'since the audience is more media-savvy and less susceptible to a conventional campaign', while marketing that is too hipster-specific 'can turn off a mainstream audience'.[63]

Films perceived as striving too hard to gain hip credentials are also likely to be rejected as inauthentic or fake by some viewers, as seen in some responses to the cultural signposts cited in *Juno*.[64] The distinction between hip and mainstream can easily be overstated, however, as Thomas Frank argues more generally of the contemporary consumer economy, suggesting that corporate business and advertising culture has long embraced many of the discourses associated with 'rebellious' or 'bohemian' youth cultures of the kind usually dated back to the 1960s. 'Today', Frank suggests, 'hip is ubiquitous as a commercial style, a staple of advertising that promises to deliver the consumer from the dreary nightmare of square consumerism.'[65] Signifiers of 'hipness', according to this account, accompany products that extend in their reach beyond the cultural ground in which they might originate, although mixed with more conventional/mainstream qualities in a manner that seems similar to the blend offered by films such as *Little Miss Sunshine*, *Juno* and other products of the indie/Indiewood crossover zone that can be seen as part of this broader economic-cultural domain.

2

Industry 2.0: The digital domain and beyond

Four Eyed Monsters is an innovative feature by Susan Buice and Arin Crumley, a semi-fictionalisation of the story of their own relationship. It was made in typically constrained very-low-budget indie circumstances, completed at the cost of $100,000 in debt for the filmmakers. In some aspects of its texture, the film is a good example of what has become known as the 'desktop aesthetic', drawing on the particular qualities of image manipulation made possible by the use of digital video as a medium of production, a dimension examined in detail in Chapter 5. *Four Eyed Monsters* also offers a useful example of the exploitation of digital technologies in the industrial domain, especially in its demonstration of the potential value of a variety of online resources. The strategies employed by the filmmakers, including the use of social networking media, podcasts and the screening of the feature on YouTube, gained media recognition beyond the realm of the indie sector, giving the film the status of a somewhat ground-breaking case study. As such, it provides a good starting point for the wider consideration in this chapter of a number of initiatives through which filmmakers have sought to find new channels for distribution

and/or sale of their work, and also to embrace the potential of the internet in other dimensions such as the building of audiences and the early development and funding of production.

The use of digital video as a production medium is the most obvious technological benefit to have come to lower-budget indie filmmakers since around the turn of the century, bringing with it the potential to open up a whole new realm of micro- or virtually no-budget production. The cost of digital video can be extremely low compared with even the lowest-budget production on the cheapest of celluloid formats used for feature production, which would generally be 16mm reversal stock (a format in which no negative or other intermediates are produced and all post-production is performed directly onto the original stock). Footage of an acceptable quality can be produced on everyday consumer-product cameras, the cost/quality ratio of which improved rapidly during the 2000s. As writer–director Mike Figgis put it in 2007: 'a reasonably priced DV camera that you buy in a store today is a better camera than an incredibly expensive hi-tech professional camera from ten years ago.'[1]

Editing and sound mixing can be performed on home computers with the use of software programmes such as Final Cut Pro or Avid, the results of which can be exhibited digitally, transferred to 35mm film (which is likely to involve significant additional cost) or exported to DVD.[2] Even more basic editing packages can also be used, including the standard iMovie software provided with Apple computers, as most famously employed in Jonathan Caouette's *Tarnation*, examined in Chapter 5. Digital video production can also be done at a higher end, using top-of-the-line HD cameras and the resources of a sophisticated post-production house, but the possibility exists for the first time in the history of cinema – beyond the world of the avant-garde or home-movie use of 8mm or analogue videotape – for the filmmaker of ordinary substance to be able to own and control the means of feature production and post-production.

Ownership of the means of production has benefits other than the initial saving of money, compared with the traditional expense of renting (more often than buying) film cameras and hiring access to edit suites. It gives a great deal more flexibility to the whole process, permitting shooting and editing to spread, if necessary, over longer

periods of time. Cost limits are greatly reduced as a constraint on the amount of footage that can be shot, with a falling-price/larger-capacity equation also applying to the availability of storage media, another marked contrast with the expensive use of celluloid (costly in both stock and processing fees). The use of DV, in some cases with small or hidden cameras, can also enable very low-profile shooting of a kind that has further appeal to those working on shoestring budgets, including avoidance of the bureaucracy and costs often associated with gaining permission or formal permits required for filming in some locations, and for low-impact shooting without the disturbance of the surrounding world.[3]

Digitally-based production and post-production were rapidly adopted by many indie filmmakers in the first decade of the twenty-first century. Perhaps even more prominent in indie discourses of the period, however, has been debate about the potential offered by the digital domain for new sources of distribution, sales and exhibition, an issue that remained far from resolved at this time of writing. Distribution, as the crucial stepping stone en route to exhibition or sales, remains a key stumbling block in the indie world (as it does for any kind of alternative cinema). Whether or not the established indie theatrical model was considered to be under threat or in any kind of crisis significantly different from those identified in the past by the end of the 2000s, it remains the case that many films struggle or fail, as they always have, to gain either any or anything more than very limited access to the established theatrical market. This is particularly the case at the lower-budget end of the scale and for works less likely to appeal to the studio speciality divisions, the clout of which enables them to dominate substantial parts of the market.

The digital world has potential to offer a number of alternative channels, ranging from digital exhibition in conventional or alternative venues to the use of the internet, either as a resource for direct sales on DVD or as a medium for distribution/sales by streaming video or download. Streaming or downloading are likely to become increasingly central to the Hollywood economy but this is an arena that has a particular appeal to smaller scale, more radical or emerging filmmakers seeking to bypass the control of the existing dominant players.

The use of digital tools and channels of distribution of these kinds in the indie sector can be viewed as part of a broader opening up of cultural production in what Jochai Benkler terms 'the networked information economy' of the 2000s, a realm in which 'the physical capacity required for production [of various kinds] is broadly distributed throughout society.'⁴ This is viewed by Benkler, and other commentators, as a marked change from the twentieth-century era in which media were far more exclusively dominated by the high-cost industrial-scale operations of large players such as Hollywood or the major television networks. A number of freedoms are promised in Benkler's account, including a greatly increased scope for the role of production and exchange motivated by social rather than market-based factors, and for the development of a more participatory and critically informed cultural scene. Other aspects of digitally based indie production and circulation examined in this chapter can also be understood in these kinds of terms, Benkler standing as a good representative of those who argue for the democratic merits of this new realm (even while being cognisant of difficulties, including the attempts of the larger players to maintain their control through various strategies such as the strengthening of laws relating to copyright and brand images). These include the use of the digital sphere by social-issues-oriented documentary filmmakers, the motivation for which is often other than market-based.

What, then, of the model offered by Buice and Crumley's *Four Eyed Monsters*? The industrial strategies surrounding the film are examined here in some detail, as an example of a work that has drawn on a number of the digital dimensions outlined so far. This is followed, in the remainder of this chapter, by a broader consideration of the manner in which such initiatives have been explored in the indie sector in recent years. This includes a more detailed consideration of the concept of Web 2.0 and the extent to which indie filmmakers can really be understood to have embraced its notion of a more formative web-mediated bringing together of the traditionally separate realms of producer and viewer/consumer or to have produced work that manifests the critical/alternative dimension identified or advocated more generally by theorists of the digital domain such as Benkler.

Four Eyed Monsters: a case study

The story of how online resources were used in the distribution of *Four Eyed Monsters* by the filmmakers themselves has become well known in indie circles, not least because of the commitment of Crumley and Buice to the spreading of knowledge about their own practices and discoveries in the process. Crumley has since become one of the chief promoters of such methods through his involvement in a number of other initiatives. The production of the film was itself unconventional even by low-budget indie standards, a number of scenes having been shot before the writing of a formal script and the recruitment of all members of the final cast and crew.[5]

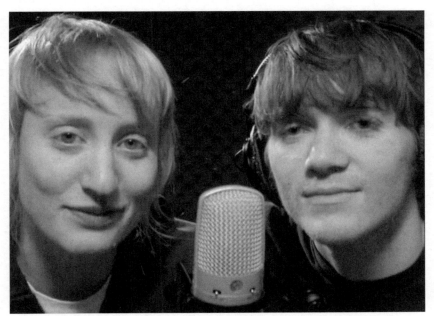

7. To camera: Susan Buice and Arin Crumley introduce the first of their podcasts about the creation of *Four Eyed Monsters* © Four Eyed Monsters LLC

The filmmakers hoped to obtain a conventional deal for theatrical distribution after being accepted into the Slamdance Film Festival and receiving a positive audience response. Nothing was forthcoming,

however, which prompted them to develop their own strategy to demonstrate the potential appeal of the film. This began with the production of a daily video blog recording their experiences during a second festival appearance at South by Southwest (SXSW) in Austin, Texas. The blog generated some interest and the idea was expanded into the creation of a series of short podcasts about the creation of the film, posted on the popular social networking site MySpace and subsequently as free downloads available on YouTube and via the Apple iTunes store. The first of the five-minute episodes was launched the same day as Apple's announcement of its first video-screen iPod, a coincidence that attracted indie and more mainstream media coverage of the initiative.

In response to the podcasts, Buice and Crumley received numerous emails asking where the film could be seen, among other reactions, material that proved to be a valuable resource in the subsequent attempt to secure theatrical screenings. A limited release followed when the film was invited to be one of the titles included in *indieWIRE*'s Undiscovered Gems series, a showcase for a package of films judged to be the best undistributed productions of the year, sponsored by *The New York Times* and Emerging Pictures. Each film in the series was screened for one month in a minimum of 11 cities in venues participating in Emerging Pictures' consortium of digital projection outlets.

The filmmakers had collected email addresses and zip codes from viewers who responded to the podcasts and contacted those living in areas where the screenings of *Four Eyed Monsters* took place, the result of which was that some were sold out. The next stage in the process involved the creation of a map that linked enquiries about screenings to their geographical location, a resource used by Buice and Crumley as leverage to organize another limited theatrical release by cold-calling theatres in the six cities that had generated more than 150 requests for screenings. The result was one screening a night on every Thursday in September 2006 at venues in New York, Los Angeles, San Francisco, Boston, Chicago and Seattle, attended by a total audience of 1,691. The box office that resulted – $13,523 – was modest although considered by the filmmakers to be respectable, but their key achievement was to have constructed a mechanism via online responses through which to demonstrate directly to theatres that some

audience existed for the film, as they had suspected after its reception at Slamdance, without being able to convince a conventional distributor. The whole process was also recorded in the continuing podcast series, offering an ongoing dialogue with actual or potential viewers.

The September screenings were followed by a one-week run in New York, sponsored by the web-hosting company Cachefly, which generated the valuable currency of positive reviews in publications such as *The New York Times* and *The Village Voice*, key sources of publicity and markers of esteem in the indie or wider speciality market. The film gained additional coverage at this point by achieving nominations for two Independent Spirit Awards (for best cinematography and the John Cassavetes Award, for best feature with a budget less than $500,000), for which it became eligible when it achieved what was defined as a regular theatrical release, as opposed to the Undiscovered Gems screenings, which were deemed not to qualify. It also achieved another digital milestone at this point, becoming the first feature to be screened in a virtual theatre in the online world of Second Life, an interactive experience in which viewers were able to post questions and responses to the filmmakers. A further boost came with the news that the film had won the audience award given by the Sundance Channel to the most popular title in the Undiscovered Gems series, a prize valued at $100,000, including a theatrical release to 31 cities on Valentine's Day 2007 and a television premiere on the channel. Buice and Crumley also began at this point to sell DVDs of the film from their own website.

At this stage, the filmmakers suggest, they were earning money through theatrical screenings and the sale of the DVD, but only enough to cover the expenses of their operation and not sufficient to begin to pay off the debt incurred in the making of the film. The next step, which generated some more substantial revenues, marked another online milestone: the uploading of the entire film onto YouTube, the first feature to be shown in full on the site, where it achieved more than a million views of some kind, benefitting from being highlighted on the website's home page. It also subsequently became the first feature to be shown on MySpace. The aim of the filmmakers was to make the film available free of charge on YouTube, if only for a limited period to build further word-of-mouth reputation, but also to generate income.

YouTube agreed to provide a share of its revenue from advertising on the site. More significantly, a sponsorship deal was also achieved with the film website Spout.com, according to which the filmmakers received $1 for each viewer who followed the encouragement in the introduction to the film to register with the site, up to a ceiling of $100,000. The particular attraction of the arrangement, the filmmakers suggest, was that the payment of sponsorship was tied to a concrete action on the part of viewers (and one valued by Spout, for which registrations added to its own currency), rather than being sought on the basis of a more diffuse promise of referrals. This brought in some $47,000, a total of $50,000 including the share of advertising revenue. At the same time, Buice and Crumley report, sales of the DVD also increased substantially, suggesting that no mutual incompatibility need exist between free download (of a lower quality version, as a kind of taster) and paid-for DVD release. The increased attention received by the film as a result of all of these initiatives, and the media coverage they attracted, resulted in a $100,000 deal for broadcast television and retail DVD release and generated interest in overseas markets.

The overall strategy, as it developed, had a cumulative effect based on a close combination of novel, web-based and more traditional indie ingredients. The online posting of podcasts, and the responses they generated, played an important role in the building of interest from a potential audience, and in the demonstration of this to exhibitors. Screenings in online venues such as YouTube, Second Life and MySpace also gave a distinctly new twist to the generation of interest in, and in some cases revenue from, the film. Indie films are generally well-placed to take advantage of online resources of these kinds, including social media fora such as bookmarking sites, many of which might be expected to be suspicious of being used for the promotion of more mainstream, commercially-oriented productions.[6] This might be especially the case for a production such as *Four Eyed Monsters,* in which the central characters belong to a young artistic and tech-savvy milieu similar to that often associated with the culture of key social media sites.

Theatrical screenings remained important to the filmmakers, however, and were the goal of some of these strategies, not least because of their significance in the achievement of other important sources of

attention such as reviews in high-profile traditional media outlets and awards nominations, each of which remained tied to the conventional notion of theatrical opening as a marker of legitimacy. Financially, the outcome remained extremely modest, even for a film that gained significantly more media attention than would be likely in most cases as a result of its status as a pioneer of strategies such as its use of podcasts and the YouTube release. How far, then, does *Four Eyed Monsters* offer a model that has been, or might be, followed by other indie filmmakers? And to what extent does this, or other examples to date, represent a fully-fledged example of the participation of indie film in the broader phenomenon associated with the concept of Web 2.0?

2.0 or not 2.0?: Indie on the web

Among the key ingredients in any of the prevailing definitions of Web 2.0 are notions of participation and collaboration, as opposed to one-way publication, communication or sales online. A characteristic example of the distinction, made in one of the first formalizations of the concept, is between Britannica Online (the web version of the famous encyclopaedia) and Wikipedia.[7] The former offers a more or less fixed and centralized product to subscribers, written by accredited experts in their field, while the latter generally is open to amendments and contributions by any users who choose to do so. As Don Tapscott and Anthony D. Williams put it in their popular account *Wikinomics: How Mass Collaboration Changes Everything*: 'While the old Web was about Web sites, clicks and "eyeballs", the new Web is about the communities, participation, and peering [horizontal collaboration among productive users]. As users and computing power multiply and easy-to-use tools proliferate, the Internet is evolving into a global, living, networked computer that anyone can program.'[8] This is also a key characteristic of other accounts, including Benkler's notion of the networked information economy.

It is important to note from the start, however, that much of the interest in the potential of the internet for indie filmmakers has been, and remains, at the level of the 'old' web (or Web 1.0, as it is sometimes known in retrospect, not that the distinction is always entirely clear cut, as most commentators acknowledge). The primary concern

has been with the potential of the web to offer new channels of distribution/exhibition and/or sales, through various combinations of download, streaming video or online sales on DVD, for the reasons outlined above. In this dimension, the web offers the promise of a way around the dominance of traditional channels exerted by the major studios and/or their speciality divisions and the largest independent players. Any filmmaker can put their film up on the web at very low, if any, substantial cost, either on their own website or via the kinds of social media employed by Buice and Crumley in the case of *Four Eyed Monsters*. Films sold for streaming or download in this way, or by direct online DVD sales, provide an immediate and larger-than-usual share of revenue to the producers. The filmmaker is also freed from any potential influence of traditional distributors on content (although other restrictions might come into play, depending on the nature of the online channel that is employed).

What is involved here is, as Angus Finney puts it, a tightening and simplification of the film-value chain, a reduction in the number of stages and intermediaries that exist between the initial and subsequent windows through which any particular production might move during its release.[9] A contraction in the chain offers considerable advantages to smaller-scale indie operation by removing several layers of dependence on others and creating the potential for closer and more direct links with target audiences. This is a process treated, unsurprisingly, with much suspicion by corporate Hollywood, given its hegemonic control over existing chains and uncertainly as to whether new online outlets will constitute additional sources of profit or come, as many suspect, to replace all other post-theatrical slots, with a resultant reduction in the number of platforms through which individual features can repeatedly be exploited over time through a series of exclusive windows (that is to say, films going directly from theatrical to online release instead of through successive intermediary stages, controlled and paced by the studios, such as release on video/ DVD, cable and broadcast television).[10]

The biggest remaining problem for the small-scale indie filmmaker is finding ways of gaining any attention for a production released in a more direct online manner. One of the most important dimensions of conventional theatrical distribution, and one of the sources of

dominance by the big players, is the cost of marketing; hence the particular importance of the festival circuit, as a source of attention, to the lower-budget end of the indie spectrum. A range of low-cost online forms of promotion have also been explored, although this is itself a crowded and competitive territory.

All of the above can be explored to a significant extent without any shift from the principles of Web 1.0. A film is created in the usual manner (if with the added low-budget benefits resulting from the use of digital video) and then publicised, distributed/exhibited/sold online. This remains a strictly hierarchical rather than a participatory operation. The filmmaker/s are at one end and viewers (hopefully) at the other, with online instead of more traditional gatekeepers and promoters in between (for example, those who determine which videos receive home-page billing on the likes of YouTube or the writers of influential film or culture related blogs); or, more often, a mixture of elements from the digital and more established domains.

In this kind of usage, the web is a resource to be employed after the completion of the finished film rather than a factor in the shaping of the text itself in the manner implied by the major tenets of Web 2.0. This might be entirely in keeping in all other respects with indie practices of the past, the only change being at the point of distribution/exhibition and sales. This was largely the case with *Four Eyed Monsters*, even if in this instance web-based resources were also employed to seek to build a prospective audience constituency that was used as leverage in the obtaining of theatrical screenings. In this more limited sense, the use of the web remains an important part of the industrial arena, various aspects of which are considered in further detail below. A number of efforts have also been made to move into a territory that can properly be defined as exhibiting the characteristics of the more participatory/collaborative Web 2.0, however, although the substance or effectiveness of some of these, and their future potential for real change, remains open to question.

One element of this more formative use of web-based participation is found in the case of *Four Eyed Monsters*. Buice and Crumley report that feedback from their podcast audience influenced future episodes in the series and, more significantly, some aspects of the editing of the film itself. Realising that their constituency was largely comprised of

users of MySpace, the pair changed one detail in the plot, claiming to have met as a couple on the social networking site rather than the other online dating venues they had in fact used.[11] Other more general aspects of the rhythm, pacing and music employed in the final version were also informed by the impression of the audience gained from feedback to the podcasts. If the MySpace change is a minor detail as far as the substance of the film is concerned, the latter suggests a shaping of the broad parameters of the text by an online constituency – rather than by more immediate collaborators on the production – that represents a substantial move towards the world of Web 2.0. Other manifestations can also be identified elsewhere at various stages of production and pre-production, although it remains unclear how far these are likely to become anything more than relatively marginal practices or, in some cases, gestures, rather than more thoroughgoing 2.0 strategies. Examples considered below include the involvement of web constituencies in dimensions such as funding, writing, casting, shooting, editing and the creation of promotional trailers.

Perhaps the most obvious source of web-based partnership is in the search for funding for indie productions, a practice known more generally in Web 2.0 discourses as crowdfunding. A successful example is Robert Greenwald's documentary *Iraq for Sale* (2006), an exposé of private corporate profiteering after the 2003 invasion of Iraq, for which donations were solicited by the mass emailing of supporters of antiwar groups.[12] More than 3,000 contributions were received, mostly in sums of around $25 to $50, raising a total of $220,000, a significant proportion of the $775,000 budget of the film. (An earlier, pre-web precedent for such fundraising might be said to have been established by an appeal made during a radio interview by John Casavetes that led to some $2,000 being contributed by listeners to the production of *Shadows* [1959], although this proved to be a one-off occurrence[13].) Politically oriented documentaries of this kind are particularly well placed for such initiatives, often being able to draw upon existing constituencies with a commitment to such causes, a practice followed by Greenwald in various aspects of the production and distribution of this and other features.

For his previous feature, *Uncovered: The Whole Truth About the Iraq War* (2003), for example, information was supplied to the membership

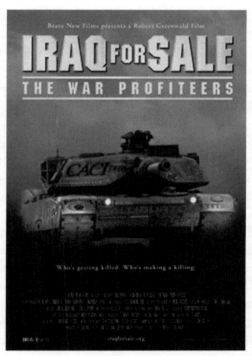

8. Crowdfunding success: Poster for Robert Greenwald's *Iraq for Sale* © Brave New Films

list of the Democratic party activist group MoveOn, along with an offer to buy the film on DVD and to organize domestic house-party screenings.[14] Some 120,000 copies of the DVD were sold as a result, far exceeding Greenwald's initial expectations. All of those who donated to *Iraq for Sale* received a producer credit at the end of the film. Some more active collaborators were recruited to contribute to the research on which the film was based and even to the shooting of some of the interviews used in the text. Work of this kind seems to fit most clearly into the realm of collaborative social production identified by Benkler.

A number of online resources have been created to institutionalize the kind of funding practice employed by Greenwald in *Iraq for Sale*, a process that became known as Do-It-With-Others (DIWO), as distinct from the Do-It-Yourself (DIY) model employed in some cases of indie distribution (on which more below). The sums involved

in individual donations are usually modest, sometimes very small, a micro-financing strategy given prominence through its use by some American politicians, most notably in the campaign that brought Barak Obama to power in 2009. Initiatives established in the late 2000s included IndieGoGo, a site initially primarily dedicated to indie films, and Kickstarter, the brief of which covered a wider range of artistic and other creative projects from the start.

IndieGoGo, launched at the 2008 Sundance festival, described itself as 'an online social marketplace connecting filmmakers and fans to make independent film happen.'[15] Any actual or prospective filmmaker could, without any charge, post the basic details of the pitch for a project and seek donations for which a variety of non-financial rewards, or VIP perks, were offered, the site retaining nine per cent of the funds raised. Perks for donors typically involved privileges ranging from email updates about the progress of the project, at the lower end, to benefits such as credits, roles as extras, visits to the set or invitations to premiere screenings; the nature of the reward usually depending on the sum donated. Visitors to the site could also provide feedback by posting comments on and rating the quality of projects. Kickstarter operated on much the same basis after its creation in 2009, although with some variations, and had gained higher profile within the existing indie landscape at the time of writing. Promised funds were only paid out if and when the target total was reached, rather than being received by those behind a project at the time that they were committed, as was the case with IndieGoGo, an approach designed to avoid the creation of awkward situations in which some money was contributed but not enough to permit a work to go ahead.[16] In neither of these cases did contributions constitute an investment in the project concerned, with all the potential legal complications that might result if that were the case. Full ownership was retained by the creators, a situation that was expected to alter in some cases with changes in the law being introduced at the time of writing that would loosen the regulations on the use of such contributions as equity stakes.

One example of a project that sought funding in this manner was the next feature in which Arin Crumley was involved after *Four Eyed Monsters*, the collaborative documentary production *As the Dust Settles*, shot during the Burning Man festival in 2008, an annual community event at a location in the Nevada desert. Producer Mike Hedge and

director Crumley posted a target sum of $4,650 on IndieGoGo to cover post-production costs, of which $900 was raised by expiry of the deadline in 2010.[17] Donors offering between $1 and $50 would receive email updates. Those offering from $50 to $250 would be invited to become members of a test audience, able to give feedback to the directing and editing team involved in the production before the final edit was made, a rough cut being made available by download. Such donors would also be listed in the 'special thanks' credits of the film. A donation of more than $250 would result in an associate producer credit, in addition to the benefits of being a member of the test audience, and invitation to any test screenings held in advance of the download of the rough cut. A contribution of $1,000 or more would garner the status of 'partner' in the production, with additional benefits including invitation to an event in Park City, Utah, home of the Sundance and Slamdance festivals, downloads and DVDs of the finished film and 'a VIP invitation' to the world premiere of the final edit 'most likely at a world class film festival.'

The most successful film to raise funds on IndieGoGo at the time of writing was *Tapestries of Hope* (2009), a documentary produced and directed by Michaelene Christini Risley about the rape and sexual abuse of young girls in Zimbabwe, which raised $23,000, in excess of its initial target of $20,000. Contributions from 75 individuals were in categories ranging from $5 to $10, to become a 'friend' of the film, to three 'VIP Gold Member' donations of $1,000 or more, and two 'Associate Producer' donations of $2,500 upwards. This was another case in which contributions were sought for post-production rather than initial shooting, which seems to be a context in which funding is more likely to be forthcoming in general, when it is clear that a project already has some substance rather than merely existing on paper.

Tapestries of Hope is also further evidence of the advantage documentaries appear to have over fictional features in this domain, particularly those which engage in contentious social issues that receive less coverage in mainstream media and might more readily find support from existing campaigning groups or individuals. The sum raised on IndieGoGo was less than 10 per cent of the total budget, however, the majority having been obtained through other means, including the filmmaker's own website.[18] It may be the case that funding through such sources can help to encourage other

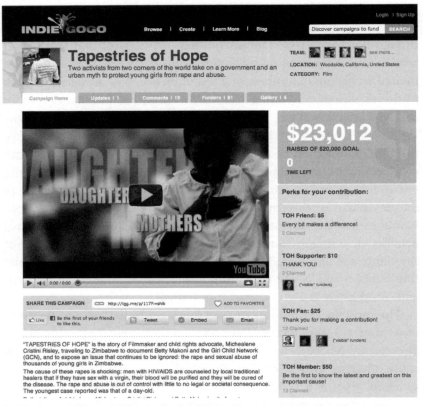

9. Target achieved: The IndieGoGo fundraising page for *Tapestries of Hope*

contributions, as was claimed by Slava Rubin, one of the founders of IndieGoGo, who suggests that projects typically raise five times what they earn through the site as a result of their presence on the service, many contributors preferring to go directly to the filmmaker.[19]

Less success appears to have been enjoyed to date by fictional feature-length projects, particularly when seeking funding from scratch or when from entirely unknown sources. One such example, taken largely at random but listed under 'successes' at one point on IndieGoGo, was the prospective production *Black Creek*, by a Vancouver-based team including Nicholas Humphries and Ryan Copple.[20] The target set for the project, described as 'a modern day fairy tale' about the

relationship between a bullied high school girl and a mute boy she finds shackled and with a bag over his head, was $50,000, to fund pre-production and production, with an aim to begin shooting in February 2010. As of the deadline for contributions, only $1,975 had been committed by a total of five donors, two earning a 'Silver Medal' ('Special Thanks' credit, DVD, invitation to the premiere and a signed copy of the screenplay) and three awarded a 'Gold Medal' for donations of $250 or more (with additional perks including the opportunity to appear in the film as an extra, should it eventually go into production). Other examples can usually be found on the site for which few if any contributions have been made, which might suggest its limited potential, especially for projects that lack a clearly pre-established target constituency, although an increasing number of projects did appear to be starting to raise some significant sums at the micro-budget end of the scale by 2012. Examples included *The Dutchman Project*, a scenario with echoes of *The Blair Witch Project* (1999) involving three filmmakers who disappear in the Superstition Mountains of Arizona while documenting their search for a lost mine, which had raised $10,955 (initial target: $10,000) from 66 donors by April 2012.[21] Other successful campaigns tended to involve even more modest sums for short films or completion of existing productions.

A broadly similar picture, but with larger-scale funding in some instances, including some fiction projects, was found on Kickstarter, where one of the early successes was *Battle for Brooklyn* (2011), a documentary about the efforts of local activists to prevent a major development project. By the closure of the allocated period in December 2009, a total of 373 backers had achieved the target figure of $25,000 to complete the production. In this case, the funding model was based largely around the pre-selling of digital downloads and/or the film on DVD, 233 pledging at least $25 to receive a copy in both formats. A substantially larger sum was raised by one less typical use of Kickstarter, through which Jennifer Fox raised $150,000 from 518 backers to cover costs incurred after completion of her 2011 documentary about Buddhism, *My Reincarnation*, three times her initial target, some $25,000 of which went towards the cost of hiring part-time employees to run an intensive campaign of ongoing updates on the site.

The biggest success on the site at the time of writing was achieved by *Blue Like Jazz* (2012), an adaptation of a best-selling semi-autobiographical account of the college coming-of-age experiences of a young future pastor, a project that was taken to Kickstarter after losing one of its original funders and went on to raise what was at the time a record $345,000 from 4,495 backers, about half of the total budget, having set an initial target of $125,000.[22] This is clearly a project different in kind from the typical material of low-budget indie film, in that it was strongly pre-sold via the book of the same title by Donald Miller. It also had the kind of constituency-specific support gained by some of the documentary productions cited above, in this case through a number of Christian organizations that promoted the project during its theatrical release after the film was acquired by the distributor Roadside Attractions. Another prominent success for Kickstarter, one that that gained media coverage beyond the indie realm for the triumph of its funding campaign (including a report on CNN), was Jocelyn Towne's *I Am I* (2012), the fictional story of a woman who meets the father who abandoned her as a child (and whose memory-loss syndrome causes him to think she is her mother), which raised $111,965, half of its budget, from 905 backers. This was another campaign that gained from elements that gave it a higher-than-usual profile, including the presence in the cast of Simon Helberg, one of the stars of the popular sitcom *The Big Bang Theory* (2007–), who promoted the project to his large number of followers on the Twitter social network and elsewhere.[23]

A success story perhaps more typical of what the site offers to the low-budget fiction sector is the thriller *Black Rock* (2012), directed by Katie Aselton and written by Mark Duplass, the latter a figure with some indie name recognition through association with the mumblecore tendency examined in the next chapter, which raised $33,501 for production from 121 backers (initial target, $20,000) for its tale of a girls' weekend trip to a remote island that turns into a fight for survival. The established indie figure Allison Anders also turned to Kickstarter to fund her micro-budget 2012 digital feature *Strutter*, featuring an aspiring rock musician, co-written and co-directed by Kurt Voss, which raised $19,877 after setting an initial target of

$17,500, plus another $5,672 subsequently for music rights.[24] This was another project that suggested the growing appeal and success of this approach at the lower-budget end of the sector, particularly for projects with some existing hook or basis of familiarity to either the indie, wider or more subject-specific potential funding constituency.

Crowdfunding is one of a number of 2.0 strategies in which collaborations and associations have been formed with more established indie-oriented institutions. The Sundance Institute signed a deal with Kickstarter under the terms of which filmmakers involved with any of the initiative's development programmes, or the Sundance festival, could use its branding and social media support in their Kickstarter entries.[25] The Rotterdam festival, a European event associated especially with alternative film, launched its own crowdfunding programme, Cinema Reloaded, a venture that gained increased profile through its use by Harmony Korine for the launch of a new project in 2010.[26] Major indie-oriented festivals also benefited from the presence of films funded in this manner. An impressive total of 17 films with Kickstarter funding premiered as official selections at the Sundance festival in 2012, including *Black Rock*, nearly 10 per cent of the entire programme, prompting a *The New York Times* columnist to describe the site as having become 'a significant and now very visible player in independent film.'[27] Thirty-three titles with funding from the site played at the SXSW Festival in Austin, Texas, the same year, including the premiere of *Blue Like Jazz*, further marking its integration into the arena of existing indie support institutions. At this point, Kickstarter reported, its film and video section had accounted for $60 million of the $175 million pledged during its first three years, although it was unclear how much of this sum had been paid out, or was likely to be, given the important proviso that the money only changed hands in cases where the target was achieved.[28]

In most cases, bids for funding on websites such as these do not offer the prospect of collaborative input into the shaping of the film, which remains solely the creation of those most immediately involved in the production. There are a number of exceptions, however, including *As the Dust Settles* and *Battle for Brooklyn*, in both of which cases some

contributors were offered access to a rough cut and the promise of input into the final version of the film (in the case of the latter, this was a perk for those pledging $500 or more). Quite how substantial any such influence might be remains difficult to measure.[29] *As the Dust Settles* was from the start a collaborative project, the intention being to assemble the final cut from 12 separately edited segments produced by individual members of the team. In some other cases, a more open form of collaboration has been offered at the editing stage, in the spirit of the wider open source component of Web 2.0, in which tools and resources are made available to any user.

For his 'action-mystery' project *The Power of Few*, for example, Leone Marucci established an online competition in 2011 in which anyone who signed up to the film's website could edit one action sequence, the winner being promised the use of their version in the completed work. Relevant script pages were provided, along with the raw footage and audio tracks and an editing interface. Voting was then enabled, to choose the most popular cuts, one of which was selected by the filmmaker. This was unusual in being located within a relatively larger-scale production, the budget of which was estimated to be $7.5 million, with an ensemble cast including Christopher Walken and Christian Slater. Additional collaborative dimensions of the project included online voting to determine the casting of one role with a first-time performer and the naming of another member of the cast.[30]

Other productions have gone further in soliciting the body of the work on an open-source basis, including two separate zombie-related projects launched in 2006.[31] One, *Lost Zombies*, is a faux documentary for which contributors were invited to submit footage containing supposed 'proof' of zombie outbreaks or other related material, a project that was still acquiring footage in 2012. The 'documentary' context, in which viewers might expect a uneven mixture of found footage, offered in this case a good rationale for the variety of styles and content (and audio-visual quality) likely to result from the use of open-call contributions. The other project, *Nation Undead*, provided a relatively more conventional framework in which a central narrative premise was established within which contributors could work. Some submissions were made, but this venture appeared no longer to be active at the time of writing.

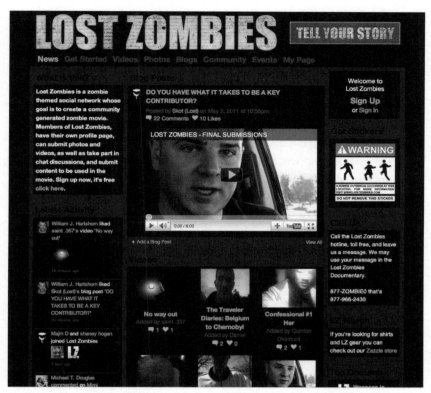

10. Invitation to the undead: Web page for *Lost Zombies* open source project

A different twist on this kind of web-based collaboration was offered by Massify.com, a site that invited pitches for projects that were then voted upon by its community of members to decide which went into production. A similar process was used to decide principal casting. Massify's first project was for a horror feature, which led to the production of *Perkins 14* (2009), a story about the turning of kidnap victims into a brood of zombie killers, another innovative twist on the genre, shot in Romania on a budget reported to be $1 million.[32] The film gained theatrical distribution in the independent After Dark Films' 'Horrorfest', an annual weekend-long event featuring a total of eight films subsequently released on DVD by the substantial independent Lionsgate. If fiction projects have so far appeared to enjoy less success than documentary in the arena of online

collaboration, it is perhaps no accident that some of the ones that have proved more viable have been rooted in popular genre material of this kind for which online fan-collaborator constituencies are more likely to exist than might generally be the case.

A significant feature of Massify is the way it worked in partnership with established indie players, bridging the gap between new forms of online collaborative enterprise and parts of the existing industrial infrastructure. A two-year deal was announced in 2009, for example, with Killer Films, a notable part of the more radical end of the New York indie scene since the 1990s, beginning with an open invitation for pitches for a short film project that would be fully funded as part of the arrangement with Massify. The eventually winner, *Loop Planes* (2010), written and directed by Robin Wilby, was chosen by Killer and produced by Christine Vachon, probably the best-known producer in the indie sector of recent decades.

A similar initiative was launched in 2010 with Lionsgate, one of the largest independent companies outside the control of the major studios. The plan in this case was for the Massify community to choose the best submission, development of which would be overseen by Lionsgate, starting with pitches for a script for a male-focused comedy short with potential for development into a feature. The winning entry out of some 1,400 submissions was *The Wrong Guys for the Job*, by Barbara Gray, the director of which, Sean Sinerius, was also selected from submissions made via the site. For established production companies, such arrangements offer ready access to the potential pool of new or emerging talent made available through online communities of this kind; for the latter, they represent the possibility of a valuable shortcut to the resources and profile possessed by noted players on the indie scene.

Another individual open-source example is Brett Gaylor's *RIP: A Remix Manifesto* (2008), a documentary about remix culture itself, particularly in music, and the struggles it has faced against copyright law. The initial version was produced over a period of six years, featuring remixed work by hundreds of contributors to Gaylor's website.[33] Several different cuts were shown at film festivals and a further version was offered in 2010. Unlike some open-source projects, in which very general calls are made for contributions, Gaylor

made more specific requests for particular offerings. In one case, for example, an initial five-minute sequence featuring the mashup artist Girl Talk (Gregg Gillis) was posted online, followed by an animation of Gaylor making a request for any audio samples that might work well with one particular section of the footage. Numerous other suggestions were made for contributions to subsequent parts of the original version of the film.[34]

In the case of *RIP*, remixes by online participants appear to have played a substantial role in the production of the finished article (although one of the points of such activity here is to move away from the notion of the entirely completed and bounded text), the practice being closely related to the subject matter of the film. There are instances in which such elements are less central to the construction of the core text and might be considered to be little more than eye-catching gimmicks or stunts. This might be said of Marucci's *The Power of Few*, for example. Richard Linklater, director of the indie classic *Slacker* (1991), invited followers to create their own version of a trailer for his Indiewood feature *A Scanner Darkly* (2006, produced and distributed by Warner Independent Pictures), a gesture that appeared similarly marginal to the central fabric of the film itself (the practice of inviting open-call contributions to advertising campaigns is one that has been used more widely, by companies including Chevrolet, Dove and Frito-Lay[35]).

If such practices often seem of primary significance as publicity stunts rather than as ways genuinely to open up the processes of production and postproduction, we should remember that the battle for attention is one of the most important fronts in the struggles faced by lower-budget indie films to gain the kind of recognition that can lead to theatrical release or success in the online world. This is a dimension that remains central to most if not all of the initiatives outlined above, including the strategy developed by Buice and Crumley in the case of *Four Eyed Monsters*. The strand that binds together many of these various threads is an attempt to use a variety of social networking sites as resources to build audiences, often from an early stage, before any kind of release and sometimes in advance of production.

A key factor in this process is the generation of some kind of investment on the part of followers, users or contributors. This might

be financial in some cases but can spread more widely, whether or not any funds actually change hands. One of the assumptions behind initiatives such as IndieGoGo and Kickstarter – and, presumably, elements of online collaboration such as those offered in Marucci's *The Power of Few* – is that those who contribute financially or creatively are likely to become part of a loyal base of support for the project involved, following it in the future and spreading the word to others. This might be of more value in many cases than the relatively small amounts of funding or creative input usually involved. Such investment might be particularly strong for those who invest the larger sums or who have content, remixes or suggestions used in the shaping of the final text. But it might also exist for the potentially larger number who offer material that is not used or who just enjoy the process of following the development of a project from its early stages and so gain a sense of greater involvement and proximity to a production in more general and diffuse terms.

As far as the initial spreading of the word is concerned, one of the founding principles for those who advocate the merits of Web 2.0 is that a small core of the most active users can have an impact out of all proportion to their numbers. As Amy Shuen puts it:

> Online platforms are a convenient shortcut for reaching the passionate, authentic, and interactive users – 1 to 3% of the total – who can catalyze a social network and community, generating collective user value and raising average lifetime values exponentially. It's possible to do a lot with a little in Web 2.0.[36]

Key targets in this kind of campaign are the types of influential figures identified by Malcolm Gladwell, individuals who are particularly well placed in any field to spread the word as a result of factors such as their enthusiasm and knowledge and their wide networks of connections, particularly those across (rather than just within) a range of cultural niches.[37] Within a more specific realm, these might include key bloggers in a field such as indie film or aspects of its broader milieu, or influential posters to prominent late 2000s online bookmarking sites such as Digg, reddit, del.icio.us and their successors.

The ultimate measure of success in this arena is for a product to 'go viral', to pass a threshold – Gladwell's much-cited 'tipping point' – at which the spread of word becomes a self-fulfilling dynamic; one in which, for example, the more people who recommend something that gains positive momentum, the more will continue to do so again, and so on, until the cycle eventually runs dry. This ideally involves what the network theorist Duncan Watts terms a 'global cascade' in the spread of any particular innovation, a more localised version of which might be imagined for the indie film that achieves notable success within its own more limited parameters.[38] This remains an uncertain process, however, the success of which can never be ensured.

As Watts suggests, a successful cascade 'has far less to do with the character of the innovation [for which we might read the film], or even the innovator, than we tend to think.'[39] The quality, price or presentation of a product is a factor but not in itself determinant, a significant part always being owed to the role of random chance encounters within the assemblage of clusters that comprises networks of these kinds.[40] For every *Blair Witch Project* that achieves very widespread success, Watts argues, others exist that might have equal potential but in which the process is stalled at some stage for reasons that cannot be predicted in advance.

The ambitions of the kinds of indie films discussed in this chapter are generally more modest, targeted at the building of audiences large enough to sustain low-budget productions and without any expectation of setting the wider world alight. Sites such as IndieGoGo provide numerous tools of the kind typically associated with Web 2.0, designed to encourage the spreading of word of mouse about projects, even if their scope might be limited.[41] These include one-click methods of inviting contacts with addresses in popular email accounts such as Gmail, Hotmail and Yahoo, along with direct links to key late 2000s social media such as Facebook, MySpace and Twitter. The site also makes it easy to create widgets – small and highly portable applications containing the key details and current status of a project, linked to the relevant IndieGoGo page – that can be pasted into emails, blogs or other online texts or forums.

As Buice and Crumley's strategy with *Four Eyed Monsters* demonstrated, the acquisition of contact details of followers and/or potential

audience members, especially email addresses and zip codes, can be a valuable resource, both in the spreading of awareness of a production and in attempts to secure public screenings. That filmmakers should seek to collect such data from anyone interested in their project, prospective or completed, became one of the axioms of DIY or DIWO production and distribution around the end of the first decade of the twenty-first century (the provision of such information is usually a requirement of participation in any of the collaborative initiatives outlined above). Other increasingly recommended practices included creating blogs and seeking to gain links from prominent bloggers and other sites in the field and posting early footage as a taster as widely as possible on personal websites, blogs and other social media, including those cited above.[42] The provision of appealing early content is especially recommended by advocates of Web 2.0 marketing, as a way of seeking to gain more than passing interest from website visitors, good examples of which are the Buice and Crumley podcasts. A contrast is highlighted by promoters of this approach between traditional forms of advertising and marketing – the basis of which is in the interruption of the usual activities of consumers, viewers or readers, or in communication principally through other established media sources – and the direct provision of materials that are attractive in their own right to the particular constituencies to which they are targeted.[43]

This kind of strategy is also of specific benefit to smaller-scale products such as indie films, both in its low cost and its ability to reach carefully targeted niche audiences. Other social media tools such as RSS (Really Simple Syndication) feeds can also be employed to enable precise micro-constituencies to subscribe to materials such as blog updates or new episodes of podcasts such as those posted by Buice and Crumley. This ability for users/viewers to define for themselves exactly which materials they wish to receive, as part of their own investment in any particular territory, is another key dimension of Web 2.0 promotion that has been embraced by those active in this part of the indie arena and viewed as part of a process of creating an ongoing relationship between audiences and filmmakers. The latter is another key connection between the strategies followed by some of those involved in this region of the indie sector and those recommended more broadly by advocates of advertising and marketing

strategies attuned to the use of online social media. In each case an emphasis is put on the importance of building relationships with viewers/consumers that go beyond the confines of the single transaction, figures such as Crumley seeking to establish a more sustained audience or constituency of supporters that can be maintained from one project to another.[44]

Crumley took a leading role in the development of an initiative designed to open up and develop a central aspect of the *Four Eyed Monsters* strategy to wider and more radically decentered use, as co-organizer (with the software developer Kieran Masterton) of OpenIndie, a platform launched in 2010 after successfully raising $12,000 on Kickstarter. OpenIndie is described as 'a user generated film screening site with the aim of democratizing distribution'.[45] It enables users to discover and bookmark films in which they are interested on the site and to request a screening in their area or themselves organize a showing of any of the films included in the project, in the latter case also to collect donations for the filmmakers. In the first phase, the site invited 100 filmmakers to pay $100 each to have their productions included. They were asked to provide details of the project and a file containing any contact email addresses and zip codes they had collected. When a screening was arranged and notified on the site, anyone living in the nearby area would be informed and able to respond to an invitation to attend. Any such responses would be visible to other users in the area, via a range of links to social network sites, creating what Crumley suggested would be 'a social media echo chamber of interest around these films'.[46]

The strategies employed by Crumley and others have been treated themselves as a kind of open-source product on which other filmmakers are encouraged to draw through several forums. These include The WorkBook Project, created by Lance Weiler, director of *Head Trauma* (2006) and co-director of *The Last Broadcast* (1998), an early proponent of DIY approaches to theatrical distribution, further detail of which is considered below. The WorkBook Project's website includes guidance on various aspects of DIY or DIWO production and distribution, much of which is also distributed in the form of an email newsletter.

Events organized by the project include the DIY Days series of seminars, in which Weiler and Crumley have joined others in passing

on direct accounts of their experiences, and From Here to Awesome, an annual showcase. The latter invited submissions of videos (without the fees usually required by traditional festivals) that could be viewed on sites such as MySpace, YouTube and Current TV. Viewers then voted to decide which dozen or so features and shorts among those submitted were given a wider platform via selective theatrical screenings and online through outlets including Amazon and Netflix. More traditional festivals have also collaborated with major online outlets and social media sites. The Sundance festival spread into the virtual world in 2007, for example, with an 'island' on Second Life in which users could attend screenings and social gatherings. The Sundance Channel was also involved in a collaboration through which festival interviews with filmmakers shot by Buice and Crumley were posted daily on YouTube, while another deal led to 32 short films being sold at the Apple iTunes store.[47]

Hybrid distribution and exhibition: From streaming, downloading and online sales to theatrical release

In some cases, including *Battle for Brooklyn*, online funding campaigns have been linked directly to sales of the resulting production via download and DVD, pledged contributions effectively being purchases made ahead of the completion of the film. A wide array of other strategies has also developed through a range of outlets, including moves into this territory by large online players such as Amazon, Netflix, Google and YouTube. An emerging consensus among many indie filmmakers and pundits at the end of the 2000s suggested the benefits of a hybrid strategy based on a mixture of web-based and/or collaborative practices and more traditional forms of production, distribution and/or exhibition. If theatrical release remained the gold standard for most – a requirement, still, usually, for serious review coverage from most traditionally authoritative sources – an increasing array of channels became available for online sales in one form or another, even if some questions remained about their ability to generate other than relatively modest revenues.

New initiatives towards the end of the first decade of the twenty-first century saw a number of established online enterprises joining the

ranks of more traditional distributors in search of promising material on the film festival circuit. These included YouTube, which established a virtual Screening Room in 2008 that highlighted four films each week, including feature-length works as well as shorts, a key method of directing attention to particular productions among the vast numbers of videos uploaded onto the site.[48] The selected films were chosen by an editorial panel in conjunction with partners such as the Sundance Channel. Successful filmmakers had the option to have a 'Buy Now' button attached to their work for direct sales of DVDs or digital copies and received a majority share of advertising revenue generated from viewings of their work. A notable achievement was the choice of the venue by the established filmmaker Wayne Wang for the premiere of his feature *The Princess of Nebraska* (2007), an event that resulted in the first *New York Times* review gained by a screening on YouTube.[49]

Another leading investor in this territory was Amazon, which enabled online self-distribution through its CreateSpace facility, with options including downloading films to own or to rent in formats viewable on home computers and a range of hand-held devices. An early success through this channel was Matt Gannon and Michael Sarner's hockey film *In the Crease* (2006), which was reported to have taken $400,000 in gross sales on the site and to have made back its budget within 40 days, the typical Amazon deal being for a 50 per cent split on download revenues.[50]

Netflix, initially established as an online DVD rental service, also entered the bidding at festivals such as Sundance, often in partnership with theatrical distributors, with streamed viewings open to subscribers through its Watch Instantly facility. In one example, the documentary *Maxed Out: Hard Times, Easy Credit and the Era of Predatory Lenders* (2006), a theatrical release described by *Variety* as 'minimal' was followed by a reported 65,000 rentals in the film's first week on Netflix and streamed viewings by 35,000.[51] Google Video was launched by the dominant online search company in 2006 with two features, the bio-thriller *Waterborne* (2005) and a *Aardvark'd: 12 Weeks with Geeks* (2005), a documentary about computer interns, each of which became available for paid download, although this service was ended the following year.[52] MySpace also created a Filmmaker section in which shorts and excerpts of up to 20 minutes could be posted, along with video blogs.[53]

A key strategy for many filmmakers in this era was to break down rights to their work into separate packages, keeping overall control in their own hands rather than accepting the traditional demands of distributors to gain everything in one bundle. This is a central part of the hybrid strategy as defined by Peter Broderick, an indie film consultant who played an important role in the popularization of the available-resources low-budget indie production model of the early 1990s. As Broderick puts it:

> While in the Old World of Distribution all domestic rights were usually given to one company, hybrid distribution enables rights to be split more finely and effectively. Filmmakers retain direct sales rights, including the right to sell DVDs from their websites and at screenings, and the right to sell downloads and rentals from their sites. Most often filmmakers also retain theatrical and semi-theatrical. VOD [video-on-demand], television, and retail DVD deals are usually made with separate distribution partners.[54]

Direct sales may come at the cost of losing the promotional benefits brought by an established distributor but also give a far larger share of revenue to the filmmaker. This is another arena in which an advantage is gained by productions that have some link to established audience constituencies, whether those linked with social/political causes or other interest groups. One example of the latter is the $500,000 budget aviation documentary *One Six Right* (2005), which director Brian Terwilliger decided to handle himself after being unimpressed by the sums offered by distributors for theatrical and subsidiary rights. Pre-release attention was gained through a range of aviation-oriented websites and Terwilliger followed a one-week self-funded theatrical run with a mass emailing offering the film for sale on DVD. The result was some 20,000 sales within just a few months.[55]

A similar model is offered by the wrestling drama *Reversal* (2001), the producer of which hired interns to establish links between the film and wrestling websites, reportedly achieving some 400 links and more than $1 million in DVD sales. The difference in income for the filmmaker was highlighted by Broderick in 2006. In a traditional deal for a $25 DVD, the producer would receive a 20 per cent royalty on

the $12.50 wholesale cost, 'or $2.50, assuming everyone's honest'; 'That same film, at a production cost of $1 per DVD plus shipping and handling, could bring in $24 per sale that goes directly into your bank account.'[56]

A number of more or less DIY options became available to film-makers in arenas such as DVD, streaming and downloads, as outlined by Scott Kirsner in his how-to-do-it manual *Fans, Friends and Followers: Building an Audience and a Creative Career in the Digital Age*, which includes a number of case-study examples offered as inspiration to those involved in fields such as indie filmmaking, music or publish-ing.[57] The easier the option, generally, and the more it involves using the services of an outside agency, the smaller the share of revenue likely to accrue to the producers. In DVD, for example, the first option suggested by Kirsner is to use a service such as Amazon's CreateSpace to produce on an on-demand basis, which means no up-front investment on the part of the filmmaker and no need to try to predict in advance the size of the market. All that is required is to post a copy of the DVD to Amazon and upload the artwork for the cover and the disc. As of 2011, Amazon was offering a royalty of $16.30 on a title sold for $25.[58]

A somewhat more profitable approach was for filmmakers to cre-ate batches of their own titles and have orders handled by a fulfilment house such as Film Baby or Neoflix, which would take care of the sales and despatch end of the business. The risk with such an approach, as Kirsner suggests, is that it is possible to overestimate sales potential and be left with unsold copies. An initial set-up fee is also usually charged (for example, $238 by Neoflix at the time of Kirsner's account, plus a monthly charge of $35, after which the company would take 12 per cent of each sale).

The most profitable, and time-consuming, option is for filmmakers to handle the whole process themselves, or directly to employ some-one to do so, from taking orders through a website to making copies, packaging them and posting out to buyers. It is important to note, however, that DIY web-based sales on DVD can remain well behind those achieved through more traditional bricks-and-mortar stores, even in the case of productions that have adopted some of the more novel initiatives examined in this chapter. Jon Reiss, for example,

another prominent advocate of the hybrid approach, reports that his documentary about graffiti artists, *Bomb It* (2007), sold 9,000 copies when distributed to stores and only 800 from the film's website.[59] Another example, Michael Blieden's marijuana documentary *Super High Me* (2007), sold 600 online and 80,000 from retail shelves. Cases such as these demonstrate the continued importance not only of this very conventional sales channel but also the benefits that could result from using an established DVD distribution company that has existing relationships with stores and major online retailers.

A similar range of options applies in the case of downloads, which can either be sold directly by the filmmaker or through major online operators such as iTunes and Amazon. The latter, Kirsner suggests, will usually offer about 70 per cent of revenue to the creator. A number of services were available to support direct download sites, including E-Junkie and PayLoadz, which usually charged monthly fees. As is the case with do-it-yourself DVD, a greater share of revenue could be gained in this manner. A big advantage of using the services of the major players, however, is that they attract large numbers of visitors and have mechanisms through which individual titles can be recommended on the basis of previous purchases, increasing the likelihood of work being discovered by viewers who are not already aware of its existence.[60] The profile brought by such platforms was the main reason why established indie director Ed Burns and his producer Aaron Lubin decided to bypass a theatrical release to make their film *Purple Violets* (2007) the first feature to open exclusively on iTunes. While feature downloads remained a limited market at the time, the aim was to take advantage of the national showcase provided by Apple to drive subsequent DVD sales, a function similar to that often served by theatrical release.[61]

Access to sales by some of these outlets requires the use of an intermediary operation, either an aggregator, as was the case with *Purple Violets*, or a digital distributor.[62] An aggregator acts as little more than a gatekeeper for the major online delivery channels such as iTunes, saving them from having to deal directly with individual producers (having initially welcomed submissions direct from filmmakers and then become swamped with offerings, iTunes moved to a policy of only accepting material from aggregators). The alternative, beginning

to develop at the end of the 2000s, is a distributor specialising in digital rights, the remit of which would be much the same in this arena as in the traditional theatrical realm, developing a broader release strategy and marketing the film, rather than just presenting it to the outlets with which it deals, as is usually the case with an aggregator. An early example was Cinetic Rights Management, co-founded by John Sloss, a noted figure in the independent scene since the 1990s, with strategies particularly tailored to the needs of the indie sector.

More distinctly indie/niche-oriented channels also developed for distribution by download and/or streaming, alongside the more main-stream sources such as iTunes and YouTube. The most substantial of these, set up in 2007 at a cost of $23 million, was Jaman, a US-based peer-to-peer download network focused primarily on the commercial independent and international speciality market. By 2010, Jaman had a catalogue of 7,000 titles available for rental or purchase in high definition, or in some cases for free viewing, and a registered user base of 1.8 million from across the world (far from all titles were available to all users, however, as a result of territorial rights restrictions).[63] A strong emphasis was put in this case on the availability of viewer rating and preference mechanisms, in an attempt to create a social and inter-active dimension to the experience. A similar combination of global focus and film-enthusiast social networking characterized MUBI (for-merly The Auteurs), a video-on-demand site specialising in a curated range of independent, international and classic material.[64]

Another notable example was Babelgum, founded in 2005, an advertising-funded and programmed site with a broadly indie/alter-native/green ethos, offering free-to-view streaming of shorts and features to computer or mobile phone. While Jaman and MUBI acquired rights to films through traditional sources such as distribu-tors and other rights holders, Babelgum was open to direct submissions from filmmakers, but differed from the likes of YouTube in subject-ing uploads to quality controls and a preference for particular kinds of material of a professional or semi-professional standard. The site gained headlines in 2009 for what was reported to be the first mobile phone premiere of a feature (or, at least, the most high-profile exam-ple at the time, with performers including Judi Dench, Eddie Izzard and Jude Law), Sally Potter's *Rage*, a US/UK co-production released

in episodes for viewing on Apple iPhone and iPod devices at the same time as it was screened theatrically in New York and released on DVD.[65] In this case, the novel platform was appropriate to the central premise and formal confines of the film, a narrative constructed through a series of to-camera monologues ostensibly recorded on a mobile phone.

Downloads and streaming video were also available, along with DVD rentals, from the indie/alternative-oriented GreenCine, which invited direct submissions from filmmakers and distributors for its video-on-demand service. The existence of sites such as these suggests another point of continuity with the offline world, one in which curated speciality distribution/exhibition channels coexist with mainstream commercial outlets (and, online, with more free-for-all platforms such as YouTube). The established documentary site SnagFilms also began to move into the realm of narrative features during 2011.

The kind of hybrid model advocated by Broderick often includes theatrical self-distribution, as in the case of Terwilliger, another growth area in which a number of institutions developed to offer support to the individual filmmaker. Theatrical self-distribution was nothing new in itself in the 2000s, having been pursued in numerous cases in the past, usually as a last resort but also in some other cases in which filmmakers have been unhappy with the terms and conditions offered by existing institutions. The distinctive characteristic of this period was the tendency for such distribution at the theatrical level to be more closely linked with DIY strategies across the wider range of fronts considered above, some having been prompted towards this approach by a general decline in the level of advances paid by distributors.

A characteristic example of the blend of newer and more traditional approaches, including the retention of all rights by the filmmaker, is that adopted in the case of Weiler's psychological chiller *Head Trauma*, which built on the earlier experience of the director in the self-distribution of *The Last Broadcast*. Weiler started with a conventional source of media attention by gaining a premiere for the film at the Los Angeles Film Festival. He then booked a 15-city theatrical release over a six week period designed to allow time to attend screenings and promote them locally.[66] A revenue split was negotiated with

theatres, which were promised a grassroots marketing plan – itself a familiar indie approach dating back at least to the 1980s – conducted partially through the film's website and the use of networking sites including MySpace.

Weiler also employed a number of approaches beyond the fixed confines of the text in an attempt to increase the number of potential points of access to the feature, including live performances with the film, remixes, various ways of engaging through social media and the development on an online game, *Hope Is Missing*, the story of which intertwined with that of *Head Trauma* and which offered inter-actions including mobile phone calls and text messages from the characters. The audience grew, he suggests, through the development of a 'storyworld' across a range of different types of screens (static and mobile devices) as more forms of engagement were offered.[67] This idea of extending the product beyond the confines of a stand-alone feature was taken up by a number of other filmmakers in the period, another advocate being the animator M. Dot Strange. Buice and Crumley offered a similar extension of the feature experience in their podcasts, a second series of which documented the travails and eventual break-up of the pair in the period after the completion of *Four Eyed Monsters*. The downside of all of these activities is the amount of time, effort and resources they can consume on the part of the filmmaker. Reiss suggests that DIY filmmakers should devote much the same amount of time and money to distribution and marketing as to the planning and production of the film itself – a source of control and in many cases of maximizing the revenues that can be achieved, but also a serious constraint on their ability to move on to the next project.[68]

As in other parts of this landscape, new institutions evolved during the 2000s to support filmmakers in the achievement of theatrical release beyond the activities of conventional distributors. One of the earlier of these initiatives was the creation of the Emerging Pictures consortium of digital exhibition venues by Ira Deutchman, an estab-lished figure in the indie landscape whose past career including running the distributor Fine Line Features, a former division of New Line Cinema. Emerging Pictures acted in some ways like a distribu-tor, attending festivals and tracking likely projects to support. In some cases, it managed to find conventional indie distributors for the films

with which it became involved, but in others it helped to organise a release through existing non-mainstream chains such as Landmark Theaters or ad-hoc collections of venues.[69] Its own network, Emerging Cinemas, included independent art house cinemas and a wider range of media arts centres and other institutions in which digital screening facilities were available.

Another option was offered by Truly Indie, a initiative launched in 2006 by Mark Cuban and Todd Wagner, heads of 2929 Entertainment, the holdings of which include the indie distributor Magnolia Pictures and Landmark Theaters, as cited in the introduction. To filmmakers lacking a distribution deal, Truly Indie offered a guaranteed run in theatres operated by Landmark for a fee that varied according to the number of markets in which the film was placed, the minimum being five and the maximum a total of 20.[70] The filmmaker took all of the box office revenue under this arrangement and retained control over marketing and other rights, while also benefiting from the promotional expertise of figures from both Magnolia and Landmark.

The importance of the ability to gain such a release, even as a loss-leader, especially in order to secure positive reviews in traditional media as a basis from which to secure further screenings or revenues from elsewhere, was underscored by Jay Craven's *Disappearances* (2006), staring Kris Kristofferson, which turned to Truly Indie after post-festival interest from distributors in which theatrical release tended not to feature. The film was shown in five major markets, at a cost to Craven of $57,000, while he was free to pursue additional screenings elsewhere, eventually playing in some 200 venues before being released on DVD.[71] Truly Indie was also involved (with the small speciality distributor Vitagraph Films) in the release of one of the most successful films to follow this kind of route, the fashion documentary *Valentino: The Last Emperor* (2008), the theatrical run of which led to a gross of $1,755,000.[72]

This kind of option, usually known as a 'service deal', has in the past been a source of stigma for the filmmaker.[73] The practice can carry some of the negative connotations of the paid-for vanity publishing of books, the implication being that the work is not strong enough to stand up on its own terms in the normal marketplace. Attitudes towards such approaches underwent significant change in

the 2000s, however, for books as well as films and other cultural products. Various forms of self-publication or distribution, with or without additional paid-for support from a distributor, gained a new respectability and credibility in the Web 2.0 environment, and often in relation to more independent or alternative products perceived to exist in some kind of opposition to the controllers of the dominant traditional channels of circulation. Self-distribution, or the use of a service company for those with sufficient resources, became a more positive option for some filmmakers, rather than a sign of desperation, particularly as part of a hybrid strategy in which the main function of a limited theatrical opening might be to provide publicity for subsequent release via download or DVD.

Jon Reiss, for example, opted for self-distribution of *Bomb It* on the hybrid model recommended by Broderick (being unable to afford a service deal), not because he received no offers to handle the film but because, as is often the case, what was offered was very little money in return for all rights for at least 10 years. The usual practice would be the cross-collateralization of theatrical and subsequent forms of release, in which the often considerable costs of theatrical would be set against revenues from DVD and any other formats: 'Translation: The likelihood that we would see any additional money beyond the tiny advance was small. Plus we would lose all control of the film and its revenue stream for many years.'[74] Self-release still entails significant costs, however, put by Reiss in 2010 at between $30,000 and $50,000 at the lowest end to $200,000 at the higher – for a small release. Much of the cost is in marketing, a certain spend on which is a condition of gaining access to some theatres, especially in the most competitive but key markets of New York and Los Angeles.[75]

An additional player in this territory was Withoutabox, initially established in 2000 as a web platform through which more easily to enable filmmakers to submit their products to festivals, subsequently developing to include resources for self-distribution through theatres, DVD and download. Withoutabox offers a good example of the extent to which some of the initiatives examined in this chapter began to come together under more aggregated business dealings by the larger companies, having been acquired by the Internet Movie Database (IMDb) which in turn was owned by Amazon. The Withoutabox

website included plugs for the IMDb, as a promotional tool which had its own streaming platform and options for filmmakers to upload trailers, clips or entire films, and also for Amazon's CreateSpace as a channel for sales and downloads.

Another approach included in some instances of the hybrid strategy is simultaneous release in theatres and via DVD or download, as in the case of *Rage*, although this remains controversial, especially with traditional cinema owners who see such a move as a potential threat to the primacy of their opening place in any series of release windows. 2929 Entertainment first made headlines in the indie realm by experimenting with such a policy with a group of titles including Steven Soderbergh's *Bubble* (2006), which opened at the same time in theatres, on cable and DVD. A more sustained version of this approach has been employed by IFC Films, the distribution arm of the Independent Film Channel, offering simultaneous theatrical release, particularly through the high-profile IFC Center in New York, and national availability on-demand via cable.

This strategy appeared in the late 2000s to offer a promising model for smaller independent distributors, being credited in the trade press for the most profitable year of both IFC and Magnolia in 2009, the latter claiming seven-figure revenues from video-on-demand (VOD) for several of its releases.[76] The main argument in favour of this policy is that non-theatrical channels are able to benefit more directly from reviews or any other publicity gained at the time of theatrical release. The other option is to maintain a small gap between the two, to give some exclusively to theatrical while maintaining any momentum it generates into other channels, as was the case with *Maxed Out*. This is the strategy advocated by Reiss, who suggests an ideal gap of two months to permit enough time for a film to be rolled out gradually in limited release in a number of markets while allowing any resulting publicity also to support the launch of a DVD.

Sales could also be made on DVD as early as during festival screenings or the latter could be used as themselves part of a theatrical release, the aim again being to capitalize on the festival as a peak moment of publicity and general momentum around a production. This was the strategy employed by Michael Mohan for his relationship comedy drama *One Too Many Mornings* at Sundance in 2010, a move

interpreted in *The New York Times* as a response to a contraction in the market for theatrical distribution.[77] The film was available for download or purchase on DVD at the same time as its Sundance pre-miere, which was followed by a number of additional festival appearances and a selective theatrical self-release (the film's website also included the novelty of a 'get it now' button to purchase domes-tic theatrical rights for $100,000). A higher-profile example of immediate leveraging of coverage provided by a festival appearance was the release of Wes Anderson's more Indiewood-oriented *Moonrise Kingdom* in 2012 within days of its opening night screening at Cannes, a strategy that resulted in a record per-screen average for its initial weekend on limited release.

One Too Many Mornings also featured among a package of five Sundance films, including two from the previous year, made avail-able for rental on YouTube for a 10-day period during the festival, the first venture of the video site into the provision of viewer-paid content. This initiative was generally considered a disappointment, however, despite the featuring of the titles on the YouTube home page, with each of the films reported to have received viewings of only around the 300 mark shortly before the end of the experiment, suggesting the reluctance of the site's audience to pay for material in a venue associated with free access.[78]

Different approaches are likely to suit different kinds of products and the differing priorities of the filmmaker. If the main concern is to maximise coverage and access, as part of the process of establishing a name and building a career, or to spread the word about a cause, it may make sense to sacrifice later potential for commercial deals for more immediate impact by releasing simultaneously on multiple fronts, and sometimes without charge. This might include free streaming access to either extracts or a whole film as a taster, perhaps in relatively low quality, which might prompt subsequent DVD sales or downloads in higher definition.[79] Some of these approaches have also been used by well-established indie filmmakers, particularly those whose work has remained more commercially marginal, a good example being Hal Hartley, whose Possible Films website has offered a combination of free streaming of some short material and paid-for direct downloads, sales or links to the Amazon store.

Online resources were also created in this period to support local community screenings on DVD as a form of exhibition beyond the usual commercial or 'artistic' channels, organized by supporters of particular products. A leading example was Brave New Theaters, a forum through which filmmakers could post details of titles available for screenings in venues ranging from homes to public or semi-public locations such as community centres, libraries and university spaces.[80] This was an initiative created by Greenwald's Brave New Films to seek screenings of *Iraq for Sale*, following the house party model employed successfully in the case of his earlier feature, *Uncovered*. The *Iraq for Sale* entry on Brave New Theaters included resources for organizers of screenings including promotional posters, logos and a press release providing background about the film, along with encouragement to follow it in fora such as MySpace and Facebook. Screenings of this kind are often followed or accompanied by social activities and fundraising and are another element of online-organized dissemination that has tended to be dominated by issues-related documentaries rather than fiction features.

Change and continuity

What, then, is the significance of these various new dimensions of indie practice, from funding, production and postproduction to distribution, exhibition and online sales? That they have attracted attention and investment from major internet players such as Amazon, Google and YouTube suggests that certain elements are viewed as having serious commercial potential, even if the most effective models for this remained unclear in some cases by the end of the first decade of the century. Some elements of the practices outlined above are likely to become adopted as standard by the bigger indie and Hollywood players, the most obvious being the potential for download and streaming to displace hard-copy sales on DVD or other physical media. Others, such as the collaborative online shaping of texts in production or post-production, are likely to remain marginal, either as practices in their own right or as eye-catching devices used to gain attention to particular productions.

The financial returns associated with many of the innovations considered in this chapter remained modest at the time of writing, limiting the attention they received from the larger established institutions. Their greatest value appeared to lie in the new scope they promised to those operating closer to the margins, particularly to the large percentage of films that have always failed to achieve any or anything more than the most marginal distribution along traditional lines (even of films that make it into the most prestigious festival, Sundance, for example, only a small minority go on to secure a conventional theatrical release).

If DV has created potential for a real democratization of access to production, along the kinds of lines celebrated by commentators such as Benkler, the various online initiatives examined above have done or promise to do something similar in the realms of distribution and sales. But a range of choices remains in place for filmmakers, from entirely DIY release, online sales, streaming and download (whether all or some of these are paid-for or free) to the use of institutions that themselves range from those tailored specifically to the smaller end of the indie scene to subsidiaries of the largest corporate-owned online enterprises.

At one end is a very new freedom; at the other is more ready access to existing constituencies of viewers, with a trade-off generally in place between the one and the other. Where some kind of institutional support is sought, a range of gatekeepers remains in place, including relatively new players such as digital rights aggregators and web channels such as Jaman, MUBI and Babelgum. This is one of a number of substantial sources of continuity identified in this chapter between the traditional indie model and elements that qualify for the web-specific dimension of the 2.0 label. The situation of indie film in this realm can also be understood in the context of debates about the nature of the wider online sphere in relation to concepts such as filtering, clustering and the economics of attention.

The internet has not become the domain of random chaos anticipated by some earlier commentators, Babelgum having been named in part after the supposed 'Babel' effect, according to which the freedoms of the net were thought likely to be undermined by the impossibility of being heard among so many competing voices.

Instead, as Benkler suggests, the online world is characterized by a tendency towards clustering and congregation around common choices, patterns in many cases not being imposed from on high but emerging on a distributed basis as a result of many small-scale independent choices.[81] The issue of attention remains an important one, amid so many competing attractions, for independent filmmakers as well as for users of the web more generally, but 'patterns of attention are much less distributed' than had been anticipated, Benkler argues, his conclusion being that a balance between chaos and concentration has developed in such a way as to be supportive of more democratically open discourse overall.[82] Hence the 'gum' of Babelgum, as a kind of 'stickiness', a source of filtering and control within an arena that remains very much more open than that associated with dominant media institutions such as the Hollywood studios, their speciality divisions or the major television networks.

The significance of the process of gaining attention is another major point of continuity with earlier indie practices, even if low-cost means of spreading word of mouth/mouse have expanded into the online world of social media and other web-related fora. A key factor here, and more generally in the ability of indie films to find new potential for circulation through online sources of the kind examined in this chapter, is the development of the phenomenon known as 'the long tail', as initially identified and promoted by Chris Anderson.[83] The term refers to part of the shape of a typical sales curve, the head of which is dominated by very large quantity sales of a small number of hit products, a component of the model that applies clearly to both Hollywood and the most high-profile part of the indie sector. The curve falls steeply from the small number of top sellers to a larger number of products each of which sells relatively or very few. The long tail is the term given to the extension of the latter in the age of broadband internet distribution, a context in which a very large number of products are able to make some, if very modest sales, sufficiently so for their aggregated value to be profitable to online retailers.

An important dimension of the long tail is the existence of online consumer feedback and recommendations, 'an amplified word of mouth', as it is termed by Anderson, that can offer a form of free marketing to products that could not afford paid-for promotion.[84] This is

precisely the domain targeted by many of the web-based initiatives examined above and a further reminder of the central importance in these processes of gaining and maintaining the attention of actual or potential constituencies of viewers, all the more so in a context in which DV production is increasingly accessible/affordable and likely to increase. Here, too, the strategy employed by many filmmakers remains a hybrid one, mixing newer and more traditional sources of attention. The latter include the central place still occupied by one of the core components of the classical indie model: positive reviews in authoritative print sources such as *The New York Times* or *The Village Voice*, the primacy of which remains in place despite the increased role that can be played by influential blogs and other online sources of recommendation, as seen in the previous chapter (the function of reviews is considered further in relation to the constitution of indie art worlds in the examples examined in Chapters 3 and 4).

The territory covered in this chapter is characterised more generally by a blend of change and instability – the function or impact of some of the practices or institutions cited above are liable to change in the near future, making some of the detail of any fixed writing on this topic liable to become out of date – but also a good deal of continuity, including the continued involvement of established parts of the indie or wider media landscape. And while many of the strategies advocated by figures such as Crumley, Reiss and Weiler are marked as alternative in character and different from those found closer to mainstream indie, Indiewood or Hollywood, these also include an emphasis on marketing that has rather different connotations in the discursive arena surrounding indie cinema.

Reiss advises the prospective DIY filmmaker/distributor to consider marketing strategies as early as possible in the life of a production, preferably from the very start. A similar case is made by other how-to guides focused on independent marketing and distribution.[85] This is an approach that, as Weiler suggests, is likely to seem uncomfortable to some, given the extent to which indie/alternative has often been marked rhetorically by a distinction from the marketing-oriented approaches on the grounds of which Indiewood or Hollywood have been criticized. Such distinctions are often products of exaggerated rhetorical construction and boundary-marking rather than accurately

reflecting the exact nature of one form of production or another, however, as suggested in the introduction. Some form of marketing or of prior consideration of the likely audience, explicit or implicit, has been a part of established indie practice in many cases, if not necessarily on the part of filmmakers themselves and if not to the extent or so consistently throughout the entire development and production cycle as is more typical of mainstream Hollywood.

It is perhaps an irony that some of the more 'cutting-edge' initiatives in the 2.0 domains of contemporary indie practice have reinforced a need for a focus on a dimension often associated (negatively) with the more conventional end of the spectrum, but also further evidence that such oppositions are never as simple as is often implied in the prevailing discursive regimes within which they are located. A resistance to the kind of marketing associated with Hollywood can be a central component of the process through which indie cinema, with its claims to more artistic status, is distinguished rhetorically – and often in an over-simplified manner – from what is marked out as the more thoroughly industrialized realm of the commercial mainstream.[86] But an earlier focus on marketing might in fact be a way for indie and overseas filmmakers to compete more effectively against Hollywood.

A major advantage of studio productions is their ability to control this and other dimensions throughout the cinematic value-chain, as Finola Kerrigan suggests, from development through to production, distribution and the design of promotional campaigns.[87] Non-Hollywood films suffer from the absence of the vertically integrated supply chains controlled by the studios, the result being a need for anything other than very low-budget productions to draw at various stages upon a complex and often unstable variety of players such as financiers, sales agents and distributors.[88] This is a context in which, Kerrigan suggests, the early development of marketing strategies can be of considerable benefit, in the selling of films to industry intermediaries and gatekeepers as well as to the final target audience.

How far the kinds of strategies examined in this chapter have really led to the production and circulation of a more diverse range of material – a key element in Benkler's wider case for the more democratic nature of his understanding of the

networked information society, as a significant new contribution to culture – might remain subject to question. The strongest case could be made for some of the social-issues-oriented documentaries considered above, the kinds of production that, to date, seem to have benefited most clearly from approaches such as crowdfunding and/or sales/circulation via various online or hybrid means. Some of these might still have existed without the use of digital resources, but probably not all, especially those made by less established filmmakers.

There does seem here to be a genuine increase of scope for dissent from the kinds of perspectives found in more mainstream media, in both what can be produced and the channels through which it can be circulated. As far as fiction features are concerned, it is harder to make a clear-cut case as yet, beyond the general support this domain can offer to already existing but embattled forms of indie film, the differences of which from the mainstream tend to be relative and to exist on a variety of grounds. A case can always be made for these, as widening the bounds of expression, even where the results might appear somewhat modest from any more socio-politically oriented perspective, the latter of which might be said of the group of films considered in the next chapter.

3

Mumblecore

The world of online social media targeted in some of the initiatives explored in the previous chapter is familiar territory to many of the filmmakers, and the fictional characters, associated with what became the first distinctive tendency to be identified in the low-budget indie landscape of the new century. The term 'mumblecore' was coined, initially, it seems, as a joke, to characterize a group of features on the basis of a shared minimal-budget low-key naturalism that in most cases involved the use of hand-held DV footage, along with lo-fi sound quality and the vocal hesitancies of non-professional performers, among them a number of the filmmakers themselves. How far the films that went by the name could really be said to constitute a movement in any real sense has often been questioned by those involved. A number of similarities can be identified between the works with which the term came to be associated, however, along with a web of links between some of the filmmakers, several taking roles as performers or collaborators in the films of each other. It might reasonably be said to represent a distinct version of some more familiar indie tendencies, the most characteristic features being ultra-cheap DV aesthetics and a quite narrow focus on the everyday relationship foibles and inarticulacies of a 'twenty-something'

post-college generation in the era of the text message, email and YouTube.

The starting point is generally agreed to have been Andrew Bujalski's *Funny Ha Ha* (2002), a typically mumblecore portrait of a young woman adrift in the space between finishing college and settling down into a regular job or relationship, although this and Bujalski's following feature, *Mutual Appreciation* (2005), are distinctive in being shot on 16mm film rather than the usual DV. The sound mixer of the latter, Eric Masunaga, has been credited with the coining of the label during the 2005 South by Southwest (SXSW) festival, the impression of the emergence of something like a concerted new tendency having been created by the appearance at the same event of four candidates: *Mutual Appreciation, Kissing on the Mouth* (Joe Swanberg), *The Puffy Chair* (Jay and Mark Duplass) and *Four Eyed Monsters*.

Few if any connections appear to have existed among the filmmakers before the festival, the geographical bases of those who became established as the core members of the group being spread across the United States (Bujalski in Boston, Swanberg in Chicago, Aaron Katz in New York and the Duplass brothers moving from Austin to Los Angeles). They met at SXSW, and elsewhere subsequently on the festival circuit, which represents an important phase in the life of work of this kind, staying in touch and forming connections that crystallized in a number of future collaborations.[1] A quintessential example of the format in this respect is Swanberg's *Hannah Takes the Stairs* (2007), the non-professional cast of which includes the director and two of the other filmmakers, Bujalski and Mark Duplass, each of whom had also appeared in their own productions, among a number of other figures who became associated with the movement.

The mumblecore label itself entered into the discourse of the indie sphere when used by Bujalski in an interview with *indieWIRE* in August 2005, although it is a term generally regarded with ambivalence at best by himself and the others with whom it became associated.[2] It gained much wider currency, as did the filmmakers involved, with the launch of a two-week programme, 'The New Talkies: Generation DIY', at the IFC Center in New York in August 2007, a showcase including *Hannah Takes the Stairs* and Katz's *Quiet*

City (2007) that generated high-profile coverage in publications including *The New York Times* and *The Village Voice*. Opinion was somewhat mixed, but this was the stage at which mumblecore can be understood to have gained recognition by some authoritative commentators as a significant point of reference in the wider film/cultural landscape, dubbed by Dennis Lim in *The New York Times* as 'the sole significant American indie wave of the last 20 years to have emerged outside the ecosystem of the Sundance Film Festival.'[3]

By the end of the decade, the term was sufficiently established to have become a regular point of reference in the trade press and indie circles for a range of other low-key, low-budget productions, whether or not they were deemed part of the original phenomenon.[4] While some critics were scornful of the rough, home-made or amateurish-seeming quality of the dominant mumblecore aesthetic, others responded positively and praised the films, or certain examples, for what was judged to be an 'authentic' insight into the lives of their particular social constituency. This is one of several instances examined in this book in which notions of a 'new' or more 'true' indie grass-roots spirit was championed by some commentators, a quality typically articulated as existing in opposition to the knowing or manufactured quirkiness of examples such as those considered in Chapter 1.[5]

The higher profile generated around 'The New Talkies' also produced a backlash, however, demonstrating the extent to which such phenomena can surround indie films of provenances as different as those of mumblecore and the likes of *Little Miss Sunshine* and *Juno* whenever they are raised to higher levels of public or critical prominence. Elevated to the status of any substantial kind of movement or tendency, or celebrated for its new authenticity, mumblecore itself could be seen as in part a manufactured category or brand (regardless of the intention of its practitioners) as some critics were keen to point out, including a piece by Amy Taubin in *Film Comment* that highlighted the role played in its promotion by the head of SXSW, Matt Dentler.[6] Dentler was, Taubin suggests, 'a tireless blogger' on behalf of mumblecore, the association of the festival with the phenomenon, which continued after 2005, making SXSW likely to be one of the chief beneficiaries of any increase in its critical or (very limited) commercial currency. This is typical of the manner in which festivals have

tended to function in recent decades, particularly those outside the elite group at the top of the international hierarchy, in seeking to mark their own distinctive identity through association with their 'discovery' or championing of various new waves, movements or individual 'auteur' filmmakers.[7]

It appears generally to be accepted by both the filmmakers and critics that the former, and their individual works, benefitted considerably in profile from association with the mumblecore label, whatever the reservations of any about the extent to which it might be either uncomplimentary in its connotations or reductive in its tendency – like that of many such tags – to stress similarities rather than differences across a particular body of works. The death of mumblecore was asserted by numerous commentators towards the end of the decade on various grounds, including the ageing of its practitioners and potential moves closer to the mainstream (or more mainstream-indie territory) or more genre-inflected uses of some of the qualities associated with the term.

Industrially, mumblecore is associated with the very margins of feature production, the budgets of the early work of Swanberg and Katz tending to be limited to sums of around $3,000, those of Bujalski considerably higher, as a result of shooting on 16mm, but still very low even by indie standards (the figures have not been made public but would be somewhere in the region of five to low-six figures). Theatrical distribution ranges from non-existent, beyond the festival circuit, to at most very limited. *The Puffy Chair* achieved the largest take at the box office with a domestic gross of $194,523 during a 15-week run after gaining a joint release by Netflix and the distributor Roadside Attractions, the role of promotion to its subscribers by the former being credited with much of its relative success both theatrically and subsequently on DVD.[8]

Bujalski also achieved a degree of relative box office respectability with grosses of $77,070 and $103,509, respectively, for *Funny Ha Ha* and *Mutual Appreciation*, figures that would have been considered modest even before the onset of the indie boom of the late 1980s (and without even adjusting for inflation).[9] The most that could be expected was a very narrow release in a handful of art-oriented venues, a maximum of seven at any one time being achieved by *The Puffy Chair* and

five by *Mutual Appreciation*. Bujalski's films have demonstrated the greatest sticking power, with total runs of 20 and 28 weeks for his first two features, a factor that might be taken as a marker of the greater resistance of even the marginal theatrical market to DV productions such as those of Swanberg. Of the latter's films at the time of writing, only two received theatrical release for which data was available, *Hannah Takes the Stairs* earning $22,818 on a maximum of two screens, *Nights and Weekends* $5,430 on one. Katz's *Quiet City* grossed $15,610 in a five-week run, also on no more than a single screen at a time. Brief theatrical appearances of various kinds were made by some of at least six Swanberg features released in 2011 (*Uncle Kent, Silver Bullets, Art History, The Zone, Caitlin Plays Herself* and *Autoerotic*, the latter co-directed by Adam Wingard), a total that testifies both to the prolific nature of his output in this period and the often rough-and-ready quality of the films, none of which were available in time to be included in the detailed analysis in this chapter.

While something akin to a conventional theatrical platform often remains an important source of review coverage for industrially marginal productions such as these, key arenas for the distribution of mumblecore include some of those examined in the previous chapter. These range from theatrical self-distribution to direct or semi-direct sales online and/or the combination of theatrical shop window and cable release on-demand favoured by IFC Films, the distributor of *Hannah Takes the Stairs, Nights and Weekends* and *Autoerotic*. *Funny Ha Ha* turned out to be an early innovator in simultaneous distribution through multiple channels, even if this was a product of circumstance rather than design. At the same time that it opened in New York, self-distributed with the aid of a financier and the producer's representative Houston King, under the label Goodbye Cruel Releasing, it was already playing on the Sundance Channel and VHS tapes were being sold from the film's website, factors said by King not to have damaged the theatrical return.[10] In this case, an initial offer for a small release from an existing distributor fell through.

With *Mutual Appreciation*, King says, offers were made but fell short of what was considered satisfactory, leading to another foray into self-distribution and subsequent sales to a DVD distributor and the Sundance Channel. *Quiet City* was self-distributed by Katz and his

team before acquiring a DVD release on the niche label Benten Films, in a joint package with Katz's shorter earlier film *Dance Party USA*, which also handled Swanberg's *LOL* (2006). DVDs are typically sold from the websites of the filmmakers, either directly or via links to retailers such as Amazon (as in the case of Swanberg), and/or through related fora such as MySpace pages for individual titles (for example, *Quiet City*, 'friends' of which encompassed other films and filmmakers both including and beyond those associated with mumblecore). Alternative theatrical venues have also been used in some cases, three of the Swanberg releases of 2011 having had their New York opening at the reRun Gastropub Theater in Brooklyn, a niche venue offering digital projection on a 12-foot screen, bar service and audience accommodation in 60 reclaimed car seats.

The claims to authenticity made by films associated with the mumblecore label, or those identified by some critics, are rooted in central formal qualities that demonstrate a strong element of continuity with broader indie traditions. These include low-key narrative strategies and *vérité* style hand-held visuals, each of which are in themselves familiar components of independent cinema dating back, variously, to the films of John Cassavetes from the 1960s onwards and many exemplars of the indie boom of the 1980s and 1990s, including the work of figures such as Jim Jarmusch, Kevin Smith and Richard Linklater, as well as having antecedents from other cinematic traditions. Such qualities are in some cases heightened in mumblecore, the influences of which also include audio-visual phenomena more closely associated with this particular generation such as 'reality' TV, the ubiquitous products of casual self-documentation through the camera-phone and the widespread availability of the latter and other lo-fi or home-made productions on YouTube and other online video-sharing sites.

The remainder of this chapter begins with a close analysis of these qualities, primarily in relation to a sample representative of both the continuities and some points of difference that can be identified among prominent examples of mumblecore: *Mutual Appreciation*, *Hannah Takes the Stairs* and *Quiet City*. This starts with an examination of the narrative dimensions of the three films, with some reference also to other works by the filmmakers at the level of the formal qualities themselves and how their employment can be understood in the

context of the evocation of a particular socio-cultural milieu. A similar approach is then taken to the audio-visual qualities of the films, which include some marked differences between Bujalski's use of 16mm and the in some respects contrasting examples of DV aesthetics found in the work of Swanberg and Katz. Consideration is then given to the extent to which mumblecore might be interpreted as an expression of a particular generation or demographic and some aspects of its political implications, generally and particularly in relation to gender. The chapter concludes with a return in more detail to some of the discursive articulations within which mumblecore has been both located and disputed in the indie realm, including its status in relation to broader debates about cultural production situated in between the domains of the amateur and the fully professional.

Just kinda slinking around

One of the dimensions all films associated with mumblecore have most closely in common, along with their minimal budgets and general DIY practice, is a commitment to very small-scale narrative frameworks, the primary focus of which is on what are presented as more or less everyday experiences of life and the difficulty of relationships among the particular constituency it depicts. A major plot turning point for the typical mumblecore production is something that barely exists; an event that often does not quite happen, a relationship that stutters and stalls awkwardly or a connection that does not come fully to fruition. These are films with a limited number of central protagonists around which our interest is focused, as in the dominant classical Hollywood or canonical narrative style, but the characters tend to lack much in the way of the kinds of clear-cut goals and actions more typical of the commercial mainstream.

The figure with perhaps the greatest focus on a relatively conventional ambition is the musician Alan (Justin Rice, from the indie group Bishop Allen) in *Mutual Appreciation*, but his former band appears to have fallen apart and no indication is given that his career is heading in any particular direction after the scantily-attended one-off gig he performs during the film with the aid of a temporary drummer. Most typical in this department are characters such as Charlie (Cris Lankenau)

in *Quiet City* and Mike (Mark Duplass) and the more marginal figure Rocco (Ry Russo-Young, director of films including *Orphans* [2007]) from *Hannah Takes the Stairs*. Charlie, when asked what he does, replies 'not much', having quit his job a few weeks ago and 'just kinda been slinking around', a term that might equally well describe the characteristically meandering mumblecore form. Rocco responds to a similar question with: 'Hanging out. Just killing time – looking for a job but not really looking for a job.' The sense of doing something that might involve a substantial commitment but not *really* doing it, or wanting to do it, seems to apply more widely to the activities of many of the denizens of mumblecore.

One familiar trope in this vein involves characters who play music to some extent, although generally less than the more earnest onstage performance ambitions of the likes of Alan in *Mutual Appreciation* or Alex (mumblecore's resident composer Kevin Bewersdorf) in Swanberg's *LOL*, even if neither of these appear to be particularly successful in their chosen field. Thus, we have Charlie in *Quiet City* playing a one-fingered but not unmusical spontaneous keyboard duet with Jamie and declaring himself also able 'barely' to play guitar and drums, or Hannah (Greta Gerwig) and Matt (Kent Osborne) closing *Hannah Takes the Stairs* with a halting trumpet rendition of the '1812 Overture' performed naked in the bath. If not necessarily played on screen, instruments are a common presence in the background, as at the home of characters in *Funny Ha Ha* and *Kissing on the Mouth*. Dabbling, in place of commitment, seems to be something of a stage-of-life principle for such characters, in a variety of spheres. Mike has a background 'playing in bands' that appears to have led nowhere. He has also given up work and declares a more positive ambition to do nothing in terms that suggest almost a parody of Hollywood-style goal-oriented action and characterization. He wants to go to the beach and 'hang out', he says, 'and that's my goal and I'm gonna complete it and I'm gonna feel good about it.'

'Hanging out' is an (in)activity that takes up much of the (usually brief) running time of the features examined in this chapter, as characters sit or lie around talking, sometimes with animation, sometimes in desultory fashion, or negotiating awkward periods of silence. *Mutual Appreciation* revolves around a three-way relationship between

Alan and his friends, the couple Ellie (Rachel Clift) and Lawrence (Bujalski). Alan has a not-really relationship with a radio DJ, Sara (Seung-Min Lee), and an almost-but-not-quite-dalliance with Ellie, the film ending abruptly after a three-way hug seems to restore relations among the principals. *Hannah Takes the Stairs* charts a short period in the life of the central character: ending her relationship with Mike, beginning and ending another with Paul (Bujalski) and closing with the start of what appears likely to be another short-lived fling with his television script-writer colleague Matt. *Quiet City* offers an even smaller-scale version of similar material: Jamie (Erin Fisher) arrives in New York to visit a friend who fails to turn up at the planned rendezvous, instead spending the night and following day with Charlie, the pair meeting when she asks him for directions from the Brooklyn subway.

Along the way, the dominant impression is one of drift rather than strongly motivated or planned activity. Alan seems to have drifted into a sort-of relationship with Sara, who kisses him passionately on a number of occasions, largely because he lacks the courage to do otherwise until prompted by Ellie. Alan and Ellie, meanwhile, almost come together romantically on two occasions but in neither case is either quite able to make more than what appears to be an abortive approach. Jamie and Charlie meet by chance in the subway in *Quiet City*, the latter also seeming to drift through inertia more than anything else into both waiting with Jamie in the diner where she was meant to meet her friend and inviting her back to his apartment. A similar quality characterizes most of the activities of the following day: he has nothing to do and says she offers a 'pleasant distraction'. Nothing that might be identified clearly as a romantic attachment appears to develop between the two main characters, the film ending with the pair falling asleep at the end of the night on a subway train before a distant shot of a plane taking off that no more than implies her return home. Hannah also seems to drift from one relationship to the next, suffering, as she puts it, from 'chronic dissatisfaction', her choice of partners appearing to be on the basis of convenience as much as anything else and without the impression of gaining anything in the exchange from one to another.

For some of their detractors, of which there have been plenty, online and elsewhere, this kind of narrative approach is a measure of

the filmmakers' lack of ability to produce anything more convention-
ally or dramatically structured, but there is a clear fit between the
strategy employed by the likes of Bujalski, Swanberg and Katz (and
their collaborators) and the more substantive content of the films.
Narrative form seems clearly to be motivated by the portrait they
offer of a certain cohort of young adult college-educated Americans
who experience difficulties with commitment to either relationships,
work or both. Narrative drift and relative shapelessness is an expres-
sion of drifting or shapeless lifestyles, in keeping with a well-established
tradition in both indie cinema and various expressions of quotidian
realism in film.[11]

A particular subject of this portrait is the inarticulacy, both verbal
and emotional, attributed to some of the central figures, characteristic
examples of which are the two apparent near misses experienced by
Ellie and Alan, particularly on the part of the latter. The first occasion
appears to have been an opportunity manufactured by Ellie, who
offers Alan a ride home and finds an excuse to go up with him to his
room. After some initial exchanges he sits alongside her on his bed
and she says she would like to talk about 'real things' with him,
but comments on the impossibility of getting him to discuss anything
other than his music or career without first feeding him three or
four beers, a reference to his reluctance to address personal matters
when sober.

Ellie notes, somewhat reflexively, the 'long awkward pause' that
follows, wondering how long it will last and likening it to a staring
contest. He says nothing, leaving her to make all the running, which
seems typical of his somewhat passive-aggressive behaviour. He
makes one or two brief remarks, eventually saying he is flattered but
is not sure what he is trying to say or what else he should say at this
point, after which general awkwardness she describes him as 'a good
man' and leaves.

The pair find themselves on the same bed two or three scenes later,
drinking beer, Alan this time having taken the initiative by visiting
her workplace. She says the experience is 'like, weird', after which he
takes her hand, tentatively, and says he did not know what to say the
other night. He says he wants to say he likes her, which he does, but
seems to be doing so slightly at one remove rather than actually saying

11. 'Long awkward pause': Ellie and Alan don't quite get it together in *Mutual Appreciation* © Mutual Appreciation LLC

it directly. He rubs her arm, saying he can stop if she wants. She says it feels nice but 'er, this is like [pause], I can't do this, not yet'. They both lie back on the bed, she saying 'this cannot happen', he agreeing, and she adding that it is not going to happen, to which he agrees again. She says she should go, leans over and kisses him, and repeats the comment. He asks her to stay, saying it will be fun not awkward (the latter how it has clearly been so far). He says he does not see anything wrong with that, although she does, but she seems to agree as they end up facing each other – at which point we cut to the next morning, the pair still facing each other on the bed although with no particular suggestion that any further physical contact occurred, beyond the fact that each has removed an outer layer of clothing.

The multiple hesitancies and repetitions in all of this, the awkwardness and discomfort, are typical mumblecore material, notable here in their uncertain, anticlimactic dominance of what more conventionally might be expected to be the major dramatic action of the film. The

approach is one that makes valid claims to capture an impression of the messiness and uncertainties of real-life relationships to a far greater extent than the generally reconciliatory fantasies of even the more prickly of contemporary mainstream romances or romantic comedies. Another characteristically awkward scene follows, with numerous uncomfortable moments of silence, when Ellie tells Lawrence about the incident, a 'strange moment' between her and Alan, although she says nothing happened and they did not even kiss, a sequence that ends with her apologizing and affirming that she does not want to break up with him.

Much of this kind of material is articulated in a manner that seems specific to a particular post-college age constituency: that which does not yet feel fully adult/mature but is equally far from childhood or adolescence. Charlie in *Quiet City* gives voice to a question that seems implicit in the treatment of a wider range of mumblecore characters:

> I dunno, do you think it's like that we're just kind of like naïve
> and impatient and then when you get older you sort of mature into
> like a person that can actually sustain a real relationship? Or is it that
> you're just [pause], you know, you're stubborn when you're young
> and as you get older you kind of lower your standards and settle?
> [To which Jamie answers: 'God, I hope that's not true.']

Hannah gives expression to a related sentiment in her moment of greatest self-reflection, commenting on the fun and excitement of having crushes on people until 'one by one they sort of become like real and problematic and people get hurt and, um, it stops being thrilling', although she follows this with a typically mumblecore-hesitant backing away from her own diagnosis with the suggestion that, 'I don't know what I'm talking about; I've just had a bad day.' The primary emphasis of the films is on the problematic and the uncertain, rather than the thrilling; the awkward groping towards and often abrupt ending of romantic connections, an oscillation built quite closely into the narrative fabric of the work.

The texture of vagueness, uncertainty and distraction also tends to spread more widely, characterizing many of the more banal interactions depicted by these films, considerable stretches of which are often devoted to footage of the protagonists going through everyday activities (taking

showers, brushing teeth and having haircuts of various kinds are among recurrent tropes, particularly but not exclusively in the films of Swanberg). A typically hesitant and wandering series of exchanges occurs between Jamie and Charlie in *Quiet City*, shortly after their arrival at his apartment. He asks her if she would like a drink or something, to which she replies, 'Sure.' Do you want a drink, he asks, 'or, like, a drinky-drink?' All he has, it turns out, is a bottle of wine given to him by his father which he 'was actually kinda trying to save', although he quickly goes on to declare somewhat dismissively that it all tastes the same to him. He asks a vague question about pinot noir, which she says is supposed to be better than 'like, merlot or cabernet'. They drink but cannot at first think of anything to 'cheers' to, choosing in the end to drink just to the wine itself. It smells weird, he observes. 'It's pretty bitter', she adds, 'and kinda sweet at the same time.' Is that good, he asks. She replies: 'It depends on what you like.' Charlie: 'I don't really know.' Jamie: 'Do you like bitter things or do you like sweet drinks?' Charlie, with characteristic lack of any real commitment: 'I guess I like sweet, maybe.'

A key factor in the production of this kind of material, including the authentic-seeming looseness of much of the dialogue, peppered with its 'ers' and 'likes', is the use of improvisation on the part of the non-professional performers. In the case of *Quiet City* and the films of Bujalski, improvised performance is combined with scripted material, the balance between the two varying. Much of the scripted dialogue of *Quiet City* was abandoned in favour of improvised material in which the actors were encouraged to draw on their own life experiences.[12] This includes parts of the sequence cited above, although some distinctive phrases, such as 'drinky-drink', remain the work of co-writer and director Katz. The sequence in which Charlie and Jamie play together on the keyboard is one of numerous examples of complete improvisation in the film, which also made use of props and settings provided by the cast (Cris Lankenau's own apartment serves as that of his character).

Bujalski's films appear to give relatively less space for improvisation, although room for what he terms 'happy accidents' is provided within scripted material.[13] Bujalski takes sole writing credit for *Funny Ha Ha* and *Mutual Appreciation*, in contrast to Katz, who shares credit for *Quiet City* with his two leads, and Swanberg, whose films make the largest commitment to improvisation and collaboration. Swanberg's

approach is one in which formal scripting is generally foregone in favour of general outlines of scenes within which the performers are asked to improvise. For the production of *Hannah Takes the Stairs,* the cast spent a month living together in an apartment in Chicago during shooting, without a script, the contributions of all being recognized in the credits. Much of the more locally detailed 'business' of the film, activities in which characters engage while undergoing their various conversations, resulted from props or other suggestions brought by the performers, including a variety of toy-like objects that play a part in mediating some of the exchanges (one example being a slinky provided by Gerwig, through which Paul talks to her after being invited up to her apartment for the first time).[14]

Openness to improvisation is another respect in which mumblecore has been associated with established independent tradition, a dimension in which it has been compared with the work of John Cassavetes, a figure often viewed as a key progenitor of the variety of indie cinema that gained prominence from the 1980s. Any parallel is far from exact, improvisation having played an important role in the films of Cassavetes, but usually during rehearsal, the results having been written into the script on which the final performance would be based, while much of the work considered in this chapter is improvised directly to the camera.[15] A broader link can be identified, however, in the priority given by both mumblecore and its predecessor to the capture of performance rather than, in most cases, to the creation of any other audio-visual qualities, as considered below, although the tone of the material is rather different, mumblecore tending to be played in a lower and more off-hand register than the often demonstrative theatrics found in the world of Cassavetes.

None of the argument above is to suggest that the films of Bujalski, Swanberg, Katz and others associated with mumblecore are entirely without more conventional narrative dimensions, beyond the presence of a limited number of central protagonists around which events or non-events revolve. Some other more familiar elements also coexist, to a variable extent, with the wandering, hesitant or episodic qualities of the films, another respect in which they are consistent with broader indie or art-cinema tendencies, in which departures from more classical-type routines are often a matter of relative degrees

rather than absolutes. If relatively little happens during the 78 minutes of *Quiet City*, for example, the narrative is bracketed by quite conventional opening and closing tropes, beginning with an arrival and ending with what appears to be a departure.

Mutual Appreciation opens with what seems an arbitrary plunge into the middle of an inconsequential scene in which Alan and Ellie lie on a bed chatting about nothing very much in particular. A more random sequence opens *Funny Ha Ha*, the arrival of the central character, Marnie (Kate Dollenmeyer), at the room of a tattooist who declines her custom because she has been drinking and who plays no further part in the film. While the ending of *Mutual Appreciation* suggests some movement towards a reconciliation of tensions between the three principals (the group hug), however tentative this might appear and despite the abrupt cut to the credits, that of *Funny Ha Ha* again seems some degrees more arbitrary. An abrupt cut to black in this case follows a low-key scene in which Marnie and Alex (Christian Rudder) – a potential beau suddenly revealed to have got married earlier in the film – indulge in silly, joking conversation in a park, without any suggestion that this represents a stage in any particular development of a relationship between the two.

Hannah Takes the Stairs opens, in not untypical Swanberg style, with the central character naked in the shower, a certain symmetry being created by the naked bath scene with which it ends. The broader movement of the film does describe a kind of character-based arc, via the progression through the three central relationships, and Hannah might be understood to have come to a degree of greater self-awareness, in the confessional nature of some of her comments to Matt; but the stronger impression is one of her continuing to plough the same old chronically dissatisfactory furrow. The film has a overarching narrative shape to a degree perhaps greater than usual for mumblecore, described by Swanberg and Gerwig as akin to the palindromic name of the title character, although the structure (end of one relationship, whole of a second relationship, start of a third) is not strictly reversible. Gerwig describes her character as undergoing something akin to a spiral movement – implying some progression upwards as well as the circularity suggested by the sequence of relationships– although Swanberg's observation that his interest lies not in

mainstream-conventional notions of character change and develop-
ment seems generally more closely to reflect the nature of this and the
other films associated with the movement.[16] This widespread tendency
in mumblecore, towards a portrait of life just going on, in its various
familiar and repetitive routines, without any transformative action or
change, is another basis of any claim it might have to verisimilitude and
another clear inheritance from a variety of earlier realist traditions.

Hand-holding

The visual style of mumblecore is characterized by a reliance on
hand-held photography of an image quality that would generally be
judged to be rough or technically low-grade, as befits its minimal-
budget conditions of production. This is, at the same time, another
key contributor to the effective claims to authenticity – and sincerity
of engagement – made by this strand of indie film and a marker of its
relationship in many cases with the aesthetics of other low-/no-
budget forms of user-generated online audio-visual production.
A number of consistencies can be identified across the works of fig-
ures such as Bujalski, Swanberg and Katz, but also some significant
differences, certain of which might be attributed to their variable reli-
ance on the performance of improvised material. This section begins
with a close examination of the Swanberg style as manifested in
Hannah Takes the Stairs, a representative example of both his output
up to the time of writing and of the form generally associated more
widely with the mumblecore corpus.

A general pattern can be identified in *Hannah Takes the Stairs*, and
most of Swanberg's work, in which the unsteady, hand-held quality
of the photography is most apparent in close shots. This is the result
both of proximity itself, in which any unsteadiness is always likely to
be magnified, and the tendency of the closer camera to move in order
to follow action or the development of dialogue or emotional cur-
rents. *Hannah Takes the Stairs* opens with a characteristic sequence,
starting with the sound of a shower and the voices of Hannah and
Mike audible beneath the last part of the opening titles. The first
image of the film-proper is immediately slightly unsettling, Hannah
first being glimpsed just as she enacts a quick downward movement

in the shower as she appears to drop and catch something (presumably the soap). The effect is the creation of an awkward jumpy sensation, a frustrating impression of barely or peripherally catching – or just missing – an action, even if it remains in itself a trivial one. The camera is hand held but quite steadily so. It adjusts slightly downward and up again with Hannah's ducking movement but not in a pronounced or exaggerated manner that seems overtly to follow the action.

A quite abrupt cut is made to the following scene – another recurrent device in the work of Swanberg, Bujalski and Katz – in which we see the two characters waist-upwards in a two-shot in the bathroom after their shower, slight movement of the camera evident at the margins of the frame. A similar cut, somewhat abrupt but not exaggeratedly so, takes us to a close shot of Mike's head at the right-hand side of the screen. The camera zooms out slightly and pans to the left to a shot of Hannah's arm, zooming in closer onto the arm as Mike tries to rub off quantities of fluff with which she has become covered after using a new blue towel. The close shot is quite unsteady, the camera then wavering rightwards to his head and back again to her with a slight outward zoom as she examines one of her breasts. A cut follows to a mid shot of her continuing the same action. Mike is in the lower-right part of the screen, still rubbing her arm, an action that continues in a cut to a closer shot of the detail.

The next cut is back to the previous mid shot (as Mike talks about having quit his job) with a move to a close shot of his face (as he explains his mission to go to the beach and hang out). The camera is slightly unsteady here and continues to be as it pans from his face to a head-and-shoulders shot of Hannah as she gives her response to his announcement. A cut back to his face is followed by another pan over to her body, slightly more unsteady than before, some movement up and down on her, and then a pan back to him. A further pan across to Hannah is then followed by a zoom back out into mid shot (as he is asking her to join him in taking the day off), after which the scene ends with an abrupt cut, before the discussion is resolved, to a sequence involving Mike, Rocco and Hannah at the breakfast table.

The hand-held quality contributes a number of effects to the film, including the general impression of the provisionality of the material found in most of the work associated with mumblecore. The fact that

the first action of the film is one that is only half grasped, fleetingly, as we cut awkwardly into a sequence *in media res*, contributes to the narrative impression of capturing something like 'ordinary' life in relatively unstructured form. Something similar results from the relatively abrupt shifts from one sequence to the next or within sequences, an impression of happening upon particular moments from the lives of the characters rather than of presenting a neatly self-sufficient fictional fabric. Shooting hand-held, sometimes with unstable pans and sudden and awkward little zooms, places this work clearly within an established tradition of seeking to create the impression that on-screen events are being captured as they unfold rather than being the subject of scripted pre-arrangement.

Devices such as these, borrowed from documentary or news footage, in which camera and sound are often required to follow unpredictable events as they develop, can lend a similar impression to fictional material, a well-established convention within indie cinema and other formats with aspirations towards the status of apparent verisimilitude. 'Rough' or 'amateurish', terms sometimes used in association with mumblecore, can be translated more positively into notions of 'authenticity' (as well as being sources of opprobrium), an issue to which we return below. While this is a familiar dynamic, within indie and other cinematic traditions, it might have increased saliency for the mumblecore generation in the broader contemporary currency of the rough DIY aesthetic in the era of YouTube and other video-sharing sites on which non-professional work can be posted. If hand-held 16mm carries associations with a longer tradition of documentary footage, particularly with the American Direct Cinema movement of the 1960s, low-grade video footage has subsequently become, as Jon Dovey suggests, '*the* privileged form' of supposed on-screen truth-telling, 'signifying authenticity and an indexical reproduction of the real world.'[17]

Camerawork of this kind can also be motivated by the need to follow improvised performance, however, in which case it may be the outcome of practical imperative rather than conscious desire to create a fabricated impression of verisimilitude. This is clearly an important factor in mumblecore, particularly in the films of Swanberg and Katz. The style of photography is partly governed by the need to capture

action the full detail and content of which has not been planned out in advance, but a number of options are available in how this might be achieved. Swanberg's general preference in the films examined here is to shoot at close or relatively close range, rather than to use longer shots that would allow more space for unplanned character movement within the frame. The effect is to create a greater sense of emotional proximity to the material, on some occasions quite claustrophobic. A close correlation exists between this method of shooting improvised performance and the guiding focus of Swanberg's work on small observational moments and the revelation of character that comes from what he terms the 'accidental things we do that say a lot about us.'[18] Most of the film was shot in no more than two or three takes, Swanberg reports in his DVD commentary, the aim being to use the first and most free-form take for the main substance of each sequence, subsequent versions usually serving the purpose of constructing ways into or out of each scene.

The opening sequence of *Hannah Takes the Stairs* also remains close to the conventions of classical Hollywood-style shooting and editing conventions in some important respects, however, as do many indie features that manifest departures from the norms of the mainstream in certain dimensions, including the other examples of mumblecore considered below.[19] While the editing is sometimes somewhat abrupt, more conventional continuity is also employed as in some of the transitions detailed above (for example, the cut from a closer to mid shot of Hannah examining her breast, in which the same action continues broadly across the cut, even if it is not a precisely detailed match-on-action). The editing and camera movement also tends generally to follow the logic of dialogue sequences, as evidenced in the moment in which Mike is framed in close up when talking about his plans to go to the beach and the camera pans to Hannah for her reaction.

Many of the basic building blocks of established mainstream convention remain in place or seem to act as a guiding template for the organization of much of the material. An expressive dimension is also added to the effect in some of the more heightened sequences of the film, another aspect of the style that is broadly conventional in its use of formal qualities to reflect or highlight the experiences of characters. The panning/zooming component of Swanberg's decoupage

appears to be at its relatively most unsteady towards the end of the opening scenes, for example, an effect that might be interpreted as an expression of a building tension between the two characters. This kind of effect is found to a more pronounced extent in a later sequence that leads to the breakup of their relationship.

This sequence follows a visit by the pair to the beach, the night before which ended with Hannah asking her friend Rocco if she should break up with Mike, overtly confirming the existing impression that their days as a couple are numbered. The transition from beach to the following scene is marked by a visual awkwardness greater than that used at the start of the film, although in both cases a sound bridge is employed between the two scenes (in this case a fragment of the dialogue from the latter sequence) to maintain a greater sense of continuity than would otherwise be the case. From a shot on the beach we are taken here abruptly to one in which the camera enacts a rapid and blurry shift from a momentary head-and-shoulders shot of Hannah, propped up on a mattress, to a movement of the camera down her body and then quickly slightly back up and to the left to refocus on her foot (a graze on which is being examined by Mike).

The effect is one of distinct, if brief, disorientation, a marked departure from the more conventional notion of beginning a new sequence with any kind of more stable establishing shot (or even cutting directly to a stable close-up). A blurry pan is then made up to Mike's face, at which point the camera pauses for a moment and adjusts before moving rightwards onto hers. The dialogue here, and as the sequence continues, in which each agrees what a nice time they had at the beach, is belied as much by the awkward movement and proximity of the camera as by the uncomfortable forced smile on her face. The camera then pans back to his face and back with him as he moves closer into a two-shot with her for a kiss that leaves her appearing even more discomforted.

A jump cut follows shortly afterwards, Mike getting up after Hannah declares herself too hot and then suddenly appearing back with a handful of ice cubes. The effect is again momentarily disorienting, the cut being made unusually into a close up of his hands rather than a wider shot that would provide more immediate geographical orientation to balance the temporal ellipsis. Some business

12. Up close and uncomfortable: Hannah cornered by Mike in *Hannah Takes the Stairs* © IFC Films

with Mike rubbing ice cubes onto Hannah's skin follows, her expression shifting from discomfort to something closer to panic, the camera adjusting as required to keep the pair more or less framed within close two-shots that contribute to the general expression of entrapment on her part. The eventual moment of some kind of emotional crisis then seems to be figured or heightened by a sudden and awkward lunge and zoom of the camera slightly to the right and in onto Hannah's face, some focus being lost as she adjusts her position. A subsequent pan back to the left catches Mike briefly in frame before an abrupt cut to a mid shot of the two from an angle that establishes her location, effectively cornered by Mike between two walls. She asks if she can be honest and concludes that he cannot touch her anymore. An abrupt cut then jumps forward to her getting dressed.

A moderately unsteadily panning camera, with occasional zooms, often quite sudden and awkward, is a recurring feature of Swanberg's style in *Hannah Takes the Stairs* and elsewhere, particularly in sequences involving groups of characters. The camera typically moves from one to another, sometimes using a zoom-in to emphasis a reaction, as in an office party attended by the principals or many of the workplace sequences. Single takes with a roving camera of this kind are used where many more mainstream features might tend to intercut between

a much larger number of individual set-ups (more conventional set-ups tend to be used in a few sequences, largely in the office where most of the principals work, that require the traversal of spaces either side of the 180-degree line of action).

The style is a distance, however, from the exaggeratedly mobile and unstable 'shaky-cam' associated at its most overt with works such as *The Blair Witch Project* or the Dogme95 production *Festen* (*The Celebration*, 1998). And, if some awkward movements of camera or uses of the zoom are put to expressive effect in moments of heightened emotional intensity, Swanberg also uses something close to the opposite effect in other cases. In the sequence in which Hannah exposes herself most openly, with Matt, for example, the operative dynamic is one in which camera movement is generally reduced as the intensity of the scene is increased.

This sequence begins with a number of quite wobbly pans back and forth between the two characters but shifts to a regime of increasingly longer-held shots of each, especially Hannah, as the content of the exchanges becomes more serious; first, Matt talking about his depression, then Hannah on her own difficulties, including that of how to respond given what he has now revealed about himself. The occasional transitions between the two are marked in the latter stages of this process by cuts as often as by pans, although the orchestration of the sequence also includes some slight bobs of camera movement and one classic example of the jump cut (in which the content of the frame remains much the same but a clear discontinuity is noticeable in time and in the exact content of the dialogue). At one point, a standard over-the-shoulder shot of Hannah is employed, from the perspective of Matt, but a zoom inwards shifts this into a close up of the former that is held for several minutes as if to pin her down relentlessly during the remainder of her tearful contribution, even during the periods in this part of the exchange in which Matt does the talking.

The style here is again largely a product of the particular nature of the material and its circumstances of production, Kent Osborne (playing Matt) apparently having agreed to talk about his own experiences with depression, a dimension of the exchange that had not been expected by Gerwig and to which she appears to have responded largely as herself, both in relation to his comments and in her

subsequent attempt to explain her own or Hannah's character.[20] The sequence was shot in a single 20-minute take, nearly half of which was used in the completed film. This, for Swanberg, is precisely the kind of material that his approach is designed to elicit and for which he gives most of the credit to the willingness of the performers to expose themselves. The film contains a number of other instances in which the real moods or emotions of the performers appear to have been captured – including annoyance and discomfort, one source of the latter having been the requirement to shoot some scenes during a pronounced heat wave without the benefit of air conditioning. This is another source of any claims to the status of authenticity made by these films, an important ground for the production of such material being the level of trust that exists between performers and filmmaker.

A similar sense of creating space for the development of natural hesitations and forms of expression is established by Bujalski in *Mutual Appreciation*, although the visual style is distinctly different in some important respects. Bujalski shares with Swanberg and Katz a reliance on the hand-held camera but in a more muted style, without the use of awkward pans and zooms. He also joins the other two in creating abrupt and jagged transitions from one scene to another, although this kind of dislocation is used only rarely within any individual sequence. *Mutual Appreciation* opens, like *Hannah Takes the Stairs*, with a brief moment of slight dislocation and another example of joining a scene seemingly arbitrarily in mid-conversation. The first image is of Alan framed head and shoulders lying on the bed of Lawrence's apartment, but we cut away from this quite rapidly, giving it a fleeting and somewhat oblique quality, heightened by the slight instability of the camera and the fact that Alan says nothing while in shot, the only sound being a plosive half-laugh off-screen from Ellie. This is soon established as part of a more conventionally stable sequence of shots and reverse-shots of Alan and Ellie during which the camera continues to move very slightly at the edges, the former's head being cut off by the left-hand edge of the frame to greater or lesser extents as the exact framing shifts during the shots focused primarily on Ellie.

Longer shots of characters framed together are more typical of Bujalski's style than that of Swanberg, usually combined with larger

numbers of single shots of individuals, cut together in shot/reverse-shot style, in both *Mutual Appreciation* and *Funny Ha Ha*. The camera follows character movement around the locations, but in a manner that is generally quite stable by unaided hand-held standards and without any sudden shifts of focus. An example of the difference between the two can be seen in a sequence that takes place in a bar where Alan and Ellie meet and he eventually invites her to be his manager. The sequence begins with alternating single shots of each of them seated, in standard continuity style, albeit with the slight hand-held motion visible throughout the film. A friend of Ellie's approaches, standing, and joins the conversation. He comes into shot while the camera is on Alan, the central part of the newcomer's body visible in the frame while Alan's face is turned up towards him.

At this point in a Swanberg film, we might expect the camera to enact a slightly wavery bob upwards to show us the face of the friend, with subsequent similar shifts of position back to the principals (not that Swanberg always uses this style, however; a more or less climactic argument between the two principals of *Kissing on the Mouth*, for example, is handled in alternating hand-held single shots of each). Instead, and in what seems a more classical approach, Bujalski opts for a cut out to a longer shot in which all three are included. This is followed by a return to the shot/reverse-shots of Alan and Ellie, as the friend sits between them, but he is largely eliminated from the screen, only parts of his arm and shoulder and in one case a thin sliver of his head being kept in the frame during the transitions from one principal to the next, the emphasis of this part of the sequence being placed on the knowing looks shared between them and seemingly at the expense of the visitor.

Bujalski demonstrates a further preference for longer shots in the two sequences involving the near-misses between Ellie and Alan at his apartment. Much of the first of these is presented via a mid-to-long shot of the two sitting on the bed together, a framing that emphasizes their different body language: Ellie is turned towards Alan, he somewhat away from her. Intercut with this perspective are closer head-and-shoulder type framings of each in turn, but there is no sense that the closer shots are reserved for the more emotionally or tension-charged parts of the sequence, some of Ellie's most pointed comments being presented in the more distant of the two registers.

Much of the difference between the visual approaches of Swanberg and Bujalski can be explained through their differing levels of commitment to improvisation on the part of performers. Swanberg's camera is generally more responsive to unplanned movements while Bujalski's decoupage appears to have been more closely orchestrated in advance, which tends to make it some degrees closer to the style associated with mainstream 'classical' convention. Another factor might be the practical difference between shooting on lightweight DV and with the more substantial 16mm equipment used by Bujalski. The style is noticeably different in some details, particularly in the use or otherwise of the more wavery style of pan and the awkward zoom, although there are also points of continuity between the two, including their use of many broadly classical shooting and editing regimes. The approach of Aaron Katz in *Quiet City* is closer to that of Swanberg than Bujalski in these terms, which might again reflect a tendency to follow improvised performance and character movement, although it is substantially different from each in seeking to create a markedly more lyrical and stylized impression in some sequences.

Katz makes liberal use of the wavery pan of the hand-held camera, the film generally having more unstable camera movement than *Hannah Takes the Stairs* or *Mutual Appreciation*, partly as a result of including more exteriors or generally more material in which activity on the part of the characters is involved. A typical scene of character interaction is shot with a variable mixture of shots/reverse-shots and pans from one figure to the other. The sequence during which Charlie makes the comments about *naïveté* and maturity cited above employs a number of slightly awkward and unsettling effects. It begins with a close-up of his face on the left edge of the screen and then cuts to her, but in a style that mixes together the cut or pan options, cutting into what appears to be the end of a pan in her direction and following this with a slightly awkward zoom more closely in to her face. A cut follows back to him, but catching him slightly out of focus at first. An awkward movement inwards then occurs onto part of his face followed by a slight lurch back outwards. A minor zoom further out is then accompanied by a pan across for her response, the camera distinctly wavery in its motion and zooming in to a large close up on her face. Substantial parts of the film are shot with unsteady close

camerawork that creates a somewhat claustrophobic effect, although Katz also often uses or works within regular sequences of shot/reverse-shot and/or quite conventional movements between closer and longer shots.

Quiet City includes a number of striking compositions and other visual qualities that mark it out as distinctive from the work of Swanberg and Bujalski, however, and from the dominant aesthetic generally associated with mumblecore. The first image after the title screen is a painterly composition in which an orange-gradient-toned skyscape is artfully blended with horizontal bands of moving cloud and the vertical interjections of a line of television aerials, the latter wavering slightly in the breeze. This is followed by what appears to be a shot outwards through a window towards sky and an indistinct lower half of the frame, an image dominated by a golden burst of low sun, suggestive of the magic hour light often favoured in mainstream cinematography (as used at the start of *Juno*). A plane then sweeps across the screen, evidently having just taken off, and establishing the location at an airport. These shots are also notable for being taken by a locked-down camera, with no trace of the marginal instability usually present in even the less-mobile of mumblecore photography.

The glowing sunset tones are then accompanied by more typically wavery gestures in a hand-held shot of the sky with what are presumed to be airport buildings at the lower edge. A quick cut leads to a travelling shot, combined with an awkward zoom-in and a distinctly wobbly motion, as the camera follows a large plume of smoke, before its location on a train becomes apparent as it enters a subway tunnel. A passage of entirely black footage accompanied by train noise is then followed by a sustained sequence of some 50 seconds in which an almost abstract effect is created by sequences of passing coloured lights in the tunnel. We then cut to very unstable hand-held footage of Jamie, in close-up, examining a map on the subway, over which non-synchronous sound from inside the train is sustained. This is followed by another version of the lights-in-the-tunnel effect before a cut to a low angle on a station platform into which a train emerges, passengers disembark, and into the left-hand side of which Jamie emerges and up onto whose figure the attention of the camera moves, prior to the sequences in which she meets and first starts to spend time with Charlie.

What Katz offers, together with his cinematographer Andrew Reed, is a distinctive blend of the qualities that signify both the rough and hand-held, caught-on-the-fly style, usually associated with mumblecore, and others that suggest aspirations towards a more deliberate, considered and avowedly 'arty' approach. The latter is reinforced by his use of periodic punctuating cutaway shots, also marked by their use of a static camera, of images such as traffic lights, tree branches or semi-abstracted parts of the urban landscape, framed against the sky. These, along with the use of silences or slow piano pieces on the soundtrack, give a quiet, contemplative quality to the film, as suggested by the tile, an impression very different from that usually created by more conventional mumblecore works.

The lighting of some interiors in *Quiet City* adds to the more aestheticized impression, notably the warm orange glow of Charlie's apartment at night and a strikingly chiaroscuro, strongly back-lit effect created during a windblown sequence on the rooftop. A low sun creates another instance of exaggerated back-lighting in a scene in which the central characters engage in a somewhat desultory running race in a park, an effect increased by its combination with a ground-level, upwardly-angled camera, the result being at one point to frame the two in silhouette against the sky, at another to produce an expanse of grass and distant trees bathed in golden sunlight.

13. Aestheticized composition: Strongly back-lit low-angle shot of the race in the park in *Quiet City* © Benten Films

This is very different from the harsh, flat lighting more often typical of mumblecore, as in much of the work of Swanberg – in which directional lighting, where it is more pronounced, tends to come from glary blown-out window sources – or from the grainy and sometimes indistinct 16mm monochrome of *Mutual Appreciation* (the latter a reminder of the image qualities of some of the breakthrough indie features of the 1980s and early 1990s). At the same time, though, a tendency towards more sculpted and/or directional lighting effects is combined with generally quite low-grade image quality in *Quiet City*, the DV footage of which is in itself often somewhat muzzy, with a tendency to more blurry indistinction in some of the mobile camerawork (the latter quality might explain the use of somewhat exaggeratedly stylized effects in places, in an attempt to overcome the limitations of the shooting medium).

The overall effect generated by Katz is an unusual combination of the impression of immediacy created by relatively unsteady, sometimes awkward hand-held shooting and the more distanced effect that results from some of the more aestheticized qualities. The camera is often up-close-and-personal, sometimes a little uncomfortably so, but it also withdraws entirely from the characters in the cutaway shots, the effect of which is more than just to act as a form of temporal punctuation. A clear pitch seems to be made by the filmmaker for a more 'arty' status than is usually associated with mumblecore, and not just by its detractors, certainly more so than would appear to be sought by Swanberg. The cutaway images – both the act of cutting away to images not directly relevant to the narrative and the contemplative nature of what they appear to signify, offering moments of restful calm – seem quite clearly to borrow from the inheritance of the celebrated Japanese director Yasujiro Ozu, a point noted approvingly by some critics in the kind of gesture that can contribute importantly to the status of the filmmaker in the wider film and cultural sphere.

The work of Swanberg includes some moments in which greater-than-usual attention appears to have been paid to qualities of lighting or colour design, although these are much less the norm than seems to be the case for Katz and do not appear in general to be a priority for the filmmaker. The beach sequence in *Hannah Takes the Stairs*, for example, is backlit by what appears to be late-afternoon sun,

producing an edge glow on the skin of Hannah and Mike of a kind that seems more characteristic of the Katz aesthetic in *Quiet City*. What appears to be a carefully designed impression is also created in Swanberg's *Alexander the Last* (2009) when a central couple is framed in silhouette in a blue-toned light in front of a window, a colour contrast created by a yellow doorway that frames the image on one side. Swanberg refers in his DVD commentary on *Hannah Takes the Stairs* to the deliberate use of a colour scheme involving flat primary colours, designed along with the presence of toys to imply the somewhat immature nature of the characters, but this is less immediately obvious to the viewer than the use of orange tones in *Quiet City*, particularly in the early stages where they are foregrounded in the shots of the sky, the roof supports in the subway station and in the quality of light in Charlie's apartment.

It is certainly not the case that Swanberg's films are shot in anything like an entirely unplanned or arbitrary manner, however wavery the hand-held camera sometimes appears. Even in the more fluid sequences, certain set-ups are clearly established as starting points, within which improvisation can occur; and, as in the case of Bujalski, the underlying template generally remains far more within than beyond the established norms of continuity editing and other aspects of classical style. Many of the effects outlined above can also be understood to be the outcome of deliberate design, in the options chosen from those available, even in the following of improvised performance on low resources. A conscious choice was clearly made during editing, for example, to use some moments of awkward camera movement as points into which to cut from one scene to another, the specific effect of which is not the product of chance or the exigencies of filming improvised material (or of lack of professional skill on the part of those involved). Some tendency might be observed within Swanberg's work up to that available at the time of writing towards a gradually less harsh and more subtly lit aesthetic, culminating in *Alexander the Last*, although this film also contains plenty of the style of photography characteristic of his earlier films.

Quiet City is also more expressive than some mumblecore work in certain of its uses of sound, although it shares much of the time the general low-budget tendency for background noise to figure more

loudly in the mix than would usually be the case for a more profes-
sional standard studio or higher-budget indie production. The latter is
another signifier either of amateurishness or of claims to 'street-level'
authenticity (often literally, the problem of noisy background tending
to occur primarily in exterior locations), indistinct sound quality often
being an even clearer marker of low-budget status than grainy or
muzzy images. A passing example of a more expressive approach in
Quiet City is the non-synchronous use of the train sound (a sound
established as that from *inside* the train) during the shots in which
Jamie examines the map at the station, the effect of which is the cre-
ation of a minor disjunction that seems to contribute to the expression
of her general sense of disorientation at the time. A more striking
effect is created by a use of non-diegetic music at the start of a party
sequence. A piano theme accompanies the preceding shot of a set of
traffic lights against the night sky – one of the cutaways – and contin-
ues over images of various characters dancing at the party. It is clearly
nothing like the music to which they are moving, the separation
between the two creating a lyrical effect based on another moment of
detachment from the immediate action in the scene, another space
the film opens for the viewer potentially to step back and ponder on
the material (in this case, the effect was one of the happy accidents in
which lack of budget results in creativity, as Katz explains in his DVD
commentary, the original intention having been to use the music
played at the party but for which the rights proved too expensive).

Distancing of this kind is again untypical of the films associated
with mumblecore in general, although this is another contrast that
should not be overstated. Disjunctions between sound and image are
also quite common in the work of Swanberg. In *Kissing on the Mouth*,
for example, dialogue voice-over between characters is not always
exactly contemporaneous with the accompanying visuals, establish-
ing a similar sense of more carefully articulated juxtapositions in the
audio-visual fabric. Non-contemporaneous sounds or images are also
used on several occasions in *LOL*, including a pair of sequences in
which rapidly-cut montages are inserted to illustrate comments by
two of the central characters about the activities in which they were
engaged earlier in the day. A lengthy sequence in *Alexander the
Last* features simultaneous overlapping sound from two scenes,

one involving a woman singing while playing a keyboard, between which the image track switches.

Most of the audio-visual qualities of the films considered in detail above function closely with their narrative design – or what sometimes seems like relative lack of design – in the staking of claims, overt or otherwise, to the status of providing an authentic portrayal of the worlds in which they are set. It is worth considering a little further how this functions in some of the less-heightened examples. A recurrent feature of the films of Swanberg and Bujalski, and to a reduced extent in Katz, is the use of some hand-held camerawork in shots in which no marked degree of unsteadiness is present. The fact that the camera is hand held rather than locked down on a tripod is in these cases only really apparent if sought out by the viewer, evident in a slight movement noticeable at the margins of the frame. These are sometimes longer or mid shots but also include some close ups. Why, then, employ a hand-held camera in such instances, and to what effect? The answer to the first question returns us again to the practicalities of the shooting, especially in the cases in which greater degrees of improvisation are allowed or expected on the parts of performers or camera operator. The very *slight* unsteadiness of shots such as these also seems to contribute to the broader aesthetic, however, even where it might not be drawn to the attention of the viewer. Slight shifts at the margins and a slight trembly effect, combined with relatively low-grade image quality, help subliminally to generate an impression of less-than-usually mediated rawness and discomfort in the material, an effect that produces a strong fit with the equal sense of discomfort created by many of the non-professional performances at the centre of the films.

Between a soft rock and a squishy place?

If mumblecore offers something authentic, partly grounded in its narrative and other formal qualities, this has generally been interpreted as an accurate portrait of a particular generation or of a more specific social milieu, both generally and in some of the distinct themes with which it seem to engage. Making claims about how films or other cultural products might individually or collectively stand as representatives of wider generational tendencies is a business fraught with

difficulty and potential for oversimplification, however, as was seen to some extent in the discussion of understandings of the Generation-X label in Chapter 1. It is tempting to associate mumblecore with what has been labeled as, among other terms, Gen-Y or the Net Generation, viewed as a successor to Gen-X, a key distinguishing characteristic of which for some commentators is the maturation of a generation of youth into a world of familiarity with digital technologies such as home computers, the internet and, increasingly, the affordances of Web 2.0 for the creation of user-generated content.

It seems plausible to suggest a connection of some substance between the latter and both the filmmakers associated with mumblecore and some of the characters prominent in their work. Whether this, and other thematic dimensions of the films considered above, should be understood in terms of generational shift or more local demographic factors remains open to question, however. Some of the dilemmas faced by the characters in films such as *Hannah Takes the Stairs*, *Mutual Appreciation* and *Quiet City* might more specifically be attributed to particular life stages in the experiences of figures from particular class backgrounds. Accounts of the Net Generation, such as Don Tapscott's *Grown Up Digital: How the Net Generation Is Changing Your World*, tend to be somewhat sweeping in their claims, in this case based on a combination of research and anecdote. A similar quality is found in John Palfrey and Urs Grasser's *Born Digital: Understanding the First Generation of Digital Natives*, although Palfrey and Grasser are careful to acknowledge at the start that it is an over-statement to term the object of their study a generation, given the huge global and more local divisions between those with and without extensive access to online skills and resources.

The sense of drift and problems of commitment that are relatively undramatized in the films examined above do not appear to mark anything that could be described as a clear break from the experiences often associated with Gen-X in the 1990s. Quite to the contrary, a clear continuity seems to exist between this characterization of some lifestyles in the 2000s and that of the so-called 'Slacker' generation that took its name partly from a landmark indie film of the preceding decade. Each is certainly a gross over-simplification, as are all such sweeping generational labels, the primary appeal of which tends to exist at the level of relatively superficial pop-cultural discourses, even

if they might sometimes give a flavour of certain characteristics more distinctive of some of those born in one period rather than another. A more pertinent framework within which to understand concepts such as the Slacker or Gen-Y, as they relate to mumblecore or more generally, might be constructed through a combination of various broader demographic factors and the specific historical development of particular artistic and communications technologies.

If the typical mumblecore character is at a certain stage of life, somewhere between youth and what is deemed to constitute a settled adulthood, that does not in itself imply a generational shift, just the experience of one particular cohort as they go through this phase. This is a perspective from which the experiences associated with the Slacker and subsequent generations (and potentially some that went before) might be expected to have plenty in common, albeit with particular inflections that might result from specific aspects of the texture of daily life in one period or another. Another strong source of continuity can be found at the level of social class and ethnicity. Like the archetypal portrait of the Slacker, the characteristic inhabitant of the world of mumblecore is distinctly white, middle class, college educated and as such relatively privileged and cosseted, whatever emotional upheavals they might experience, as has been pointed out by critics both friendly and hostile (one exception to this on ethnic grounds, although less frequently included in accounts of mumblecore – maybe for that reason but also partly as a result of its sparsity of dialogue – is So Yong Kim's *In Between Days* [2006], the visual style of which has something in common with the work of Katz). As Alicia Van Couvering implies in her cover feature in *Filmmaker* magazine, the dilemmas faced by the characters are hardly matters of life and death: 'The choices are often between, shall we say, a squishy rock and a soft place.'[21] These are the problems, it seems, of those who might have time and space to drift from one activity or non-activity to another, or the freedom in the case of some characters not to commit – or, at least, not yet – to the kind of dead-end job that is the effective destiny of many of those in less privileged social positions.

Clay Shirky, another prominent commentator on matters relating to Web 2.0, suggests that such decisions taken by young people in any period are best understood as the outcome of particular environmental

factors – such as the prevailing state of the economy – rather than being attributed to any notion of the essential characteristics of one generation or another. In periods of limited opportunity amid recession, such as the early 1990s in relation to Gen-X, as Shirky suggests, or towards the end of the first decade of the twenty-first century in relation to mumblecore, as we might add, 'taking a dead-end job and conserving costs by hanging out with friends and drinking cheap beer' might be 'perfectly sensible responses'.[22] This, too, might be a stance that assumes a certain kind of class-background position.

The issues relating to problems of commitment also seem to have a specific gender dimension in many of these films, although the picture here is not entirely one-sided. Swanberg has been criticized by some for displaying a sexist attitude in his penchant for the display of naked bodies, although these include males as well as females, and for gestures such as the sequence in which his character masturbates and ejaculates on screen in *Kissing on the Mouth*. Amy Taubin describes him, for example, as 'the DIY Judd Apatow', whose 'greatest talent is for getting attractive, seemingly intelligent women to drop their clothes and evince sexual interest in an array of slobby guys who suffer from severely arrested emotional development.'[23]

Kissing on the Mouth opens with a close-up sex scene, the quite harsh video quality of which gives it a feel not far from that of amateur pornography, although without anything like the kind of lingering detail that would usually entail. More time than might be necessary other than for titillating display seems to be devoted to some of the sex sequences, here and in further examples, and for others involving acts such as female depilation (this is the kind of material the inclusion of which is more often associated with the 'cheap thrills' offered by low-budget exploitation features, although in somewhat different form it is also part of the tradition of international art cinema). The overall portrayal of character in the films examined in this chapter seems distinctly critical of male behaviour in some central respects, however, which suggests an underlying dynamic rather different from the somewhat rhetorical stance taken by Taubin.

One example of this is the seemingly passive-aggressive position taken by Alan in *Mutual Appreciation*, particularly in relation to Sara, and criticized by Ellie. Charlie seems to have a similar problem in

Quiet City, despite being figured positively in many respects as a gentle and thoughtful male. When he confesses to Jamie to being 'kinda cowardly' in relationships and in avoiding facing things head on or wanting to take responsibility for others, her reply ('well, I guess I've been dating people like *you* for the past couple of relationships') suggests that this is a wider feature of male behaviour in this milieu, although this is immediately qualified by her subsequent comment that she has now become more like him in this respect, even though she does not like it. That such problems of commitment or defining the nature of relationships might transcend the gender of the individual is later implied during an exchange between Jamie and her friend Robin (Sarah Hellman) in which the latter outlines her difficulties in 'crossing the line' between sexual and non-sexual forms of engagement.

The most negatively marked characters in mumblecore are some of the more self-centred males in Swanberg's films, including Tim (Swanberg himself) and particularly Alex and Chris (C. Mason Wells) in *LOL*. Tim fails to pay sufficient attention to his girlfriend Ada (Brigid Reagan); Alex exploits one young woman, Walter (Tipper Newton), in his vain pursuit of another with whom he appears to have become obsessed via the internet; while Chris is painted in equally negative terms in some respects considered below. But one of the strengths of mumblecore as a whole, and one marker of indie status at the level of content, is its tendency to avoid one-dimensional characterization in favour of a more ambiguous presentation of individuals, most of whom might be judged to be quite flawed, inadequate or 'messed up' in one way or another. This would certainly include all of the principals in *Hannah Takes the Stairs,* and Swanberg makes it clear in his DVD commentary that he ceded control of the development of the nature of the central character to Gerwig, in a conscious effort not to impose his own male perspective onto that part of the material. The outcome is a typical mumblecore portrait of a figure who can be annoying but seems to embody the kinds of messy and contradictory characteristics that mark a genuinely indie departure from the simplistically imposed moral economy of good and bad, positive and negative, more typical of the Hollywood mainstream. Something similar can be said of the portrait of the breakup of a

long-distance relationship provided in *Nights and Weekends* (2008), jointly written and directed by Swanberg and Gerwig.

Some of the shortcomings of male characters in these films, especially those by Swanberg, are related to another dimension that seems to mark a more clearly historically or generationally specific aspect of mumblecore: its setting in a world mediated by a particular range of communications technologies, including mobile phones, email, the internet and the widespread presence on-screen of laptop computers. If mumblecore filmmakers and characters can be understood as representing a particular demographic at a particular stage of life, many of the issues relating to which might have been much the same for the preceding generation, the ubiquitous presence of such technologies is something that gives a particular flavour to their experience.[24] A major theme of mumblecore, suggested by the label, with its basis in the verbal hesitancy or inarticulacy of many of the non-professional performances, is the problematic nature of communication. This applies both generally, especially in the context of inter-personal dynamics, and in relation to the uses of some of the communications technologies broadly specific to the period.

A number of characters complain explicitly about difficulties of communication within relationships. These include a man heard talking in one of the audio recordings about break-ups made by Patrick (Swanberg) as part of a project in which he is engaged in *Kissing on the Mouth*. The unseen character refers to a conversation with a former partner that revealed how many things they did not understand about each other and that there was 'no way for us to communicate and to actually make each other aware where we were at or what we were doing', an experience that left him feeling that she had never really taken the time to understand him. Hannah complains, similarly, to Rocco that 'nobody, like, really actually listens to each other', 'everybody's in love with the wrong person and nobody, nobody actually, like, hears what anybody else is saying, ever, ever.' Mobile phones and computer-mediated communications channels such as email, instant messaging and the internet seem to hinder more than to help any of these processes, a central irony being the lack of honest and sustained communication between characters surrounded by so many potential facilities.

When Tim does his friend Chris the favour of picking him up early in the morning from the airport in *LOL*, for example, he is kept waiting while the latter talks on his mobile, one of several instances in the film in which remote forms of communication or engagement are favoured over the face-to-face (the film might equally well have been titled *FTF*, the computer-mediated world's acronym for physically present communication). When Tim takes Chris back to the airport shortly before the end of the film, the pair are at first framed in a two-shot through the windscreen of Tim's car, in which each is talking on his phone, facing largely away from the presence of the other. A mobile is used in a manner that seems more actively duplicitous by Mike in *Hannah Takes the Stairs*, when he rings Hannah at work while she is in his sight, enabling him to see her response (less than enthusiastic) as she chooses not to take the call. Instant messaging is used in a similarly inappropriate manner in a situation of physical proximity in *LOL* when Tim and a male friend enter into a series of exchanges about Ada via their laptops while she is in the same room as them, watching television. He is also distracted from the presence of Ada by the demands of his laptop in a number of other scenes, including one in which he takes it into the bedroom and the blue glow of the screen in which he was bathed in a preceding sequence still seems visible on his face as he lies in bed with her.

LOL is the production in which such uses of computer-based communications technologies figure most prominently, including Alex's email pursuit of the woman, Tessa (Kate Winterich), with whom he seems to become obsessed via the website 'Young American Bodies', apparently a soft-porn site, the name of which is taken from a mumblecore-style web video series by Swanberg. The film opens with images from the site, including an amateur striptease sequence, along with to-camera reaction shots from a series of male viewers, including Alex. The performer of the striptease has clearly been betrayed, a video designed to have been a private show for her boyfriend having been posted on the site. Alex gets a ride to St. Louis and a place to stay the night from Walter, to whom he lies about having a gig arranged as part of a tour, when his real aim is to meet Tessa. On arrival at her parents' house, his only concern is to try to get a computer set up so that he can check his email, in the hope of having

received a reply with a phone number from the object of his desire. He more or less ignores Walter for the whole time, subsequently pestering Tim late at night by phone to try to get him to check his email for him. This sequence follows the one in which Tim's laptop distracts him from Ada at bedtime, creating a concerted impression of the on-screen world coming between these male characters and physically present women to whom they pay insufficient regard.

Chris, meanwhile, seems to live much of his life within the film via his phone, using pictures taken with it to examine himself, self-regardingly, after he has a haircut and complaining to his girl-friend, Greta (Gerwig), that the naked images she sent to him on his request during his stay in New York are insufficiently explicit. Greta's presence in the film is confined to little more than these pictures and her voice, either in phone conversations with Chris or, more often, in the sounds of plaintive messages left for him, one of which plays against footage of him appearing to flirt with another woman at a party. The mobile phone and computer screens are near-constant presences throughout the film, generally figured as having negative impact on more directly human forms of communication.

Computer and related media/communications technologies are also figured more positively in *LOL*, however, in a manner that relates to the opening up of such forms to a wider range of user-generated content, an issue of relevance to the generational context of both some of the characters in mumblecore films and the produc-tion of this kind of work itself. The chief manifestation of this is the audio-visual project being compiled by Alex through montages of brief 'noiseheads' video sequences, in which individuals make noises to camera with their mouths, the outcome of which is a kind of mash-up production, sequences from which constitute parts of the texture of the film. A similar blurring of the line between work cre-ated in the diegetic world and that which contributes substantially to the film itself is made by the audio recordings of people talking about relationship break-ups in *Kissing on the Mouth*.

This is part of a wider sense of characters involved or dabbling in creative activity in many of these films, including the music examples cited above, usually at a level below that of paid, full-time or more professional engagement (examples of the latter would the television

14. 'Noiseheads': Digital mash-up creativity contributes to the texture of *LOL* © Joe Swanberg

script-writing job of Paul and Matt in *Hannah Takes the Stairs*, although even here their workplace creates a less than entirely professional-seeming milieu, along with the apparently successful work of James [Swanberg] in videogames in *Nights and Weekends*, the acting careers of two of the principals in *Alexander the Last* and the world of low-budget filmmaking that plays a central part in *Art History* and *Silver Bullets*). Other examples of dabbling, in some cases with as-yet-unfulfilled career-related ambitions, include the play being written by Hannah; references to poetry, short stories and reviews by Gerwig's character in *Nights and Weekends*; photography by Chris in *Hannah Takes the Stairs* and Helen (Amy Seimetz) in *Alexander the Last*; and the blog for which Paul has been approached about a possible book deal in *Hannah*.

The prevalence of some of this material might be taken as a reflection of the kind of subject matter or character background likely to appeal generally to creative figures such as the filmmakers themselves. Many of these activities, whether depicted on screen or otherwise,

15. Dabbling at a duet: Charlie and Jamie's improvised performance in *Quiet City* © Benten Films

are entirely traditional in nature: writing plays or stories, photography or dabbling with musical instruments. In its extent, however, and in the particular nature of some of the instances that are highlighted – especially the two examples cited above that contribute to the texture of the film itself – its seems plausible to suggest that this material can also be viewed in general in relation to the wider phenomenon of increased involvement by younger generations in non-professional creative content generation in the era of Web 2.0 and related low-cost media developments. This is one of the more widely accepted markers of membership of the cohort associated with the Net Generation, research evidence having suggested in 2005 that half of all American teens and 57 per cent of those who used the internet could be defined as 'content creators' of some kind, the latter figure rising to 64 per cent in 2007, even though much of this work may be relatively unambitious.[25] Much of the creative activity undertaken by the inhabitants of the films – Alex's video mash-ups and his music, Patrick's recordings of people talking about break-ups, the music recorded by Charlie in *Quiet City*, various writings and photographs – is of a kind that might well be shared online in this era, in much the same way as these or other low-budget films of the same period. Some similarities can also be identified in the more evaluative, sometimes polemical, debates

surrounding both mumblecore and this broader context of wider-spread distribution of creative content via online media.

Authenticity and/or amateurism

Whether or not the recent expansion in the prevalence of user-generated content, mostly accessed online, is judged overall to be a good or a bad cultural phenomenon is a question that has given rise to much debate. This often takes the form of polarized over-statements on one side or the other, a feature of some examples of a kind of trend-spotting writing (more or less journalistic in different instances, with varying degrees of underlying substance) that seems drawn to this and related issues in contemporary culture. To take two quite prominent examples: Don Tapscott, in *Grown Up Digital*, offers a paean to his notion of the Net Generation, making sweeping claims that seem significantly to outpace any of the evidence he presents, much of which is anecdotal; on the other side, Andrew Keen, in *The Cult of the Amateur: How Blogs, MySpace, YouTube and the Rest of Today's User-Generated Media Are Killing Our Culture and Economy*, offers (as the subtitle suggests) an often ludicrously exaggerated critique of what he declares to be 'a flattening of culture' created by the self-publishing of material on the web.[26] Each allows for some occasional reservation, on some specific points, but the most striking characteristic of this kind of work is its reliance on what at best seems to be hyperbolic over-statement of one case or the other, a quality that often appears to be a requisite feature for work of this kind that seeks to cross over into a more popular publishing marketplace.

While Keen rails against a blurring of lines between the professional and the amateur, others have argued more positively and in more nuanced fashion for the creation of a new range of hybrid positions that combine elements usually associated with one or the other. From a British context, Charles Leadbeater and Paul Miller identify what they term a 'Pro-Am' revolution, in numerous areas of society, the basis of which is the development of activity that remains amateur – unpaid or not a primary source of income – but to professional standards.[27] As Jeff Howe also suggests, this phenomenon can include a variable spectrum of relative degrees of more-or-less amateur or professional

status, ability or quality, in an arena in which the term 'amateur' has lost some of its previously negative connotations.[28] It certainly appears to be the case that amateur or user contributions have gained positions of real importance in some areas of economy, culture and society in the networked era, in areas ranging from astronomy and photography to gold mining, fashion design and scientific research.[29]

Mumblecore has received both praise and criticism, sometimes ridicule, as a product identified as having a similar kind of location, somewhere between the fully professionalized and the amateur.[30] Its most harsh critics have sometimes dismissed it as 'amateurish', using the term as one of derision, but it has also received its highest praise for what has been interpreted as its proximity to the wider range of informal online user-generated content. A notable example of the latter comes from Matt Dentler, the producer of SXSW identified by Taubin as a key promoter of mumblecore, who describes the films as having 'the immediacy and audacity of Web 2.0'.[31] Much like the work of bloggers and vloggers (video-bloggers), he suggests, 'these were films coming without filters and directly from the source.'

For some other commentators, however, the same judgement is the basis of criticism: the films being seen as insufficiently mediated to have the status of much more than unvarnished and hastily compiled navel-gazing video diaries, lacking dimensions such as the careful scripting that might be seen as the basis of real creativity.[32] The truth seems to lie somewhere between these extremes, the films being far from entirely unshaped, as suggested above, whether or not that is seen as a vice or a virtue. These kinds of debates are an arena in which it is also easy to overstate similarities rather than differences among the films associated with the label, although distinctions are made in some cases between one and another (the work of Swanberg often being singled out as apparently least mediated, for good or ill, although this, too, can easily be over-stated).

The kind of polemic that developed around mumblecore offers an interesting variation on more familiar indie discourses relating to notions of authenticity or inauthenticity. Those who praise mumblecore films, either individually or collectively, often do so in terms that highlight their status as more authentic than either the productions of Hollywood or what are viewed as more confected versions of

quirky indie status of the kind examined in Chapter 1. An example of the former is David Denby, in a feature in the *New Yorker*, who suggests that 'mumblecore delivers insights that Hollywood can't come close to.'[33] In relation to notions of a manufactured indie recipe, Andrew O'Hehir suggests, on Salon.com, that 'it's pretty much the opposite of the "Napoleon Sunshine" indie formula, in which quirky characters and story lines are painstakingly packaged in familiar narrative structures aimed at a semi-elite, not-quite-mass audience.'[34] For detractors, though, mumblecore goes perhaps too far in this direction, offering what is interpreted as an excess of unconstructed authenticity with insufficient distinction to mark it out from what is viewed as a surrounding fabric of similar material in the shape of video diaries, vlogs or postings on YouTube or other video-sharing websites. As in most such cases, discourses of this kind often take on a rhetorical cast in which legitimate distinctions between one form of production and another become reified and overstated into simplistic binary oppositions.

Such discourses play an important role, however, along with others operating in the indie sphere, in the broader process through which particular parts of the cultural landscape such as mumblecore are accorded or denied the status of what is considered to be legitimate art or creativity, a construction usually established in opposition to notions such as the amateur/incompetent or the excessively commercial. The place of mumblecore within the recognized pale of indie culture was largely secured through the responses of some key critics and the staging of events such as the IFC showcase, as suggested at the start of this chapter, but it has not gone without contest from other critics or commentators with investments in the protection of the bounds of what is considered to be legitimate indie practice.

The classic account of this kind of process is offered by the sociologist Howard Becker, through his notion of the 'art world' as a collective construct the constitution of which involves the activity of various participants including distributors, critics and audiences.[35] The nature of this process is made most visible, as Becker suggests, at the boundaries of established art worlds, a position occupied by mumblecore as what some would consider a marginal part of the institutionalized indie film world. Such boundaries are often

vigorously defended but can be flexible and subject to change over time, Becker argues, sometimes excluding work that closely resembles other products that are accepted, or shifting to include that which was previously considered not to qualify. The distinction between that which lies on one side or other of the boundary is thus understood to lie not in the work itself but in the ability of the art world to accept it, as evidenced by the nature of the discourses surrounding mumblecore.[36]

In Becker's account, a rough equivalence tends to exist between the volume of work designated to be of worth within a particular art world and the capacity of its distribution system. This is a key dimension of the relativistic nature of this way of understanding the constitution of what is to qualify for membership of one art world or another: art is defined, here, not as an intrinsic quality of the work but through an essentially relational mechanism. Aesthetic systems change their criteria, Becker suggests, to produce the number of certified works that a particular system can accommodate, an argument that might be applied to the context of mumblecore within the wider indie world.[37] The advent of online distribution and DVD sales of a DIY or DIWO nature has certainly increased the capacity of the indie sphere, the result of which might be, for some participants in the process of constitution, a widening of the terms of admittance to the art world of indie film. This remains quite closely contested terrain, however, the potential opening represented by online circulation and low-cost digital production being met at the same time by a characteristic attempt to reassert boundaries on the part of many with investments in the existing regime.

The position of mumblecore can also be situated in relation to wider discourses about varying degrees of 'true' independence in its association with the SXSW festival. If, for Taubin, the role of Dentler as promoter is a marker of the kind of branding and promotion that signifies inauthenticity and manufacture, SXSW itself has gained indie credibility as an event situated in opposition to the more mainstream-indie-oriented Sundance festival, the latter being an event the name of which has become a familiar byword for those who accuse certain parts of the sector of crimes such as selling-out, crossing-over or generally becoming too close to Hollywood. One shared quality

of mumblecore emphasized in some accounts of its merits is the experience of figures such as Bujalski and Swanberg in having had films rejected by Sundance. As Lim suggests: 'For credibility purposes, the perception of the mumblecorps as underdog outsiders, too indie for Sundance, is hardly a bad thing.'[38] Sundance itself has consistently argued against such claims, seeking to maintain its own indie currency in the face of criticism, through devices such as the creation of sections designed to showcase less familiarly-conventional films. Examples include the New Frontier strand, instituted to accommodate aesthetically more experimental work, and the Next section, for '"innovative and original" work in low- and no-budget filmmaking', created in 2010 in what appeared at least in part to be a response to the ground staked out by SXSW through its association with mumblecore.[39] Perhaps surprisingly, the first Swanberg film to show at Sundance, *Uncle Kent*, featured in neither of these but in the rather vaguely defined Spotlight strand, also created in the same year.

Distinctions between mumblecore and more conventional forms of indie production also began to become blurred in the work of some of those associated with the label by the end of the 2000s. A number of projects were identified as marking varying degrees of crossover into relatively more commercial territory, a further demonstration of the ongoing exchanges that have always typified the indie landscape as much as any clear-cut opposition between what is claimed to be more or less 'true' indie or authentic. The Duplass brothers were embraced by the Indiewood end of the spectrum with two somewhat more genre-oriented features that gained distribution by studio speciality divisions, *Baghead* (2008, Sony Pictures Classics) and *Cyrus* (2010, Fox Searchlight, executive produced by the Hollywood heavyweights Ridley and Tony Scott). The former combines typical mumblecore style with a playful homage to low-budget horror production, the scenario involving a group of aspiring actors holing up in a cabin in the woods to try to come up with their own idea for a film. The latter features a more indie-conventionally 'awkward' romantic relationship, prickly but ultimately upbeat in a restrained manner and employing a distinctive use of small, twitchy zooms rather than more overt hand-held unsteadiness.

Katz, likewise, combined a somewhat moderated version of his earlier style – a little less unsteady in the camerawork, slightly fewer cutaways – with a typically indie low-key take on the detective genre in *Cold Weather* (2010), distributed by IFC Films. Lynn Shelton, another figure sometimes associated with mumblecore, made a similar move with *Humpday* (2009), a film with a more commercial-seeming conceptual hook, in its tale of two reunited male friends stuck in a drunken agreement to co-star in their own home-made porn video, but one that retains the generally uncomfortable mumblecore tone and ends anticlimactically. Greta Gerwig, meanwhile, the nearest thing to a star performer to emerge from mumblecore, gained a central role alongside Ben Stiller in the glossier, conventionally-scripted Indiewood production *Greenberg* (2010), distributed by NBC-Universal's Focus Features division.

In its original form, mumblecore can convincingly be interpreted as offering a reasonably authentic impression of certain aspects of the lives of some members of the kind of social constituency it is both produced by and represents on screen, one that is markedly different from both Hollywood cinema and many more commercial varieties of indie film. This can be argued at the levels of subject matter, the manner in which it is articulated on screen and in which it draws on the real-life experiences of those involved, including the performers. It is shaped in particular ways, however, and draws on a wider heritage of cinema that makes claims to this kind of quotidian realism in one realm or another, and as such needs to be understood as a particular kind of construct rather than something that merely emerges as part of broader background flow constituted by the likes of reality TV, vlogs or YouTube videos (the latter are also particular constructs in their own right, of course, often offering their own balance between radical difference from and adherence to more familiar media tropes[40]).

The association of mumblecore with reality TV offers another way of understanding its place in the broader social-historical context, in its close emphasis on the dimension of the personal and on a claim to authenticity that appears to be rooted in personal revelation. This, for Anita Biressi and Heather Nunn, is a major component of various forms of reality television that gained widespread popularity in the

period from the 1990s onwards and which they situate as part of a broader cultural shift of emphasis in the post–Thatcher/Reagan era towards the individual at the expense of the social, as focus of popular attention and locus of explanation, particularly in documentary/realist forms. The emphasis in such products for Biressi and Nunn is 'less on capturing the rawness of an unmediated event played out before the camera' – as was the impression created by certain earlier modes of documentary such as Direct Cinema – 'and more on the hidden or secret emotional realism suggested by confession, individual close-up engagement with the camera and popular therapeutic knowledge that suggests even the layman or woman can unpack personal trauma because we all have personal histories that score our identity.'[41] A similar context is identified by Michael Strangelove as the 'cultural backdrop' to amateur video practices on YouTube.[42]

This might also be part of the appeal of the mumblecore style of filmmaking, particularly in its less-scripted and more improvisational form, as practiced by Swanberg in instances such as the personal-confessional exchange between Matt and Hannah in *Hannah Takes the Stairs*. One of the criticisms faced by mumblecore is the absence of any more explicitly social frame of reference for the experiences of the central characters. That such frameworks are far from absent in the indie cinema of the 2000s is demonstrated, however, by the examples examined in the next chapter from the work of Kelly Reichardt and Ramin Bahrani.

4

Social realism and art cinema: The films of Kelly Reichardt and Ramin Bahrani

If mumblecore remains in some respects a product of its immediate moment or generation, at the levels of both form/content and means of production and distribution, another part of the low-budget indie landscape of the 2000s demonstrates further continuity with longer-standing trends in both the American independent sector and wider movements in the history of cinema, as well as a distinct turn towards a more clearly socially-situated film practice. A notable characteristic of the latter part of the first decade of the century was the critical praise directed at a number of productions on the basis of their claims (implicit or otherwise) to the status of a low-key social realism, films that might be distinguished both from those accused of manufactured quirkiness and those seen as having the more limited range and scope associated with mumblecore. Relatively high-profile examples within

the indie world – if, usually, not much further afield – include the films of Kelly Reichardt (especially *Old Joy* and *Wendy and Lucy*) and Ramin Bahrani (*Man Push Cart*, *Chop Shop* and *Goodbye Solo*), the case studies examined in detail in this chapter, along with others such as *Ballast* (Lance Hammer, 2008), *Frozen River* (Courtney Hunt, 2008) and *Winter's Bone* (Debra Granik, 2010).

On release, these films seemed timely in their own ways, often depicting the struggle of life on the social margins, a dimension that seemed especially resonant for those which opened during the deep recession of the late 2000s. In many respects, however, the films of Reichardt, Bahrani and others emerging in this period marked a strong vein of continuity with the indie cinema of the 1980s and early 1990s, in their maintenance of something like the classic independent recipe of low-resource production and traditional smaller-scale release beyond the orbit of the studio speciality divisions. They helped to prove the continued viability of a particular strand of indie production in the budget range between hundreds of thousands of dollars and the $1 million mark. This was a sector feared by some commentators to have been lost in the squeeze between pressure for more spending, at one end – to compete with larger indie players, to satisfy the demands of unions and/or to recruit more high-profile performers – and the alternative of micro- or virtually no-budget production at the other, as manifested by examples considered in the previous two chapters.[1] Comparisons were also made with the work of filmmakers associated with the realm of international art cinema, ranging from earlier reference points such as Italian neo-realism and the minimalism of Robert Bresson to more contemporary figures including Abbas Kiarostami, Jean-Pierre and Luc Dardenne and Hou Hsiao-Hsien.

As far as the discursive field around indie cinema is concerned, these films could be located at a pole opposite to that of Indiewood or the 'designer quirky', in their low budgets and markedly sincere engagement with social issues, while also distinct from what some viewed as the relatively shallow superficiality of mumblecore. They were valorized instead as markers of the 'true indie' spirit, a dimension of their reception considered in greater detail towards the end of this chapter. We start, though, with an examination of their origins and conditions of production and distribution. This is followed by analysis of the

formal qualities through which the films of Reichardt and Bahrani are situated in the realist tradition and, in relation to this, consideration of the more socially conscious dimensions of the works, a clear marker of difference from the films considered in the previous chapter.

Origins, production and release: From 'private' to the traditional indie model

The central character of *Wendy and Lucy* is a young woman, Lucy (Michelle Williams), travelling across America, from her home town in Indiana to Alaska, in search of work. Her existence appears vulnerable. She carries few possessions, drives an old Honda and has only her dog, Lucy, for a companion. Life is lived according to a tight budget, accounted daily in a notebook, and is precarious: her car gives up the ghost and Lucy goes missing while Wendy is being held in police custody after being caught shoplifting for supplies. The production of the film was 'a lot like Wendy's situation', suggests Kelly Reichardt, 'where it's just super precarious and if anything fucks up, we're pretty screwed. One mishap could bring the whole house down.'[2] Something similar could be said of the lives of Bahrani's protagonists: Ahmad (Ahmad Razvi), struggling to manouvre his lumbering snack wagon through the pre-dawn traffic of Midtown Manhattan in *Man Push Cart*, a symbol of the more general state of his existence; the young orphan Ale (Alejandro Polanco) in *Chop Shop*, living on the margins in the chaotic world of auto-body repair shops in the Willets Point area of Queens; and, perhaps to a lesser extent, Solo (Souléymane Sy Savané), the taxi driver who seeks both to better himself and to make a connection with an elderly customer who appears to be bent on suicide in *Goodbye Solo*.

The films of Reichardt and Bahrani share to some extent in this kind of marginal status, potentially vulnerable to the dictates of fortune and the pressures of the market. Each has managed to carve out a niche that has been successful in its own terms, however, and that has demonstrated the continued viability – for some filmmakers, at least – of the more modest and small-scale variety of independent production with which the sector was originally associated from the 1980s. Success with critics, at festivals and with a core art-cinema

audience has ensured much praise and recognition for Reichardt and Bahrani within indie circles. The limited means with which each has operated, and the kinds of projects they have pursued, bring with them inevitable restrictions and hardships, but also a substantial degree of creative freedom and insulation from the compromises often associated with the higher-budget and glossier end of the indie scale. In the case of Reichardt, an embrace of this position amounts to the avowal of a private level of feature filmmaking akin to that of mumblecore and a declared intention to withdraw to more personal and experimental realms, should that prove to be financially unviable. Bahrani has expressed a desire to work on a larger scale, given the opportunity, but only if that can be combined with the maintenance of a certain level of artistic freedom.

The films examined in detail in this chapter should not be understood as existing in a vacuum, however, even in the context of products that operate in some respects in one of the less-fully industrialized parts of the indie landscape (albeit one that has more in common with traditional indie-industrial location than with the films associated with mumblecore, particularly at the level of production). Their ability to succeed in certain realms, on however-modest a scale, is directly related to their observance of certain norms, institutionalized in their own right, as suggested in the references above to the history of American indie cinema and the broader realm of international art cinema, and to the discourses with which they became associated in debates about the status of the indie sector at the time of their release. These include the recognition of each of the two filmmakers as a distinctive auteur figure, a key element in the niche-selling of their work and much of that which continues to find audiences of some kind in the indie and art film sectors. Whatever might be said of the intrinsic merits of the films, from an evaluative perspective, the main aim of this chapter is to examine them in this context, as products of a specific creative-cultural milieu, a particular region of the wider field of cultural production and circulation.

The initial points of origin of the works considered in this chapter are somewhat different, those of Reichardt having a literary basis in the writing of Jon Raymond, while Bahrani's were sparked by initial observation followed by research in the milieux in which *Man Push*

Cart, *Chop Shop* and *Goodbye Solo* are set, thus claiming a direct relationship with particular aspects of social reality. Reichardt's *Old Joy* is based on a Raymond short story of the same title, a portrait of a weekend trip into the Oregon woods by two formerly close friends who have drifted apart, one moving towards integration into mainstream society while the other remains in search of post-hippie-era alternatives. Raymond's story was itself inspired by, and published alongside, a collection of photographs by Justine Kurland, images of groups of men seeking spiritual experiences in the wilderness. Reichardt collaborated more closely with Raymond in the case of *Wendy and Lucy*, the concept of which was developed jointly by the pair before Raymond wrote the story version, 'Train Choir', on which the film, co-authored by the pair, was based.[3] Raymond also wrote Reichardt's next feature, *Meek's Cutoff* (2011), a characteristically minimalist depiction of the plight of a group of pioneers travelling precariously across the Oregon desert of the 1840s (a film released too late to be considered here other than in passing).

Bahrani's inspiration for *Man Push Cart* came during the post-911 American bombing of Afghanistan, which he says prompted him to think about the Afghanis he knew who lived in New York City, who were pushcart vendors.[4] The idea came from a combination of this and the parallel he saw between the labours of such figures and the central image of Albert Camus' *The Myth of Sisyphus*. He then spent a period of between 18 months and two years meeting pushcart vendors and learning about their routines. The development of *Chop Shop* followed a visit to Willets Point with a colleague, a location in which he subsequently spent a great deal of time in advance of production. *Goodbye Solo* had a similarly personal genesis, evolving from an encounter with a taxi driver in Bahrani's home town of Winston-Salem, North Carolina, where the film is set, and the passing sight of an older man standing outside a nursing home.

All three of Bahrani's films, reportedly budgeted in the region of just under $1 million, involved long periods of informal pre-production, during which the process of casting and finding locations contributed centrally to the shaping of the script. Non-professional performers were recruited for *Man Push Cart* and *Chop Shop*. Ahmad Razvi, who plays the central role in the former, had worked as a pushcart vendor himself,

around whose experiences Bahrani adapted some aspects of the film. In the case of *Chop Shop*, he spent more than two months auditioning for the central role after searching in schools, neighbourhoods, parks and on subway routes.[5] A lengthy process also led to the casting of the title part in *Goodbye Solo*, although this was Bahrani's first experience with performers who had some acting experience (and, apparently by chance, Souléymane Sy Savané had worked previously as a flight attendant, the job to which Solo aspires in the film).

16. On location: Alejandro Polanco (right) in the Willet's Point setting where he worked before production of *Chop Shop* © Big Beach

Shooting of Bahrani's films was also preceded by substantial periods of preparation and rehearsal by the principals, a key ingredient in his particular low-budget recipe. The lead performers of *Chop Shop* spent several extra weeks on the location, during which time the writer-director says he shot the whole film in advance on a Handycam, a process preceded by an earlier spell of several months during which Alejandro Polanco worked at the body shop where his character is employed, to ensure the authenticity of his actions. For *Goodbye Solo*, Savané spent three months living with Bahrani and the filmmaker's brother in North Carolina, a period of extensive rehearsals during which the performer paid his way, emulating his character, by driving a cab.[6] This is a marked characteristic of Bahrani's production

style, sometimes but not in all cases necessitated by the non-professional status of the performers.

Such a luxury, compared with the usual demands of the schedules of professional or more established actors, or those with other careers, has not generally been available to Reichardt. This was particularly the case with *Wendy and Lucy*, the visibility of which gained from the presence in the lead role of Michelle Williams, an established performer with a background ranging from several years on the TV show *Dawson's Creek* (1998–2003) to parts in numerous indie films and an Oscar nomination for her role in *Brokeback Mountain* (2005). She came to Reichardt's film almost immediately after completing her work on Charlie Kaufman's directorial debut, *Synecdoche, New York* (2008), which allowed little time for rehearsal or preparation before the start of shooting.

The production of *Old Joy* was described by Reichardt as 'as private as you can get for a film', involving a small cast and crew, almost all of whom were close friends of the filmmaker.[7] The budget is estimated to have been $30,000, an extremely low figure for a feature shot on location on film, even for Super 16mm, although Reichardt benefited in profile from the presence of one notable name in the credits, that of the director Todd Haynes as executive producer, a significant marker of approval in the American indie sphere. Haynes had two points of contact with those involved in the project, Reichardt having worked in props and set dressing on his breakthrough feature *Poison* (1991) and Raymond, whose writing Haynes is said to have admired, being the director's assistant on *Far From Heaven* (2002). It was Haynes who subsequently introduced Reichardt to Raymond, leading to their collaboration, and who also got a copy of the script of *Wendy and Lucy* to Williams (who had a role in Haynes's *I'm Not There* [2007]), a performer Reichardt had assumed to be out of her reach.[8]

Wendy and Lucy was another small-scale production on a budget estimated at the substantially higher figure of $300,000, still very little for a non-DV feature production. It was shot in 18 days on location with a crew of volunteers, using only available light. Shooting was followed by a period of some six months of editing by the filmmaker in her apartment, with occasional returns to the Oregon setting for the capture of additional background and atmospheric footage.

Bahrani's budgets have been relatively higher, but still tiny by Hollywood or some larger indie/Indiewood standards, with an average crew of 14 (less than half what might be expected to be the norm) and shooting on high-definition video, blown up to 35mm for theatrical release. Bahrani's major luxury has been an insistence on a longer shooting schedule, usually 30 days including built-in periods for reshoots, time on location being a quality the filmmaker says he prioritizes over the benefits of having larger or more expensive crews. The relatively long shooting schedule, for low-budget production, enabled Bahrani to shoot some 20 to 30 takes of most scenes in *Chop Shop*, for example, as many as 40 or 50 in some cases. Most of the camerawork and action was carefully mapped out and planned in advance, including many quite complex mobile single-shot sequences, although the crew also responded to some chance encounters on the location.[9] Sources of economy on crew included having all costumes prepared in advance, eliminating the requirement for a costume person on set, and an absence of anyone doing make-up or hair (on *Wendy and Lucy*, meanwhile, Reichardt insisted that Williams not wear make-up or wash her hair at all during the shoot, as a contribution to the authenticity of her impoverished appearance).

For both filmmakers, the process is hands-on throughout, from conception, planning and writing to directing and editing, in a mode of production that is artisanal rather than industrial in some key dimensions. Important roles are also played by key collaborators, however, most notably the cinematographers employed in the five films examined in this chapter: Peter Sillen and Sam Levy for Reichardt in *Old Joy* and *Wendy and Lucy*, respectively, and Michael Simmonds in the case of all three works by Bahrani. Simmons is described by Bahrani as a 'very close' collaborator, involved in his films from the first draft of the script onwards, in casting and in the editing room, as well as on set.[10] Bahrani also worked with a co-writer, Bahareh Azimi, on *Chop Shop* and *Goodbye Solo* and acknowledges the contributions of both to his ability to work so quickly and, by implication, on such limited resources. An experienced cinematographer can be of particular value to low-budget or less-experienced filmmakers, often being able to contribute to visuals that belie the lowness of budget, as well as bringing their own recruits to the camera crew. Sillen was reported

to have persuaded his crew to work for next to nothing on *Old Joy*, on the basis that he would help them to get paid commercial jobs afterwards.[11]

Positive responses on the festival circuit were crucial to the critical success of all these films, creating early interest and marking them out as works of note, even where this failed later to be translated into significant commercial returns. This is another dimension in which the work of Reichardt and Bahrani falls solidly into the classic/traditional indie mould and demonstrates its viability, for a certain level of production, well into the twenty-first century. In many cases, the films considered here were placed in niche strands or sidebars, especially at the larger festivals, channels that play an important role in the circulation of smaller or less conventional features than those which tend to predominate in the major competitions. *Old Joy* was well received at the Sundance festival in January 2006, where it screened in the Frontier section, the strand dedicated to experimental projects. It subsequently won an award at the Rotterdam film festival, the first major European event of the year and one particularly associated with innovative work, a breakthrough that gained greater attention for the film when it played elsewhere, including the Berlin International Film Festival, one of the most prestigious events in the festival calendar.[12]

Wendy and Lucy, defined similarly as 'one of the hits of the year's festival circuit' two years later, had its premiere in the 'Un Certain Regard' section at Cannes, subsequently playing at major events in New York, Toronto, Los Angeles and London.[13] Bahrani's films also made their mark on the circuit. *Man Push Cart* had its world debut at the prestigious Venice International Film Festival, playing numerous others, including a screening in the Spectrum section at Sundance, a forum designed to accommodate new voices. *Chop Shop* played in the Director's Fortnight at Cannes and at other leading events, including Toronto, London and Berlin, while the achievements of *Goodbye Solo* included the critic's prize at Venice.

The critical praise and profile gained by such films through the festival circuit is vital currency in the indie arena, especially for smaller-scale productions of these kinds for which other forms of promotion are limited. Festival appearances, particularly those at the most prestigious events, act as sources of 'value addition', as Marijke de Valck suggests,

providing certification of quality and early opportunities for critical recognition.[14] Playing on the international festival circuit can become an alternative to more conventional theatrical release, but such screenings can also be translatable, more or less directly, into benefits such as distribution deals and interest in future projects, as has been seen in some examples examined earlier in this book. *Old Joy*, for example, left Sundance without a buyer, which is hardly surprising, considering its marginal status at that point; it played in a small, 150-seat theatre, while, at the other end of the scale, *Little Miss Sunshine* packed out a 1,275-seat venue on the same day. Four months later, after the development of its reputation, it was picked up by Kino International, a small New York distributor, for a figure put at 'low five figures', a modest outcome but as much as was likely to be achieved by a film of its nature.[15]

Wendy and Lucy gained its distributor some two months after its screening at Cannes, where it was thought to have been seen by the buyer, Oscilloscope Pictures, a company co-founded by Adam Yauch, a former member of the Beastie Boys. This was another small, specialist entity, the experience of which at the time was limited to the release of a couple of documentary features. It was designed to operate in the small-scale DIY manner of some indie record labels, with everything handled in-house, from marketing and choice of individual theatres to DVD production. The deal for filmmakers involved a smaller advance (how much is unclear) but a larger share of any eventual profits and more involvement in marketing, an approach expected to appeal to a figure such as Reichardt.[16] Oscilloscope also subsequently released *Meek's Cutoff*.

Man Push Cart was picked up by another very small distributor, Films Philos, the day after its screening at Sundance. The film was also seen at the festival by a representative of the production company Big Beach, which financed *Little Miss Sunshine*. This led to the agreement of Big Beach to back Bahrani's next feature, the then in-development *Chop Shop*. A positive *Variety* review following the premiere of *Man Push Cart* at Venice also started the process of putting resources behind the nascent project that would become *Goodbye Solo*: a call from the eventual co-producer, Jason Orans, who had access to development money from the public-service-oriented

Independent Television Service (ITVS) for any work with an immigrant/ethnic focus, which led to Bahrani writing a treatment for the film ahead of the production of *Chop Shop*.[17] The latter had to wait until late in its festival run before gaining a distribution deal in December 2007 from Koch Lorber, a New York-based specialist in overseas, independent and documentary films. US distribution rights to *Goodbye Solo* were sold to Los Angeles-based Roadside Attractions at the American Film Market, a major event in the US sales calendar, at which rights were also sold for overseas territories including Canada, the UK, France, Brazil and Japan.

When it came to theatrical distribution, all of these films followed the classic indie model, in keeping with their scale of production, the limited nature of the audience they were likely to reach and the presence of their distributors towards the marginal end of the indie spectrum. They started with very small beginnings in specialist venues beyond which any expansion remained either limited, very limited or non-existent, although most were considered to have performed well, or at least respectably, in their own terms, a far cry from the much-larger releases achieved by the examples considered in Chapter 1. *Old Joy* opened on a single screen in Portland, Oregon, in August 2006, a location chosen to take advantage of the local connections of the film, where it remained for four weeks before transferring to the Film Forum, a prestige speciality venue in New York. At the Film Forum, it was considered to have performed 'spectacularly well', earning more than $29,000 in its first week and another $21,000 in week two, figures that represented a very healthy per-screen average for the indie sector, even if restricted to the single screen.[18]

As a small operator, Kino was unable to afford to buy full-page newspaper advertisements but ran a number of smaller ones. Its investment in the release also included $40,000 to blow up the film from 16mm to the standard theatrical release of 35mm, $24,000 on 22 prints, $6,500 on 200 trailers, $4,000 on printing 50,000 promotional postcards and some $3,000 on web adverts, an effort described by *The New York Times* as 'heroic'. The distributor opted for a two-strand approach, targeting both the traditional art-film audience and music-oriented viewers who might be attracted by the presence of the singer/songwriter Will Oldham in one of the lead roles and the

score by Yo La Tengo.[19] At its widest, the film played on 11 screens. The domestic gross was $255,923 with another $45,124 overseas, making a total of $301,047.[20]

As a relatively more conventional work in some respects, benefiting from the presence of a higher-profile central performer, *Wendy and Lucy* fared considerably better and had a somewhat wider release, increasing gradually from an initial two screens (in December 2008, towards the end of the autumn/pre-Christmas period of maximum speciality competition) to a maximum of 40 by March 2009. The resulting domestic gross was $865,695 and a worldwide total that broke the million-dollar mark at $1,191,050. A comparable pattern led *Meek's Cutoff* to a domestic gross of $977,772.

Bahrani's films experienced a similar move upwards in scale of release and box-office returns, although again remaining firmly within the bounds of the lower end of the spectrum and the traditional low-resource indie model. *Man Push Cart* was considered to have performed respectably, with a $13,694 return from its first week on a single screen at the New York speciality venue Angelika Film Center in September 2006 – again, in the highly competitive autumn season – although it only lasted one more week and that was the end of the US run, a gross of $36,608 boosted to a still very modest total of $55,903 by its overseas takings. *Chop Shop* opened on one screen at the Film Forum, where it was the highest speciality performer of the week with $8,475 in March 2008. It outlasted its predecessor by a large margin, remaining on release until mid July, although never on more than one, two or three screens (gross: $125,045 domestic, $96,182 overseas, a total of $221,227). Its subsequent bookings also included arts-oriented institutions beyond New York, described by the distributor's president Richard Lorber as 'semi-theatrical' in nature, venues such as the Wexner Arts Center in Columbus, Ohio, the Cleveland Cinematique and the Northwest Film Forum in Seattle.[21]

The handling and performance of *Goodbye Solo* quite closely matched that of Reichardt's *Wendy and Lucy*, each being perceived by its distributor to have relatively greater commercial potential than its predecessors. The film followed *Chop Shop* in being given a March release, in the spring season that is a popular period for speciality releases, avoiding the mainstream-dominated summer and Christmas

peaks, but generally less crowded with larger indie/Indiewood releases than autumn. It opened on three screens rather than one, reaching 11 in its third week and gradually building to a high point of 34 in its twelfth week, during a run that continued until early November. The domestic gross was almost identical to that of *Wendy and Lucy*, at $870,781, with a very modest additional $71,428 from overseas.

All five features were warmly received by many critics on their release, particularly by those at the 'quality' end of the media spectrum, in addition to the praise they received earlier on the festival circuit. A number also figured in the Independent Spirit Awards. *Old Joy* featured strongly in the awards for smaller productions, winning the Piaget Producers Award, for emerging producers working on highly limited resources, and being nominated for the John Cassavetes Award, for the best feature made for less than $500,000. *Wendy and Lucy* featured in the nominations for the higher-profile awards, for best feature and best female lead, although was successful in neither. *Man Push Cart* received similar mainstream Spirit nominations, for best first feature, best male lead and best cinematography. *Chop Shop* was nominated for best director and best cinematographer and won for Bahrani the 'Someone to Watch' award, a $25,000 grant created 'to honor a talented filmmaker of singular vision who has not yet received appropriate recognition.' *Goodbye Solo* was considered by some indie commentators to have been snubbed in not being nominated in the top categories, instead receiving an unsuccessful nomination for Savané as best male lead.

What, then, was the basis on which these films appealed to critics, festival-goers, awards nominators and to a certain, if distinctly limited, audience? The next parts of this chapter looks at the work of Reichardt and Bahrani in more specific textual detail, starting with formal qualities, including narrative structure and visual style, before considering the broader social, political or ideological implications of the material.

'Realism' in form: Narrative, visual style, sound

If the films of Reichardt and Bahrani make claims to the status of realism, and have certainly been praised on that basis, this is partly

because of the subject matter with which they deal: the lives of what are represented as relatively ordinary or marginal figures, rather than typical movie protagonists, even of the kind that might be expected of some indie features, a dimension the broader implications of which are considered later in this chapter. Their realism is also a product of core formal qualities, however, as would be expected and as in the case of the films examined in the previous chapter, including narrative structure, visual style and the use of sound.

Narrative

Narrative is one of the dimensions in which these films are most clearly marked both as departing firmly from the norms of mainstream/Hollywood commercial cinema and as belonging to the traditions of the American indie and broader art-cinema sectors. All opt for a low-key narrative approach in which major outbursts of drama, transformative character arcs and other such features, characteristic of the dominant model associated with classical/canonical Hollywood narrative, are markedly absent. Instead, the focus is on something presented as closer to the rhythms of real daily life, although the extent to which this is the case should not be exaggerated. Each of the films considered here remains a fictional construct that draws to some extent, even if in muted form, on certain established dramatic devices and conventions, generally to a somewhat larger extent than is the norm for mumblecore. Their difference from the classical or mainstream-conventional model is substantial but remains relative, as is the case in most dimensions of all the productions considered in this book, and most indie cinema in general. In adopting this approach to narrative, the films of Reichardt and Bahrani are situated very clearly in established indie territory, the use of low-key or downplayed narratives being a defining feature of many of the 'classic' films of the 1980s and 1990s, as suggested in the previous chapter, from the early features of Jim Jarmusch to many other examples.[22]

Old Joy goes the furthest in this minimalist direction, the primary reason for its situation in festivals and elsewhere as a production that leans somewhat towards the experimental end of the feature-narrative scale. It

still has a number of reasonably conventional narrative ingredients, however. The initial scenario is not unfamiliar: two former friends getting back together for a trip into the woods. The manner in which they are characterized also seems conventional enough: Kurt (Oldham) has remained true to what appears to be a past of 'alternative' hippie-type lifestyles, as particularly figured by the initial background setting of Portland, Oregon, while Mark (Daniel London) seems if not to have sold out at least to have settled down into Volvo-driving domesticity, with a wife in the latter stages of pregnancy. What follows from this starting point is a distance from what might be expected in a more conventional treatment, however. The relationship between Kurt and Mark is handled in a subtle, elusive manner, one that evokes hesitancy and uncertainty rather than any definitive, transformative or revelatory arc, effectively capturing the awkward and unstated currents than run beneath their surface behaviour and dialogue.

The emphasis of the film is on a sense of leisurely drift rather than forward narrative momentum. As Kurt and Mark drive from the city to the mountains, quite lengthy sequences are devoted to travelling shots from the car, recording the various urban and rural landscapes through which they pass. Looking for a particular spot to camp before trekking in the morning to a hot spring, they become lost, but routinely rather than dramatically so, eventually spending the night in a far from idyllic rubbish-strewn area at the end of a track, a setting at odds with what might be expected of a travel-into-the-wilds narrative.

Mark seems a bit uptight throughout, a contrary pull away from any renewed bonding with Kurt being exerted by phone calls from home. A certain skepticism is suggested toward Kurt's descriptions of his various experiences since their last meeting and what appears to be a slightly forced optimism on his part. But this is all implied, through subtleties of gesture and expression, rather than being stated outright. Little if anything develops that could be defined as conflict, in a more conventionally dramatic sense, even if a slight edge of annoyance enters Mark voice on one or two occasions. Kurt shifts register at one point, over the campfire, into a more direct attempt to confront Mark, letting down his guard for an emotional outburst

17. Leisurely pace: At the hot spring in *Old Joy* © Kino International

about how badly he misses him and wants to be friends again. But this is only a passing moment, neither a point of sustained crisis nor a step on the way to any apparent resolution. Mark holds back, maintaining that 'we're fine', an insistence that leads Kurt to back-track and apologize, regaining control and saying that he was just being 'crazy'.

Further leisurely sequences accompany the remainder of their journey to the hot spring and their quiet sharing of the experience it offers. At the spring, Reichardt and co-writer Raymond again resist any temptation to fall into more conventional narrative routines. Kurt goes into a lengthy monologue, concluding with a line that explains the title of the film: the suggestion by a character in one of his dreams that 'sorrow is nothing but worn out joy'. This is an expression that might be applied to the experiences of the protagonists, but any such conclusion is again left implicit, Mark appearing to offer no reaction to the notion. A physical connection is then articulated between the pair, as Mark relaxes and gets over his initial moments of reluctance and discomfort to enjoy a massage from Kurt, a sequence accompanied, as previously in the hot springs location, by cutaway shots of water running or dripping and other aspects of the surrounding natural scene. This, though, is followed by an abrupt cut to their walk back along a

trail to the car, rather than overtly being developed or built upon in any way. On their return to Portland, Kurt is dropped off by Mark, with the film offering no definitive suggestion about the status of their relationship. Mark says the experience was 'awesome' and Kurt promises to call him soon, but it is entirely unclear to what extent any real connection has been re-established between the two. A similar degree of indeterminacy of conclusion is found in all of the films examined in this chapter, the implications of which are considered further below, not least in terms of the socio-political location of the texts.

Wendy and Lucy revolves around a more conventionally dramatic central plot device than *Old Joy*: the narrative crisis created by the disappearance of Lucy and the resulting quest entailed by Wendy's attempts to find her dog. This is material that has clear potential to be developed in a mainstream-conventionally sentimental direction, although any such temptation is largely avoided in Reichardt and Raymond's script. *Wendy and Lucy* also shares with *Old Joy* a starting point that has familiar resonance in American cinema and US culture more broadly, the protagonist being engaged in a version of the classic westward journey towards frontier lands, in this case the promise of work in the far north-western state of Alaska. The film is mostly an account of stasis, however, in which Wendy's journey is halted and the emphasis is on the close detail of the realities of her straightened circumstances. No back-story is supplied to explain any specific personal reasons for departure from home, beyond a search for employment, which gives her effectively the status of an every-person, a representative of the ordinary working (or unemployed) classes of America. In characterization, Wendy, like Kurt and Mark in *Old Joy*, is again far from the Hollywood or otherwise more mainstream norm in which central figures tend to be marked as 'special' or capable of transcendence in one way or another. She is marked as quite physically attractive, in conventional terms, as portrayed by Williams, but stripped of any glamour and not always entirely sympathetic in the sometimes curtly defensive manner in which she deals with others.

The film does deploy some quite conventional narrative tropes, as suggested above. Having economically established the basis of Wendy's situation, including her limited means, a somewhat sentimentally-inclined device is used to motivate the shoplifting incident

that, in turn, leads to the loss of Lucy: the revelation that her owner has run out of dog food. And it is primarily dog food that Wendy seems to attempt to steal, rather than anything much for herself, which might be taken to be an extra appeal for sympathy. A conventional form of suspense is generated in the quite lengthy sequences in which she is processed at the police station, including two shots of clocks to indicate the passing hours, during which time the viewer is aware that Lucy has been left unattended. The slowness of the process is of a piece with the tendency of the rest of the film to allow time and space for the exercise of various humdrum routines, however, as part of its commitment to an evocation of something like the rhythms of quotidian experience on the margins of society. In general, as with *Old Joy*, very little happens during the film, in the sense of additional dramatic narrative events.

In both films, alternative, more plot-oriented scenarios could easily be imagined within the same initial situations. At one point while searching for her dog in *Wendy and Lucy*, for example, Wendy comes across the officious shop assistant, Andy (John Robinson), who insisted on her prosecution. For a fleeting moment, it might seem as if some initially unlikely connection could be made between the two, as might be expected in a more conventional meeting-of-opposites treatment, but this is not to be the case. The film presents itself as a piece of harsh realism in which no such fantasy confections could be allowed, even of a quirky kind that might be expected of more mainstream-oriented indie cinema. There is one other dramatic episode, when Wendy is forced to sleep rough while her car is in the garage and her night is disturbed by the frightening presence of a stranger (Larry Fessenden). But this incident is rendered indistinct and confusing by a combination of near-darkness and the loud background noise of a slowly passing train, an effect that seems all the more effective in capturing an impression of the likely nature of the experience of such an incident. A similar primary emphasis on the rhythms and rigours of daily experience is at the heart of *Meek's Cutoff*, despite the inclusion of structuring tensions around more plot-based elements such as a shortage of water and the presence of a Native American captive.

The sense of creating an impression of the routine and the quotidian, at the expense of more plot-oriented or conventional drama, is if

anything even stronger in the films of Bahrani, especially *Man Push Cart* and *Chop Shop*. The former returns, repeatedly, to a basic dynamic involving the daily routines of the operator of the snack cart: arriving at the warehouse depot, loading supplies, hauling it along the road (it is usually pulled rather than pushed) and into position, making coffee, pre-loading paper cups with tea bags ready to be filled, preparing bagels, and so on. Always with him, it seems, Ahmad carries the unwieldy gas bottle that powers the stove, a reminder of the burden that accompanies him even when he is not in charge of the cart. This seems to be the primary framework around which the film is constructed and to which other narrative components are subordinated.

It is only gradually and sometimes quite obliquely that Ahmad's back-story emerges, belatedly spelling out exactly what is at stake in his personal struggle to improve his situation. We become aware quite early that he has a young son from whom he has become alienated; later, that his wife has died and that her mother blames him, for some reason, and is blocking access to the child. We discover that Ahmad, a Pakistani immigrant, had a very different past in his home country, as a singer who released what appears to have been a successful CD. The potential for a more conventional narrative of transformative success is created by the presence of the wealthy Mohammad (Charles Daniel Sandoval), a fellow Pakistani who recognizes Ahmad and promises to put him in touch with connections who will be able to revive his music career (meanwhile, either helping him out or taking advantage of him – or an uncomfortable mixture of the two – by employing him to paint his apartment). This comes to nothing, however, partly as a result of Ahmad's pride and stubbornness, it seems, and partly because of the semi-exploitative and blasé attitude of Mohammad and his associates; something similar can be said of the not-quite-ever-realized potential for a romantic involvement with a young Spanish woman, Noemi (Leticia Dolera), with whom he becomes friendly.

Only very belatedly is the full scenario clearly spelled out: that Ahmad has been saving money in order to buy his cart, and the rights to its pitch, for himself, and that this, in turn, is motivated by an ambition to gain a proper apartment in which he hopes to be able to live with his son. A considerably different dynamic would have

been created had this been made so clear from the start, as a motivating framework for his efforts. Instead, Bahrani has chosen to put into the foreground the detail of the daily routine, giving this priority rather than allowing it to be subordinated to the more personal-emotive dimensions of the story. *Man Push Cart* climaxes with what might seem a more conventional moment of crisis, and one that is signaled quite predictably in advance. At last, we find out, Ahmad has raised the $5,000 required for the initial payment that makes the cart itself his own responsibility (although considerably more is required to gain the full rights). He is warned that he should make sure that it is insured, a device that provokes expectations of disaster that are eventually fulfilled, in the second of two occasions on which the film opts for a more sentimental register than is typical overall (the earlier being the demise of a tiny kitten adopted by Ahmad, as a kind of surrogate for his son).

The loss of the cart comes when he leaves it untended while chasing after a pair of street vendors to buy a toy for his son, a cheap plastic recorder, as part of his attempt to regain the love of the boy (this device is, in some respects, an equivalent to the stealing of dog food in *Wendy and Lucy*; an other-centred departure that has negative consequences). He returns to find it stolen, a moment of devastation comparable to the central inciting incident of the Italian neorealist classic *Ladri di biciclette* (*Bicycle Thieves*, 1948). As is a tendency in many of the films examined in this chapter, however, this is not presented as a transformative event, as might more conventionally be expected. Just as the lives of Kurt and Mark seem likely to go on, more or less unchanged as far as we can tell, at the end of *Old Joy*, and Wendy continues on her journey, if sad and now alone, in *Wendy and Lucy*, Ahmad also seems set to endure. It is another morning and his friend Altaf (Altaf Houssein) is struggling with his own cart, after the breakdown of the van he uses to tow it into position. Ahmad helps out and we are left with him setting up for business, once again, in the familiar routine, as if nothing has changed.

Chop Shop follows a similar pattern in some respects, although the key components of character-related plotting are developed rather earlier in the piece, interspersed with our introduction to the daily regime of Ale's experiences in and around the body shop in which he

performs chores, learns aspects of the trade and above which he lives. No back-story is provided in this case; no indication of how he came into such an existence, what happened to his parents, or anything of that kind. Early scenes establish attempts to make telephone contact with his older sister Isamar (Isamar Gonzales), who he meets from a train some 11 minutes into the film. At this point, part of the basic scenario is established: Ale, acting as if the older of the siblings, has found Isamar a place to stay (we learn that she has left a safe house) and a job, working for the proprietor of a snack van, a business that represents half a step upwards from the push cart of Bahrani's previous feature. Shortly after this, we are introduced to Ale's plan, another attempt at self-betterment and family restitution. Ale is saving up, like Ahmad in *Man Push Cart*, in this case to buy an old, clapped-out snack van to restore to give Isamar her own independent livelihood. An additional urgency is given to this quest some 30 minutes into the film when Ale discovers that she is selling sexual favours to the local population of truck drivers.

The project seems doomed to failure from the start, however, judging by the apparent state of the van, as is eventually confirmed when it is declared incapable of being brought up to required health and safety standards. Ale is offered $1,000 to break it for spares, an option we subsequently and somewhat abruptly see to have become a *fait accompli*. Like Ahmad in *Man Push Cart*, Ale is left seemingly back where he started, with most of his savings gone, but the film ends on what seems to be an at least partially upbeat note. He falls out with Isamar after disrupting a session between her and a customer in a car, after which she shuts herself in the bathroom overnight. A tentative restoration of the relationship is signified when Ale joins Isamar outside the body shop on the following morning, attracting a flock of pigeons by spreading bird seed onto the ground. Isamar glances in his direction with a slight smile and scares away the birds with an exultant-seeming stamped foot and a shout, the camera following the birds momentarily into the air before they pass out of shot and the white frame fades to black and the final credits. The image of the birds in flight is a somewhat conventional and potentially clichéd symbol of freedom and escape, but employed here only fleetingly, in a manner that seems typical of the overall pitch of the films examined in this chapter.

A rather different approach again to the deployment of key narra-
tive data is used by Bahrani and Azimi in *Goodbye Solo*, in which
the major organizing device is introduced abruptly in the opening
moments of the film. The viewer is plunged into the middle of a
conversation (somewhat mumblecore style) in which it becomes clear
that the taxi-driver Solo has been offered $1,000 to take an elderly
passenger, William (Red West), on a two-hour drive to a mountain-
top location at which he is not meeting anyone and from which he has
no plan to return. Solo's initial puzzlement is replaced by the realiza-
tion that William plans to kill himself, which raises a number of major
questions that might be expected to be resolved during the remainder
of the running time, including: why does William want to commit
suicide, what will be Solo's response, and what will be the outcome?

The front-loading of the film with these questions, with the effect of
immediately making clear what is at stake in the nature of the relation-
ship that might or might not develop between the two central characters,
seems a more mainstream-conventional narrative ploy that those of
Man Push Cart or *Chop Shop*. The melodramatic potential of the situa-
tion is established from the start, although the suddenness with which
this is done is itself a considerable departure from the norm, not least
because of the risk it poses of some viewers missing important informa-
tion when it is presented so close to the start (it would be more usual to
allow at least a few more minutes before building up to so crucial an
exchange, to enable the viewer to gain more general orientation). It is
also notable that the offer has already been made at the moment that the
film begins, the details emerging for us in retrospect through Solo's
questioning of what the reasons might be for such an arrangement.

One dimension of the film then takes on the characteristics of a
detective story of sorts, with the viewer following Solo in being given
only limited information about William's circumstances and in his
quest to find out more. We learn, with Solo, as the film develops,
that William has sold his apartment and is closing down his savings
account, acts that seem to confirm the assumption that he is planning
to end his life. Whether or not he might be doing so because termi-
nally ill is investigated by Solo, who steals some of the pills he finds
William to be taking, which turn out not to be for any life-threatening
condition. Solo's detective work also leads us to the much-later
revelation that William appears to have a grandson, despite his claim

not to have had children, a young man working as a cinema cashier (which explains William's regular visits to the cinema).

Solo's principal effort, however, and the main emphasis of the film as a whole, is far less on the process of investigation or the gaining of knowledge than on his attempt to make a human connection with William, the unspoken assumption being that he hopes this will lead the latter to reconsider his decision to commit suicide. The scenario has clear potential to move in a clichéd direction at this point, with the garrulous, ever-optimistic West African immigrant figure of Solo seeking to open up and/or 'save' the gruff, grizzly old white man, to get beneath his skin and move beyond the superficiality of the limited contact he is offered as designated driver for the appointed time of William's death. Fully to enact such a dynamic would be to indulge in an overly familiar reconciliatory narrative stereotype of the kind often found in Hollywood treatments of such relationships (Bahrani himself cites *The Legend of Bagger Vance* [2000] as one example from which his film was distinguished by an appreciative festival viewer[23]).

Goodbye Solo does seem to buy into this dynamic up to a point, in the characterization of Solo and details such as his emphasis to William that in his own culture, in Senegal, an old man would be looked after by his family rather than left on his own. William repeatedly rebuffs Solo's pleas that he open up and explain what is wrong with him, but some limited ground does seem to be gained by the latter as the film progresses (some contact is established through help William offers Solo in his preparations for an examination he is taking in an attempt to get a job as a flight attendant, and in one or two exchanges with Solo's step-daughter, Alex [Diana Franco Galindo]). Any development of this towards more concerted reconciliation is halted, however, when Solo pushes too hard and confronts William with what he has discovered so far, which leads to an angry outburst and punch to the face from William, who then seeks to cancel the arrangement for Solo to drive him to his final assignation.

William's insistence on the privacy of his core situation remains adamant, the film proceeding from this point with a tacit acceptance between the two that they will conduct the exchange on the original basis (although Solo asks that he be able to take Alex along for the ride, to save him from having to return alone). They arrive at the destination, the landmark Blowing Rock, from which William is assumed to be

18. Understated climax: The final parting of William and Solo in *Goodbye Solo* © October 20 LLC

planning to jump, at which point Solo and Alex leave him to his fate (unknown to the child), which is left implicit for the viewer. This is another climax that mixes the more and less conventional, the act of suicide itself being entirely off-screen and underplayed, without any final expressions of emotion in the parting between Solo and William, while the setting has an otherworldly location that implies the possibility of something vaguely transcendent. Blowing Rock is established as a unique location, a misty wind-blown overhang at which point items thrown off the edge fly upwards rather than down, a setting that gives a mystical/poetic resonance to the ending of the film. The flying-upward imagery, and all that it implies as a familiar trope of escape or transcendence of circumstances, is akin to the final shot of *Chop Shop* and also, perhaps, Solo's continuing ambition to achieve a career in the air.

Sound and visuals

The other formal dimensions of these films, their visual style and use of sound, are in many respects the corollary of the types of narrative structure outlined above, contributing centrally to overall impressions of reality/authenticity established by Reichardt and Bahrani. This is another respect in which they join mumblecore in fitting solidly into existing indie trends and broader inheritances from the realist cinema

tradition. Some of the films examined in this chapter also include more aestheticized or expressive dimensions, however, another feature of some of their indie predecessors and one that can complicate the degree to which they might be interpreted or judged as aspiring to the unvarnished reflection of particular versions of reality.

The most obvious marker of a realist shooting style is the use of unstable, handheld camerawork, particularly evident in the first two films of Bahrani. This can be understood, as in the case of mumblecore, in the context of both creating an impression of authenticity, of capturing in *vérité* style what appears to be a spontaneous unfolding of events, and of following improvisational or not entirely pre-planned dimensions of performance. Shooting in such a manner can also be an effective means of working quickly on location on limited resources, without the crew and equipment associated with larger or Hollywood-style productions, or for working with low impact on the background environment, the uninterrupted presence of which can be an important part of the overall aesthetic. All of these factors seem to be quite clearly in play in both *Man Push Cart* and *Chop Shop*.

The former begins *in media res*, without any prior introduction or establishment of character or setting. The first image is of a light shining uncomfortably towards the hand-held camera through the plastic flaps of the entrance to a warehouse, through which comes a figure who proves to be Ahmad, carrying his gas bottle. All we can see with any clarity is the bottle and his legs before a slight jump cut to his figure walking away from the camera, rather dark and indistinct. The camera swings around through a space the nature of which is unclear, briefly following another figure walking in the opposite direction. Two shots of close detail follow, of someone (presumably the original figure, Ahmad) fiddling with some mechanism, which proves to be part of his cart. Throughout these shots, and as the sequence develops, the tendency is to cut just before it is clearly established what exactly is happening, this and the prevailing darkness and confusion of action creating a disorienting impression for the viewer, similar to that found in the opening moments of some mumblecore films, even as the general nature of the activity – the preparation of the cart for a day on the street – begins to be established. The formal qualities used here strongly support the narrative priority given to the depiction of Ahmad's daily routine in favour of the elements of character background.

The characteristic style of the film is for the camera to create the impression of following the action, responding and adjusting to the movements of characters, accompanied in many instances by slightly abrupt editing regimes that add significantly to the overall effect of capturing the unfolding of activity, rather than achieving the kind of smoothly perfect articulation associated with traditional Hollywood-style continuity. The camera is not constantly in motion by any means, or always unsteady, but it often shifts quite awkwardly to adjust to events, at a local, small-scale level. When Ahmad is trying to sell DVDs to a pair of men loading drink cartons into a cellar, for example, the camera swings around, dips down and rises, to follow the different positions of those involved in the exchange. On his first meeting with Noemi at her newsstand, when she drops his pack of cigarettes, the camera sweeps down, unsteadily and inexactly in its positioning, trying to follow its movement towards the ground. The repeated shots of Ahmad struggling to manouvre his cart on the streets are frequently taken from the far side of the road, the camera follow-ing his progress but as if observing from a distance, the view often blocked by passing traffic, a standard faux documentary approach.

A similarly distanced effect is created in the sequence in which he buys the toy for his son and when he is searching, in panic, for the stolen cart. The camera here tends to hold its position, panning from side to side to follow Ahmad's movements, staying at a distance when he crosses the road to question the proprietor of a shop, on some occasions cutting into a shot already in panning motion to increase the urgency of the impression that results. The effect might appear to be motivated quite specifically on this occasion by the particular nature of the event, although the style here is not inconsistent with that of much of the remainder of the film.

Much the same aesthetic is characteristic of *Chop Shop*, although to a slightly lesser extent, again established from the opening moments, in this case the camera wavering on a group of day labourers, among them Ale, waiting at a roadside in the hope of securing employment. Shortly afterwards, the handheld aesthetic is very much to the fore as Ale and his friend Carlos (Carlos Zapeta) seek to earn money by sell-ing candy on the subway. The camera follows the pair, quite unsteadily, onto a train carriage, wheeling around to give a frontal

19. Observation from a distance as Ahmad lugs his burden through the Manhattan traffic in *Man Push Cart* © Noruz Films

view of Ale and subsequently of Carlos, as they do their selling spiel. An abrupt cut then leads into the middle of negotiations with one group of passengers, all shot in much the same way, the camera displaying wavering movements and seeming to follow rather than lead the action. As in a number of other instances in the film, these sequences were shot among real individuals as if in a documentary, with real sales being made by the two boys and their customers paying little if any attention to the presence of the camera.[24]

A similar style governs the characteristic action of Willets Point itself, unsteady camerawork and slightly abrupt cutting, sometimes into already moving shots, seeming to evoke the at times chaotic nature of the environment, especially the process through which Ale hawks for business for his employer, competing to lead cars into his rather than rival lots. The unsteadiness aesthetic appears quite clearly designed to follow the action, however, rather than seeking artificially to heighten particular individual events or processes. It is notably not increased, for example, in a sequence in which Ale avoids the attentions of a security guard to steal hubcaps from a car, a situation in which an extra edginess might have been introduced to create an increased impression of suspense (the sequence is, in fact, more stable than many in the film, the primary focus being on Ale's removal of

the hubcaps, the coverage of which does not require much movement on the part of the camera). A more than usually rapid camera lurch is exhibited on another occasion, during a scuffle between two characters, but this appears to be motivated entirely by the attempt to follow the physical movement of one of the combatants.

Handheld camerawork also features in much of *Goodbye Solo*, but in this case it is generally far less noticeable, the result, it seems, of the rather different nature of the material. The camera again often moves and adjusts to follow the positions of characters, but the principal settings and actions are such that any *vérité* impression is far more muted and underplayed, including numerous sequences shot in the confines of taxi interiors in which little space is available – or little need exists – for a wavery style of camerawork. Two more abrupt movements are motivated in the same way as in the last example from *Chop Shop* cited above: on the two occasions that Solo is punched by other characters (once by William and again in a clash with another driver), the camera lurches down rapidly with him as he hits the floor, extreme movement being justified by reaction to heightened character motion.

The Reichardt film that presents the most obviously realist credentials, *Wendy and Lucy*, marks a further departure from the type of *vérité* style found in *Man Push Cart* and *Chop Shop*. Reichardt shares with Bahrani the employment of the distant, withdrawn camera in some sequences set on the streets of the small town in which Wendy becomes stuck, with traffic passing in similar manner between the protagonist and the viewer. In general, however, Reichardt's approach is very different, opting primarily for either static camerawork or stably panning movement of the camera and almost entirely avoiding any use of the unsteadycam aesthetic. A characteristic example is her treatment of an early sequence in which Wendy feeds Lucy on the street. Wendy gets water and food out from the boot of her car. As she bends down to pour the water, the camera remains trained at the height of the boot, in the position adopted in the earlier part of the sequence, rather than following her downward movement towards the floor. The camera pans sideways slightly to follow Wendy's movement as she repeats the action with dog food, but this time cuts to a separate shot of the pouring of the food into a bowl at

ground level, rather than moving the camera downwards to capture the whole of the action in one shot. Another example follows shortly afterwards, when Wendy is bathing in the sink of a nearby gas station washroom. The character dips out of frame at times during the process, rather than the camera going with her in an attempt to follow the action. A more overt instance of this approach is seen in an image in which Wendy is pulled out of frame by the dog on its lead, instead of the camera lurching to the side to follow the movement, as might be expected in a Bahrani treatment of a similar event (the difference is in this respect akin to that between the strategies favoured by Swanberg and Bujalski, as identified in the previous chapter).

Each of these visual styles makes it own claims to the status of a kind of *vérité* realism, underlining the extent to which such effects are constructs the nature of which can vary from one example to another. Bahrani creates something like a documentary effect by having his camera attempt, often inexactly, to follow the action. Reichardt creates a similar effect, the impression of events not being pre-planned exactly for the camera, by allowing it to miss certain details rather than trying to capture every moment or movement. It is notable in *Wendy and Lucy* that no sign of the wavery, unstable camera is found in some of the passages of most heightened suspense or reaction, including the shoplifting sequence, which is depicted in a blend of stable pans and some stationary shots, and the immediate aftermath of the discovery that Lucy has gone. When Wendy goes into the store to ask the cashiers, or when she searches the street outside, there is no trace of wavery camerawork, in sequences in which it might easily have been motivated by her heightened state of anxiety and the urgency of her visual gaze from one spot to another.

Reichardt uses the unsteadycam only once in the film, not during the sequence in which Wendy is frightened by the stranger at night in the woods but to heighten her delayed-action response, when she reaches the safety of the washroom, the camera enacting a number of wavery movements accompanied by jump cuts. Overall, the realist claims of the film are created through a quiet and undemonstrative visual style, the muted quality of which seems in keeping with the nature of the events and relative non-events around which the film revolves. Much the same can be said of *Old Joy*, in which handheld

camerawork is used on some occasions but also in an understated manner not designed to draw the attention of the viewer. The distanced-camera-on-the-street is used briefly at the very end, in the closing images of Kurt, but the bulk of the film embodies a style marked as calm and relaxed, whether in quite long-held stationary shots or pans. Partially obscured shots of Kurt and Mark are used in some parts of the sequence depicting their trek to the hot springs, but this is not the dominant approach even here. In general, the film obeys broadly mainstream conventions of continuity editing, if with some shots held a little longer than standard.

The central section of the campfire sequence is a good example. The first part of this is covered primarily in a locked-down two-shot of the pair, with the fire between them and the camera, before a shift to closer single shots of each at the point where Kurt makes his more openly heart-felt appeal for renewed friendship, greater proximity to character being a standard way of highlighting the more emotive part of the scene, as seen in the examples considered in Chapter 1. *Old Joy* also deploys some more apparently stylized or expressive visual qualities, however, if quietly so, a quality it shares with some of the work of Bahrani, particularly *Chop Shop*, and that, as suggested above, complicates the simple attribution of a realist label to this kind of work.

A number of cutaway images are used during the sequences in which Kurt and Mark bathe in the water from the hot spring, details that seem to go beyond the factual evocation of place and expressively to suggest something of the natural harmony conventionally associated with such an experience. We see various images of the water itself, flowing through channels, giving off steam, or dripping; detail from the structure that houses the baths; images of nature such as a bird balanced on a leaf, and a slug. These are offered as moments of peaceful contemplation (they have something in common with the cutaway images used by Aaron Katz in the urban context of *Quiet City*), privileged instances in which the protagonists seem to achieve something of what they seek from their trip into the woods. *Old Joy* also includes a number of longer sequences that seem to function in a similar manner and that constitute a central part of the fabric of the film: the travelling shots, some of them quite extended, that accompany the drive from city to country and back again and that

punctuate the film on several occasions. These are quite clearly marked off from the remainder of the text, particularly through their accompaniment by the music of Yo La Tengo.

In some cases, shots of the passing landscape – from urban to increasingly rural and back again – are relatively brief and intercut with material from inside the car, including dialogue exchanges between the two principals. But this kind of material takes on a greater weight of its own much of the time, making a central contribution to the slow and unhurried pace of the film (a similar effect is created by many extended travelling sequences in *Meek's Cutoff*, in which the camerawork is primarily static, highlighting the often painful passage of the protagonists across the landscape via a narrow, Academy-ratio frame that seems to mirror the constrained view afforded by the hooded bonnets worn by the film's central female characters). This can be understood, up to a point, as a kind of documenting of place, as is suggested below in relation to all of the films examined in this chapter, but the extent of such footage – shots from the point-of-view of the car, shots looking out at the passing landscape, shots of the car itself in the landscape – is such as to seem to transcend any such literal function and to display an intent that seems more evocatively and poetically minded (a point of similarity in the work of Katz here would be two relatively lengthy travelling sequences, to music, in *Dance Party USA*).

A similar dimension is found in Bahrani's *Chop Shop*, although in different form and with perhaps different implications in the context of its setting. The *vérité* effects employed in the film might seem to capture a sense of the rough, marginal and provisional nature of Ale's status, in addition, perhaps, to its potential for improvisation, but the filmmaker also seems to seek a more aestheticized dimension. Many of the night exterior shots in the film, in and around the Willets Point landscape, are rendered in a manner that seems to produce image qualities that suggest cinematic or more broadly artistic beauty, the product of the work of the lighting crew and cinematographer rather than just available light in the location. Most of these sequences are bathed in a low-key, warm reddish-brown light that produces glowing highlights in particular areas of detail, including pools of light on the ground. Ale, and sometimes Carlos with him, benefits on several

occasions from rim lighting, a glow appearing around parts of his figure as a result of back lighting.

On one occasion, this effect is combined with an aesthetically pleasing effect created by the presence of an array of street and other lights reflected in one of the huge puddles of water that characterize the unmade roads around which the auto-repair shops are located (this was also a deliberately confected aesthetic, heightened by a rippling effect created by the riding of bicycles through the water shortly before filming[25]). A warm golden glow is particularly prominent in night interiors in the quarters shared by Ale and Isamar, produced by a concealed light above their bed, shed onto the cheap wood paneling of the room and giving luminous qualities to their skin.

Such qualities are produced on some brief occasions in *Man Push Cart* – the glow of lights on a wet road surface, the gleam of reflections on the diamond-patterned metallic skin of the cart, blurring out-of-focus lights in the background to street exteriors – but to a considerably lesser extent than in its successor. *Goodbye Solo* also exhibits a tendency towards the generation of quite warm brown tones in its night-time exteriors, Solo often being lit softly and with highlights on one side of the face as he drives his cab. Any such aestheticization is almost entirely absent from Reichardt's *Wendy and*

20. Heightened aesthetics: Reflected lights and rim lighting of the central character in *Chop Shop* © Big Beach

Lucy, however, with one or two exceptions: the opening sequence, a long slow travelling shot of Wendy and Lucy in which extended shafts of late sunlight glow on parts of the surrounding grass and trees; and the scene in which Lucy uses a phone box to call the home of her sister, the image here having a slightly blueish tint, accompanied by blurry lights out of focus in the background.

Sound and the use or absence of music also contribute importantly to the realist and other formal qualities of the work of Reichardt and Bahrani. It is the guitar-led music of Yo La Tengo – gentle, slowly building, contemplative – as much as the visuals that gives the travelling sequences of *Old Joy* their more expressive and atmospheric qualities, and that signifies something rather different from the more realist formal tendencies of most of the films considered here. The conventional use of non-diegetic music (music not generated from within the fictional space of the film) can be a source of controversy in both documentary and fictional features that lean towards the realist end of the spectrum, its chief role usually being to encourage a particular emotional reaction on the part of the viewer. If such a reaction is merited by the on-screen events in themselves, the use of music can seem unnecessary and excessive; if not, it might be interpreted as an unwarranted external imposition on the material or a case of special pleading.

Man Push Cart, for example, employs a mournful theme at quite regular intervals to underline Ahmad's state of mind, first used some 17 minutes into the running time and shortly after a conversation with his father-in-law which confirms that he has not been able to see his son for the past three months. The music, one main theme and another variation, has sad, bleak and lonely connotations and seems very conventional in its usage, one of the more mainstream aspects of the film, even if relatively low-key by comparison with Hollywood-style melodrama (in its literal sense, of music-drama). In *Chop Shop,* Bahrani appears to have felt no need to heighten the material in this way, as is also the case in *Goodbye Solo*, with the exception of some music played diegetically on Solo's car radio. Musical accompaniment is also absent from *Wendy and Lucy*, as is perhaps unsurprising in the context of its general commitment to a lack of any formal heightening devices, with the exception of some

quiet humming on the part of Wendy and the background Muzak in the store. The first of these instances is an interesting one, however, particularly as used early in the film, in the first sequence in which Wendy herself appears. This is a distant shot, the one in which Wendy is walking with Lucy through a sunlit area with a background of trees. Her voice is audible in the background, speaking to the dog, while the humming is in the foreground, clearly not exactly contemporaneous, and the nearest the film comes to offering music as a more expressive accompaniment (its tenor being warm and gentle, but also hesitant and fragile).

The quality of more general background sound is another signifier of the particular modalities in which these films operate. The sounds of birds in the trees and of running or dripping water in the hot spring sequences of *Old Joy* seem realistic enough in themselves, but are put into the foreground along with the cutaways considered above in a manner that gives them a more expressive effect. More standard *vérité* effects, or outcomes where they might not consciously be designed for their own sake, are found in other examples. Background traffic tends to be loud in the mix in the street scenes of *Man Push Cart*, *Chop Shop* and *Wendy and Lucy*. This is partly a reflection of the foregrounding of passing traffic on many occasions in the visuals, the sound perspective reflecting that of the image. It can also be the outcome of the practicalities of low-budget location shooting, in which the control of sound can be a greater problem than that of the visuals.

When Ahmad is buying the toy for his son in *Man Push Cart*, for example, with the camera watching from across a busy street, the dialogue exchanged is almost entirely inaudible; whether or not this is a deliberate confection, in a bid for an impression of documentary-incompleteness, or the result of the exigencies of shooting such a sequence with non-professional performers and in guerilla-style conditions, remains unclear and does not really matter to the effect that results. The opposite technique is also used by Bahrani on other occasions, including some sequences in *Chop Shop* in which Ale and Carlos are viewed at a distance from the camera while their dialogue is audible in close-up form, the sound perspective being reversed. This could, again, be the outcome at least in part of practical factors

involved in capturing detail while shooting amid the ongoing activity of real-world environments, although Bahrani has suggested that all of the background sounds heard in this film were the result of deliberate choices made during post-production.[26]

Life on the margins, indie-style

A clear marker of the indie status of these films, and of their specific location within the broader indie sphere, is the portrait they offer of particular social realms, the outcome of both the milieux in which they are set and the manner in which this is handled (the latter, of course, including the formal qualities examined above). There is an element in each film of documenting, one way or another, a certain side of life in the contemporary United States that is not usually embraced, if acknowledged at all, in work situated closer to the mainstream, one that exists well beyond the generally comfortable, white middle-class world of mumblecore. This is particularly the case in *Wendy and Lucy*, *Man Push Cart* and *Chop Shop* and to a somewhat lesser extent in *Old Joy* and *Goodbye Solo*. As in most of their dimensions, however, there are limits to how far these might be described as works of radical difference, as far as their broader social, political or ideological implications are concerned. In this as in other respects, they occupy a position of relative difference, partly as a result specifically of their location as features that can in some respects be situated in relation to the wider dynamics of indie and art cinema as recognized and institutionalized forms.

Wendy and Lucy was welcomed by some critics as a work that seemed timely on release, as suggested at the start of this chapter, its opening coming a few months after the initial 'credit crunch' that led to the damaging recession and job losses of 2009 and after. The genesis of the film was directly related to real-world socio-economic events, although not those of its period of release, which would have been impossible given the time involved in the filmmaking process. Reichardt and Raymond conceived the project in the context of the aftermath of the devastation and homelessness created by Hurricane Katrina in 2005. In this light, the concept has been framed by Reichardt as a fictional test of one of the most fundamental of

American–capitalist ideologies: the notion that individuals, in what-ever difficulty, can pull themselves up by their own bootstraps. As she puts it in an interview: 'Let's say you want to improve your situation and have the gumption to get out of a place and recognize that there is an opportunity somewhere else, can you just do that if you don't have any sort of financial net to begin with?'[27]

The film suggests that such an endeavour – the basis of a central strand of the much-vaunted 'American Dream' – is, at the very least, fragile, far from easy and not guaranteed success. Stated in the way Reichardt puts it, this alone is a quite radical stand, given the currency the myth has maintained in American culture. The film presents this more implicitly, but the message seems to be quite clear. Perhaps most importantly, the implication of the film is that this is a profoundly *social* matter, not just a question of the capacities of individuals. *Wendy and Lucy* does offer a conventional narrative frame, in that it revolves around the relatively heightened experience of a single central char-acter, but within this framework it implies that Wendy's experience can be taken as more widely representative. This is partly the result of the ordinary qualities ascribed to the character, as suggested above.

Wendy's fate is not ascribed at all primarily to the action of indi-vidual antagonists, despite the crucial role played by Andy in ensuring her prosecution. He remains a marginal figure whose determination to have Wendy brought to book might be attributed to youth, arro-gance and ignorance. Others with whom Wendy interacts are generally sympathetic and helpful as far as they can be, within the constraints of their own roles and/or lives, but this is limited. The most notable aide is the Walgreen security guard (Wally Dalton), first positioned as an antagonist, the requirements of his job obliging him to wake Wendy and remove her car from the store's parking lot early in the film. The guard subsequently becomes an avuncular presence, offering advice and allowing Wendy to use his cell phone in her efforts to find Lucy.

It is clear, however, that there are limits to how far any of these figures are able to go. The garage proprietor can knock a little off the price of a tow, but cannot save Wendy's car at a cost that is remotely affordable. The manager of the store where she shoplifts does not seem personally inclined to prosecute, but has no argument to overcome

Andy's narrow insistence on following the letter of the law. These are presented as ordinary decent working people who will do what they are realistically able to do, but can in no way offer anything capable of transcending the limitations of immediate practical constraints (as might be expected, for example, in a Hollywood fantasy set in anything like the same terrain). A measure of these limits is caught nicely by the final gesture of the guard, one significant enough to himself that he has to conceal the act from a woman we assume to be his current partner: the handing over to Wendy of a financial contribution – the very modest, but in this context clearly not insignificant sum of $6.

21. 'It's all fixed': Wendy and the security guard share their verdict on life in *Wendy and Lucy* © Oscilloscope Pictures

The problem, *Wendy and Lucy* suggests, is systemic rather than something that exists at the level of individuals or their behaviour. Wendy's journey is motivated by a search for work, a quest in which the film indicates she is not alone. This is addressed explicitly, and economically, in one exchange between herself and the guard. There are not many jobs around locally, he confirms. There was a mill but it closed a long time ago. 'You can't get a job without an address anyway', she comments, 'or a phone.' Guard: 'You can't get an address without an address, you can't get a job without a job. It's all fixed.' That, Wendy suggests, is why she is going to Alaska, where

she has heard that work is available. Anywhere else, it is implied, it is close to impossible for those who are excluded to find a way into the system as a result of a vicious circle in which only those already in possession – of jobs, homes and the like – are qualified to gain the basics of a stable life.

The radical nature of this conclusion, within the context of prevailing American ideologies, is perhaps qualified by the maintenance of the hope associated with the existence of a 'frontier' territory such as Alaska, in which such restrictions might not exist. That is an overly familiar American cultural trope, although not really mobilized here in a very strong or optimistic manner, especially given the extent to which Wendy is stripped of resources – car and companion – en route. The film closes with her continuing the journey, having jumped aboard the box-car of a freight train, another highly resonant and potentially mythic image, but one that seems to connote a state of desperation as much or more than one of any real hope of escape to better things. *Meek's Cutoff*, situated in more literal frontier territory, offers a comparable sense of the precarious, combined with a stoical sense of endurance, ending ambiguously with a fade-to-black at a moment of qualified optimism rather than any clear-cut depiction of survival or otherwise on the part of the protagonists.

A similar emphasis on those who live on the unofficial margins of society is found in the films of Bahrani, especially *Man Push Cart* and *Chop Shop*, each of which is founded to a large extent on the portrayal of strata usually hidden from the more affluent levels of American life. *Goodbye Solo* and *Old Joy* also seem to evoke, in their backgrounds, a sense of America in decline, particularly in the industrial landscapes through which their protagonists drive at various moments in their diegeses. The former also includes an implicit indictment of the individualist basis of American culture in Solo's comment that an elderly figure such as William would be looked after by family in his homeland, Senegal.

The experience of immigrant characters is a major frame of reference for Bahrani, along with the less clearly defined Latino background of the protagonists of *Chop Shop*. That poor and/or immigrant figures are the lead characters in his films is, as Bahrani himself puts it, 'a political statement', as he suggests is the manner in which their status is

simply taken for granted rather than commented upon as such. These figures are generally treated as ordinary/everyday characters rather than in terms of any 'colourful' ethnic qualities: 'there is no exotic food, or clothes, or dance, or music in any of the films. You do not learn about Pakistani spices. You don't learn about Latino dancing. You don't learn about Souleymane's music and food.'[28] There are some references to the significance of the very broadly 'ethnic other' status of Ahmad in *Man Push Cart*, in the context of post-911 discrimination against anyone who might loosely be associated with vaguely defined notions of the 'Arabic' or the 'Islamic'. 'You know it's getting harder for people like us these days. We have to be careful', advises one of his friends. Earlier, we saw why, one member of the group with which Ahmad socializes displaying the enormous scar left by an attacker who had labeled him a 'terrorist'. References such as these do enough to establish the context but remain very much in the background of the piece, the main focus of which is on more prosaic matters of daily life.

Any obviously imposed didactic 'morality' is also largely absent from Bahrani's films, in a manner not dissimilar to the treatment of the peripheral characters in *Wendy and Lucy*. In *Chop Shop*, for example, no real indication is given to suggest what we should make of a character such as Rob (Rob Sowulski), Ale's employer. He provides work, lodgings and the learning of a trade, and is at times, if gruff, a paternal figure. But is he not also exploiting Ale, as does Ahmad on occasion (and Mohammed in relation to the Ahmad of *Man Push Cart*)? What we should make of this is left for the viewer to decide, the impression being that all the characters are following the logic of what they have to do in their own contexts, doing what they can for others where that is possible, but only within the practical limitations of the situation.

The absence of any artificially imposed notions of good and bad, in favour of a more matter-of-fact focus on the imperatives of the everyday demands of particular regions of the social world, is another clear marker of distinction from the norms of the more Manichean Hollywood-oriented mainstream. Explicitly political discourse is also generally absent from these films, with the exception of the brief dialogue exchange cited above from *Wendy and Lucy* and the presence in *Old Joy* of voices from a talk radio show, to which Mark listens before and after picking up Kurt. The latter appears to be a

marker of a continued commitment by Mark to an alternative political perspective, although part of the content is focused on the limitations of the Democratic party as a source of opposition in the era of Bush Jr. (a clear political point is established in one sequence focused on the disproportionate impact of inflation on those living on lower incomes).

The nature of the endings of these films is clearly an important factor in their broader socio-political leanings, as has already been suggested above. None has a straightforwardly positive or upbeat conclusion, although the resonances are to some extent mixed, as we have seen. The closing tone of *Old Joy* is indeterminate. The protagonist of *Wendy and Lucy* does manage to continue on her journey but only after suffering losses and in a mood that seems bleak and uncertain. All three of the films by Bahrani are marked by the failure of the central characters in their major plot quests: the loss of the push cart, the scrapping of the van and Solo's inability to shift William from his determination to end his life. These films also suggest that their protagonists will persevere, however, and each has been shown to be both industrious and determined. Bahrani's films, in particular, seem to tread a line between gloomy realist portrayal of harsh circumstances and the maintenance of what might be seen as somewhat questionable liberal verities revolving around some notion of the 'human spirit' and its ability at least to some extent to transcend its everyday circumstances. It is not hard to see why this might be the case, but it is something of a classic liberal dilemma. Bahrani's films offer a celebration of the survival – and more than just survival – skills of their central figures, a note that seems at its strongest in *Chop Shop* and *Goodbye Solo*, Ahmad in *Man Push Cart* seeming to suffer partly as a result of his own state of depression in response to his plight. Giving such space to figures generally denied this kind of representation in American cinema, it is understandable that Bahrani should want to portray them as more than just victims of their difficult circumstances, although that is not easy to achieve without falling into a range of potential clichés.

The position of these films on such issues is directly related to their specific area of location in the wider cinematic landscape, as indie rather than more radically distanced from the mainstream and as productions that lean towards the art-cinema end of the indie spectrum.

They are not radical texts in the manner of more overtly political films such as those associated with Third Cinema, for example, a movement with roots in Cuban and Latin American films of the 1960s that sought to take up a more revolutionary position of consciousness-raising. The best example of such cinema in the United States is what became known as the LA School, established in the 1970s, particularly the work of the Ethiopian-born Haile Gerima. Gerima films such as *Bush Mama* (1976) and *Ashes and Embers* (1982), narrative features in which parallels are drawn between the plight of black Americans and victims of neocolonial oppression overseas, dramatize a process of coming to political awareness on the parts of their protagonists and are overtly didactic in their approach. The films considered in this chapter are situated more closely towards a tradition described by theorists of Third Cinema as 'Second Cinema', defined broadly as a cinema of artistic expression, both Third and Second being marked by their difference from the dominant, mainstream-commercially oriented 'First Cinema'.[29] These are somewhat sweeping distinctions that can over-simplify the range of approaches that might be found within so broad a category as 'a cinema of artistic expression', but there are certain reasonably clear points of distinction between this and the position of anything closer to the status of Third Cinema.

A widespread marker of art cinema, or art-leaning indie cinema for our purposes, is the presence of ambiguity, hesitancy or uncertainty, qualities that would not generally be seen as virtuous by those committed to a more insurgent film practice or one dedicated to more immediate aims of raising political consciousness. Ambiguity is a key dimension identified, for example, in the influential account of art cinema narrative offered by David Bordwell.[30] Exactly how art cinema should be defined has remained a subject of debate, however, the term often being used somewhat loosely to suggest a variety of less commercial alternatives to the Hollywood-type mainstream. Rosalind Galt and Karl Shoonover offer a definition similar in some respects to my definition of indie film, locating it as a category 'defined by its impurity' and occupying a space that 'moves uneasily between the commercial world and its artisanal others.'[31]

Ambiguity and uncertainty are qualities that can often be associated, quite strongly, with typically middle-class or bourgeois cultural

formations, creating the capacity for the activation of particular forms of acquired and/or inherited cultural capital to which access is limited. These are also the kinds of qualities that tend to be celebrated by more serious critics and on the festival circuit. It should be no surprise, therefore, for pragmatic reasons, notwithstanding any personal inclinations on the parts of the filmmakers, that such qualities are likely to be favoured by works for which critical and festival success are so important (or, more exactly, to be found in works that *achieve* such success), as is clearly the case for films such as those examined in this chapter. This is also a key context in which to understand the tendency towards aestheticization found in some of this work, as suggested further below.

Art cinema and 'true indies': Critical reception and consecration

The films considered in this chapter were certainly received by leading critics in the context of international art cinema as much as anything else, with numerous references to Italian neo-realism and to a range of subsequent work viewed, to varying extents, as belonging to the neo-realist or a similar heritage. The dominant reference point used in relation to Bahrani is, unsurprisingly, the work of Iranian filmmakers (his parents being Iranian), particularly from the 1990s onwards, and most prominently that of Abbas Kiarostami. This is true of his first two features, on the general grounds of style and subject matter, and in more specific relation to the suicide plot as a central dimension of *Goodbye Solo* and Kiarostami's *Ta'm e guilass* (*Taste of Cherry*, 1997). References to the minimalism of Robert Bresson are found in reviews and other coverage of the work of both Bahrani and Reichardt, specific detail including the suggestion that some sequences of *Man Push Cart* were inspired by *Pickpocket* (1959) and comparisons between the role of Wendy in *Wendy and Lucy* and the similarly eponymous protagonist of *Mouchette* (1967).[32]

A wide range of reference points are provided in a number of articles that appeared in *The New York Times* between 2006 and 2009, important sources of recognition for films and filmmakers of this kind, culminating in a high-profile magazine piece in which the work of Reichardt and Bahrani featured centrally as part of a movement

labeled 'neo-neo realism'.[33] In addition to general aspects of style and content, *Wendy and Lucy* is situated here, for example, in relation to predecessors such as the Italian neo-realist classic *Umberto D.* (1952) – 'a lost dog as symbol and symptom of an increasingly heartless society' – and *Rosetta* (1999) by the Dardenne brothers, with its focus on 'a young working-class Belgian in a state of stubborn, futile revolt against her circumstances.'[34] *Rosetta* is also reported to have inspired So Yong Kim's *In Between Days*, a portrait of the life of a Korean girl living in the United States, while Kim's second feature, *Treeless Mountain* (2008), drew on the Japanese production *Dare mo shiranai* (*Nobody Knows*, 2004). The web of connections identified here, and the overseas origin of some of those involved, has been viewed as marking a degree of internationalization or globalization of this part of the indie landscape.[35] This is not to suggest that 'American' indie film has ever been an exclusively or one-dimensionally American phenomenon in all respects, the sector having often involved various degrees of international co-production or financing, not to mention the presence of overseas filmmakers and/or performers and the role of imports in the slates of US speciality distributors. It has been suggested by some commentators, however, that the indie landscape has become more complex in this respect, in at least some cases, including the presence of productions shot overseas by American filmmakers.[36]

The tone of the coverage cited above is highly positive, the connections being interpreted in the context of broader artistic inspiration and exchange, rather than negatively-coded acts of appropriation, and in keeping with more academic accounts that situate contemporary art cinema as a distinctly global phenomenon.[37] The marking of associations with canonized traditions, or the work of canonized predecessors, performs an important role in the process through which filmmakers such as Reichardt and Bahrani are recognized as significant figures in their own right, a practice described by Pierre Bourdieu as one of 'consecration', through which the value of cultural goods is created by agents such as critics and distributors within any particular field of production and exchange.[38]

This is also a key dimension in the constitution of art worlds, and of the reputations of particular artists or products, through the mechanisms identified by Howard Becker, as cited in the previous chapter.

As Becker suggests, the reputation of individual creative figures is the outcome of a sociological process, not just something inherent in the quality of a body of work; a process that depends on the existence of the range of components that constitutes any particular art world, including the roles of critical criteria, established canons and conditions established by distribution systems.[39] A similar process was involved in the critical praise – but also challenged, where this was contested – that resulted in the recognition by some influential critics of the filmmakers associated with mumblecore.

Critical discourses also consecrated the films of Reichardt and Bahrani quite clearly as part of a 'true indie' inheritance that could be distinguished from both Hollywood and the threat perceived to exist to any such notion from the Indiewood sector and the kind of production examined in Chapter 1. At a time when the studio speciality divisions were in a state of retrenchment, one of the *New York Times* features cited above referred to the work of Reichardt, Bahrani, Kim and Hammer as part of a flourishing world of 'small-scale, local, truly independent filmmaking.'[40] For *Variety*, *Wendy and Lucy* was an 'old-school indie portrait of regional American life that feels, in the best sense, as though it could have been made 25 years ago', while the *Los Angeles Times* was similarly positive in its description of the film as the 'anti-"Slumdog Millionaire"', a pointed comparison with the more flashy Indiewood-released treatment of impoverished circumstances (although a more apt point of comparison among the films considered here might be Bahrani's *Chop Shop*, which shares with the high-grossing Danny Boyle feature a focus on a resourceful child protagonist).[41] A feature interview with Reichardt in *Filmmaker* described the film, and *Old Joy*, as 'samples of American independent cinema at its strongest, arriving just when the possibility of such work seems most threatened and when audiences need it most.'[42] Bahrani's films were generally received in a similar manner, *Man Push Cart* being praised by *The New York Times* as 'an exemplary work of independent filmmaking' while *Variety* described his second feature as 'the sort of sociological study far more associated with Third World than with American movies'.[43]

Critics also offered praise for the 'beauty', lyricism and 'poetic' qualities of these films, however, alongside their approval of factors

such as subtlety, low-key narrative strategies and the 'true indie' use of minimal resources and focus on socially marginal characters. This remains an important dimension of their ability to gain the kind of critical and festival success outlined above and thereby to achieve consecration as inheritors of traditions associated with art cinema. Whether or not the kind of aestheticization found in some of this work should be seen as a factor that limits how far it can go in offering a radical alternative to the mainstream, or more mainstream indie/ Indiewood, is open to debate. Is there a problem in the aestheticization of a landscape such as that presented by Bahrani in *Chop Shop*, for example, the instance to which this question might appear most obviously relevant? Does such an approach undermine any focus on the realities of life as otherwise depicted in the film – a question variants of which might be asked of many examples of international art cinema in which depictions of poverty or life on the margins are in some instances rendered visually pleasing or to which an approach is taken that might broadly be defined as lyrical, poetic or heavily stylized (examples of which might range from some of the background landscapes and lighting employed in Walter Salles' *Central do Brasil* [*Central Station*, 1988] to the visual and narrative pyrotechnics of Fernando Meirelles' *Cidade de Deus* [*City of God*, 2002])?

A tension might exist here between the dictates of the market for international art cinema, or for the consecration of individual filmmakers, and the politics of such forms of representation. But other arguments might be made against the depiction of such realms in a manner that is unrelentingly grim (treatments that tend more in this direction might include examples such as *Los Olvidados* [*The Young and the Damned*, Luis Buñuel, 1950] and *Pixote* [Hector Babenco, 1981]). There is nothing in the use of visually pleasing images that inherently and inevitably undermines a critical political stance, in some kind of zero-sum game. It might be a way of figuring some sense of human or collective warmth and strength among characters, for example, as seems to be the case with some of the lighting in *Chop Shop*, or more generally contributing to the figuration of something other than a one-dimensional portrait of dispossession.

Any 'prettification' of such locations designed primarily to sell into a particular marketplace, as a 'sweetening of the pill', might appear to

be a suitable object for suspicion. But we should also be aware of the range of implicit value judgements involved in the denigration of the supposedly 'seductive' qualities of the visually pleasing image, a recurrent theme of western aesthetic and film theory the roots of which are traced by Rosalind Galt to a conjunction of patriarchal and Orientalist discourses. Galt identifies a widespread tendency to assume that attractive imagery necessarily undermines political critique, rather than being able to contribute to it, the latter being what she suggests is the case in a number of examples including *Cidade de Deus* and the work of Derek Jarman among others.[44] The puritanical dimension of some conceptions of the 'true' indie might be included within the broader complex examined by Galt, a central thread of which in post-war film theory and art cinema is associated with the valorization of either stripped-back neorealism or austere modernism as opposed to the visually rich, decorative or stylized.[45]

In the characterization of the occupants of materially impoverished worlds, an alternative might be presented between the entirely downbeat and realistic, on one hand, and the fairy-tale upbeat, on the other. One of the strengths of Bahrani's films appears to be their ability to tread a path somewhere between these extremes, as does the avoidance of sentimentality found in Reichardt's *Wendy and Lucy*. Michael Rosenberg makes a case for the development in fiction of a 'slum aesthetic' in which such locations are figured fully and roundly, rather than in one-dimensional terms, an argument that can be applied up to a point to *Chop Shop*, although Rosenberg's use of the term includes a more complex articulation of the economic, political and geographical dimensions of such territories:

> the slum aesthetic seeks to balance the beautiful with the ugly,
> the pleasing with the disturbing, and, perhaps most importantly,
> the dignified with the pitiable. This balance is crucial to the
> presentation of slums as slums – disadvantaged problem places
> with suffering people who in some sense or another, need help –
> but also as places filled with fully human people and legitimate
> ways of life which cannot and should not simply be blotted out
> by more affluent and 'legitimate' conceptions of the city.'[46]

The result, for Rosenberg, is that such a process can help us to imagine slum dwellers as potential subjects rather than just as objects of pity. This much is certainly applicable to *Chop Shop* and aspects of some of the other films considered in this chapter, although a distinction can be made between the manner in which the protagonists are characterized and aestheticization at the level of beautiful/lyrical/poetic audio-visual forms. The fact that the one does not necessitate the other is demonstrated by a comparison between an example such as *Chop Shop* and Reichardt's much more plainly shot *Wendy and Lucy*.

5

The desktop aesthetic: First-person expressive in *Tarnation* and *Four Eyed Monsters*

Highly expressive and taking full advantage of the panoply of inexpensive audio-visual effects available to the contemporary micro-budget digital filmmaker, the films examined in this chapter mark a return from the neo-realism of Bahrani and Reichardt to something closer to the more private/personal worlds associated with mumblecore. *Tarnation* and *Four Eyed Monsters* have the appearance of distinctly quirky one-off productions in some respects but can also be viewed as representative of wider potential in their use of a digital desktop aesthetic, the product of a variety of filmmaking in which post-production effects can be created on non-professional-level personal computers, and its employment in the expression of autobiographical and often highly subjective material. Both films set out to document real events in the lives of their protagonists. *Tarnation* is an account by Jonathan Caouette of his own experiences, partly refracted

though those of his mother, an apparent victim of repeated and unnecessary electric shock treatment, and her parents. The fabric of the film is an often densely textured mix of old 'home movie' footage, reconstructions, image manipulations and extracts from a variety of other film and television sources. *Four Eyed Monsters* offers a reconstruction of the troubled romantic relationship between its two creator-principals, Buice and Crumley, including their process of documenting the experience in digital video and other artistic media. Both titles gained critical attention for a combination of extra-textual reasons – the use of social media and other online resources in the case of *Four Eyed Monsters*, as examined in Chapter 2; the eye-catching nature of the initially reported budget of $285 for *Tarnation*, along with the fact that it was home edited on the standard iMovie consumer software provided with a Macintosh computer – and their striking use of an assortment of expressive effects on-screen.

A key dimension of each of these productions is the distinctive texture created by the digital medium, the expressive potential of which is closely linked in these cases to its affordability. Digital video has a number of appealing qualities for the low-budget indie film-maker, as suggested in some of the preceding chapters, even if it is still viewed as a second-class format by many devotees of celluloid or as an option forced upon some only by economics. It can be used in a very small-scale form of production that has the benefit of both little cost and low impact on the shooting environment. It can also have some particular expressive qualities of its own, both in the pixellated texture that results from some usages and the many ways in which it can be manipulated during post-production. Some of the latter effects, a number of which are employed by Caouette in particular, are specific to the digital format and could not conventionally be created on celluloid. Many others would simply not be affordable on limited indie budgets or require time and access to other resources that would not be practicable.

A number of indie filmmakers have put aspects of lower-grade digital quality to expressive effects, examples I have considered elsewhere including Harmony Korine's *Julien Donkey-Boy* (1999), Hal Hartley's *The Book of Life* (1998) and Miguel Arteta's *Chuck and Buck* (2000), not to mention the high profile use of lo-fi Hi-8 video

as one of the two visual sources in *The Blair Witch Project*. A key influence on the take-up of DV in the American indie sector in the 1990s was its use under the umbrella of the Dogme 95 movement, launched by the Danish directors Lars von Trier and Thomas Vinterberg, especially in the latter's *Festen*.[1] The more expressive qualities of the medium have also been exploited by other established European filmmakers associated with the art-house market, including Jean-Luc Godard in *Eloge de L'Amour* (*In Praise of Love*, 2001) and Peter Greenaway in a number of works including *The Pillow Book* (1996) and the various elements of his *Tulse Luper Suitcases* project (2003–c2008). Greenaway, in particular, has sought to take advantage of the potential of the computer desktop in post-production as an arena in which to offer composite, multi-layered imagery in which the attention of the viewer is likely to be drawn to the process of construction, the latter a quality shared in some ways by the two films at the centre of this chapter.[2] The use of digital video has as a result gained resonances that mix those of the ultra-cheap and a style sometimes associated with unvarnished realism (as in most cases of mumblecore) with those of a more experimental variety of art cinema.

The analysis of the films examined in this chapter begins with consideration of their narrative structures and the bases of composition within which their expressive qualities are located. The latter are then examined in detail, followed by an exploration of where exactly these and other dimension of the two works are as a result positioned in the wider film-cultural landscape – including their relationship with other realms such as those of the avant-garde and the more commercial world of music video – and the broader social context of their articulations of individual subjectivity.

Narrative, structure, composition

Both films are to some extent structured around quite conventional narrative frameworks, as is the case with all the films considered so far in this book. These are focused, in typically mainstream/classical style, on a small number of central individual characters and their experiences/goals/achievements/frustrations. *Four Eyed Monsters* has

something in common with the romantic comedy genre, although it deploys such tropes in a distinctly indie-quirky manner at the level of both the nature of the relationship between the central couple and the manner in which it is evoked, the emphasis being put on the difficulty, awkwardness and discomfort of such experiences. *Tarnation* offers a narrative familiar in its focus on individual autobiographical experience, albeit again marked by the distinctly quirky-unconventional nature of the central character (one of the highlights of which is footage from his unlikely-sounding school production of a musical version of the David Lynch film *Blue Velvet* [1986]). In these respects, both films fit solidly into the realm of established indie convention: the use of underlying templates that are familiar from more mainstream film or other cultural products but given a particular kind of twist via both the nature of the central characters and some of the formal strategies through which this is expressed.

Each of these features is quite conventional in its outline structure, largely chronological and linear, although other currents also run beneath the surface, especially in the case of *Tarnation*. *Four Eyed Monsters* begins with a familiar individual-centred narrative trope in which the focus of attention shifts from the more general to the specific; from an array of overlapping voices, places and figures to a close focus on the two central characters. A sequence involving head-and-shoulders portraits of numerous couples leads into a figuration of the desire of Crumley to find a partner of his own, comically rendered through details such as a fantasised embrace in a launderette and disparaging vignettes from his three previous sexual partners. Crumley and Buice are introduced separately, she largely through the compilation of her own entry on an online dating site, another entirely conventional narrative device, an initially parallel structure designed to create a clear expectation that the pair will at some point become romantically or romantic-comically involved.

The two eventually arrange to meet at the restaurant in which Buice is employed ('artist in theory; waitress in practice'), an avowedly quirky impression being created when Crumley (in garish yellow-and-blue baseball cap and big shades) gets cold feet and ends up in comically furtive pursuit of Buice with his video camera instead. Having followed her home, he posts some of the images to her

computer, to which she reacts positively and proposes a meeting of some kind that could do justice to the unconventional nature of the 'stalking' experience. Fantasy sequences of such an 'anti-date' follow, including one in which she kicks a football past his feeble efforts in goal (shades of *Gregory's Girl* [1981]) and another in a church. Crumley proposes a no-speaking rule, to the accompaniment of an animated depiction of two faces exchanging typical first-date banalities about preferences in movies (with an indie twist in references to Steven Soderbergh's *Schizopolis* [1996]), after which we see their actual coming together in a desolate stretch of wasteland in Brooklyn.

This is one of a number of occasions on which the film appears to be both playing with and still enacting some of the central conventions of romance or romantic comedy. The comically-coded fantasy inserts – including an earlier one in which the pair do meet at the restaurant and utter mutually agreed conclusions of 'no' – imply an ironic distance from more familiar convention, in relation to both Buice and Crumley's attitudes as characters and the manner in which these are enacted in the text. But *Four Eyed Monsters* then proceeds to establish something much closer to the standard form, albeit with an off-beat register, as Crumley and Buice arrive at the destination for their date, sitting together at the water's edge in a region of decaying old commercial piers facing across to the Manhattan skyline. The setting is romantic in its own 'alternative' way, when compared with the many more obviously established romantic landmarks of New York City, increasingly so as a time-lapse sequence, one of many employed in the film, takes it from daylight into night. The marked quirkiness of the sequence is located primarily in the absence of speech, instead of which the two communicate through comments written in a large yellow lined pad, subsequently employed as the ground for a number of line-drawn animations (themselves quirky in the same kind of lo-fi manner as the credit sequence from *Juno* examined in Chapter 1) used to illustrate and dramatise the background stories related by each in turn, including her experiences during a period living in Italy and his playing in a band and founding his own video production business.

The animation climaxes with a number of abstract patterns that follow the image of two hands joining together, another part of the sequence that suggests a conventional kind of bonding between the

pair. This is further established in following scenes, including one featuring the two at his apartment, surrounded by scribbled writings on post-it notes, and an expressive sequence involving romantically-coded footage of clouds, sunsets and pigeons taking flight. A moment of crisis then intervenes, another standard device in romantic comedy or many other narrative templates, in which Crumley makes a discovery in the shower that leads him to an STD clinic and a diagnosis that drives the newly established couple apart and into various mutual accusations and recriminations. Buice eventually leaves the city to take up a period of residency in an artists' community in Vermont, during which the two communicate, primarily via digital videotape. Eventually she returns, having been declared 'clean' via a blood test. The relationship appears at more than one point to be re-established but this proves to be on shaky ground, Buice accusing Crumley of seeking to control her through the no-talking rule.

The film ends with the status of the couple uncertain, along with reflexive matter such as references to the completion of the production and its acceptance into the Slamdance festival. The final scene has each giving the other a haircut, moments of intimacy that seem balanced by preceding scenes of tearful conflict and tension. The resolution, or its absence, seems typically indie in character in its commitment to the depiction of the difficulty and awkwardness of real-life relationships, a clear marker of distinction from the fantasy ending more typical of Hollywood romantic comedy, and its combined use-of and distance-from more straightforward genre convention.[3] A common characteristic of many indie or Indiewood products is to offer irresolution as a way of keeping open the possibility of a happy ending while avoiding the danger of cliché that might come with its explicit enactment, although in this case it appears also to be a product of the state of the real relationship between Buice and Crumley at the time. The second series of podcasts related to the film, created after the feature, traces the process leading to the eventual breakup of the relationship.

Tarnation opens with a dream-like montage of sounds and images – of figures that prove to be Caouette's mother, initially singing a religious song, and grandparents, of greenery as viewed from a train, of Caouette himself on board – the precise location of which is

unclear at the time. A fade to black is followed by a title that establishes a concrete time and place (New York, March 2002), after which a sequence involving Caouette and a male partner leads into another in which he is researching lithium overdoses online and then manifestly upset. The nature of events becomes clearer, after another fade to black, when he is viewed on the phone seeking an update on the status of his mother and asking about the repercussions, establishing the fact that she has been hospitalized by an overdose. A sustained number of travelling shots follows, these and various other audio-visual effects, coupled with an earlier reference to Caouette 'leaving', suggesting a journey home and that this is what was figured more obliquely in the opening sequence.

At this point, after beginning *in media res*, first somewhat poetically and then with the sketching of a more grounded emotional and personal crisis, the film shifts partially into a more clearly narrative-based mode with the first in an ongoing series of written titles presented across the middle of the screen. In a deadpan manner that only emphasises the appalling nature of some of the material, these relate the stories of the lives of Caouette and his mother, Renee, beginning: 'Once upon a time in a small Texas town/in the early 1950s.' We learn of Renee's early stardom as a child model and then of a defining moment in her life when, aged 12, she fell from a roof, landed awkwardly and was paralysed for some six months. Her parents, the titles relate, began to think the paralysis was 'all in her head' and took the advice of a neighbour who recommended electric shock treatment. This was performed 'twice a week', a title informs us, a delay until the next line of text increasing the impact of the revelation that this occurred 'for two years', the start of what became a lifetime of psychiatric treatment for which the film suggests there was no initial justification. A number of further traumas form part of the dramatic core of the narrative, as recounted through the titles, including: the rape of Renee in front of her son during a trip to Chicago; a period of two years spent by Caouette as a child in foster care, during which time he was subjected to 'extreme emotional and physical abuse'; and a later incident in which he smoked two marijuana joints unaware that they had been laced with the hallucinogenic drug PCP and dipped in formaldehyde, the result of which was that he suffered

a depersonalisation disorder that involved recurrent episodes of feeling detached from himself and unable to concentrate.

A chronological time-line is established during the bulk of the film, eventually catching up with the events of March 2002 and their immediate aftermath. At the level of its narrative content, then, *Tarnation* exhibits a number of quite conventional features, particularly for individual-focused documentary productions, in its focus on melodramatic/traumatic and larger-than-life events of the kind outlined above. To sketch such an outline is only to capture one dimension of the film, however, much of which is comprised of material that seeks to evoke the subjective nature of Caouette's life experiences rather than merely to relate them in narrative form. Something similar can be said of the broader texture of *Four Eyed Monsters*, although to a lesser degree that results from the different nature of the raw material from which it is constructed.

The manner in which they were composed is another level on which these features depart from mainstream norms, neither, according to the filmmakers, having been written or designed from the start in a sequential manner. The assemblage of Caouette's various sources of footage was in many cases orchestrated to the music employed in the film, to favourite songs from his own CD collection. This is a key aspect of the subjective nature of what the film seeks to express. The aim, Caouette suggests, was to convey through montage sequences what the music was evoking for him at an emotional level in relation to the events of his life, examples of which will be examined in detail below. A repeated refrain in his commentary on the DVD release is that the structure of the film was not pre-planned, but effectively 'composed itself', in his experience of the process, as a result of this overriding subjective imperative. Caouette reports a number of abortive plans to have employed his footage within a fictional frame (one version ending with him in heaven after being shot by his grandfather), as a device through which to gain more distance from the material. The first cut of the film, the version shown in its initial festival appearance, ran some three hours in length and included a number of additional subplots involving other members of the family, before a final decision was made to focus more closely around the footage relating to himself, his mother and his grandparents.

Four Eyed Monsters evolved from a number of products created by Buice and Crumley during the early stages of their relationship when, as re-enacted in the film, they agreed to communicate only through media such as writing, drawing and video recording. They decided to develop such materials into a narrative feature, beginning with a one-page outline and what they describe as a series of 'very crude' storyboards. A number of sequences were then shot and only at that stage was a script written, from which point more collaborators were involved and the production process became more sustained.[4] In both cases, the films offer a combination of linear narrative material, as outlined above, and more expressive and stylized sequences that exploit the particular formal potential of the digital medium.

The existence of two such dimensions is most evident in *Tarnation*, in the separation out of the task of explicit narration into the domain of the externally imposed titles. These are couched in a distanced and 'objective' register, phrased in the third person, that stands in contrast to the more subjective first-person tone of the principal audio-visual fabric. The third-person component might be taken as a portrayal of something like the depersonalisation suffered by the film-maker: his own expression but one that offers the detached position of an outside observer, part of the definition of the condition described in the film. A recurrent strategy of *Tarnation* is to evoke events first, as in the case of the opening sequence, and only afterwards to spell them out explicitly in the titles. The titles serve effectively to ground the more expressive sequences, many of which are quite densely textured and might otherwise remain opaque to the viewer. Without the titles, the film would lean further towards the avant-garde end of the independent film spectrum, a domain in which a first-person approach towards subjective material predated its more widespread use in documentary, an issue to which we return below. In *Four Eyed Monsters*, the process of narrative exposition is more closely interwoven with the articulation of expressive material, expressive sequences tending to play a substantial role in the development of narrative events relating to the shifting status of the relationship between the central characters.

Desktop expressionism

Tarnation

One example that illustrates how this process works in *Tarnation* is the five-minute sequence focused primarily around the drug experience that led to Caouette's depersonalisation disorder. It begins with a white-on-black title establishing the date (1986) of the events. The sound track begins with a voice, probably that of Renee, singing in a thin, hesitant register, underlain by a quiet extradiegetic guitar accompaniment, to what appears to be period colour home-movie footage: two bluish-tinged travelling shots of passing suburban houses, followed by a yellowy-white close-up of the staring eyes of a face. The remainder of the sound is dominated by a voice clearly locatable at this point, some 22 minutes into the film, as that of Caouette himself, a quite distant sounding lo-fi audio recording made during his stay in hospital for treatment after smoking the adulterated marijuana.

The recording offers a rambling, sometimes tearful account that includes references to various aspects of the past life of himself and his mother (her schizophrenia, the incident in which she was raped in front of him), comments about his own gayness, and what at the time remain quite oblique references to the drug incident and its effect on his state of mind. The visuals seek to give expression to the subjective experience of such events. In some instances, the connection between commentary and visuals seems literal and explicit. At one moment, for example, the audio refers to Renee's fall from the roof of the family home, accompanied by a low-angle shot looking up towards the top of the building. For the most part, however, the effect is marked as more poetic and impressionistic.

A detailed recounting of the various elements that comprise a sequence such as this only goes a limited way to evoking the overall effect that results, the latter being more than the sum of its parts. The components of this passage include many shots of Caouette himself, a combination of what appear to be reasonably objective sequences from this period of his life and other footage to which more obviously expressive dimensions have been added through treatment or

manipulation of the original material. The former includes a number of extracts from a sequence shot in and around the garden of his childhood home, in which the teenage Caouette wears a blue shirt and white trousers. These appears quite early and are used more extensively in the later stages of the passage, often held significantly longer than some of the more rapidly cut elements of the piece. This component seems, as the passage develops, to provide a kind of ground against which to set the more obviously expressive material.

The latter includes many shots in which the image quality is affected either by age and original poor quality (highly grainy, flecked with damage spots) or has been subjected to various forms of manipulation on Caouette's iMac. Many of the shots are more or less subtly tinted in a range of tones, while the director also makes periodic use of what he admits to have been his favourite feature in the iMovie software, the 'in-square' facility through which images can be replicated in numerous grid-works of squares across the screen. The impact of effects such as colour tinting is one of the many dimensions of the image quality that tends to be broad and cumulative rather than easy to tie down to particulars. It may in some cases just be a way of giving more visual interest to relatively poorly defined old footage but also seems to function in a more motivated manner to help convey qualities such as memory of past events and some of the altered states of mind implied by the context in which many of the images are articulated.

One highly-grained shot features the teenage Caouette from the naked waist up, performing to the camera, the image quite strongly tinted in shades of blue and red. The accompanying voice-over relates post-drug experiences, the nature of which have not yet been spelled out to the first-time viewer, including forgetting what it was like to be 'normal'. A moment of more literalised expression follows in this instance, as Caouette's figure disappears from the fleeting remainder of the tinted frame, as if dramatising the experience of depersonalisation or loss of self. The red and blue tint does not seem directly to express any particular quality but takes its place within the sequence as one of many impressions involving the stylisation or distortion of images of the subject.

This is one of numerous fragments in this and other expressive sequences that draw on footage of Caouette's impromptu youthful

performances to camera, a dimension of the film that has by this stage been introduced to the viewer. The melodramatic, sometimes histrionic nature of these adds to the impression of conveying a broader state of emotional upset or confusion, further heighted in some cases by a frenetic speeding up or slowing down of the action. We see, at various moments in this sequence, Caouette emoting direct to camera or via his mirror reflection. In one case he poses, wearing an outsize jacket and smoking, intercut with images including a syringe being inserted into an arm and blood subsequently flowing from the incision; this is also combined with a series of shots of Renee, presumably from the same period, and one image of his figure in front of a bright, sun–like source of light.

Additional elements that add to the expressive qualities of the sequence involve other fragments that are not always easy to identify, especially on first viewing. These include a series of bloody extracts from one of Caouette's underground–influenced Super 8 films, the existence of which have not at this stage been explained, deployed in the latter stages of the section described immediately above. At its most stylized and expressive, the sequence employs a number of more overt manipulations of the image. One quite disturbing example comes close to the start, in which another naked waist-up portrait of the teenage Caouette is subjected to a distortion that creates the demonic or tortured impression of two faces on the same head, an image that, although fleeting, seems to resonate with the themes of personality breakdown relating to both Renee and the subject.

Other examples involve the use of the in-square function, although it is employed with greater restraint in this sequence than in some other parts of the film. Its first use in this passage starts from an initially indistinct, high-contrast black-and-white Caouette facial image that subsequently morphs into multiples within a grid layout. The face is a highly stylised white mask, from the nose downwards, set against a black background and with a yawning black mouth that connotes some notion of personal disturbance. The image opens out into several of these in square formation before closing back inwards towards the dark corner of one, at which point a cut is made to the next image and a comment follows about PCP or LSD having 'depersonalised my mind'. A similarly stylized use of the in–square format comes at the end

22. In-square: Narrative via titles combined with stylized imagery in *Tarnation* © Tarnation Films

of the sequence, this time with a very grainy image of the filmmaker's teenage head and shoulders framed in red light and surrounded again by black. The head is multiplied four times and the speed increased, the image drawn from another bout of youthful melodramatics.

At this point, the sequence morphs into the distinctly different register created by the provision of a series of titles that sets out clearly and explicitly the sequence of events that led to the depersonalisation experience. There is not in this case a complete separation of narration and expression, some elements of the former being conducted in the preceding section through the medium of Caouette's original audio recording. This reiterates some events that have already been narrated through the titles earlier in the film, including references to elements such as Renee's mental health and the rape witnessed by Caouette. This part of the sequence is untypical of the more expressive portions of the film as a whole in the presence of such a contemporaneous and subjective commentary from the filmmaker, although the referent for much of the material is unlikely to be clear to a first-time viewer. A significant expressive dimension also continues in the narrated passage that follows.

If Caouette's strategy is to use favourite passages of popular music as the emotional glue for many of the expressive articulations of his various sources of footage, this is often done in conjunction with the titled sequences, as is the case on this occasion. A transition occurs during the part of the sequence intercut with the red-tone squared images of Caouette, juxtaposed here with further shots of him posing in the outsize jacket and sounds of his distress on the audio track. The only musical accompaniment to the sequence up to this point has been the quiet background presence of the guitar theme, but here music comes equally centre-stage with the narrative titles. A building sound of drums marks the intro to Lisa Germano's 'Reptile', the full mellow tones of which wash in as a kind of balm, following distressed lines from the teenage Caouette including 'I want to die' and 'Oh God, it hurts'.

The effect is to offer a soothing full richness in the soundtrack that stands in contrast to the distanced and pained commentary that has characterised the preceding passage, the first line of the song being accompanied on screen by the four-squared red image of Caouette across which now comes the first in the new title sequence, 'Between 1987 and 1993'. For the viewer, this and the remainder of the sequence offers a much easier and more comfortable position. The titles provide a clear grounding to the visual material of both the first part of the sequence and that which follows, the latter involving more use of the four-square imagery, one part of which has an agonized-looking Caouette seeming histrionically/performatively to cut himself in front of a mirror, intercut with various shots including parts of sequences used beforehand and culminating in a rapid montage as the full nature of 'depersonalisation' is set out in dictionary-style definition across the whole of the screen.

It is likely to be much more explicitly clear, in this phase, what the imagery might be expected to signify, with some specificity in this case, once the nature of this particular experience has clearly been explained. The music also offers a kind of relief in its own right, in its lush seductively haunting tones, giving the viewer the space to sit back and allow the pieces to fall together – a combination of the hints provided up to this point and that which is spelled out in writing across the screen – rather than having to work harder to assemble a meaning from the fragments. Caouette himself suggests that the 'almost out of synch' beat of the song helps to convey musically the symptoms of depersonalisation he seeks to figure visually and though the combination of sound and image.[5]

In his most explicit attempt to explain the basis of the film's aesthetic in his DVD commentary, Caouette cites an incident when he was nine years old and ill and awoke from a dream with an awareness of having occupied a state somewhere between wakefulness and sleep. He describes this as a brief moment of epiphany, a lost state of insight that cannot be recovered from the fragments that remain afterwards. This is the experience he says he is seeking to transpose into cinematic terms, much like the more general attempt to grasp the fleeting impressions of a dream. Such an explanation might also apply to the experience of the viewer – and maybe more especially those seeking to break down and analyse the effect in academic work of this kind.

It is difficult in words to convey a sense of the overall impression created by individual sequences as they break down and recombine various aspects of the footage used and manipulated by Caouette. The effect is to create an emotional impact greater than the sum of the individual parts, as suggested above, a process that seems quite successfully to enact in reverse something like the experience of seeking to recover a lost moment of epiphany. Here, instead of fragmentary impressions being left over in an entropic state after a dream or the experience of an in-between sleep/wakening state, the fragments are brought together in heighted expressive passages that seek to offer emotional epiphanies to the viewer, even if the exact nature of what they signify might not easily be spelled out in literal-prosaic terms. These moments tend to be those in which the music plays a central orchestrating role, much as 'Reptile' does in bringing together and helping to express the feelings generated by the sequence outlined above. Caouette cites as a good illustration the material in play during this part of his commentary on the DVD, one in which the musical signature is provided by a plaintive rendition of 'Frank Mills' from the musical *Hair*, lip-synched by his teenage self in one of the various components of a three- or four-way split screen. The 'Frank Mills' passage follows, and borrows some earlier imagery from, a section of the film in which material from the Caouette family archive is intercut with a variety of extracts from film and television. These include scenes from *Rosemary's Baby* (1968), *The Little Prince* (1974), *The Best Little Whorehouse in Texas* (1982) and a number of children's television programmes. This Caouette describes as his 'television mythology segment', one he explains as establishing a number of connections he made with his mother and grandparents through ideas gained from such products.

How these elements figure and function, specifically, within this passage is far from always clear. With the benefit of Caouette's commentary, we might agree that the performer Ruth Gordon in *Rosemary's Baby* bears a resemblance to 'a slightly more swanky, East Coast version' of his grandmother. A reverse angle from the first clip from the film situates Caouette as if watching it on television, a device maintained in some of the further extracts that follow. If the link with the grandmother is made by the viewer, the creepy impression of a red-toned scene – in which a naked group, including the character played by Gordon, gathers menacingly around a subjectively located camera – might be increased, particularly given the implication of Caouette's film at this stage that the grandparents were to blame for the inappropriate treatment of his mother (later being subject to further accusations of abuse). The voice of the Gordon character continues to play, in a whispery menace overlapped with other fragments of dialogue, across subsequent imagery, including various shots of Caouette. A viewer familiar with *Rosemary's Baby* might understand Caouette's figure effectively to have been substituted here for that of the victimised eponymous heroine of the earlier film; otherwise, a more diffuse impression of menace and discomfort is offered.

At this point a somewhat incongruous shift occurs into a sequence in which Dolly Parton sings the upbeat title song of *Best Little Whorehouse*, from which cuts are made to material including musical sequences from two children's television programmes, the tones of which are marked as those of youthful *naïveté* and exuberance. A darker impression is created, however, by the insertion of fleeting imagery in between these and an assortment of further extracts that follows. The other clips offer a mix of light and dark material, the latter including sequences from a documentary about the Jonestown, Guyana, massacre of 1978 and footage from at least one low-budget horror movie. Each cut from one to the next is accompanied by a harsh sound effect and the insertion of little more than a flash-frame, a still image of Caouette's grandmother – a cold, blue-toned visage like that of a death mask – overlain at the point of cutting with the impression of a television interference pattern; a presence that seems to haunt this part of the sequence.

The sum effect of this passage is to create an impression of youth – the youth of Caouette – over which hangs a variety of disturbances and potential threats. The literal significance of some elements is

liable to remain unclear. What motivates the presence of the extract from *Best Little Whorehouse* might be taken at this stage to be a general campiness sometimes associated with Parton, although a more literal explanation appears later in the film, when we see Renee singing part of the same song to Caouette's camera. The deathly image of the grandmother, Rosemary, also returns later, in denotative and less impressionistic form, in a sequence that explains her appearance in the context of the aftermath of suffering a stroke. A lighter note is added to the latter part of this segment as the titles tell of Caouette's repeated fantasy in this period of being in rock musicals such as *Hair* (motivation for the choice of music to follow; we subsequently discover that he also performed in a production of the musical during a more recent period as an actor) and the list of performers who would play himself and members of his family if he were to meet the producer Robert Stigwood and collaborate with him on a rock opera about his life.

23. Orchestration of fragments: Part of the 'Frank Mills' sequence in *Tarnation* © Tarnation Films

The part of the sequence accompanied by 'Frank Mills' begins with period footage of Renee and her father, Adolph, in the garden of their home. Renee dances around while the camera shifts between the two, her movements being rendered into slow motion at one point as this material shrinks within the screen, sliding upwards to become the apex of a screen divided into three, subsequently into four, components. Caouette's lip-synching image, stylized through strong lighting from below and to one side, moves in and out of the various combinations of images that occupy the different frames. This functions as a literal bringing together during the song of a number of the previous fragments, and other related images, a shift from temporal to a mixture of temporal and spatial juxtaposition in which the interplay between the various components is closer, the various potential mutual resonances more strongly developed through greater proximity.

Nothing that could really be described as a resolution of the parts is achieved at the visual level, where the viewer is still required either to work hard to try to make sense of the image patterns or to abandon any such attempt to synthesise a clear interpretation of the whole, as might be the case in many instances. The music again seems to perform a crucial role as connective tissue. As in the previous example, the rendition of the song is plaintive and longing, with a theme of loss in the lyrics, but also creates a soothing impression in its offer of an overarching emotional tone and as respite from the miscellaneous fragments of sound effects and dialogue accompanying the preceding film and television clips.

A similar role is played by the track 'Diviner' by Hex during one of the most exaggerated uses of the in-square effect, employed in the context of titles referring to a period in 1992 in which Caouette 'acted out' in various ways in reaction to his own psychological problems and the lack of structure in the family home. The raw material is the filmmaker mouthing the words of the song to camera, the image then processed into an effect in which his visage is doubled and inverted, primarily along the horizontal axis, creating a face with one pair of eyes but multiple noses, two pairs of ears and a mouth at top and bottom. This construction is then subjected to further manipulation, squeezing in from the sides and initially intercut with various other still and moving images of Caouette, some sped up and others

24. Multiplying images: The distorted features of Jonathan Caouette in part of the 'Diviner' sequence in *Tarnation* © Tarnation Films

manipulated in one way or another, before being multiplied vast numbers of times in a range of dizzying patterns and zooms in and out using the in-square facility, across which read the titles referring to his behaviour at the time. The fairly obvious connotations of the imagery here revolve around notions of fragmentation, distortion and disturbance, some of the visual effects clearly being orchestrated to the music (cuts on the beat, the cueing of some of the sweeping visual patterns to aural crescendos), the latter seeming in its own tones both to express and to offer some relief from the nature of the subjective experience the sequence seeks to convey.

Caouette offers a number of explanations in his DVD commentary of exactly what he was seeking to evoke through the generation of particular audio-visual effects in specific moments of the film. In the opening footage of Renee in her kitchen, for example, he used high brightness and contrast settings 'to give it the appearance of flickering saturation' designed explicitly to create an impression of what it was

like to watch his family through his own eyes. In the sequence that follows, featuring Renee in hospital, the footage is slowed down and accompanied by the delicate and mournful tones of 'Laser Beam' by Low 'to evoke a sort of waking-from-a dream feeling', in this case to seek to express what he thought his mother felt at the time. This effect is heightened by being intercut with the contrasting sped-up travelling footage that represents the filmmaker's journey home.

Much of the expressive power of *Tarnation* comes from the different image textures of a range of samples of old footage, treated in various such ways to create particular effects through which otherwise lower-quality imagery is given what is marked as a poetic resonance within the context established by the film. Relatively little appears to have the status of unfiltered original home-movie material, much less than might initially be assumed. In this and other related respects, *Tarnation* offers a good example of the extent to which documentary, in all its forms – whether avowedly subjective and expressive, as in this case, or making claims to the status of more objective *vérité* – remains a construct, rather than any more passive or neutral 'window on the world'.

Substantial parts of the footage of the film are not, in fact, exactly what they appear to be. The opening images of Renee are not old Super 8 but more recent Hi-8 video material run through particular effects in iMovie to emulate its appearance. The 'travelling' footage is not from Caouette's actual journey back to visit his mother at that time, as is implied, but taken from another occasion (the journey of the time was made by plane, the filmmaker explains, because of its urgency, but was not documented). The same goes for a number of other travelling shots used later in the film to represent Caouette's original move away from home to New York, footage taken not even in the United States but in Germany and Austria; imagery of packing prior to the journey was shot years later, when he was helping a friend to make a similar move. Another substitution occurs in the sequences accompanying the textual commentary about the filmmaker's time in foster care, during which Caouette's own son, a figure not mentioned in the feature, stands in for his childhood self, another example in which Hi-8 video was manipulated to resemble Super 8. In a number of instances, Caouette uses original footage of

his mother or grandmother from one occasion to stand in, either explicitly or in a broader expressive sense, for other events and experiences. A sad, blue-toned, slowed sequence featuring Rosemary after her stroke (from which the more disturbing insert cited above during the television montage was taken) functions implicitly, Caouette suggests, to evoke the experience of his mother in the months immediately following her lithium overdose, a period in which he says she suffered from complete aphasia very like that of a stroke victim.

One criticism sometimes made of films of this kind, particularly in which footage is offered of elderly or mentally incapacitated individuals in states of confusion or distress, is that they can become guilty of exploitation, of taking advantage of people who are in no state to be aware of, or to give proper consent to, being put on screen. Caouette responds to such criticism by emphasising the normality, in his life, of the behaviour that he shot and by making a distinction between his position, as a family insider, and the kind of exploitation that might be entailed if such material were produced by someone coming from outside. It is notable, however, that he did not shoot everything – again, contrary to the impression that might be gained initially by the viewer from the painful nature of some of the material that is presented. If his grandmother post-stroke is used to stand in for one experience of his mother, the reason he says is that there was 'no way in the world' he was going to point a camera at Renee at that time. As a result, a lengthy sequence that appears to represent her in this post-overdose state, one that includes business such as Renee dancing with a pumpkin, in fact utilizes footage from some two years earlier during a more routine manic episode. For much the same reason, that he would not have been able to film himself at the time, staged reconstructions are used for the early scenes involving Caouette and his partner, David, in New York at the time of the overdose.

The history of documentary is replete with controversies surrounding what is sometimes taken to be the misrepresentation of events, including substitutions of these kind or other such manipulations or reconstructions, in which literal truth is compromised in the interests of the broader ends pursued in one case or another. Notable

examples would include, but be far from limited to, the many attacks (often politically motivated) made on the avowedly provocative films of Michael Moore. From the perspective of more academic analysis, however, all such debates tend further to emphasise the *essentially* constructed (and thereby contestable) nature of documentary representation suggested above.

In the case of an example such as *Tarnation*, appeal might be made to a more 'poetic' notion of truth; one that entails the capturing of impressions that offer a means of expressing the nature of a series of experiences, rather than anything that claims the status of a literal rendition of actuality, even if any conception of underlying truth remains subject to contest and the expression in this case that taken only from one subjective perspective. It is clearly possible for meanings actively to be constructed (rather than for pre-existing meanings merely to be expressed) through the kinds of strategies employed by Caouette. The disturbed nature of a figure such as Renee is quite easily figured through devices such as the slowing down or speeding up of footage, the imposition of colour tints and the use of dark or discordant sounds, as is that of the filmmaker himself through the various strategies detailed in some examples above. There are, clearly, moral dimensions to the production of such material, but it is worth emphasising again how much this applies to documentary as a whole and not just work such as this at the more overtly expressive end of the scale.

The digital medium can be seen to have added a new dimension to questions of construction, reconstruction and manipulation in audio-visual media, documentary or otherwise, although the implications of these are in some respects easily overstated. As commentators such as Lev Manovich and David Rodowick have argued, the move from celluloid photography to digital capture entails some change in the nature of the relationship between image and reality. As Rodowick puts it: 'In digital capture, the indexical link to physical reality is weakened, because light must be converted into an abstract symbolic structure independent of and discontinuous with physical time and space.'[6] Manovich makes a similar argument about a loss of 'privileged indexical relationship to pro-filmic reality' at the point that

live-action footage is digitized or directly recorded in a digital format: 'If live action footage was left intact in traditional filmmaking, now it functions as raw material for further compositing, animating and morphing. As a result, while retaining visual realism unique to the photographic process, film obtains the plasticity which was previously only possible in painting or animation.'[7] Such an argument might be made of some of the sequences from *Tarnation* examined above, particularly those in which images have been heavily processed, creating what Manovich terms an 'elastic reality', or instances in which image manipulation has served to make one kind of footage (especially when reconstructed) appear to be something else (especially when that might appear to be more authentic or original).

Such observations can, in some more popular incarnations, lead to a kind of moral panic relating to a loss of certainty about the grounding of images in some more concrete reality, photographic images often having been assumed to gain a privileged degree of authenticity and credibility through their claims to present a direct physical tracing of the external world. Even if such a difference might exist in ontological terms, however, the fact remains that moving pictures, of all kinds, have always been a construct, offering a heavily mediated rather than anything like an immediate vision of the world. How exactly the world might be represented has always been dependent upon numerous choices ranging from technical matters such as framing, lighting and editing to broader issues affecting the perspective from which any particular representation is constructed, factors that apply to documentary as much as to fictional forms and to celluloid as well as to digital formats. The change from photographic to digital might be interpreted as one of kind, at a certain level, in the reduction of the indexicality of the image or the greater ease with which manipulation can be achieved without notice, but this should not be taken to imply the existence of any prior moment when the transition from external world to representation was ever in any way unproblematic.

The approach taken by Caouette to his material fits clearly into the category of expressive documentary defined by Michael Renov, one of what he suggests are four fundamental tendencies of non-fiction film and video.[8] Of the other three overlapping categories outlined by

Renov – 'to record, reveal, or preserve', 'to persuade or promote', 'to analyze or interrogate' – the first is also applicable to the film, part of the motivation of which appears to be to put on record the impact on Renee of her treatment by his grandparents as well as its subsequent effect on himself. Some aspects of the latter two might also apply. Much of the texture of the film lies in the expressive dimension, however, a long-standing facet of non-fiction that has tended to be repressed in documentary history in favour of claims towards the status of objectivity. All forms of documentary involve some degree of expressivity, as Renov suggests, 'some of which may appear more "artful" or purely expressive than others'.[9] Contrary to the view of Bill Nichols, that documentary is primarily a 'discourse of sobriety', Renov argues that it can also be 'a discourse of *jouissance*'; of pleasure, desire, 'even of delirium', a reading that seems applicable to our understanding of the sequences from *Tarnation* examined above.[10]

Rivalling 'knowledge effects' can be the pleasures of 'ecstatic looking', the evocative and the delirious, including the ability of the non-fiction producer to 'unleash the visual epiphany [...] that wrenches the image free of its purely preservational moorings.'[11] This, again, seems to capture a sense of what is offered by the film: a use of expressive and poetic strategies to seek to evoke something of the states of mind and emotion resulting from the events detailed in the more literally grounded dimension most clearly manifested by the on-screen titles.

Four Eyed Monsters

Four Eyed Monsters employs a number of expressive devices similar to some of those used in *Tarnation*, although generally to a lesser extent and in less exaggerated or delirious fashion. Similarities of audio-visual texture include the widespread use of fast- or slower-motion footage, rapid montage sequences, the combination of different kinds of image sources and qualities, and the use of music as a key source of the orchestration of the relationship between the various different components of its more heightened sequences. The opening has something in common with that of Caouette's film, its initial evocation of

multitudinous people/places involving a not dissimilar use of rapidly cut travelling shots and manipulations of the speed of the footage. A number of hyper-fast, time-lapse effects are included as the New York location is established: images of day shifting to night, clouds scudding fast across the skyline, people whizzing telegraphically through the streets, passing neon rendered almost abstract from the rapidly moving perspective of a vehicle; all to the accompaniment of a restlessly jangly indie-sounding guitar theme produced by Crumley and the musician/composer Andrew A. Peterson, one of Buice and Crumley's more general collaborators in the shooting and development of the film.

The following sequence employs an effect that more literally mimics the computer desktop, as the filmmakers continue to evoke the crowd out of which the protagonists will be singled. Video files of various characters appear as separate windows within the screen, one on each occasion coming to life in sound and motion in a device familiar from some of the examples of mumblecore examined in Chapter 3 (a similar effect, created with the use of Adobe Photoshop software, introduces the comically-coded passage involving Crumley's three previous sexual partners and some later material). A blurred rapidly scrolling effect is also included, to signify a multitude of potential faces and voices, after which the film homes in on the figure of Buice. More fast-paced shots follow, of people moving on the streets, a shift of register then occurring as a series of couples are isolated from the flow by being rendered in slow-motion (this leading into voice-over comments by Crumley about the nature of couples, the 'four eyed monsters' of the title).

Changes in the speed of footage are clearly motivated through these opening scenes by shifts in focus from evocations of the more general to the particular, the various uses of hyper-rapid footage seeming quite conventional in their employment to express a sense of the blurry masses populating the metropolis. Another similar effect is created through the hyperbolically rapid editing used shortly afterwards in a sequence in which Crumley is presented as being overwhelmed by the sheer number of women's voices and visages to be found on a dating website (a series of real images taken, with permission, from MySpace pages).

25. Stylized blur: Figures moving hyper-rapidly on the streets in
Four Eyed Monsters © Four Eyed Monsters LLC

Like *Tarnation*, *Four Eyed Monsters* moves between more and less
audio–visually heightened passages, although the overall mix is rather
different and the number of larger set-pieces considerably fewer and
lacking the peak of hyperbole attained in some of Caouette's in-
square sequences. *Four Eyed Monsters*, having a relatively more
narratively/generically/fictionally conventional core, devotes less of
its running time to such material, although shifts of image texture
occur quite regularly throughout. The expressive material is also sub-
stantially less densely textured and, as a result, offers considerably less
interpretive challenge to the viewer. Some of the most heavily styl-
ized and expressive passages are also quite conventional in their choice
of style and the particular signifiers employed.

The 'romantic' sequence involving the shots of pigeons taking
flight is a good example, a more extended use of the positive con-
notations of such imagery suggested in relation to its fleeting use at
the end of *Chop Shop* in the previous chapter. Here, repeated images
of the birds, lit by a low sun, are used in a rapid montage, the other
principal components of which are shots of clouds (initially, in a
number of heightened sunset colours) and footage of Buice and
Crumley on his bed, some of which is in the highly pixellated quality
of Crumley's camera-within-the-film, seen being wielded by both

characters. The latter part of the sequence builds from large close-up images of parts of Buice's face and body to oblique footage of the two making love, in the thickened texture of the pixellated visuals, the whole passage being accompanied by richly soothing synth/keyboard tones from a piece by Peterson. The sequence ends with the flock of pigeons returning to ground on the rooftop, a clear-enough signifier of the end of what is implied to have been a successful sexual union.

A similar kind of rapid montage is used some minutes later to signify what appears to be the negative fallout from the encounter, after the diagnosis of Crumley's STD. The signified in this case is a general impression of uncleanliness, including as major components images such as repeated shots of feet walking on the ground, tattered plastic bags hanging on barbed wire against the sky, various instances of garbage, flies perched on turds, a rat, a derelict building, a shitting dog and a number of perspectives that appear to have been taken through dirty glass, in this case orchestrated to the sound of a reverb-heavy 'dirty' guitar theme underlain by a number of darker elements. Notably, this passage ends with a more sustained panning shot depicting what appears to be the same flock of pigeons as that featured in the earlier sequence, in this case standing on a rooftop the surface of which is visibly flecked with a mess of discarded feathers and bird shit, a striking shift in the nature of what they are now used to signify. A more contemplative mood is established in other sequences rendered in slow motion, examples including the moment of Crumley's discovery of his infection and a passage in which we are given his perspective on the charms of a succession of women he passes on the street after the sequence in the launderette.

An expressive approach is used on numerous other occasions to signify the shifting emotional currents of the relationship between the two central characters, particularly in the latter stages of the film. One sequence, for example, starts by creating a generally positive mood, after Crumley's written announcement that he is 'going to say something' and film it, an apparent concession to Buice's complaint about the power dynamics underlying his previous refusal of speech. A warmly building musical accompaniment gives an upbeat impression to a series of large pixellated close ups of the faces of the two principals, images that appear to signify a renewed intimacy in the relationship.

As the music continues to develop a forward-moving impression, the camera pulls back to reveal the previous footage as playing on Crumley's laptop, a more tightly-framed version subsequently coming into picture on a neighbouring monitor on his workbench, in front of which the pair seem happily engaged in an unheard conversation (now, presumably, working on the film of which the footage has become a part), the soundtrack still being dominated by the musical accompaniment.

A series of jump cuts follows, one of many used to signify the passing of time in the film, during which the impression remains positive, as continues to be the case in a further jump-cut sequence during which the pair and Crumley's room-mate work to disassemble the somewhat precarious structure of his home-grown editing suite (here and in some other instances in the film Buice and Crumley jump cut within and between short passages during which the camera is tracked slightly backwards in a repeated motion, the result of which is the creation of a simultaneous impression of continuity and discontinuity). Subsequent images give the impression of the creation of new light and space in the apartment – with further positive resonance, the activity appearing in fact to be the disassembly of the 'Arin's apartment' set created in the more roomy loft shared by the real-life couple at this

26. Film-within: Buice and Crumley at work in front of their makeshift editing suite in *Four Eyed Monsters* © Four Eyed Monsters LLC

stage – while the protagonists appear to be planning the outline structure of the film via an array of photographs taped onto a whiteboard.

As the sequence progresses, however, through various other shots of the two in the apartment and further re-arrangements of furniture, the music turns more uncertain and hesitant in mood and voices-over from the characters introduce an increasingly fractious dimension that culminates in tearful scenes involving each in turn. A disjuncture is maintained between the images and the voices, none of which are presented in synch on the screen until the moment of Buice's tears and a similar reaction from Crumley after he is seen taking his phone call from Slamdance. A further series of effects follows, including rapid time-lapse passages and additional shots of each of the protagonists in tears, the effect of which is to give expression to the outpouring of various mixed emotions prompted by the combination of events. This is a form of discourse that differs markedly, here and elsewhere in the film, from a more conventional dramatic staging.

Four Eyed Monsters shares with *Tarnation* an orchestration of various different kinds of source image, in these and other examples. Set off against the general unmarked background digital video, shot on a Panasonic DVX100 capable of recording at the standard film camera rate of 24fps, are a range of variants, including the highly pixellated DV footage marked as the product of Crumley's diegetic camera, motivation for which is provided quite clearly by his activities within the film and his establishment as a frustrated maker of videos of events such as weddings and bar mitzvahs. Highly pixellated footage of this kind can have an expressive potential in its own right, as exploited to potent effect in examples such as Harmony Korine's *Julien Donkey-Boy*.[12] This also seems to be the case in some instances in *Four Eyed Monsters*, even if this quality of the image also functions more immediately to mark out the product of the diegetic Crumley's own work (and of that produced by Buice in one sequence during her residency in Vermont).

An expressive dimension is given to the pixellated surface in examples such as its employment in the romantic passage and the start of the 'going to say something' sequence, another point of some similarity to the expressive usage of lower-quality image forms in *Tarnation*. The same can be said of some of the most extended pixellated sequences, manifested by the videos exchanged by the two characters during Buice's period in Vermont. It is partly through the quality of

these images, with their warmly-toned and highly textured – almost painterly – surfaces, and raw/naturalistic-seeming connotations, that a particular sense of intimacy between the characters is established on numerous occasions. It is important to note that these textures are the result of multiple forms of processing, rather than representing any raw state of digital footage, including extensive colour correction during post-production. The pixellated grid itself, a quality often associated with lo-fi digital, was in fact an entirely constructed effect, created through the superimposition onto the image of a picture taken from a computer screen.[13]

Other marked forms of imagery, in addition to the manipulations of speed considered above, include the use of monochrome instead of colour footage, still frames, elements of Buice's artwork, the written exchanges produced by the central characters and outline animation sequences such as the one employed during Buice and Crumley's first date at the waterfront. The status of a number of dream and fantasy sequences is indicated though the use of filters to create a blurring in one layer of the image, accompanied by non-naturalistic colour correction in post-production.[14] Another distinctly expressive effect is created in one instance by the manner in which the camera is held by Crumley in a close, low-angled shot on the street that creates a fleeting impression of dislocation that seems to express his subjective response to a sense of being surrounding by desirable but presumably unavailable women (the background shifts unsteadily in keeping with his movements while his own figure remains stable in relation to the frame, a device used to create similar effects of alienation in *Julien Donkey-Boy* and more extensively in Darren Aronofsky's *Pi* [1998] and *Requiem for a Dream* [2000]).

The overall effect of the combination of so many different kinds of footage is one in which the expressive dimension is liable to be brought to the attention of the viewer, another point of parallel with *Tarnation*, all the more so in this case through the explicit references made throughout the film to the processes and problems involved in the act of artistic creation and communication. The sight of Crumley with his camera in hand is a reminder of the more specific dimension in which the film itself was made, including the sequences viewed self-consciously through his lens – sequences in which we are reminded of the process of mediation by the presence on our screen

27. Expressive self-referential digital textures: The protagonists via
the camera-within-the-film in *Four Eyed Monsters*
© Four Eyed Monsters LLC

of the peripheral detail provided by the diegetically-located camera viewfinder (data such as battery level and time code). Even more reflexive is the material surrounding the expressive video footage constructed by Buice in Vermont, after receiving from Crumley a package containing the necessary editing software and his hand-written instructions on its use. We are shown Buice shooting and editing some of her own raw material, before her expressive sequence (including material such as time-lapses passages of her at work on her art, cloud shadows on the snow, the formation of icicles, and speeded-up footage of her dancing outside on the street) becomes part of the texture of *Four Eyed Monsters* itself. What the film offers is, in part, a reconstruction of the basis of its own composition, particularly as regards the footage seen to be shot within the film, as well as a reconstruction of particular stages of the relationship between the two characters.

Between the avant-garde and music video

As in many such cases, the precise location occupied by these works within the broader film-cultural landscape can further be established through comparison with both more- and less-mainstream forms that

exhibit some similar textual qualities. Some of the sequences from *Tarnation* examined above, for example, might be situated somewhere between the realms of the avant-garde and music video. Its relationship with the former can be understood via Renov's attempt to open up the domain of documentary more inclusively, to admit and celebrate expressive strategies employed by a range of figures including avant-garde filmmakers such as Stan Brakhage and Jonas Mekas, in addition to some of its textual qualities.[15]

A connection with music video is perhaps more obvious, in the manner in which many of the more showy expressive sequences are orchestrated to Caouette's selections of popular music. The distinction between the two is far from absolute, music video often having borrowed a range of styles and devices from the world of the avant-garde, although the positioning of each is very different in the cultural landscape (one being highly exclusive and of very limited circulation, the other an established part of commercial popular culture). Another, related, point of comparison suggested by Holly Willis is what she terms the digital 'design short' of the 2000s, an often music-driven format that itself blends aspects of the avant-garde and commercial forms such as music video and other audio-visual promotional materials.[16]

If we compare *Tarnation* with one of the epic diary films of Mekas, some similarities can be noted but also a number of significant differences. *Diaries, Notes & Sketches* (1969, also known as *Walden*) is a three-hour work based on diary-style footage shot by Mekas between 1964 and 1968. It was the only one of Mekas's diary films available on DVD in the United States at the time of writing, at a cost in the region of $70 that marked its status as a product associated with highly specialized interest. The material shot on a more-or-less daily basis by the filmmaker, an influential figure in the avant-garde scene of his time, is in many parts transformed into a highly expressive fabric, characterized variously by devices such as jittery camerawork, jump cuts and some sequences in which the editing is blindingly fast (some images being shot in single frames and much of the editing done in-camera at the time of shooting), occasionally verging on the abstract in effect.

The strategies adopted by Mekas can be understood as a way of aestheticizing and rendering into a poetic, expressive or impressionistic

form that which might otherwise be given the status of 'ordinary' amateur footage. This is a sense in which they have something in common with Caouette's approach to parts of *Tarnation*, even if the contexts within which this was achieved might have been very different. A key point of distinction between the two is the general absence of any apparently overarching narrative framework in *Diaries, Notes & Sketches*, although Mekas has suggested that the material was assembled – or, rather, 'strung together', a telling phrase – in chronological order.[17] Mekas provides on-screen titles for many of the sequences that comprise the film, but this superficial element of similarity with *Tarnation* only serves to emphasise the underlying difference. The titles here identify individual locations or occasions but offer no equivalent to the clearly ongoing narrative dynamic established throughout Caouette's film, even if some kind of implicit narrative dimension might be available to those with expert knowledge of what the film suggests about the wider project of the filmmaker.[18] *Diaries, Notes & Sketches* also lacks anything resembling the emotionally melodramatic tone of *Tarnation*, a key difference that relates closely to its contrasting use of sound or music, an issue to which we return below.

One dimension that is in some ways shared by the two films, however, and perhaps some parts of *Four Eyed Monsters*, is what Willis terms a 'kaleidoscopic vision', a term drawn from the work of Scott Bukatman in relation to a range of perspectives that he interprets as attempts to capture the disorienting experiences of urban modernity.[19] For Willis, this is a central trend in both music video and the design short, one that can be understood in the context of a common inheritance from the avant-garde as well as the wider range of cultural products cited by Bukatman (including urban entertainments such as phantasmagoria, amusement parks and cinema itself). Something of the kaleidoscopic, which in Bukatman's account involves qualities such as 'delirium' and 'kinesis', is particularly evident in the in-square sequences of *Tarnation* and short video work by Rico Gatson cited by Willis.[20] A broadly similar impression is created by some of the most rapidly cut and unsteady passages of *Diaries, Notes & Sketches*, examples including a part of the second reel that involves a group of people singing a Hare Krishna song on the street, a sequence released earlier as a separate short film.

In Gatson's work, Willis identifies a political agenda, in the use of multiply reflected images to create juxtapositions between elements from different generic contexts (for example, footage from *Foxy Brown* [1974] and *The Good the Bad and the Ugly* [1966] combined in *Gun Play* [2001]), although as she suggests 'a great deal of the kaleidoscopic imagery in music videos and shorts operates as spectacle, providing a dazzling visual treat.'[21] The latter can be said of the more heightened passages in both *Tarnation* and *Diaries, Notes & Sketches*, although the visual treat is made much more accessible in the former through its combination with the development of melodramatic narrative material.

If music video would usually be located at the more popular/mainstream end of the spectrum, particularly when compared with work associated with the avant-garde, it is important to note that this is also a format that can offer its own forms of difficulty and challenge to the viewer, as has been documented in detail by Carol Vernallis.[22] As Vernallis suggests, the exact meanings generated by music videos are often difficult to pin down, largely as a result of the combined but usually far from entirely unified contributions made by the three dimensions of image, music and lyrics, and the inability of the viewer simultaneously to track each element in full. The characteristic quality of music video, for Vernallis, is elusive, ambiguous and polysemic. Even when the three dimensions are put into relation, she suggests, 'a sense of vagueness remains', an impression of connection often being apparent between shots but its exact nature frequently left obscure.[23] This is very similar to the experience suggested above of seeking to unpack the exact impressions created in every moment by some of the expressive sequences of *Tarnation*, particularly in any viewing context other than that of a close academic analysis.

The use of music remains a central point of difference between the work of Caouette and that of Mekas. In its employment in the articulation of key dimensions of the melodramatic narrative (remembering the literal meaning of melo-drama as music-drama, a form of drama in which music is used to heighten emotion), music gives a strong lead to the viewer of *Tarnation*, as suggested in the examples considered in detail above. The same is true of *Four Eyed Monsters*, although in this case even the more heightened imagery is quite

easily legible within the narrative context, without the problems of detailed interpretation raised by music video or parts of *Tarnation* taken on their own The music serves narrative-emotional purposes in *Tarnation* to a greater extent than Vernallis suggests is usual in music video, even if this might remain short of a simple one-to-one or strictly hierarchical relationship.

Music is also used in some passages of *Diaries, Notes & Sketches*, but generally to different effect. Much remains largely in the background and does not serve the kind of heightened emotional purpose found in *Tarnation* or to a lesser extent in *Four Eyed Monsters*. In some instances, the music seems expressive of mood in a manner that appears to have positive emotional resonance, but this is not typical. One such example is a series of sequences following the title 'A Visit to Brakhages', in which choral pieces by the French composer Lili Boulanger contribute to the impression that this part of the film constitutes something of a rural idyll, a visit by Mekas to the family of fellow filmmaker Stan Brakhage that includes very home-movie-type raw material involving a house and woods in the snowy countryside and children at play.

For the most part, however, the music here does not appear to bear direct relationship to the images and, in some of its more sad and elegiac tones, might be considered to carry an emotional force not really supported in any specifics by the footage. The expressive dimension of the Boulanger pieces is perhaps strongest in retrospect, as the film charts the return of Mekas to the city. Here he employs an effect used frequently in the film in which the whooshing and roaring sounds of the New York subway serve as aural accompaniment, the impression created by which is one of disturbance or dislocation. This is an effect that stands in contrast to the ameliorative role of much of the music in *Tarnation* and that underlines the more disjunctive avant-garde status of a work such as *Diaries, Notes & Sketches* (even if the former also includes some sound effects designed to create a more disturbing impression in relation to the state of mind of one or other of the central characters).

In *Tarnation* and *Four Eyed Monsters* music and images appear to be combined in close coordination, in broad terms, at least, while *Diaries, Notes & Sketches* offers a relationship between sound and visuals that seems generally less easy to resolve into clear-cut resonances. This is

another marker of the different status of the works and of the clearly more mainstream orientation of the former two within the wider independent sphere. The Mekas film keeps the viewer at a greater emotional distance from the material on screen, in a manner similar in kind to (if much greater in degree than) that of the more ironic narrative features cited as counter-examples to *Little Miss Sunshine* and *Juno* in Chapter 1. Sound seems to operate in *Tarnation* and *Four Eyed Monsters* in the manner suggested more generally by Walter Ong, a source also cited by Vernallis in relation to music video.[24]

Vision, Ong suggests, is a sense that isolates and separates the viewer from the viewed, while sound incorporates and envelops the listener, is something into which the auditor can become immersed. Sound 'is thus a unifying sense', the ideal of which for Ong is the creation of harmony, 'a putting together', a formulation that might not apply to all uses of sound (which can also be disjunctive, as we have seen) but that seems usefully to capture the manner in which the music functions in *Tarnation* especially in bringing together – literally, orchestrating – the various fragmentary image sources used in the expressive sequences examined above.[25] If music functions in a simi- lar manner in the majority of commercially released feature films, as an often neglected dimension of their infrastructure, particularly in the establishment or confirmation of emotional tone, it has in this case more work to do than might be usual because of the particularly frac- tured nature of some of the imagery with which Caouette works. An element of such harmony might be created on occasion in *Diaries, Notes & Sketches*, including some usages of piano pieces by Chopin, but even in these cases the effect is often far less unified or consonant.

Tarnation, Four Eyed Monsters and *Diaries, Notes & Sketches* all offer something of the visual or audio-visual exhilaration associated by Bukatman and Willis with the kaleidoscopic effect, although these are located and might be understood somewhat differently in each case. The frenetic imagery of much of the Mekas film, shorn of any very obvious narrative context and generally not orchestrated to music that has an ameliorative potential, creates the impression often associ- ated with 'higher' art forms of offering a fresh mode of perception of the world. It is possible to take a pleasure in the intrinsic audio-visual qualities of the work, as a form of spectacle, but it does not appear to

invite attention at this level alone. The qualities of the film, and, of equal importance, the context in which it was produced and was or is likely to be viewed, encourage its consumption as a work of 'serious art' and as part of the wider field of the avant-garde.

Tarnation offers a version of audio-visual exhilaration closely correlated with a distinctly more mainstream-familiar brand of emotionally melodramatic narrative, although this is balanced by the painful nature of much of the material, even where some amelioration is offered by the music, and a number of subcultural associations that establish the film distinctly as part of the low-budget indie sector, a considerable distance on either side from the avant-garde or more conventional indie or Hollywood fiction. There are some passages in which the texture of *Tarnation* is closer to that of the Mekas film, including an early sequence in which a series of quite jittery travelling shots is accompanied by a scratchy voice-over of Renee reading from a poem, but these are generally situated rather differently, as in this case, in which a disjunctive passage is soon followed by the first of the film's title sequences.

The position of the film towards the margins of but clearly within the indie sphere is also marked by the channels through which it came to attention. The lengthy first cut premiered at the New York Lesbian & Gay Experimental Film/Video Festival (aka MIX), earlier footage having been admired by John Cameron Mitchell, director of *Hedwig and the Angry Inch* (2001) and a notable figure within gay-oriented indie circles, after Caouette sought to audition for Mitchell's *Shortbus* (2006).[26] Both MIX and Mitchell can be taken as representative of small-niche-oriented parts of the indie landscape, each subsequently coming into closer relationship with the film. The director of the festival, Stephen Winter, became the producer of *Tarnation* while Mitchell took on the more supportive role of executive producer. Gus Van Sant, a bigger name in both gay-oriented and wider indie circles, subsequently signed on in the same capacity as Mitchell, offering his endorsement to the project in a manner typical of the process through which established indie filmmakers have often sought to support newcomers whose work they admire.

Tarnation subsequently made appearances at high-profile festivals, often in sidebars of the kinds occupied by some of the films considered in the previous chapter, including Sundance (Frontier section), Cannes

(Director's Fortnight) and Toronto, where critical praise ensured its consecration as a work of note as an 'experimental' or 'poetic' form of documentary.[27] A modest theatrical release followed, by the art-house-oriented distributor Wellspring, which also offered finance for the completion of the film, including the payment of substantial music rights and a blow up to 35mm. *Tarnation* opened on a single screen, reaching a total of 22 at its height and a US gross of $590,873.

Four Eyed Monsters occupies a somewhat unusual position in the hybridity that results both from its fictionalized documentary origins and the industrial strategies with which it has become associated. The film started out, Crumley suggests, as an art project, as reflected to some extent in the text, rather than with the intention of becoming an indie film as such. What resulted, however, fits very much within the established indie repertoire in many of the textual dimensions considered above. It has also been embraced by many indie commentators as something of a trail-blazer in the forms of digital distribution and related activities examined in Chapter 2. This is a dimension in which it might be understood to have pushed beyond the usual confines of established models, but in a manner widely seen as a necessary extension of practices required within the lower-budget parts of the indie sector.

Tarnation and *Four Eyed Monsters* can also be situated in relation to the wider contemporary turn towards the subjective in documentary and other 'reality' formats, as identified by commentators such as Biressi and Nunn, cited in Chapter 3, an issue of relevance to their broader political resonance and that of the indie sector more generally. *Tarnation* in particular fits into the context identified by Biressi and Nunn in which the revelation of personal trauma and psychological damage is seen as a predominant modality of documentary/reality discourse, part of a wider realm of therapeutic culture.[28] Within documentary, Alisa Lebow suggests, a 'sprinkling' of first person films in the 1970s led to a increase in their production in the 1980s and 'a virtual explosion in the 1990s, showing no sign of abatement today.'[29] The latter part of this process was no doubt encouraged by factors such as the increasing accessibility of low-cost digital video and the unprecedented box-office success of a limited number of higher-profile examples, particularly the films of Michael Moore. Other factors include the advent of the 'video diary' and the spread of other

'reality' television formats (predecessors can also be suggested in the shape of avant-garde work such as that of Mekas that also appears to offer a highly subjective portrait of the world).

Jon Dovey identifies a broader cultural complex surrounding the emergence of particular forms of factual television that amounts to the espousal of a new 'regime of truth' based on 'the foregrounding of individual subjective experience at the expense of more general truth claims.'[30] This rather sweeping verdict is related by Dovey to a declining faith in Enlightenment-style claims to rationality and objectivity but it can also be understood to be a deeply ideological notion in its ontological and epistemological privileging of the individual, as suggested by its initial association with the Reagan/Thatcher era. A turn towards the subjective in documentary can also be understood in the more immediate context of its prior suppression in favour of over-simplified notions of objectivity, as suggested by Renov and Lebow, and its employment by filmmakers concerned with the politics of sex, gender, ethnicity and other forms of identity.[31]

A central focus on individual subjective experience is a factor that has always tended to limit the politically more radical potential of indie cinema, as I have argued elsewhere.[32] Indie films tend to share such an emphasis, a central plank of capitalist ideology, with the products of Hollywood, although the nature of the individual experience that is depicted might be rather different in many cases, as is suggested by a number of the films examined in this book. It is possible to offer more radical challenge to individual-centric portraits of the world but this is rarely achieved in products designed or likely to receive any kind of commercial distribution. On this score, *Four Eyed Monsters* seems largely conventional while *Tarnation* might be interpreted as having some more radical potential, even if this was not how it was primarily interpreted by reviewers or other commentators at the time.

The dynamic with which *Four Eyed Monsters* begins can be taken as symptomatic of the standard mainstream or indie orientation, in its basic shift from plurality to close focus on the central couple and the travails of their relationship. The presence of so many other faces and voices in the early stages might help to situate the couple among a wider multitude, rather than extracting them entirely; it might help

to suggest that they are in some respects typical rather than in any way special, the latter kind of inflection usually being implicit in the Hollywood equivalent (although such a view might be undermined by their artistic leanings; if typical, they would only be so in relation to a particular constituency, one that has something in common with the denizens of mumblecore, with which the film has sometimes been associated). But the primary ground on which the film appears to rest is individual-centric, as is the motivation for the expressive material examined above.

The latter is equally true of *Tarnation*, although Caouette's film contains material that might be taken as expressive of a less singular or fixed notion of subjectivity than is typical of the indie sector as a whole. As Lebow suggests, the tense in which first-person documentary films are expressed tends not to be the first-person singular: 'Autobiographical film implicates others in its quest to represent a self, implicitly constructing a subject always already in-relation – that is, in the first person plural.'[33] This appears quite overtly to be the case in *Tarnation*, both in the importance of other family figures to the narrative and in the particular manner in which Caouette himself is represented in the film. *Tarnation* could be read as a figuration of a more fragmented notion of individual subjectivity or of its status as a social construct rather than an ontologically-grounded essence. An initial division might be identified between Caouette as filmmaker and as subject of his own film, as indicated in the split between subjectively expressive sequences and the apparently objective nature of his own commentary in the titles. He also occupies a number of different guises within the text, not just in being represented at different ages but as a figure shown to be prone to dressing up and acting out, more or less theatrically, in a variety of ways. He appears to be a character who was, at some level, required on several occasions to reinvent a notion of himself during his formative years. On top of this is the hyperbolic act of splitting or multiplication achieved in some of the filmmaker's most favourite visual effects.

In one sense, all of this could be said quite clearly to be motivated and governed by the presence of the single subjectivity of Caouette. If, on the one hand, the film might be viewed as a dramatisation of

the kind of challenge to conventional notions of the individual that might be found in the work of some post-structuralist theorists, as a radical questioning of the nature of subjectivity, it is clear that this is not how the film was mediated to potential viewers through either mainstream or more indie-oriented media coverage. Caouette is clearly established in such material as the unproblematically fixed individual auteur, whatever psychological or other problems he or other members of his family might have suffered. A distinct tendency in the narrative surrounding the film, as expressed by Caouette and others, is to see it as having served a therapeutic purpose, effectively in the stabilization rather than any questioning of his subjectivity, both at the time of shooting much of the past footage and in the compilation of the finished text.

Conclusion: Indie lives!

Some industry commentators, most prominently Ted Hope, a figure of considerable authority within the business, have argued that indie film, as a relatively distinct category, is dead. For Hope, indie had split by the late 2000s into two components: his notion of the 'Truly Free', as cited and questioned in the introduction to this book, and 'the prestige and genre arms' of the corporate studio entities, otherwise widely known as Indiewood.[1] A similar conclusion about the status of indie has been made to some extent within academic circles. Yannis Tzioumakis offers a breakdown of the history of recent independent cinema in which the indie era is dated, approximately, from 1989 to 1996/7, followed by Indiewood from approximately 1998/9, the impression being given that the one substantially replaced the other.[2] Gary Needham, meanwhile, in his volume in the 'American Indies' series edited by himself and Tzioumakis (a series to which I have also contributed), seems to conflate indie and Indiewood, using the former term to denote what I would suggest is more helpfully signified by the latter.[3] A combination of these approaches is offered by Alisa Perren, whose primarily industrially-focused analysis (a study of Miramax and its broader context) reserves 'independent' for companies without any ties to the major studios and uses 'indie' to refer

to studio speciality divisions and their output.[4] This latter usage seems unhelpfully restrictive to me. Some important distinctions might indeed be made between the typical output of studio divisions and that of stand-alone independents, but I would suggest that these are less clear-cut than is suggested by such a usage, which also ignores the wider discursive resonances of the term as it has been applied to films from both within and beyond the domain of the studio divisions, and to various associated institutions and consumption contexts.

Perren also maps her distinction onto an historical framework (akin to that of Tzioumakis, although with a different periodisation) according to which independent is associated with the 1980s and indie with the 1990s. This, again, seems to me to oversimplify the picture. While some clear differences can be identified between some major tendencies of the two decades, as Perren suggests (including in some cases the centrality of filmmakers of different generations), I would argue that the distinction is over-stated when put in this way and downplays significant elements of continuity that can also be traced between the two periods and beyond. It also falls short of capturing the complexity of the picture as a whole, something Perren seeks to emphasize in other respects, which is not best characterized by the use of fixed labels of this kind for one period or another. Even if it might be true that the term 'indie' gained wider general usage from the period of the consolidation of the sector during the 1990s, such operative usage was not, and continues not to be, restricted to the output of the studio divisions.

Distinctions have often been made between independent and indie within prevailing discourses (within industry or more public circles) about this part of the film landscape in recent decades, often implying value judgements about what is deemed more deserving of the sometimes more valorized notion of 'independence' when separated from indie in this way. I would argue, though, that this process of distinction-marking is one that requires critical interrogation and analysis – as an active process that involves various kinds of position-taking of the kind considered in the introduction – rather than being accepted in something closer to its own terms, through the adoption of such terms as fixed categories, in academic study. If we need a distinct term to designate the realm of the studio divisions, Indiewood seems

a more useful and specific term (and/or just studio indie divisions or speciality divisions) rather than limiting indie to so restricted a territory (even here, films produced and/or distributed by the studio divisions encompass some considerable variety rather than being of any single identifiable type). Perren additionally argues that the 'indie film phenomenon' came to an end at some point (presumably the late 2000s), something that does not seem right in either her particular or my wider use of the term.[5]

Tzioumakis suggests that the terms independent or indie have lost their appeal, for both audiences and critics, as a result of factors such as a questioning of their meaningfulness in some cases and their overuse. 'After so much appropriation, overuse and abuse, the label [independent] was inevitably rendered meaningless for critics and the cinema-going public alike.'[6] This is a sweeping and surely unwarranted conclusion and another with which I would take issue, however contested the use or meaning of such terms might sometimes be (again, that very process of contest is something we need to examine as a cultural phenomenon, not to go along with at face value). The evidence cited to back up such a claim seems unconvincing to me and outweighed by indications to the contrary, including the use of indie and/or independent as categories by major online sources of information or sales such as the Internet Movie Database and Amazon.[7] Tzioumakis favours, instead, the less loaded terms 'specialized' or 'speciality', labels used within the industry, particularly in relation to the studio divisions. These are useful descriptors from the perspective of industrially-focused analysis, especially when the emphasis is on the variety of forms of speciality that might be embraced in particular instances by either fully independent or studio-related operations (forms that have often included otherwise contrasting productions at the art or exploitation ends of the spectrum that have provided fertile territory for independents, as either too lofty or too disreputable to appeal to the main arms of the studios). Such terms are much less useful, however, in capturing a sense of the broader cultural ground implied by, and contested across, the still-resonant 'indie' or 'independent'. The tendency to seek excessively to compartmentalize the use of these terms seems in the above cases to be the outcome of work in which the main focus is on the

industrial domain alone, sometimes perhaps at the expense of an understanding of aspects of the broader cultural context and of textual qualities and viewing practices that often overspill the more fixed boundaries suggested by Tzioumakis and Perren.[8]

To some extent, this is all a matter of debate about the particular meanings given to particular terms, part of a long and ongoing process of definition – sometimes nuanced, sometimes contentious – of what exactly is constituted by one or another version or understanding of the meaning of the much-contested term independent or any of its cognates or diminutives. Such debate is more than just 'academic', however, in the dismissive usage of that term, because it goes to the heart of much of the discourse that surrounds various parts of the independent landscape and that provides a key framework through which individual films or broader movements and tendencies are categorized, understood and consumed. My argument is that, contrary to the suggestions cited above, indie, used with the particular connotations employed in this book, is very much alive and reasonably well at the time of this writing, and that a significant continuity can be identified across the period from the breakthrough years of the 1980s and early 1990s to the work analyzed above. I would use indie here in an inclusive sense, to embrace films ranging from very-low and modestly budgeted features to some that have one foot in the camp of Indiewood, as primarily constituted by the realm of the studio speciality divisions, and many that lie somewhere in between. This would cover the range of work considered in *Indie 2.0*, from *Juno* (not entirely Indiewood) to mumblecore and from the work of Bahrani and Reichhardt to *Four Eyed Monsters* and *Tarnation*.

This is not to suggest that the indie sector has been static throughout the period identified above, or has not gone through various phases when considered in broad terms. The account offered by Tzioumakis identifies a number of developments of importance to our understanding of the resonances of terms such as independent, indie and Indiewood, although I would suggest that the divisions suggested are too clear-cut and give insufficient attention to some significant continuities. There certainly was an increased involvement of entities owned by corporate-based Hollywood during the 1990s and into the 2000s, with a subsequent impact on prevailing

industrial strategies, followed by a withdrawal by some major players towards the end of the latter decade. Across this period, however, can be found numerous films that share, broadly, many of the textual features associated with the variety of production with which the term indie originally became associated in reference to work from both within and outside the confines of the speciality divisions. That this continued to be the case well into the 2000s is demonstrated through the close analysis offered in this book of particular qualities of narrative, audio-visual style and subject matter. The same goes for the continued importance of traditional sources of attention for indie films such as festivals, theatrical openings (even very limited ones) and positive responses from critics in key publications, channels that remain crucial even where they might be supplemented in, or used as springboards for strategies located within, the online domain.

The Indiewood divisions may have come to embrace significant parts of the indie landscape, to have contained it in some respects and to have cherry-picked the most commercially attractive prospects, along with some smaller and more idiosyncratic examples, while making life more difficult for unattached operations that struggle to compete against their superior resources. But, even at its peak of influence, in the heyday of Miramax, for example, Indiewood has at no point anything like entirely displaced the unattached indie/independent sector, however commercially marginal the position of some of the latter might remain (as much of it has always been).

A particular aspect of Hope's questioning of the status of indie at the time of writing relates to the question of commercial viability, an issue of obvious importance to those directly involved in the sector. For Hope: 'Indie film was a legitimate career for about a decade, but it has returned to the realm of the "amateur" – in that it is now truly all about the love.'[9] This appears to be another example of rhetorical distinction that oversimplifies the case, of the kind examined in the introduction. Some of the work examined in this book does have some qualities, or is created in some practical circumstances, that can be said to verge on the amateur, although the boundaries between what is counted as amateur or professional, or those that might be imposed on the art-world of indie film, are far from entirely fixed, as suggested in Chapter 3.

The new potential for ultra-low-budget operations created in the digital sphere of production and distribution has heightened the salience of this issue, in a contemporary context where almost anyone can gain the physical means (if not necessarily the talent) to seek to participate in the indie arena. But the indie sphere has always included plenty of filmmakers whose primary motivation might be said to have been 'the love' far more than the money, along with those for whom it has been a sustainable career or a stepping stone to Hollywood. The picture of the low-budget filmmaker whose labours might be appreciated and celebrated within indie circles but who might still require a day job to pay the rent and/or struggle to find anything other than very marginal distribution or funding for subsequent work is a familiar rather than just a recent one.

The likes of Bahrani and Reichardt offer a particularly clear illustration of this kind of continuity, one that runs from what Tzioumakis marks off as the 'independent' era (approximately 1979 to 1989 in his account) to the period of this writing, cutting across any other tendencies, consolidations or movements that might be identified in between. And they are far from alone in occupying this kind of position. In the greater avowal of seriousness or social conscience that the term independent is sometimes taken to imply in this context, in those accounts in which it is seen as distinctive from 'indie' (particularly when the latter is used in a diminutive and less valorized sense), the films examined in Chapter 4 might seem to fit that label as well as any of those produced during the 1980s. This would include some of the 'regional cinema' associated with the early years of what became the Sundance festival (not to mention the status of the work of Bahrani and Reichardt as firmly separate from anything to do with the studios at the industrial level, the basis of Tzioumakis' use of the term independent in the earlier period).

I would include such work within the realm of the indie, in the use of that term broadly to suggest the particular forms of independent feature production and consumption that came to the fore and gained a certain kind of cultural recognition from the 1980s and early 1990s (as a way to distinguish these particular tendencies from the whole history of independence as a signifier of non-studio production). Debate is likely to continue about the various merits and potential

categorizations of these and other strands of indie film, given the range of investments that exist in the use of such categories, but I think the term remains a useful one in demarcating a particular range of cinematic–cultural territory that includes all of the examples embraced in this book and not just a particular realm sometimes seen as of less qualitative merit or as in certain ways less fully or rigorously independent in one way or another, or as a phase that is now considered to be past. It remains a term that can embrace a considerable range and within which plenty of scope exists for arguments about differing degrees of distinction from mainstream commercial cinema, on various grounds. It can include work closer to the art-cinema end of the spectrum – the challenging, difficult, prickly, relatively minimal, for example – and that which seeks to position itself as more 'cool', stylish or overtly quirky: varieties of indie that can be distinguished in some ways that might be significant, but not, for me, to the degree that they merit separating out under different fixed labels.

Whether or not the term is taken to include some of the material handled by genre-oriented operations such as Miramax's Dimension brand or Lionsgate is one of the questions that remains open to debate, this being a point at which distinction-marking lines are often imposed as a result of the rather different location of much of this kind of work (horror of a not conspicuously arty variety, for example) within prevailing cultural hierarchies that merit further study in themselves. But even here the lines can still be blurry; as Perren argues, the Dimension brand was situated by Miramax simultaneously as a separate space in which more nakedly commercial films could be handled, but as one that also sought to claim some share in the cachet of the Miramax name. The indie sector beyond the realm of the studio divisions or that of larger integrated independent operations such as Lionsgate might often be economically precarious or marginal, but that has always been the case for many indies and constitutes an important part of the manner in which any notion of the 'true indie' has always been defined, in positive as well as negative terms and in a discourse premised on notions of opposition to either Hollywood or Indiewood.

Notes

Introduction

1. '10 (9 Actually) Responses to the Issues Brought Up at the "Indie Film Summit"', http://networkedblogs.com/p12871622.
2. 'A Thousand Phoenix Rising: How the New Truly Free Filmmaking Community Will Rise from Indie's Ashes', keynote address, Film Independent Filmmakers' Forum, 27 September 2008, accessed via http://letsmakebetterfilms.hopeforfilm.com/2008/09/film-independents-filmmaker-forums.html.
3. I would not propose the use of the term here, though, in the mathematical sense that implies a problem-solving method that comes ever closer to achieving a greater degree of accuracy.
4. For more on the background to this, see King, *American Independent Cinema*, introduction. I have tended in my previous work to use the terms 'indie' and 'independent' mostly interchangeably, although with an acknowledgement that 'indie' has sometimes been used to signify the specific form that came to prominence from the 1980s.
5. For another argument that defines indie as a distinctive film practice, see Janet Staiger, 'Independent of What? Sorting out Differences from

Hollywood', in Geoff King, Claire Molloy and Yannis Tzioumakis, eds, *American Independent Cinema: Indie, Indiewood and Beyond*.

6. *Indie: An American Film Culture*, 4.

7. For more on how this can be understood, with a particular focus on the mode of engagement that indie film encourages, see Newman, *Indie*, Introduction. For more background on the broader indie culture of the period, although not including film, see Kaya Oakes, *Slanted and Enchanted: The Evolution of Indie Culture*.

8. See, for example: David Hesmondhalgh, 'Indie: the Institutional Politics and Aesthetics of a Popular Music Genre', *Cultural Studies*, vol. 13, no. 1, 1999; Ryan Hibbett, 'What is Indie Rock?', *Popular Music and Society*, vol. 28, no. 1, February 2005; Wendy Fonarow, *Empire of Dirt: The Aesthetics and Rituals of British Indie Music*.

9. Bourdieu, 'The Field of Cultural Production', in *The Field of Cultural Production*.

10. For the classic account of cultural capital, see Bourdieu, *Distinction: A Social Critique of the Judgement of Taste*.

11. For a more detailed account of this process as it might relate to the indie sector, see King, *Indiewood, USA: Where Hollywood Meets Independent Cinema*.

12. The total number of feature submissions for each of these years were as follows: 2009, 3,661; 2010, 3,724; 2011, 3,812; 2012, 2,042. Figures from press releases accessed at http://www.sundance.org/press-center/.

13. For examples of the reporting of sales at Sundance in 2011 and 2012 see, respectively, Dana Harris, 'All Sundance 2011 Acquisitions, By Distributor and by Sales Agent', *indieWIRE*, 2 February 2011, accessed via indiewire.com, and Josh L. Dickey and Jeff Sneider, 'Sanity prevails at busy Sundance 2012', *Variety*, 26 January 2012, accessed via variety. com.

14. For more on this, see King, *Indiewood, USA*.

15. Anthony Kaufman, 'The New Studio Indies', *Filmmaker*, Spring 2011, 18.

16. Scott Macaulay, 'Creative Destruction', *Filmmaker*, vol. 17, no. 1, Fall 2008, 110.

17. *The New York Times*, 7 September 2008, accessed via nytimes.com.

18. Anne Thompson, '2009 Sundance a Breeze', posted at variety.com, 22 January 2009.

19. Steve Ramos, 'A Quieter Sundance, But The Films Still Made Noise: Sundance '09 Wrap Up', 26 January 2009, accessed via indiewire.com; Dargis, 'In the Snows of Sundance, a Marked Chill in the Air', 23 January 2009, accessed via nytimes.com.

20. Becker, *Art Worlds*.

21. 'Frequently Asked Questions', at www.spiritawards.com/frequently-asked-questions.

22. *Empire of Dirt*, 25.

23. *Empire of Dirt*, 25–6.

24. *Empire of Dirt*, 27.

25. *Empire of Dirt*, 28.

26. *Empire of Dirt*, 28.

27. For more on this kind of use of the term 'mainstream', see Sara Thornton, *Club Cultures: Music, Media and Subcultural Capital*.

28. *Empire of Dirt*, 36–7.

29. *Empire of Dirt*, 63.

30. *Empire of Dirt*, 29.

31. *Empire of Dirt*, 3.

32. *Hellfire Nation: The Politics of Sin in American History*, 5.

33. *Hellfire Nation*, 45.

34. 'Indie culture: In pursuit of the authentic autonomous alternative', *Cinema Journal*, vol. 48, no. 3, 2009, 17.

35. 'Indie: the Institutional Politics and Aesthetics of a Popular Music Genre'.

36. 'Indie', 45.

37. 'Indie', 40.

38. *Liveness: Performance in a Mediated Culture*, 82.

39. *Liveness*, 82.

40. See, for example, 'A Thousand Phoenix Rising'.

Chapter 1

1. 'After Midnight', in J. P. Telotte, ed., *The Cult Film Experience: Beyond All Reason*.

2. For examples in each case, see *American Independent Cinema*, chapters 2, 3 and 4.

3. MacDowell, 'Notes on Quirky', *American Independent Cinema: Past, Present, Future*, Liverpool, John Moores University, May 2009.

4. Sconce, 'Irony, Nihilism and the New American "Smart" Film', *Screen* 43:4, Winter 2002.

5. An example singled out by MacDowell is the ending of *Adaptation* (2002), which I consider in very similar terms in *Indiewood, USA: Where Hollywood Meets American Independent Cinema*, chapter 1.

6. I am grateful to Paul Ward for help in explaining the technical basis of this and some of the other animation effects in the title sequence considered below.

7. See interview with Smith at www.watchthetitles.com/articles/0068-Juno.

8. Todd Martens, 'The Quirks in "Juno's" Score... with Audio', *The Los Angeles Times* blogs, 18 December 2007, accessed via latimesblogs.lattimes.com.

9. 'Irony, Nihilism', 355.

10. 'Irony, Nihilism', 356–57.

11. *Cool Rules: Anatomy of an Attitude*. As with many such accounts of social attitudes, Pountain and Robbins risk overstating their case, suggesting that 'cool' has become a new mode of contemporary individualism.

12. *Romantic Desire in (Post)Modern Art and Philosophy*, 25. This is another area in which it is easy to oversimplify such concepts, however, with terms such as modernism and postmodernism being complex and often contested in their associations. For another account very similar to that of de Mul, see Timotheus Vermeulen and Robin van den Akker, 'Notes on Metamodernism', *Journal of Aesthetics and Culture*, vol. 2, 2010.

13. 'Notes on Quirky'; Sontag, 'Notes on Camp', in *Against Interpretation*. There are also some significant differences between MacDowell's understanding of quirky and Sontag on camp, however. Sontag suggests that camp proposes itself seriously but is not taken seriously, which is not a quality associated with quirkiness.

14. 'Notes on Quirky'.

15. 'Quirky: Buzzword or Sensibility', in Geoff King, Claire Molloy and Yannis Tzioumakis, eds, *American Independent Cinema: Indie, Indiewood and Beyond*. For an account of the post-ironic in literature, one of a number of additional sources cited by MacDowell, see Nicoline Timmer, *Do You Fee It Too? The Post-Postmodern Syndrome in American Fiction at the Turn of the Millennium*, Amsterdam: Rodopoi Press, 2010.

16. 'Genericity in the Nineties: Eclectic Irony and the New Sincerity', in Collins, Hilary Radner and Ava Preacher Collins, eds, *Film Theory Goes to the Movies*, 246.

17. 'Genericity in the Nineties', 257.

18. Accessed via www.maximumfun.org/blog/2006/02/manifesto-for-new-sincerity.html. For more uses of the concept, see 'New Sincerity' entry on Wikipedia, via Wikipedia.com.

19. 'Irony and Sincerity', in Rombes, ed., *New Punk Cinema*.

20. 'If I Can Dream: The Everlasting Boyhoods of Wes Anderson – Review', *Film Comment*, Jan 1999, accessed via http//findarticles.com.

21. For a useful counter to the exaggeration of the supposed hegemony of irony, see Lee Konstantinou, *Wipe that Smirk Off Your Face: Postironic Literature and the Politics of Character*, Introduction. For an account that seeks to extrapolate from Sconce and that also argues for a process of negotiation between the ironic and the sincere, via elements of Deleuzian film theory, see Claire Perkins, *American Smart Cinema*.

22. 'Introduction' to van Alphen, Bal and Smith (eds), *The Rhetoric of Sincerity*.

23. 'Documenting September 11: Trauma and the (Im)possibility of Sincerity', in van Alphen, Bal and Smith, 244.

24. Details, variously, from Martin Grove, 'Five-Year Road Trip to Screen for "Sunshine"', *The Hollywood Reporter*, 21 July 2006, accessed via hollywoodreporter.com; Andrew Barker, '"Sunshine" repeatedly rejected before getting made', *Variety*, posted at variety.com, 18 January 2007; Sharon Waxman, 'A Small Film Nearly Left for Dead Has Its Day in the Sundance Rays', *The New York Times*, 23 January 2006, accessed via nytimes.com.

25. Patrick Goldstein, '"Juno" Born of a Talent Mandate', *Los Angeles Times*, E.1, 5 February 2008, accessed via latimes.com, archives.

26. Stephen Galloway, 'Marketing Movies with VW Vans and Lots of Blood', *The Hollywood Reporter*, 8 May 2007, accessed via hollywoodreporter.com.

27. Stephen Galloway, 'OSCARS: This Year's Top Films Took a While to Emerge', *The Hollywood Reporter*, 15 February 2008, accessed via hollywoodreporter.com; John Horn, 'Nursing It into A Hit', *Los Angeles Times.*, S.40, 19 December 2007, accessed via latimes.com, archives.

28. Quoted, respectively, in Steve Ramos, 'The Golden Child: "Juno" Makes Fox Searchlight the 2007 Market-Share Leader, Lures Young

Adults to Theaters', *indieWIRE*, 4 January 2008, accessed via indiewire. com; and Ramos, 'It's A Hit: "Juno" Delivers Big Crowd For Searchlight', *indieWIRE*, 11 December 2007, accessed via indiewire.com.

29. Horn, 'Nursing It into a Hit'.
30. John Horn, 'Sundance Film Festival; End of Story: A Record Deal', *Los Angeles Times*, E.1, 23 January 2006, accessed via latimes.com, archives.
31. Ramos, 'It's A Hit'.
32. For details of the basis on which these various ratings and calculations are made, see explanations provided on rottentomatoes.com and metacritic.com.
33. Others examined include the *Chicago Sun-Times*, *USA Today*, the tabloid *New York Post* and the websites Salon.com and Reel.com. I have also scanned reviews and/or extracts from a larger number included in the *Rotten Tomatoes* samples.
34. Manohla Dargis, '"Little Miss Sunshine"', 26 July 2006, accessed via nytimes.com
35. Carina Chocano, 'Movie Review', E1, 26 July 2006, accessed via latimes.com, archives.
36. Stephanie Zacharek, 'Little Miss Sunshine', 26 July 2006, accessed via salon.com.
37. Jim Ridley, 'Ain't No Sunshine', 18 July 2006, accessed via villagevoice.com.
38. A.O. Scott, 'Seeking Mr. and Mrs. Right for a Baby on the Way', 5 December 2007, accessed via nytimes.com.
39. Carina Chocano, 'Movie Review', E.1, 5 December 2007, accessed via latimes.com, archives.
40. Stephanie Zacharek, 'Juno', 5 December 2007, accessed via salon.com.
41. Robert Wilonsky, 'Knocked Up', 27 November 2007, accessed via villagevoice.com.
42. John Horn, 'At the Movies / Word of Mouth: A Surprise Package', E.1, 10 January 2008, accessed via latimes.com, archives.
43. Nick Chordas, 'Comedy Pits Smart-Aleck Teen Against Odds', 24 December 2007, accessed via dispatch.com, archives. Another critic in the same paper pronounced a similar verdict on *Little Miss Sunshine*.
44. Jon Weisman, 'Little Miss Sunshine: The Contenders', 16 November 2006, accessed via variety.com.
45. David Rooney, 'Little Miss Sunshine', 21 January 2006, accessed via variety.com.

46. Todd McCarthy, 'Juno', 2 September 2007, accessed via variety.com.

47. Stephen Garrett, 'Park City '06 Critic's Diary', 22 January 2006, accessed via indiewire.com.

48. For another account of this process, a 'de-authentication' of the film's indie credentials, see Michael Z. Newman, *Indie: An American Film Culture*, 232–45. Newman's account and mine, written independently at about the same time, cover some very similar ground.

49. Stephen Garrett, 'Toronto '07 Critic's Notebook', 11 September 2007.

50. Michael Koresky, 'Attitude Adjustment: Jason Reitman's "Juno"', 4 December 2007, accessed via indiewire.com.

51. Eugene Hernandez, et al., 'indieWIRE's Top Ten Lists for 2006', 27 December 2006, accessed via indiewire.com.

52. Brian Brooks, et al., 'indieWIRE's Top Ten Lists for 2007', 27 December 2007, accessed via indiewire.com.

53. Lisa Y. Garibay, 'My Super Sweet 16', *Filmmaker*, Fall 2007.

54. 'Oscar Nominations: A Sad Day Indeed', 'The Projectionist', 22 January 2008, accessed via nymag.com.

55. These were the just the first 50 of 44,659 results from a Google blog search, sorted by relevance, conducted 30 June 2009.

56. Noel Murray, 'A Second Look; Indie Flicks with a Quirk Ethic', E.12, 13 April 2008, accessed via latimes.com, archives.

57. 18 January 2000, accessed via blogs/suntimes.com/scanners.

58. 'Juno Bashing', 'The Travers Take', 30 January 2008, accessed via rollingstone.com/blogs/traverstake.

59. Sample as accessed 30 June 2009, starting at http://www.amazon.com/ Juno-Single-Disc-Jason-Bateman/product-reviews/B000YABYLA/ ref=cm_cr_pr_link_1?ie =UTF8&showViewpoints=0&sortBy=bySubmissionDateDescending.

60. Sample as accessed 1 July 2009, starting at http://www.amazon.com/ Little-Miss-Sunshine-Steve-Carell/product-reviews/B000K7VHQE/ ref=cm_cr_dp_all_helpful?ie= UTF8&coliid=&showViewpoints=1& colid=&sortBy=bySubmissionDateDescending.

61. Figures from imdb.com.

62. *The Royal Tenenbaums* took $52 million at the US box office, but on a budget of $21 million; *The Life Aquatic*, $24 million on a budget of $50 million; and *The Darjeeling Limited*, $11.9 million on a budget of $17.5 million (all figures from imdb.com). The first two of these were co-

produced and distributed by elements of the mainstream studio system, Touchstone and Buena Vista, respectively, each parts of the Disney empire; the latter was co-produced and distributed by Searchlight. No budget information was available at the time of writing for *Moonrise Kingdom*, released by Focus Features, which made headlines for record per-screen revenue on its first weekend as this book was going to press.

63. Steven Seitchik, 'Shooting for the Hip', *The Hollywood Reporter East*, 2 July, 1 and 6.
64. For more on this process, see Michael Newman, 'Movies for Hipsters', in Geoff King, Claire Molloy and Yannis Tzioumakis, eds, *American Independent Cinema: Indie, Indiewood and Beyond*.
65. *The Conquest of Cool: Business Culture, Counterculture, and the Rise of Hip Consumerism*, 32.

Chapter 2

1. *Digital Film-Making*, 5.
2. For a more detailed account, see Figgis, 120–2.
3. Some of the above is included in a brief account of the appeal of DV shooting in my *American Independent Cinema*.
4. *The Wealth of Networks: How Social Production Transforms Markets and Freedom*, 6.
5. Unless otherwise indicated, most of the detail that follows is from Buice and Crumley's own account in 'Four Eyed Monsters DIY Distribution Case Study', London International Film Festival, Nov 2007, a video recording of which is available online at http://a31.video2.blip.tv/3470000016822/Arincrumley-FourEyedMonstersDIY DistributionCaseStudy195.m4v?bri=49.0&brs=2142.
6. How-to guides on the use of social media for advertising or marketing warn of the importance of ensuring that such a fit exists between the product and the culture of such forums; see, for example, Tracy Tuten, *Advertising 2.0: Social Media Marketing in a Web 2.0 World*, 27. Other such texts drawn upon in my account include Bernie Borges, *Marketing 2.0: Bridging the Gap Between Seller and Buyer Through Social Media Marketing;* and David Meerman Scott, *The New Rules of Marketing and PR*.

7. See Tim O'Reilly, 'What Is Web 2.0: Design Patterns and Business Models for the Next Generation of Software', published on the O'Reilly website, 30 September 2005, http://www.oreillynet.com/pub/a/oreilly/tim/news/2005/09/30/what-is-web-20.html.

8. *Wikinomics*, 19.

9. *The International Film Business*, 15.

10. For more on this, see Jeffrey Ulin, *The Business of Media Distribution*, 5–6.

11. This and the following point is from a personal email communication from Crumley, 4 January 2010.

12. This and the following detail is from Scott Kirsner, *Fans, Friends and Followers: Building an Audience and a Creative Career in the Digital Age*, 8, 76; and Kirsner, 'Digital Do-It-Yourself', *The Hollywood Reporter*, 13 November 2006, accessed via thehollywoodreporter.com.

13. Thanks to Yannis Tzioumakis for pointing out this connection.

14. For additional detail on this see Chuck Tyron, *Reinventing Cinema: Movies in the Age of Media Convergence*, 97–102.

15. 'General FAQs', indiegogo.com.

16. This and the following detail on Kickstarter is from 'Frequently Asked Questions', at kickstarter.com/help/faq.

17. This and the following detail is from the film's entry at indiegogo.com/AsTheDust.

18. Tom Isler, 'Funds from the Madding Crowd: Raising Money through the Internet', International Documentary Association website, www.documentary.org/print/6388.

19. Quoted in Jon Reiss, *Think Outside the Box Office: The Ultimate Guide to Film Distribution and Marketing for the Digital Era*, 113.

20. Details from indiegogo.com/Black-Creek.

21. Details at indiegogo.com/thedutchmanproject.

22. For more detail, see the film's Kickstarter entry, starting at http://www.kickstarter.com/projects/2128223578/save-blue-like-jazz-the-movie-0?ref=live.

23. Anthony Kaufman, 'Has Kickstarter Reached Its Goal of Changing the Way Movies are Made?', *IndieWIRE*, 2 June 2011, accessed via indiewire.com.

24. See initial Kickstarter entry at http://www.kickstarter.com/projects/strutter/strutter-music-fund. For more on this and additional material on

some of the other examples cited above, also see Gordon Cox, 'Crowdfunding Draws Crowds', *Variety*, 8 January 2011, accessed via variety.com.

25. Brian Brooks, 'Sundance Institute Teams With Kickstarter in Three-Year Deal', *IndieWIRE*, 27 January 2011, accessed via www.indiewire.com.

26. Brian Brooks, 'For New Film, Harmony Korine Joins Rotterdam Fest Crowd Funding Initiative', *indieWIRE*, 8 September 2010, accessed via indiewire.com.

27. David Carr, 'At Sundance, Kickstarter Resembled a Movie Studio but Without the Egos', 'Media Decoder' blog, 30 January 2012, accessed at http://mediadecoder.blogs.nytimes.com/2012/01/30/at-sundance-kickstarter-resembled-a-movie-studio-but-without-the-egos/.

28. The figures cited here are from the Kickstarter website, at http://www.kickstarter.com/pages/Sundance2012.

29. I have tried, without success, to get some indication of this from the makers of these two examples.

30. For more detail, see www.thepoweroffew.com; budget figure from the Internet Movie DataBase, imdb.com.

31. Details from Eric Kohn, 'Fanning the Fear, Pursuing User-Generated Storylines via the Internet', *indieWIRE*, 16 October 2008, and the two project's websites, lostzombies.com and nationundead.com.

32. 'Web Scout' blog, 'Filmmakers finding new action online', *Los Angeles Times*, 2 July 2008, accessed at http://latimesblog.latimes.com/webscout/2008/07massifyfilmakaj.html.

33. See opensourcecinema.com; also Kirsner, *Fans, Friends and Followers*, 8.

34. Kirsner, *Fans, Friends and Followers*, 8.

35. See Tuten, *Advertising 2.0*, 100–14.

36. *Web 2.0: A Strategy Guide*, 172.

37. *The Tipping Point: How Little Things Can Make a Big Difference*. Gladwell divides influencers into three main categories: connectors, mavens (sources of information, keen to pass it on) and salesmen.

38. *Six Degrees: The Science of a Connected Age*.

39. *Six Degrees*, 243.

40. The theoretical and mathematical bases of this kind of network theory is elaborated in detail by Watts.

41. For more on the use of such tools generally, see Tuten, *Advertising 2.0*, 43–4.

42. For an example of the advocation of such strategies from a source supportive of independent film, see Scot Kirsner, 'Independent Filmmaker Working with New Technologies: Case Studies by Scott Kirsner' posted on the website of the Independent Television Service (ITVS), 2009, at www.itvs.org/producers/ digitalinitiative/fieldreport/index.html.

43. See, for example, Borges, *Marketing 2.0*, and Scott, *The New Rules of Marketing and PR*.

44. See Borges, *Marketing 2.0* and Tuten, *Advertising 2.0*.

45. For this and the following detail, see details in Kickstarter entry at kickstarter.com/projects/arincrumley/openindie, including explanatory video by Crumley.

46. How successful this initiative had been was not yet clear at the time of writing.

47. This and the above detail is from Gregg Goldstein and Alex Woodson, 'Sundance Festival a Click Away', *The Hollywood Reporter*, 17 January 2007, accessed via hollywoodreporter.com.

48. This and the following detail is from Associated Press, 'YouTube Opens Virtual Screening Room', *The Hollywood Reporter*, 19 June 2008, accessed via hollywoodreporter.com.

49. Eric Kohn, 'The Year in Digital', *New York Press*, 7 January 2009, accessed via nypress.com.

50. Anne Thompson, 'Frustrated Indies Seek Web Distrib'n', *Variety*, posted at Variety.com, 15 Feburary 2008.

51. Thompson, 'Frustrated Indies'.

52. Gregg Goldstein, 'Filmmakers Take Direct Flight to DVD', *The Hollywood Reporter*, 30 March 2006, accessed via hollywoodreporter.com.

53. Goldstein, 'Filmmakers Take Direct Flight'.

54. 'Declaration of Independence: The Ten Principles of Hybrid Distribution', *indieWIRE*, 21 September 2009, accessed via indiewire.com.

55. This and the following example is from Goldstein, 'Filmmakers Take Direct Flight'.

56. Quoted in Goldstein, 'Filmmakers Take Direct Flight'.

57. *Fans, Friends and Followers*, 154–5.

58. Details from 'What You Get Paid' section at www.createspace.com/Products/DVD/.

59. This and the following detail is from Reiss, *Think Outside the Box Office*, 251.

60. Kirsner, 156.

61. Lance Weiler, 'Navigating the Digital Divide', *Filmmaker*, Winter 2008.

62. This and the following detail is from Reiss, *Think Outside the Box Office*, 305–7.

63. See Jon Silver, Stuart Cunningham and Mark David Ryan, 'Mission Unreachable: How Jaman Is Shaping the Future of On-line Distribution', in Dina Iordanova and Stuart Cunningham (eds), *Digital Disruption: Cinema Moves Online*.

64. For more on MUBI, see Paul Fileri and Ruby Cheung, 'Spotlight on MUBI: Two Interviews with Efe Cakarel, Founder and CED of MUBI', in Dina Iordanova and Stuart Cunningham (eds), *Digital Disruption: Cinema Moves Online*.

65. See, for example, Sam Thielman, '"Rage" to receive new-media premiere', *Variety*, posted at variety.com, 2 September 2009.

66. This and the following detail is from Eugene Hernandez, 'DIY Distribution', *indieWIRE*, 17 August 2006, accessed via indiewire.com.

67. Weiler, 'Culture Hacker', *Filmmaker*, Summer 2009, 20.

68. *Think Outside the Box Office*.

69. Gregg Goldstein, 'Alt Output Gaining Steam in Indie Scene', *The Hollywood Reporter*, 29 March 2006, accessed via hollywoodreporter. com.

70. Goldstein, 'Alt Output Gaining Steam' and Rebecca Ascher-Walsh, 'A New Alternative Distribution Program Gets Filmmaker Kudos', *The Hollywood Reporter*, 30 August 2007, accessed via hollywoodreporter.com. As reported by Goldstein in 2006, the standard fee varied from $40,000 for five screens to $150,000 for twenty.

71. Ascher-Walsh, 'A New Alternative Distribution Program'.

72. Broderick, 'Declaration of Independence'.

73. See, for example, Reiss, 'My Adventure in Theatrical Self-Distribution, Part 1', *Filmmaker*, Fall 2008, accessible at filmmakermagazine.com/ fall2008/ bomb_it.php; and Gregg Goldstein, 'For Indies, Service Is This Year's Model', *The Hollywood Reporter*, 27 January 2010, 1, 14.

74. Reiss, 'My Adventure in Home Video, Part 2', *Filmmaker*, Winter 2009, accessed at filmmakermagazine.com/winter2009/bombit.php.

75. Reiss, *Think Outside the Box*, 40.

76. Sharon Swart, 'Indies Stay Alive in 2009', *Variety*, posted at variety. com, 29 December 2009; Peter Knegt, 'Box Office 2.0: The Biggest Stories of the 2009 Indie Box Office', *indieWIRE*, 29 December, 2009, accessed at indiewire.com. As Knegt suggests, the performance of films on VOD is usually hard to access, such data not being published in the routine manner associated with theatrical returns.

77. Brooks Barnes, 'At Sundance, New Routes to Finding an Audience', *The New York Times*, 25 January 2010, accessed via nytimes.com.

78. See, for example, Andrew Wallenstein, 'Rentals Are a Reach for YouTube', *The Hollywood Reporter*, 20 January 2010, accessed via hollywoodreporter.com.

79. For more on such options, see Reiss, *Think Outside the Box*.

80. For more detail on how this service works, see http://bravenewtheatres. com: 80/filmmakers.

81. *The Wealth of Networks*, 172–3.

82. *The Wealth of Networks*, 214, 239.

83. *The Long Tail: How Endless Choice Is Creating Unlimited Demand*.

84. *The Long Tail*, 107.

85. See, for example, Mark Bosko, *The Complete Independent Movie Marketing Handbook*, 6; and Stacey Parks, *The Insider's Guide to Independent Film Distribution*, x.

86. For more on the function of such discourses in related to the arts in general, see Howard Becker, *Art Worlds*.

87. Kerrigan, *Film Marketing*.

88. On the complex structure of the supply chain in non-Hollywood film, see Angus Finney, *The International Film Business*, 1.

Chapter 3

1. See, for example, Swanberg's account in Peter Debruge, 'Interview with Joe Swanberg', *Variety*, 5 March 2008, accessed via variety.com.

2. Michael Koresky, 'The Mumblecore Movement? Andrew Bujalski On His "Funny Ha Ha"', 22 August 2005, accessed via indiewire.com.

3. 'A Generation Finds Its Mumble', *The New York Times*, 19 August 2007, accessed via nytimes.com.

4. A search of the online archives of *Variety* in March 2010 revealed a dozen uses of the term as a point of reference in reviews of films not usually included in the mumblecore canon between late 2007 and early 2010.

5. See, for example, Andrew O'Hehir, 'Beyond the Multiplex', Salon. com, 23 August 2007, accessed at http://mobile.salon.com/ent/ movies/review/2007/08/btm/; and Andrea Hubert, 'Speak Up', *The Guardian*, 19 May 2007, accessed via guardian.co.uk.

6. 'All Talk?', *Film Comment*, November/December 2007, accessed at www.filmlinc/ com/fcm/nd07/mumblecore.htm.

7. For more on this process, see Marijke de Valck, *Film Festivals: From European Geopolitics to Global Cinephilia.*

8. Lim, 'A Generation Finds Its Mumble'.

9. These and the following figures are from boxofficemojo.com.

10. This and the following detail is from email correspondence with Houston King, 1 June 2010.

11. For more on this in general, see King, *American Independent Cinema*, chapter 2.

12. See comments by Katz and other members of the production team in commentary on the Benten Films DVD release.

13. See, for example, Koresky, 'The Mumblecore Movement', for Bujaski's comments on the balance between script and improvisation in *Funny Ha Ha.*

14. Detail from IFC Films DVD release, commentary by Swanberg, Gerwig and Osborne.

15. See King, *American Independent Cinema*, 76.

16. DVD commentary.

17. *Freakshow: First Person Media and Factual Television*, 55.

18. DVD commentary.

19. For more on this in general, see King *American Independent Cinema*, chapter 3.

20. This and the following detail is from Swanberg on the DVD commentary.

21. 'What I Meant to Say', Spring 2007 .

22. Shirky, *Cognitive Surplus: Creativity and Generosity in A Connected Age*, 122.

23. 'All Talk'.

24. For an argument that stresses this connection, tracing some aesthetic qualities of mumblecore, and particulalry Swanberg's *LOL*, to those of the vlog or webcam, see Aymar Jean Christian, 'Joe Swanberg, Intimacy, and the Digital Aesthetic', *Cinema Journal*, 50, 4, 2011.

25. Amanda Lenhart and Mary Madden, 'Teen Content Creators and Consumers', Pew Internet Reports, 2 November 2005; Amanda Lenhart, Mary Madden, Aaron Smith and Alexandra Macgill, 'Teens and Social Media', Pew Internet Reports, 19 December 2007. Accessed via www.pewinternet.org. The definition of content creation used by Pew, in relation to online activities, includes creating or working on a blog or a webpage, sharing original content (artwork, photos, videos, stories) online or remixing content found online into new creations.

26. Keen, 2.

27. *The Pro-Am Revolution: How Enthusiasts Are Changing Our Economy and Society.*

28. *Crowdsourcing: How the Power of the Crowd is Driving the Future of Business.*

29. For these and other examples, see Howe, *Crowdsourcing*, and Tapscott and Williams, *Wikinomics*. For an account of how the 'homemade' has been valorized as more authentic in some instances of indie music, see Ryan Hibbett, 'What Is Indie Rock?', *Popular Music and Society*, vol. 28, no. 1, February 2005, 61.

30. For one series of responses that includes reaction across the spectrum between praise, qualified praise and dismissal, from a website oriented towards an audience for non-mainstream cinema, see the discussion threads on theauteurs.com (later renamed Mubi.com) at www.theauteurs.com/topics/3855 and mubi.com/topics/105.

31. 'First Person: Matt Dentler on Indie Film for the MySpace/YouTube/iPod Generation', *indieWIRE*, 19 August 2007, accessed via indiewire.com.

32. See, for example, some of the responses on theauteurs and MUBI cited above.

33. 'Youthquake', 16 March 2009, accessed via thenewyorker.com.

34. 'Beyond the Multiplex', Salon.com, 23 August 2007.

35. *Art Worlds.*

36. *Art Worlds*, 227.

37. *Art Worlds*, 143.

38. 'A Generation Finds Its Mumble'.

39. Dave McNary, 'Sundance Unveils New Next Section', *Variety*, posted at variety.com, 2 September 2009.

40. See, for example, Michael Strangelove, *Watching YouTube: Extraordinary Videos by Ordinary People.*
41. *Reality TV: Realism and Revelation.* For an earlier articulation of a similar argument, on which Biressi and Nunn draw, see Dovey, *Freakshow.*
42. *Watching YouTube*, 51.

Chapter 4

1. See, for example, Anthony Kaufman, 'Industry Beat', *Filmmaker*, vol. 17, no. 1, Fall 2008, 22.
2. Peter Knegt, 'By Any Means Necessary: "Wendy & Lucy" Director Kelly Reichardt', *indieWIRE*, 10 December 2008, accessed via indiewire.com.
3. Both stories are available in the collection *Liveability*, 2009.
4. This and the following detail is from Scott Macaulay, 'The Last Ride', *Filmmaker*, Spring 2009, and Saul Austerlitz, 'The Director's Craft', *Los Angeles Times*, 5 April 2009, Sunday Calendar, D1, accessed via latimes.com.
5. S. T. VanAirsdale, 'In the Cinema of the Street Kid, Casting at Ground Level', *The New York Times*, 13 August 2006, accessed via nytimes.com.
6. Details from VanAirsdale and Macaulay.
7. Dennis Lim, 'Change Is a Force of Nature', *The New York Times*, 26 March 2006, accessed via nytimes.com.
8. Douglas Perry, 'Writer Jon Raymond Sees His Work Realized in Oregon Films', OregonLive.com, 5 January 2009, accessed via oregonlive.com; Larry Gross, 'Animal Rescue', *Filmmaker*, vol. 17, no. 1, Fall 2008, 125–6.
9. Commentary by the director on Koch Lorber DVD release.
10. Macaulay, 'The Last Ride', 55.
11. Kaufman 'Industry Beat', 22.
12. Jay Weissberg, 'Pre-Berlin Glow for "Pivotal" Pics', *Variety*, posted at variety.com, 15 January 2008.
13. Mark Olsen, 'They Have the Will, Yes, But Is There a Way?', *Los Angeles Times*, Sunday Calendar, E.14, 14 December 2008, accessed via latimes.com.
14. *Film Festivals: From European Geopolitics to Global Cinephilia*, 129.

15. Manohla Dargis, 'Hollywood Shines on Sundance; Independent Film Gets Burned', *The New York Times*, 21 January 2007, accessed via nytimes.com.

16. Melena Ryzik, 'Offstage, a Beastie Boy Enters the World of Independent Film', *The New York Times*, 9 September 2008, accessed via nytimes.com.

17. Macaulay, 'the Last Ride', 54.

18. This and the following detail is from Dargis, 'Hollywood Shines on Sundance'.

19. Steven Rosen, '"Science of Sleep", "American Hardcore" and "Old Joy" Sing a Blissful Box Office Tune', *indieWIRE*, 26 September 2006, accessed via indiewire.com.

20. These and other box office figures cited in this chapter are as reported by boxofficemojo.com.

21. Steven Rosen, 'Beyond the Art House: True Indies Find Real Theatrical Alternatives Outside Commercial Venues', *indieWIRE*, 17 March 2008, accessed via indiewire.com.

22. For more on this, see King, *American Independent Cinema*, chapter 2.

23. Macaulay, 'The Last Ride', 56.

24. As confirmed by Bahrani in the DVD commentary.

25. Bahrani, DVD commentary.

26. DVD commentary.

27. Gross, 'Animal Rescue', 60.

28. Macaulay, 'The Last Ride', 53.

29. Fernando Solanas and Octavio Getino, 'Towards a Third Cinema: Notes and Experiences for the Development of a Cinema of Liberation in the Third World', reprinted in Michael Chanan (ed.), *Twenty-Five Years of the New Latin American Cinema*. For more on the LA School, see King, *American Independent Cinema*, 201–9.

30. *Narration and the Fiction Film*, London: Routledge, 1985, 205–33.

31. See 'Introduction: The Impurity of Art Cinema', in Galt and Schoonover (eds), *Global Art Cinema: New Theories and Histories*. For another useful account, see András Bálint Kovács, *Screening Modernism: European Art Cinema, 1950–1980*.

32. For the *Pickpocket* reference, for example, see Kevin Thomas, 'A Little "Push" to Search For a Better Life', *Los Angeles Times*, 22 September 2006, Calendar, E.6, accessed via latimes.com; for a reference to *Mouchette*,

see Kristi Mitsuda, 'Life on the Margins: Kelly Reichardt's "Wendy and Lucy", *indieWIRE*, 8 December 2008, accessed via indiewire.com.

33. A. O. Scott, 'Neo-Neo Realism', *The New York Times* magazine, 22 March 2009, accessed via nytimes.com. See also an earlier piece on a similar theme by the same author, Scott, 'In Toronto, Sampling Realism's Resurgence', *The New York Times*, 11 September 2008.

34. Scott, 'Neo-Neo Realism'.

35. See, for example, Dennis Lim, 'American Indie Filmmakers: Thinking Globally and Acting Locally, Too', *The New York Times*, 30 April 2006, accessed via nytimes.com.

36. See, for example, Zach Wigon, 'Critics Notebook: Is the American Indie Film Extinct?', *indieWIRE*, 20 April 2012, accessed via indiewire.com.

37. See especially, Galt and Schoonover, 'Introduction: The Impurity of Art Cinema'.

38. 'The Production of Belief', in *The Field of Cultural Production*.

39. *Art Worlds*, 360.

40. Scott, 'In Toronto'.

41. Scott Foundas, 'Wendy and Lucy', *Variety*, posted at variety.com, 2 June 2008; Sam Adams, '"Wendy": Stillness Speaks Volumes', *Los Angeles Times*, 12 December 2008, accessed via latimes.com.

42. Gross, 'Animal Rescue', 60.

43. Stephen Holden, 'Sisyphus: Making It Work on the Streets of New York', *The New York Times*, 8 September 2006, accessed via nytimes.com; Todd McCarthy, 'Chop Shop', posted at variety.com, 23 May 2007.

44. *Pretty: Film and the Decorative Image*.

45. See especially Galt, chapter 5.

46. 'Aestheticizing Slum Cities: Patrick Chamoiseau's *Texaco* and the Representation of Marginalized Space', in Gerhard Stilz (ed.), *Territorial Terrors: Contested Spaces in Colonial and Postcolonial Writing*, 286. I am grateful to Mike Wayne for suggesting this source.

Chapter 5

1. For more on this and some other examples, see King, *American Independent Cinema*, 52–3.

2. For more on Greenaway, see Holly Willis, *New Digital Cinema: Reinventing the Moving Image*, 39.

3. For more on the use of genre conventions in indie cinema, see King, *American Independent Cinema*, chapter 4; for more on examples of romantic comedy that play to some extent with the form, see King, *Film Comedy*, 57–60.

4. Detail from Episode 1 of the *Four Eyed Monsters* podcast series and from Buice and Crumley, 'Four Eyed Monsters DIY Distribution Case Study' presentation, London International Film Festival, video accessed at http://a31.video2.blip.tv/ 3470000016822/ Arincrumley-FourEyedMonstersDIYDistributionCaseStudy195.m4v ?bri=49.0&brs=2142.

5. Director's commentary on Wellspring DVD release.

6. *The Virtual Life of Film*, 17.

7. 'What Is Digital Cinema?', 1996, accessed at www.manovich.net/ TEXT/digital-cinema.html#fn0.

8. 'Towards a Poetics of Documentary', in Renov (ed.), *Theorizing Documentary*.

9. 'Towards a Poetics of Documentary', 35.

10. *The Subject of Documentary*, 23.

11. *The Subject of Documentary*, 96; 'Towards a Poetics of Documentary', 34.

12. For more on this, in this and other examples, see King, *American Independent Cinema*, 119–121.

13. This and the previous detail is from an email to the author from Crumley, 3 October 2011.

14. This and some of the other technical detail on the film cited from this chapter is from an audio commentary recorded by Crumley for the author in October 2010.

15. 'Towards a Poetics of Documentary'.

16. *New Digital Cinema*, 46.

17. Quotation from Mekas provided on back cover of Re-Voir/ Microcinema International DVD release.

18. For such a reading, relating to his attempt to evoke a lost childhood in his home country of Lithuania, see David E. James, 'Film Diary/Diary Film: Practice and Product in Jonas Mekas's *Walden*', in Pip Chodorov and Christian Lebrat (eds), *The Walden Book*.

19. See Bukatman, *Matters of Gravity: Special Effects and Supermen in the 20th Century*, 3.

20. *Matters of Gravity*, 3; for more on Gatson's work, see Willis, 56–7.
21. *New Digital Cinema*, 57.
22. *Experiencing Music Video: Aesthetics and Cultural Context.*
23. *Experiencing Music Video*, 94, 41. A number of explanations for this obscurity are suggested by Vernallis, including a production process that often involves 'guessing games' on the part of the director in trying to establish what is sought by the artist or recording company, 89.
24. *Orality and Literacy: The Technologizing of the Word*. Cited by Vernallis, 175–6, 211.
25. *Orality and Literacy*, 70. It might be argued that visuals can also seek to incorporate the viewer to a greater extent than suggested by Ong, however, in examples such as the 'in your face' impact created by some Hollywood action sequences or through the use of 3D.
26. Scott Foundas, 'What in *Tarnation*', *LA Weekly*, 14 October 2004, accessed via www.laweekly.com.
27. See, for example, A. O. Scott, 'Film Festival Review; Tracing a 20-Year Odyssey across Hope and Despair', *The New York Times*, 5 October 2004, accessed via www.nytimes.com.
28. *Reality TV*, 70.
29. *First Person Jewish*, xiii.
30. *Freakshow*, 25.
31. On the relation to identity polices, see Biressi and Nunn, *Reality TV*, 74.
32. *American Independent Cinema*, 250.
33. *First Person Jewish*, xii.

Conclusion

1. 'Reflections on "Indie Film Is Dead"', 'Truly Free Film' blog, posted 16 August 2010, http://trulyfreefilm.hopeforfilm.com/2010/08/reflections-on-indie-film-is-dead.html.
2. '"Independent", "Indie" and "Indiewood": Towards a Periodisation of Contemporary (Post-1980) American Independent Cinema', in Geoff King, Claire Molloy and Yannis Tzioumakis, eds, *American Independent Cinema: Indie, Indiewood and Beyond*.
3. *Brokeback Mountain*.
4. *Indie, Inc.: Miramax and the Transformation of Hollywood in the 1990s*, 8. Miramax, in Perren's account, thus changes from being an independent

to an indie company after being taken over by Disney in 1993. She goes on to argue, however, that the company had 'functioned as a de facto indie division even before Disney owned it' (8), which seems somewhat to undermine her usage of the terms: if it was de facto indie before the take-over, the act of being taken over seems no longer the basis of the definition of the term.

5. I also feel the need to take issue here with some of Perren's character-ization of my account in *Indiewood, USA*. Had I contextualized the films industrially, she suggests, I 'might have seen the extent to which Indiewood can be viewed as marking the *end* of the indie film phe-nomenon.' (13). I do, in fact, locate these films industrially; that is one major dimension of the book. Part of the criticism here appears to be based on the fact that the main case-study examples I use are restricted to a limited period (December 1998 to April 2004) and maybe that the precise parameters of that period are not delineated (although the latter point is not made clearly if that is the suggestion). But films of this kind continued to appear in Indiewood afterwards and have done so to date, rather than being restricted to a particular narrow window. (Perren also suggests inaccurately in a footnote to this debate that I rely solely on a vague comment from Peter Biskind's *Down and Dirty Pictures: Miramax, Sundance, and The Rise of Independent Film* in relation to the dating of the emergence of the term 'Indiewood'; this is in fact also sourced to an article on the *indieWIRE* website.)

6. *Hollywood's Indies: Classics Divisions, Speciality Labels and the American Film Market*, 14.

7. The only evidence cited to back up this notion of a decline of interest is a study of a sample of user reviews of independent films on the Internet Movie Database (IMDb) in which the term 'independent' appears infrequently (Hayley Trowbridge, 'Talking about Independence: IMDb.com and the Discourse of American Independent Cinema', paper presented at Postgraduate Research Student Conference, Department of Communication and Media, University of Liverpool, May 2011, cited by Tzioumakis, 12, an analysis of IMDb responses conducted in April 2011). No comparison is provided with any earlier moment in which the term might have been used more often in the same forum, to provide any basis from which to measure any decline. I would also question whether such non-deployment of a

specific term provides evidence for its lack of broader salience. It is my experience more generally of user reviews of this kind (primarily on Amazon.com) that terms such as indie and independent are used much less frequently than more obviously evaluative terms such as 'original' or 'complex', as is the case in the sample examined by Trowbridge. The fact that viewers do not choose to use a term in responses of this kind does not necessarily mean that the term has no salience. Responses to Hollywood films do not necessarily use the term Hollywood, a fact that would be unlikely to lead to a conclusion that Hollywood as a concept lacks continued resonance in popular culture. The very fact that IMDb, the best-known online film resource, should choose to produce a top independent films chart could be interpreted in the opposite direction, however, to suggest the continued saliency of the category. It is also notable that Amazon, the largest online retailer, includes an 'Indie & Art House' section within its genre categories (the home page of which includes plugs for the Amazon-owned CreateSpace and Withoutabox facilities cited in Chapter 1). The IMDb does not have an equivalent category in its list of genres but it does have a separate 'Independent Film' category at the same level as 'Genre' in the drop-down menu that appears under 'Movies'. All of this, I would suggest, is better evidence for the continued relevance of such categories than the study by Trowbridge is for the opposite.

8. Work closer in focus to mine in this respect, in seeking to blend an industrial with a more culturally-focused understanding of indie, would include Newman's *Indie: An American Film Culture*.

9. 'Reflections'.

Select bibliography

Anderson, Chris. *The Long Tail: How Endless Choice Is Creating Unlimited Demand*. London: Random House, 2006.

Auslander, Philip. *Liveness: Performance in a Mediated Culture*. Abingdon: Routledge, second edition, 2008.

Aymar, Jean Christian. 'Joe Swanberg, Intimacy, and the Digital Aesthetic'. *Cinema Journal*, vol. 50, no. 4, 2011.

Becker, Howard. *Art Worlds*. Berkeley: University of California Press, 1982.

Benkler, Jochai. *The Wealth of Networks: How Social Production Transforms Markets and Freedom*. New Haven and London: Yale University Press, 2006.

Biressi, Anita, and Heather Nunn. *Reality TV: Realism and Revelation*. London: Wallflower Press, 2005.

Bordwell, David. *Narration and the Fiction Film*. London: Routledge, 1985.

Borges, Bernie. *Marketing 2.0: Bridging the Gap Between Seller and Buyer Through Social Media Marketing*. Tuscon: Wheatmark, 2009.

Bosko, Mark. *The Complete Independent Movie Marketing Handbook*. Studio City: Michael Wiese, 2003.

Bourdieu, Pierre. *Distinction: A Social Critique of the Judgement of Taste*. London: Routledge, 1984.

———. 'The Field of Cultural Production'. In *The Field of Cultural Production*. Cambridge: Polity, 1993.

————. 'The Production of Belief'. In *The Field of Cultural Production*. Cambridge: Polity, 1993.

Broderick, Peter. 'Declaration of Independence: The Ten Principles of Hybrid Distribution'. *indieWIRE*, 21 September 2009, accessed via indiewire.com.

Bukatman, Scott. *Matters of Gravity: Special Effects and Supermen in the 20th Century*. Durham & London: Duke University Press, 2003.

Collins, Jim. 'Genericity in the Nineties: Eclectic Irony and the New Sincerity'. In Collins, Hilary Radner and Ava Preacher Collins, *Film Theory Goes to the Movies*. New York: Routledge, 1993.

De Mul, Jos. *Romantic Desire in (Post)Modern Art and Philosophy*. Albany: SUNY Press, 1999.

De Valck, Marijke. *Film Festivals: From European Geopolitics to Global Cinephilia*. Amsterdam: University of Amsterdam Press, 2007.

Dovey, Jon. *Freakshow: First Person Media and Factual Television*. London: Pluto Press, 2000.

Figgis, Mike. *Digital Film-Making*. London: Faber & Faber, 2007.

Finney, Angus. *The International Film Business*. London: Routledge, 2010.

Fonarow, Wendy. *Empire of Dirt: The Aesthetics and Rituals of British Indie Music*. Middletown: Wesleyan University Press, 2006.

Frank, Thomas. *The Conquest of Cool: Business Culture, Counterculture, and the Rise of Hip Consumerism*. Chicago: University of Chicago Press, 1997.

Galt, Rosalind. *Pretty: Film and the Decorative Image*. New York: Columbia University Press, 2011.

Galt, Rosalind, and Karl Schoonover. 'Introduction: The Impurity of Art Cinema'. In Galt and Schoonover, eds, *Global Art Cinema: New Theories and Histories*. Oxford: Oxford University Press, 2010.

Gladwell, Malcolm. *The Tipping Point: How Little Things Can Make a Big Difference*. London: Abacus, 2000.

Hesmondhalgh, David. 'Indie: the Institutional Politics and Aesthetics of a Popular Music Genre'. *Cultural Studies*, vol. 13, no. 1, 1999.

Hibbett, Ryan, 'What Is Indie Rock?'. *Popular Music and Society*, vol. 28, no. 1, February 2005.

Howe, Jeff. *Crowdsourcing: How the Power of the Crowd Is Driving the Future of Business*. London: Random House, 2009.

James, David E. 'Film Diary/Diary Film: Practice and Product in Jonas Mekas's *Walden*'. In Pip Chodorov and Christian Lebrat, eds,

The Walden Book. Paris: Editions Paris Experimental/Re:Voir Video, 2009.

Kawin, Bruce. 'After Midnight'. In J. P. Telotte (ed.), *The Cult Film Experience: Beyond All Reason*. Austin: University of Texas Press, 1991.

Keen, Andrew. *The Cult of the Amateur: How Blogs, MySpace, YouTube and the Rest of Today's User-Generated Media Are Killing Our Culture and Economy*. London: Nicholas Brealey, 2008.

Kerrigan, Finola. *Film Marketing*. Butterworth-Heinemann: Oxford, 2010.

King, Geoff. *Film Comedy*. London: Wallflower Press, 2002.

———. *American Independent Cinema*. London: I.B.Tauris 2005.

———. *Indiewood, USA: Where Hollywood Meets Independent Cinema*. London: I.B.Tauris, 2009.

Kirsner, Scott. *Fans, Friends and Followers: Building an Audience and a Creative Career in the Digital Age*. CinemaTech Books, 2009.

Konstantinou, Lee. 'Wipe That Smirk Off Your Face: Postironic Literature and the Politics of Character'. PhD thesis, Stanford University, 2009.

Kovács, András Bálint. *Screening Modernism: European Art Cinema, 1950–1980*. Chicago & London: University of Chicago Press, 2007.

Leadbeater, Charles, and Paul Miller. *The Pro-Am Revolution: How Enthusiasts Are Changing Our Economy and Society*. London: Demos, 2004.

Lebow, Alisa. *First Person Jewish*. Minneapolis: University of Minnesota Press, 2008.

MacDowell, James. 'Notes on Quirky', *American Independent Cinema: Past, Present, Future*. Liverpool: John Moores University, May 2009.

———. 'Quirky: Buzzword or Sensibility'. In Geoff King, Claire Molloy and Yannis Tzioumakis, eds, *American Independent Cinema: Indie, Indiewood and Beyond*. London: Routeldge, 2012.

Manovich, Lev. 'What Is Digital Cinema?' 1996, accessed at www.manovich.net/TEXT/digital-cinema.html#fn0.

Morone, James. *Hellfire Nation: The Politics of Sin in American History*. New Haven: Yale University Press, 2003.

Needham, Gary. *Brokeback Mountain*. Edinburgh: Edinburgh University Press, 2010.

Newman, Michael. 'Indie Culture: In Pursuit of the Authentic Autonomous Alternative'. *Cinema Journal*, vol. 48, no. 3, 2009.

———. *Indie: An American Film Culture*. New York: Columbia University Press, 2011.

————. 'Movies for Hipsters'. In Geoff King, Claire Molloy and Yannis Tzioumakis, eds, *American Independent Cinema: Indie, Indiewood and Beyond*. London: Routledge, 2012.

Oakes, Kaya. *Slanted and Enchanted: The Evolution of Indie Culture*. New York: Holt, 2009.

Olsen, Mark. 'If I Can Dream: The Everlasting Boyhoods of Wes Anderson – Review'. *Film Comment*, Jan. 1999, accessed via http// findarticles.com.

Ong, Walter. *Orality and Literacy: The Technologizing of the Word*. London: Routledge, 2002.

Palfrey, John, and Urs Grasser. *Born Digital: Understanding the First Generation of Digital Natives*. New York: Basic Books, 2008.

Parks, Stacey. *The Insider's Guide to Independent Film Distribution*. Oxford: Focal Press, 2007.

Perren, Alisa. *Indie, Inc.: Miramax and the Transformation of Hollywood in the 1990s*. Austin: University of Texas Press, 2012.

Perkins, Claire. *American Smart Cinema*. Edinburgh: Edinburgh University Press, 2012.

Pountain, Dick, and David Robbins. *Cool Rules: Anatomy of an Attitude*. London: Reaktion Books, 2000.

Reiss, Jon. *Think Outside the Box Office: The Ultimate Guide to Film Distribution and Marketing for the Digital Era*. Los Angeles: Hybrid Cinema Publishing, 2010.

Renov, Michael. 'Towards a Poetics of Documentary'. In Renov (ed.), *Theorizing Documentary*. London: Routledge, 1993.

————. *The Subject of Documentary*. Minneapolis: University of Minnesota Press, 2004.

Rodowick, David. *The Virtual Life of Film*. Cambridge, Massachusetts: Harvard University Press, 2007.

Rombes, Nicholas. 'Irony and Sincerity'. In Nicholas Rombes (ed.), *New Punk Cinema*, Edinburgh: Edinburgh University Press, 2005.

Rosenberg, Michael. 'Aestheticizing Slum Cities: Patrick Chamoiseau's *Texaco* and the Representation of Marginalized Space'. In Gerhard Stilz (ed.), *Territorial Terrors: Contested Spaces in Colonial and Postcolonial Writing*. Wurzberg: Konigshausen & Neumann, 2008.

Sconce, Jeffrey. 'Irony, Nihilism and the New American "Smart" Film'. *Screen*, vol. 43, no:4, Winter 2002.

Scott, David Meerman. *The New Rules of Marketing and PR*. Hoboken, NJ: Wiley, 2009.

Shirky, Clay. *Cognitive Surplus: Creativity and Generosity in a Connected Age*. London: Allen Lane, 2010.

Silver, Jon, Stuart Cunningham and Mark David Ryan. 'Mission Unreachable: How Jaman is Shaping the Future of On-line Distribution'. In Dina Iordanova and Stuart Cunningham, eds, *Digital Disruption: Cinema Moves Online*, St Andrews: St Andrews Film Studies, 2012.

Shuen, Amy. *Web 2.0: A Strategy Guide*. Sebastopol, CA: O'Reilly, 2008.

Solanas, Fernando, and Octavio Getino. 'Towards a Third Cinema: Notes and Experiences for the Development of a Cinema of Liberation in the Third World'. Reprinted in Michael Chanan (ed.), *Twenty-Five Years of the New Latin American Cinema*. London: British Film Institute, 1983.

Sontag, Susan. 'Notes on Camp'. In *Against Interpretation and Other Essays*. New York: Farrar and Giroux, 1961.

Staiger, Janet. 'Independent of What? Sorting out Differences from Hollywood'. In Geoff King, Claire Molloy and Yannis Tzioumakis, eds, *American Independent Cinema: Indie, Indiewood and Beyond*. London: Routledge, 2012.

Strangelove, Michael. *Watching YouTube: Extraordinary Videos by Ordinary People*. Toronto: University of Toronto Press, 2010.

Tapscott, Don. *Grown Up Digital: How the Net Generation Is Changing Your World*. New York: McGraw Hill, 2009.

Tapscott, Don, and Anthony Williams. *Wikinomics: How Mass Collaboration Changes Everything*. London: Atlantic, 2007.

Thornton, Sara. *Club Cultures: Music, Media and Subcultural Capital*. Cambridge: Polity, 1995.

Tuten, Tracey. *Advertising 2.0: Social Media Marketing in a Web 2.0 World*. Westport, CT: Praeger, 2008.

Tyron, Chuck. *Reinventing Cinema: Movies in the Age of Media Convergence*. New Brunswick, NJ: Rutgers University Press, 2009.

Tzioumakis, Yannis. '"Independent", "Indie" and "Indiewood": Towards a Periodisation of Contemporary (post-1980) American Independent Cinema'. In Geoff King, Claire Molloy and Yannis Tzioumakis, eds, *American Independent Cinema: Indie, Indiewood and Beyond*. London: Routledge, 2012.

Tzioumakis, Yannis. *Hollywood's Indies: Classics Divisions, Speciality Labels and the American Film Market*. Ediburgh: Edinburgh University Press, 2012.

Ulin, Jeffrey. *The Business of Media Distribution*. Oxford: Focal Press, 2010.

van Alphen, Ernest, Mieke Bal and Carel Smith, eds, *The Rhetoric of Sincerity*. Palo Alto, CA: Stanford University Press, 2009.

Vernallis, Carol. *Experiencing Music Video: Aesthetics and Cultural Context*. New York, Columbia University Press, 2004.

Watts, Duncan. *Six Degrees: The Science of a Connected Age*. London: Vintage, 2004.

Willis, Holly. *New Digital Cinema: Reinventing the Moving Image*. London: Wallflower, 2005.

Young, Alison. 'Documenting September 11: Trauma and the (Im)possibility of Sincerity'. In Ernest van Alphen, Mieke Bal and Carel Smith, eds, *The Rhetoric of Sincerity*. Palo Alto, CA: Stanford University Press, 2009.

Index